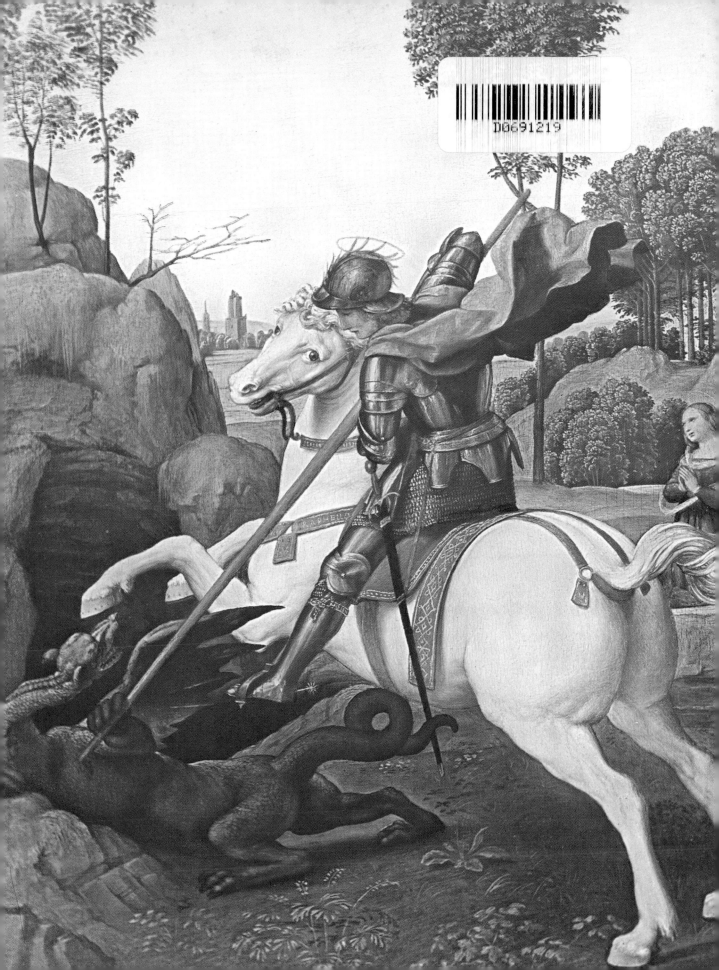

RAPHAEL: St. George and the Dragon. *Detail.*

National Gallery of Art, Washington, D.C.
Mellon Collection

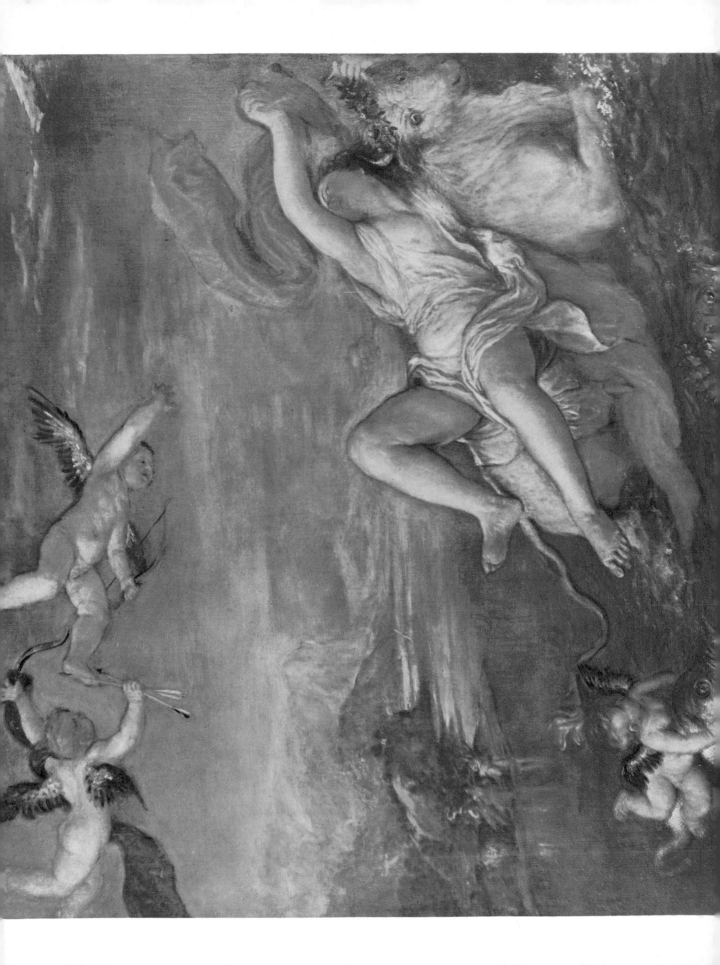

TITIAN: Rape of Europa.

Isabella Stewart Gardner Museum, Boston

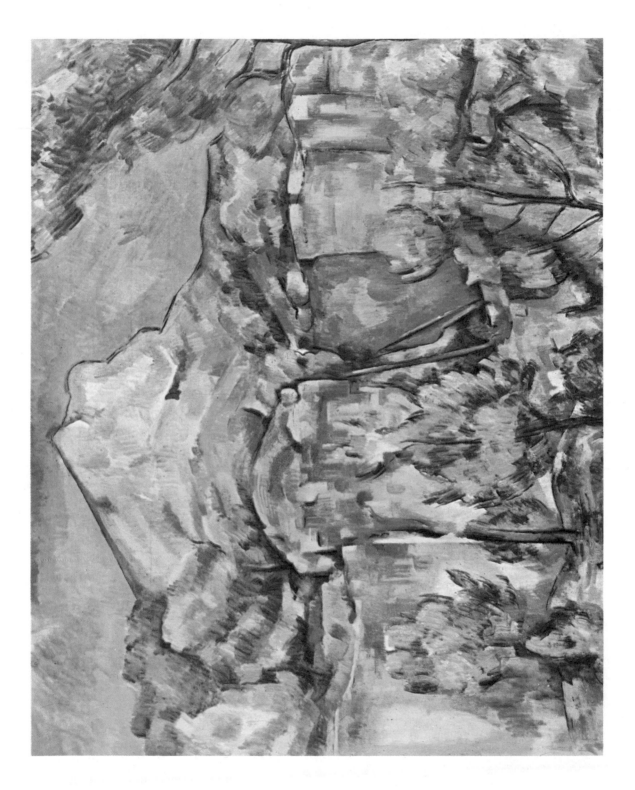

CEZANNE: The Sainte Victoire,
Seen from the Quarry called Bibemus.

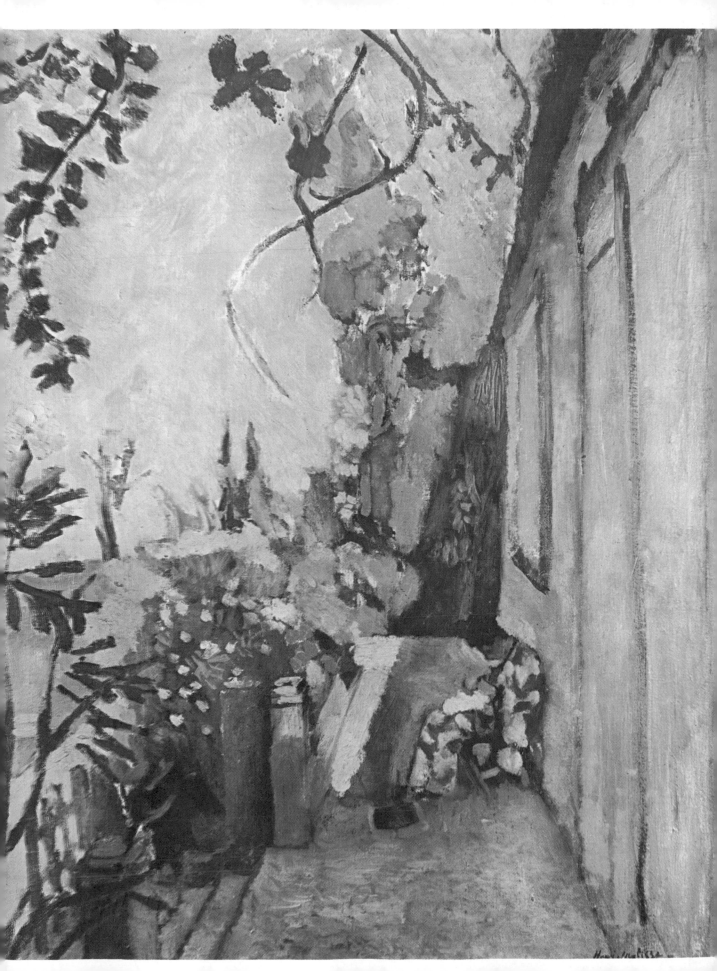

MATISSE: The Terrace, St. Tropez.

Isabella Stewart Gardner Museum, Boston

ART APPRECIATION MADE SIMPLE

BY

JOHN P. SEDGWICK JR., Ph.D.

Associate Professor of Art and Art History
Women's College, University of North Carolina

MADE SIMPLE BOOKS

DOUBLEDAY & COMPANY, INC.

GARDEN CITY, NEW YORK

ABOUT THIS BOOK

A CHALLENGE TO THE READER

Art is what we say it is.

Appreciation is what we make it.

This book puts primary emphasis on art as something of permanent value created above all for its own sake; and appreciation as our active experience of it.

Because the conception and execution of works such as the statues of the Acropolis, the cathedral at Chartres, the Sistine Ceiling, Rembrandt's portraits, or Cézanne's paintings of Mont St. Victoire are taken here to stand among the most complex, difficult, profound and far-reaching of human accomplishments, it would immediately appear a contradiction in terms to attempt to oversimplify the experience of art. This in itself must be pursued by the individual ultimately on his own: it is up to his capacity and effort. The critic can only suggest possible approaches or point to things that ought not be missed.

If we really mean to "appreciate" art, we must go to the museums, to the galleries, public and private, or if possible to the studios of serious artists. The best alternative is to obtain the finest possible reproductions of works that interest us or even that we think ought to, and put them on our walls. For it is only through constant looking at objects under varying conditions that we begin to "see" more than the immediate appearance. Thus, slowly but quite surely we discover which paintings come to change our lives, as against those which—as Gertrude Stein once put it—tend to disappear into the wall.

This book aspires (1) to indicate routes of approach to certain kinds of major art; (2) to provide historical and other clarifying information; (3) to correct some popular misconceptions and emphasize other conceptions; (4) to consider notable works of Western art as part of an overall evolution; and perhaps above all (5) to convey to the reader some continuing enthusiasm for the wonder of art creation.

HOW TO USE THIS BOOK

Unlike a book on carpentry, this is not a manual. How it may be used is up to the reader, though suggestions can be made. Perhaps the best would be to read it, put it aside, and go look at buildings and pictures. The text may be used separately or in conjunction with the plates, which can also be used separately.

In confessing that the book is personal, and therefore prejudiced, it must equally be asserted that the author has no intention of persuading the reader to surrender his own prejudices—only at most to change or develop them. And always one can prefer Delacroix to Rubens without claiming him for a greater artist.

It is sometimes said that the study of art is like that of any other history or science except easier and pleasanter in that the "data" or "documents" are agreeable to look at. It should on the contrary be plain to anyone who reads this book that art is one of the most difficult of all studies. The work in itself is complex enough, without trying to account for an economic, political, social, or religious background. Where to do so appeared essential such background has been provided. Otherwise the reader may wish to turn to one of the economic or social histories of art, or, better, to a competent history of civilization, in which art assumed its role as inevitable symbol and expression, interpreting life and the universe.

APPROACHES TO ART

On that ultimately paradoxical subject, the *significance* of the work of art, there is little to say. Both the symbolic and the expressive aspects of given works are from time to time considered here but in the end both remain inseparable and the same.

And yet all along the way art appears self-contradictory. For it is both the most direct dealing with objects and the most indirect depending on analogies creative experience can take. We say of a poet that he makes us "feel" or even "hear." Why should this simple shift in sensory experience provide such a profound tension in spiritual communication?

But it must be observed that art is, in the end, an abstraction—no matter what sensory experiences it deals with or even sustains—organized in clarity and complexity which is ascertainable yet never analyzable, which is always purposeful without entertaining a definable purpose.

Thus we look within the vehement style of Van Gogh for subtlety and articulation; we find agitation and passion in the clearly-ordered style of Cézanne.

The most immediate need within any new realm of human experience—as with the child for the world at large—is sheerly to identify. Thus the name, the identity of the work is the starting point. But far too many introductions to art have stopped at this point. For such an identification, like a person's name, is in itself only an introduction, not a definition, much less an experience. This book tries to take further steps.

One venerable technique which is at the same time legitimate criterion is to characterize works of art by certain of those qualities which we apply at large to an individual or to his career—above all to people who have "made" something of themselves—qualities such as strength, poise, energy, consistency, inventiveness, harmony, perseverance. The unique appearance of various of these qualities in a given work in no way define it as art, but do ultimately define its value as opposed to a lesser or non-work of art.

Terms such as Beauty, on the other hand, though certainly not invalid, are so difficult and treacherous as to be inadmissible here except as qualitative of special aspects—i.e., passages or renditions.

Art is emphasized here as purposeful creativity and the faculty most frequently called for on the part of the spectator is that of *imagination*—meaning not a vapid or rootless day-dreaming, but a vital and concrete experience taking us somewhere in a meaningful direction. Thus Rembrandt leads us farther, faster and to deeper purpose than any mechanical vehicle of locomotion, and Michelangelo provides shapes of experience where none existed before, and which but for him, we have no reason to expect would ever have appeared. But if this involves highly developed powers of conjecture, still it all begins and ends only with reality.

I wish perhaps above all to emphasize a factor almost impossible to discuss except in the presence of original works: namely, the unevenness of quality and value of works of art in any period, especially our own. From the Renaissance, for example, we are likely to see chiefly the best work, not the ten- or a hundred-fold quantity of lesser or even bad productions. But at that time art was in the center of the stage. No one questioned its importance. Today art is controversial; non-artists are inclined to feel they must accept "modern" art or reject it. But either is grossly misleading.

For the disparity between significant works and inconsequential or even

fraudulent works is broader today, when art is in some basic respects necessarily esoteric, than ever in the 16th or 17th centuries, when it was broad enough. And to come to know the greatness in certain of the works of Pollock and Picasso requires equally the rejection of other of their works, not to mention those of imitators and idlers.

In this respect Cubism or even Picasso's later expressionist style has already permeated our daily visual atmosphere: design, advertising, packaging, display, and so on. With such a background the average reader can probably, as this is written, step into a museum or gallery and from the experience of his own civilized environment not only appreciate a Cubist painting, but distinguish a good one from another. On the other hand it is certain (if we were to judge by prices alone, which we do not) that before long Pollock's style will have become part of our environment, and less "explanation" of his "purpose" will be called for. It will already have been experienced.

SOME POINTS OF EMPHASIS

From the magnificently long list of the world's masterworks only a very small and rather arbitrary number can be treated in any one book. The works chosen generally emphasize (1) works accessible to the American public; (2) works of contemporary interest; (3) occasional works that are less well known but ought to be better known; (4) certain milestones in the history of art.

As the writer surveys pages on widely ranging subjects he invariably finds things he would now alter or amplify. But the book remains provocative rather than definitive and must stand as it is.

Still, I should like to have recorded a somewhat higher estimate of Gauguin (for it is only what we like, not what we don't, that is of critical value); to try to show why, to painters, Ryder is a more formidable artist even than Munch; or perhaps above all to treat of the absolute attainments of the extraordinarily disciplined Van Gogh, who begins to emerge—in spite of popularization—as touching the ranks of the very greatest.

Would that there had been space to talk of the splendor of the Ravenna Mosaics, the cosmic dynamism of the Book of Kells, the painterly and musical development of Baroque and Rococo architecture, the modernity of Caravaggio and Zurbaran and Chardin, the prophecy of Seghers and Piranesi and Redon.

A noticeable gap is modern architecture, and this despite the fact that it stands as one of the key developments in Western history as well as one of our own major contributions to the world. But Richardson, Sullivan and Wright are already part of our environment; their buildings, ideas, and values are part of our landscape. Any New Yorker can experience for himself the George Washington Bridge, finest example perhaps of one of the grand architectural symbols of all time, the gigantic suspension bridge. This must be seen broadside, from above and from below, and it must be followed along its exciting approaches, onto the seemingly limitless sweep, rising to a climax, then plunging into the forbidding rock mass of the western shore. Its tall grandeur, majestic span, sure precision, strong-yet-sinuous proportioning may then be appreciated as contributing not to an object, but a *process,* the transformation of a conglomeration of steel into a bridge from the city of man towards nature itself.

Above all I should like to have presumed to say more about contemporary painting. *We are in the midst of an art development significant in history and for our own civilization.* These artists, usually called Abstract Expressionists, are un-

equal: the best are very important, many of the others not so at all. But of the best we can say they represent a heroism and a truth that *does not reflect values of their society but instead provides them.*

This is a searching art. It does not "find," as does Picasso—who recapitulates half a millennium and more of European painting. Yet its issues are neither capricious nor pertinent only to the individual artist. It deals, internally, with the roots and processes and directions of unconscious experience, and externally with man in the universe, one which for us is a constant intertransformation of matter and energy acting from the atom to interstellar space, which itself, like the space of these paintings, is not fixed but constantly expanding—to be experienced through factors of energy and time.

No art is good because it has beauty: it has beauty because it is good. If Pollock created beautiful rhythms and tones—musical compositions—from events that seem related to the organic streak patterns on a garage floor, it is precisely because that is only a starting point, only an aspect. A dean of European critics (Lionello Venturi) has recently discovered this art, and found among American painters Pollock in his view ". . . the most passionate; his work goes beyond passion to create gentle, tender arabesques and colors. And going beyond is beauty."

Yet there is more to it than beauty, and even those critics who have been most instrumental in advancing the cause of this difficult art often fail, I believe, to see that it is not limited to eloquent decoration. For one thing, the best of this painting involves incessant struggle. An amateur paints for pleasure or diversion. He only repeats, no matter how freshly or interestingly, what has been done before and is no longer of issue and is therefore meaningless. Mr. Churchill (elsewhere praised in this book) is a thoroughly amateur painter. But so indeed are countless painters today who think themselves professional.

That the struggle takes place visibly on the canvas, in a good contemporary work, is only a feature which distinguishes the latter from Renaissance art, where the struggle took place largely beforehand. But ours is a time of survival battles in every field and dimension of life, and we may see ourselves and our times re-created for eternity in these works.

The fight by itself, however, can no more than grace account for any significant artistic result. From the beginning there must be individual creative power. Talent, inventiveness, responsiveness, articulateness are nothing. *Significant art has a metaphysical value.* The artist is more than an interpreter. He is a leader.

Sometimes he is described as "gifted." But what for? A spiritual capacity is not for the self who receives it but for what he makes out of it. What other people get from it is up to them. A contemporary painter (Franz Kline) has observed: "It's assumed that to read something requires an ability beyond that of a handwriting expert, but if someone throws something on a canvas it doesn't require any more care than if someone says, I don't give a damn."

But even the "understanding" of art becomes misleading. More than one able scholar might never know that an art was dead—because he never knew it had been alive.

That which is transmitted, though complex and ever-changing, is not for that reason obscure. One might almost say it is open to the pure in heart. To return to the words of the painter, art "has nothing to do with knowing, it has to do with giving."

TABLE OF CONTENTS

PART SEVEN

LIST OF ILLUSTRATIONS BY ARTIST

OTHER ILLUSTRATIONS
CATHEDRALS, MONUMENTS, STATUES, ETC.

THE NATURE OF ART

Rembrandt's art is more difficult to understand than Picasso's, although neither is simple and both are of high rank. It is one of the chief burdens of this book to show why that is so.

We find that a normal sensitive child can respond fairly quickly to a good Picasso and—to a considerable extent—even tell you why. The child's response to a Rembrandt is likely to be slower and of a different order.

Furthermore, the average layman if confronted with an original Picasso and a Rembrandt alongside clever imitations of the two, will as quickly judge the difference with Picasso as he will with Rembrandt.

All this has little to do with the relative stature of the two artists. If Rembrandt is supreme among painters, Picasso is also a giant—and it is difficult to think of anyone more talented. The difference between Rembrandt and Picasso is mainly one between the kind of painting characteristic of the 17th century—usually called Baroque—and that of the 20th—usually called (like any contemporary art throughout history) Modern.

History. To see the difference between these two kinds of art it is necessary to investigate certain principles of the development of western art. No important work is created in a vacuum. Although any work of art is a finished experience in itself, that experience is completely significant only for the time, place, and temper that produced it. If we are to grasp more than its superficial appearance, we must be aware of its purpose, its contemporary meaning, and its place in an historical process.

Despite an emphasis on certain kinds of historical development, however, this book is neither a history of art (which is a study in itself) nor is it an examination of works of art as reflective of society, which belongs to the history and comparative study of civilization.

Nor does this book deal, except at certain points, with the study of aesthetics, which belongs to philosophy and asks the complex question, What is art?

Criticism. This is primarily a book on art analysis not to say criticism. Now it is sometimes urged that the task of the critic is to bring about a situation in which his function will no longer be required. And Picasso himself has said, in a famous remark: "Everyone wants to understand art. Why not try to understand the song of a bird?"—the implication being, quite correctly, that the latter would be easier. And Goethe has said, "Only part of art can be taught, but the artist needs the whole." This sounds as if art cannot be entirely known, measured, or analyzed. That is true, but it applies as well to religion and most other important human activities. What we seek then is to analyze those aspects of art which *can* be analyzed, and at the same time to gain some sense of what art is and has been.

The job of the critic is to indicate which kinds of art he finds most important, and why. Even if his judgment on the former is not entirely sound, or his clarity or cogency in the latter insufficient, he can still hope to increase the awareness and deepen the response of his audience simply by communicating the fruits of his own experience. Most laymen would hesitate to judge the relative quality of two surgical operations; yet the capacity to do so could be more readily learned than the capacity to judge two significant and unfamiliar works of art. Perhaps one reason the layman is often tempted to take upon himself the role of judge of art is that he observes wide disagreement among critics. This only testifies to the relative difficulty in judging art—it hardly gives license to those lacking experience. The best solution for the layman is to seek out those critics he best understands or finds illuminating.

Time and Experience. But the indispensable thing for the layman as for the critic is the test of time: and not the time of other people—how does he know he would agree with them? (And besides even today there are divided camps between those who prefer Raphael or Rembrandt, although both are pretty universally accorded the rank of greatness.) Not just passive time spent: but actively living with and working on the art—yet never too much with the mind, which is usually a block, but with all the capacities of the human system, body and soul: for in a great work they all were required to make it.

With experience most people's tastes change. Just as it is not unusual to prefer Offenbach before preferring Bach, so it is not surprising when the neophyte likes Thomas Benton before Jackson Pollock. Both in fact were American painters, and the former was the first teacher of the latter. Benton's style is more accessible than Pollock's and has had some influence on American painters. But his work remains mediocre. Pollock eventually painted some of the finest American pictures, but it is almost as if he, too, had to go through a Benton stage (a vigorous and striking, but obvious and ultimately dull kind of art) before he could effectively get to work.

Something of the same is true for the person who looks at the paintings. The old concept of producer and consumer, or giver and receiver of art is inadequate: it seems to suggest a product of consumption. A work of art is not consumed: it is *experienced*.

The consumer does not buy the painting: he buys the opportunity to live with it. If he does not develop with it in such wise that he is a better man for it, he is committing a crime of aggrandizement against, not the artist, who *has* his art, but society. As a guide at the Louvre is reputed to have said: You are not here to judge these works: they are judging you.

When a person of experience in art listens to the likes and dislikes of those without it, he is likely to be even more bored or offended than a lawyer or doctor in similar situation, for in their realms superficial common sense has at least an occasional application.

The Beginner. Art is different but in no way divorced from life, and many of the problems, situations, and feelings of life take part in art. The neophyte recognizes this in painting, when he seeks—for example—psychological interpretation in portraiture, ideal beauty in the nude, dramatic coherence in a painting of human action, or textural exploration in a still-life. His puzzlement begins when he is confronted with, say, a portrait or a religious picture which is not based on the problem that he would normally suppose but on some quite different realm of experience.

He wants to know what to look for and here is his first mistake. For even if he has learned the sort of thing that happens in one Van Gogh, he may search in vain for it in another. There is no point, then, in asking what he *ought* to think or feel in certain kinds of situations, though it is perfectly sensible to ask what kind of experience other people may have had.

For example, if he learns that one of the effective means of construction in a given picture is the tension between basic divisionings which are off center, he may be confused when he finds a Cézanne (or some other picture) which is just as vitally divided right at the center. The best one can do is to develop wide capacity for visual experience, and, as Wordsworth urged: "Come forth, and bring with you a heart that watches and receives."

Taste. But how does one know when he is right or wrong? This is a matter of training and the development of confidence (*never* over-confidence) in judgment, vision, and what the French call "taste." That they do so is typical of the Gallic temperament which likes to *savor* things, whether food, love, politics, or art. When the French painter Poussin said that the end of art is delectation, he did not mean only refined enjoyment, as the word might suggest to us, but the profound area of experience which we call sensibility.

Only when referring to the judgment of quality or importance in works of art does it make sense to say: one has taste. This refers to vision, balance, imagination, integrity and a great deal of experience with *works of the kind in question*. The Chinese have difficulty with much western painting (they did not readily see why a person's face should be painted black on one side and white on the other). By the same token a westerner may be—at first—equally charmed by a very good and a very mediocre Chinese landscape. The outstanding connoisseurs—those whose word is seriously considered, for example, in a court of law—at any given time can usually be counted on the fingers of one hand.

Art is Difficult. This may sound a little discouraging—and is meant to be. It takes far more talent and far more training to become a good judge of art than a good judge of most other things. But that has nothing to do with the potentiality for most people to get a very great deal out of a work of art.

All this emphasis on difficulty is urged as a corollary to the opening assertion that a child can appreciate Picasso. *This is because modern art is direct, not because it is easy.* Indeed the most readily popular modern art—most of the paintings of Raoul Dufy, for example, or the decorative side of Toulouse-Lautrec—is, if not always superficial, at least playful and hardly at all demanding. But Cubism is very highly demanding of the spectator, and so are the best works of Expressionism.

It is in part simply that the child suffers fewer

blocks to what happens in a painting than the average adult, who tends to *read in* all kinds of experience borrowed from other areas of living. For the spectator as well as for the artist, the process of digging through to the significant, the pertinent, the relevant is of the utmost necessity.

The Writings of Artists. What artists have from time to time told us in words about what they were doing is helpful *as an initial approach*. In the end, of course, if the work could be written, it would not need to be painted or carved. But the writing of the artist can nonetheless be highly illuminating. It can help us to see where he started, and what he was about.

The verbal expressions, however, of the visual artist are very different in different periods, and must be taken in historical context because they almost always involve the artist's position rather than his art.

The writings of the older artists—of the 15th or even the 18th century—have a very different value for the critic than those of contemporary artists. The latter would have been perfectly well understood and appreciated by the older artists, but they considered themselves (because of their historical position) not so purely artists as interpreters of life. Therefore their writings are generally preoccupied with questions of how to render nature, and seldom with the problems of picture-making as a self-conscious and internally developing process.

Modern artists are more apt to speak about the latter problems. Yet these problems are pretty much the same for all post-Renaissance painting, and so the writings of modern artists are revealing not only of their own work, but go as well for Titian or Holbein or Poussin.

With the moderns the art of painting is pursued for its own sake. This is why it is relatively easier to understand a modern work—starting from scratch—than a Baroque one. It is the older painting which most requires to be explained.

Abstract Art. There is nothing inherently difficult about abstract art, whether of the Middle Ages or the South Sea Islands. The arbitrary way in which its representational aspects have been manipulated to heighten or congeal its meaning are plain to see. There is little difficulty in understanding *the nature of the art* in Romanesque sculpture once we know the identity of the image.

With modern abstract art the situation seems at first different, because the neophyte wants to know,

What is the meaning? He is surprised to learn that the modern artist, in looking at the Romanesque work, has little or no concern for its meaning. For the modern abstract work, as for the artist, the meaning is in the work itself, in the process of expression, and the expression is that of the artist's inner nature and spiritual development. It is not an expression of how he feels about his breakfast, how he feels about his wife, or even how he feels about the state of his society—on which he may or may not be an authority.

It is instead an expression of how he feels about life, based on a good deal of experience of certain kinds—which is all that anyone can claim—experience worthy of communicating or it will not make a work of art. *While an artist's experience must be purely personal lest it lack integrity or the "ring" of truth, it must not be particular but rather general or recurrent—that is, typical or archetypal—lest it lack universality and not be art.* Such is implied when Picasso declares that all art is the same (which has nothing to do with the principles according to which a given kind of art is made).

When the able and sensitive child knows modern art instinctively it is because he knows himself the act of moving a crayon, of choosing a color, of staining a wash, of modelling earth with his fingers and thumbs. He knows that a line can be sympathetically muscular, a color juxtaposition exciting (or sonorous), and that when he is done he has what he calls a "design" or a "painting," *not* a representation of the king in his closet with the fleece about his neck. But the adult looks for the latter, and has largely forgotten how to look for the former. And so when he looks—quite rightly—for the latter in a Rembrandt, he may have almost insuperable difficulty in getting its significance, because this depends upon the former.

A Work of Modern Art. There are several possible approaches to the work of an abstract painter like Jackson Pollock. One is through the history of art: through the tradition of vast and involved painting inspired in the world of turbulent nature and seen in such widely disparate works as some of these by Leonardo da Vinci, Altdorfer, Tintoretto, Rubens, Van Gogh, Kandinsky, or Gorky. Another is through examining the nature of the work of those recent artists who particularly interested Pollock: Ryder (Plate 50c) in America, Miro and Picasso (Plate 57a) in Spain and France. Another is to become acquainted with Pollock's background: Cody, Wy-

oming; bronco-busting, high riding, violence and travel; daring, action and destruction; or even that style of open vigor in western painting which Pollock learned and rejected: such as that of Thomas Hart Benton.

But the best approach is to close in on the painting itself. Let the reader find—not the reproduction in this book (Plate 63b) which will serve only for comparison with other works as they appear in this book—but a good and preferably a large (because that is most typical) original. This will likely be at the Museum of Modern Art in New York, but might also be in other galleries throughout the country and the world and in private collections.

Let the reader approach the work not at the end of his working day (for that is not when the artist approached it) but when he is himself fresh, strong, and ready for exercise of a new kind. Let him take in the picture as a whole, because it is a whole and was not meant to stop sooner or later than it did; but let him then move in through the picture, because with this kind of painting that is what was intended.

Let him look and feel, but not try to think too much. It is not that painting is anti-intellectual, but that the intellectual vitality in art can be apprehended only *through* the experience of its purely visual presentation. In this kind of art, at least, one might urge that: first we see, then we feel, and only after that can we think. And this means think in terms of the art, not what we "think about it" or "what it means." Such crutches must be surrendered or the viewer will trip over them and never get to the painting. To ask "What is the picture about?" is to interpose your own criterion, your own ideas of relevance; in so doing you prevent yourself from learning something new. Only after you have come to know the painting fairly well will you have any idea what it is about, and then you will be far less inclined to try to put it into words, though you might very well wish to start practicing drawing or painting itself.

With the Pollock, get up there and grope around. That is what the artist had to do. This painting represents a successful piece of groping on his part, so you may take it on faith it is worth your effort and, if you get nowhere the first time, you're working at it again and again.

For here is not just paint poured onto canvas. The painting has instead profound and unavoidable suggestions of other kinds of experience, but ab-

stracted in a way that could only be done with these special materials. **What distinguishes art from decoration is precisely that art is an illusion of some other world,** but of a nature that could only be conveyed in these particular terms. For it is the ultimate human mystery in such a relationship of end and means that renders any attempt to define art impossible. All we can do is stress the "human" and emphasize that art—as we mean it—is by definition impossible for the animals and unnecessary for the angels.

Looking and Sensing. But how to approach this experience? There are hints, but they are only starters. In the Pollock, follow the threads of a given color, see what rhythms result and in what sort of musical sense the colors are related. Squint, and see what larger groupings form for the eye, and whether they transform themselves, and if so how, and with what rhythms, and how these rhythms are related to those created by the linear patterns. Squint again (it is only a device to help separate out the visually important parts) and see what spatial effects result: which patterns stand out in front of which—how far? inches? or miles? Do things seem to stand in front of or behind the surface of the painting? Where is the surface of the painting? How is it maintained? What determines the edges? Why does it stop where it does? Does the artist change his means of expression at such points?

The viewer of the painting in the original will have perceived that the qualities of order or formal organization in this kind of painting are neither measurable nor static but rhythmic, and that he must *sense* them in color, in light and dark, up and down, left and right, front and back. Suddenly he may perceive that all of these factors are *operating together at the same time.*

Yet this is only the beginning. Why should one involve oneself in the first place—whether painter or spectator—in so complex a process. What is the significance? What is being expressed?

Such questions of course cannot be fully answered. But suggestions can be made. In this particular kind of painting what may come to the apprehension of the spectator? Perhaps he will think of music of a certain informal, vehement, sporadic and extended pace.

Or he may sense wisps of moonlit clouds against an inky sky with exploding stars and trails of the Milky Way. Or he may sense experience in the realm of the geological, the meteorological, the

ectoplasmic: the microscopic or the telescopic. This is *not a representation* of what may be seen—under any conditions—through a microscope or telescope. Although it may summon up that kind of image, such is not the painting's purpose. Its effect is an intuition into the significance of such experience for people of our world: it has to do with our "view" of reality. It is in a sense, then, metaphysical. It is also historical, for such a painting could only be done meaningfully in the 20th century and, perhaps only in this country of independent pioneers into the untried and unenvisioned.

The Artist's Approach. We are at this point a little surprised to discover that the technical means employed by the artist are not so novel as they seem at first.

Pollock has pointed out that his painting does not come from the easel (painting in oil on stretched canvas on an easel had been the dominant of all visual arts in the west from the 16th through the 19th centuries). He notes: "I hardly ever stretch my canvas before painting. I prefer to tack the unstretched [thus without spring] canvas to the hard wall or floor. I need the resistance of a hard surface. On the floor I am more at ease. I feel nearer, more a part of the painting, since this way I can walk around it, work from the four sides and literally be *in* the painting. This is akin to the method of the Indian sand painters of the West." Nor is the latter the only older tradition of painting so to work. Indeed must it be emphasized that the type of relatively small, right-side-up, framed, perspective scene that most of us are used to represents only one of a great many among the world's traditions of painting (see Appendix A).

As for the medium, Pollock states, "I continue to get further away from the usual painter's tools such as easel, palette, brushes, etc. I prefer sticks, trowels, knives and dripping fluid paint or a heavy impasto with sand, broken glass, and other foreign matter added." Think of his need for resistance. Remember how these things actually work in the painting. Now we may see that such techniques are not at all whimsical, nor even so arbitrary as they may at first appear, but are the best practical solutions to a prevailing artistic need.

Range of Quality. In modern art there is a vast unevenness in quality. This was also true of the famous Quattrocento (the Italians more reasonably call the 15th century the "14-hundreds"), but of those pictures we are now likely to see only the cream. In any period the percentage of great art achieved is minuscule. Of many thousands of serious painters in either France or this country today, only a handful in either place could be called "great" and then only at certain times. Pollock himself testified that frequently his paintings turn out a mess: these, it goes without saying, he did not offer to public view. Of many a lesser painter, however, we are quite likely to see mediocre or even bad pictures, and these in some of the best places. Cézanne is one of the three or four outstanding painters of the West, yet he painted many a dull picture.

By the same token many techniques introduced in modern art out of necessity have been used by other artists, even famous ones in a frivolous way. When Braque paints a brass nameplate into a cubist picture it is a legitimate play on the meaning of textures which is a vital part of the aesthetic of the work. When Dali plays with textures it is all too likely to become a meaningless trick.

Let us consider another kind of modern painting. We see a good painting by Matisse (Color Plate), this time an oil painting on stretched canvas, like the old masters. But the painting does not otherwise look much like the old masters. Patterns of line and color take up arbitrary rhythms which transcend but do not obliterate a vivid response to the warm brightness of sunlit sea and flowers and the cool intensity of shaded wall and terrace. Or perhaps it is (one of his favorite themes) a girl reclining near an open window, wherein a strip of pale, cool, luminous green may suggest at once sky, ocean, the receding plane of a wall or ceiling, a flat tone beautiful and pure in itself and also musically evocative of other tones and areas of the painting but never quite the same as any other. And this sort of thing happens throughout a picture, so that it is continually exciting, refreshing, and sensually persuasive. We see to some extent why the picture is interesting and never dull, but what kind of picture is it? **How did he come to paint it this way?** The artist himself can tell us something of how he goes about it. Matisse observes:

If upon a white canvas I mark down some sensations of blue, of green, of red—every brushstroke diminishes the importance of the preceding ones. Suppose I set out to paint an interior: I have before me a cupboard; it gives me a sensation of bright red—and I put down a red which satisfies me; immediately a relation is established between this red and the white

of the canvas. If I put a green near the red, if I paint in a yellow floor, there must still be between this green, this yellow, and the white of the canvas a relation that will be satisfactory to me. And these several tones mutually weaken each other. It is necessary therefore that the various elements that I use be so balanced that they do not destroy one another.

How does he go about accomplishing this?

I am forced to transpose until finally the picture will seem completely changed so that after successive modifications the red has succeeded the green as the dominant color. I cannot copy nature in a servile way, I must interpret nature and submit it to the spirit of the picture—when I have found the relationship of all the tones the result must be a living harmony of tones, a harmony not unlike that of a musical composition.

For music is the most abstract of the arts, and in modern times many painters have observed the tendency of painting to approach—not music itself —but a condition related to it.

But if the colors in the painting do not "copy" nature, where do they come from? Matisse says:

I discover the quality of colors in a purely instinctive way. To paint an autumn landscape I will not try to remember what colors suit the season, I will only be inspired by the sensation that the season gives me; the icy clearness of the sour blue sky will express the season just as well as the tonalities of the leaves. My sensation itself may vary, the autumn may be soft and warm like a protracted summer, or quite cool with a cold sky and lemon yellow trees that give a chilly impression and announce winter.

Is there any theory or principle upon which the "cold blue" or the "lemon yellow" is chosen? Some painters have been known as close students of optics, on the theory of complementary colors (discussed later in the book) or principles of color as expressive of emotion. But Matisse denies this.

I . . . merely try to find a color that will fit my sensation. There is an impelling proportion of tones that can induce me to change the shape of a figure or to transform my composition. Until I have achieved this proportion in all the parts of the composition I strive toward it and keep on working. Then a moment comes when every part has found its definite relationship, and from then on it would be impossible for me to add a stroke to my picture without having to paint it all over again.

But is the purpose of the painting then purely decorative—to make a fitting musical harmony inspired perhaps by some sensation from nature? What is the artist's purpose in going to all this trouble—which must frequently result in failure? **Why is he a painter in the first place?**

Matisse insists,

What I am after is above all expression. Sometimes it has been conceded that I have a certain technical ability but that my ambition being limited I am unable to proceed beyond a purely visual satisfaction such as can be procured from the mere sight of a picture. But the purpose of a painter must not be conceived as separate from his pictorial means, and these pictorial means must be the more complete (I do not mean complicated) the deeper is his thought. I am unable to distinguish between the feeling I have for life and my way of expressing it.

But what then is meant by expression? And how is it rendered?

Expression to my way of thinking does not consist in the passion mirrored upon a human face or betrayed by a violent gesture. The whole arrangement of my picture is expressive. The place occupied by figures or objects, the empty spaces around them, the proportions—everything plays a part.

The mention of proportions recalls the painting area in the first place: the paper or canvas with its size and shape. How is this related to the necessary evolution of the work of art?

If I take a sheet of paper of given dimensions I will make a drawing which will have a necessary relation to its format—I would not repeat this drawing on another sheet of different dimensions, for instance on a rectangular sheet, if the first one happened to be square. And if I had to repeat it on a sheet the same shape but ten times larger I would not limit myself to enlarging it: **a drawing must have a power of expansion capable of bringing to life the space which surrounds it.**

Neither such different artists as Giotto nor Michelangelo nor Rembrandt nor Van Gogh would disagree with this, and it even applies to the minute panel painting of the Van Eycks, which although meant to be seen very small and close to, possesses the power of creating within itself an energetic universe.

Matisse has been quoted at length because what he says would stand basically for many kinds of modern painting, and in part at least for all the rest.

But other modern painters can speak for the art of painting, as well as shedding light upon their own work. Countering the widespread popular prejudice

that modern artists are by definition revolutionaries (as indeed some of them are), the leading French expressionist painter Georges Rouault insists: "I am a believer and a conformer. Anyone can revolt; it is more difficult silently to obey our own interior promptings, and to spend our lives finding sincere and fitting means of expression for our temperaments and our gifts—if we have any." Such words could have been uttered by Cézanne with equal conviction. Yet anyone who compares the work of Rouault or Cézanne with that of older painters sees at once how much revolution *within artistic forms* was felt to be basic and necessary by these two artists. Perhaps what they have meant here is echoed in part in G. K. Chesterton's remark, that to have time to preach his own heresy a man must be orthodox on most things.

Abstraction and Life. Braque has emphasized: "The painter thinks in terms of form and color." Many people are confused by abstract art because they suspect that it is art divorced from life. But this would be a contradiction in terms. Abstraction in art is merely the purification of the painter's language. In using language he speaks—like the poet, philosopher, scientist or composer—as a man. The artist speaks of life—what else is there to speak of? —but in his own language, the only language there is that will communicate his order of temperament and range of experience. This is part of what Picasso meant in saying flatly: "There is no abstract art."

What then is the *area* of the artist's experience? Marc Chagall says, "I am against the terms 'fantasy' and 'symbolism' in themselves. All our interior world is reality—and that perhaps more so than our apparent world." How this inner world is expressed depends on many things—among them the style of the age and the temperament of the artist. A close examination of Chagall's paintings shows that the apparently fantastical arrangements are actually composed of familiar forms and ideas, but juxtaposed or superimposed so as to induce the spectator to join the artist on a poetic flight of sensations, sometimes whimsical, sometimes keen and poignant (e.g. the Birthday). And Chagall himself emphasizes that "the fact that I made use of cows, milkmaids, roosters, and provincial Russian architecture as my source forms is because they are part of the environment from which I spring and which undoubtedly left the deepest impression on my visual memory of any experiences I have known. *Every painter is born somewhere.*"

Not all artists assert an interest in the locale of their experience, but any genuine artist shows it. Even Mondrian, one of the most apparently abstract of painters, shows clearly the influence of the limpid, cool, ordered sense of the rooms and canals of his native Holland which were rendered by his 17th century compatriots in terms of bricks and walls and windows. And the same sense of ordered space, as when we look through one room into the room behind it, and the courtyard behind that, is conveyed vibrantly in Mondrian's squares and rectangles of blue and red and yellow and white: for one of the basic ways in which we can distinguish a good Mondrian either from an imitation or from mere decorative art is the *spatial tension*, the push and pull among these areas, worked out intuitively and uniquely in terms of their relative size, shape, color, position, and the lines between them. And Mondrian emphasizes that, like all modern artists, the truths he speaks of are inspired by nature:

> The laws which in the culture of art have become more and more determinate are the great hidden laws of nature which art establishes in its own fashion. It is necessary to stress the fact that these laws are more or less hidden behind the superficial aspect of nature. Abstract art is therefore opposed to a natural representation of things. But *it is not opposed to nature,* as is generally thought. It is opposed to the raw, primitive, animal nature of man but it is one with true human nature.

And how does the artist get at this essence of nature? The reader who is familiar with the witty (Plate 53*c*), ingenious, and incisive works of Paul Klee may sense before long that, although his style is the source for much sheerly entertaining art of the 20th century (such as that of Saul Steinberg) Klee's work itself is basically serious, often tragic. A musician and musicologist, and an intense student of literal as opposed to the psychological value of visual symbols, Klee answers our question in the following words, words that would be acceptable alike to the lyric poet and the theoretical physicist:

> When intuition is joined to exact research it speeds the progress of exact research. . . . One learns to look behind the façade, to grasp the root of things. One learns to recognize the undercurrents, the antecedents of the visible. One learns to dig down, to uncover, to find the cause, to analyze.

Symbolism. The question of symbolism has been raised, and it lies at the foundation of any higher

human activity, from the art of war to the art of a liturgy. But symbols seem to be used in different ways in different activities, so that they actually have a different function.

Without entering into the abstruse study of symbols it may be possible to indicate a difference in kind between those of science, religion, and art. A scientific symbol is usually explicit and has a precise definition for its use, even though it may have further ramifications philosophically. A religious symbol, such as a serpent or a cross, is also definite in its meaning, but holds room for wide possibilities of interpretation as well as description.

But with this we border on the artistic symbol. The fish in Early Christian art, for example, is a symbol of Christ. It is thus a widespread artistic device, and one can deal with its use in a stylistic, and thus an artistic, sense. Nonetheless it remains a religious symbol, served by art.

What we mean by a purely artistic symbol can be seen in the works of Klee (or the French painter Redon, or the American, Bradley Tomlin), where a fish, or an arrow, is used not for its intellectual significance or its roadsign value but its shape, its color, its angle and direction, in other words its visual significance (though it must be pointed out that with an artist like Klee the latter factors are often played off subtly against the former).

To state these distinctions in briefest form: a triangle for the scientist is a statement of the absolute relationships between three given points. The religious significance of a triangle is a reference to the Trinity (or—for the Greeks—a Trilogy). But to the artist, a triangle is a possible means of expressing the stability of a pyramid, the aspiration of a spire, or the movement and suspension of a shooting star.

Purpose and Motive. The question is, what motivates the man who has something to offer the world, and devotes his life to the profession of art. Surely the relentless desire to remake the world, or to make a new one, or "remold it closer to the heart's desire" lies somewhere at the base of all of man's most serious and least explicable endeavor.

Connected with this is a sense of the inexplicability of life, the mystery of the universe. "To make the unknown known" applies equally to Thomas Aquinas, to Rembrandt, or to Einstein. If what is sought is truly the unknown, then it can be approached not by measuring-sticks (though they have their place of value) but through the intuitive power of faith.

It is thus that Shaw can say quite seriously: "The true artist will let his wife starve [Monet did], his children go barefoot [Rembrandt did], his mother drudge for his living at seventy [Whistler could have], sooner than work at anything but his art." We are faced with the conception of art as dealing with the absolutely relevant, the absolutely essential, the absolutely crucial. What Milton did was, if possible, even more necessary than what Cromwell did, for the most enduring work of the latter would possibly have been accomplished in time by the English political genius, but the work of the former is irreplaceable.

As Rudolph Arnheim has written: "Genuine artistic activity is neither a substitute nor an escape, but one of the most direct and courageous ways of dealing with the problems of life. To be sure one can use the peaceful silence of the studio to withdraw from reality; but *similarly the so-called active life can serve to give protection from the constant exposure to the truth.*"

Result. But what is it the artist *does* or accomplishes which permits such emphasis on his value? A superior, or truer, braver, or profounder state of being may be of absolute private value, but what does it offer to the world? Shelley contained the artist's product in a phrase:

> from these create he can
> Forms more real than living man . . .

The compelling truth of the genuine artistic image is likewise expressed in Picasso's remark on one of the greatest of his countrymen: "Velásquez left us his idea of the people of his epoch. Undoubtedly they were different from what he painted them, but we cannot conceive a Philip IV in any other way than the one Velásquez painted."

The value of art for education has (in this connection) often been observed—and that means education for adults even more than children. It promotes the development of a great deal of necessary and basic experience of which we are all aware—or suffer from it if we are not—and which is quite normally barred by the functioning intellect, by the requirements of the rational in daily situations—requirements which have been known to drive conscientious jurists to distraction and despair.

But we are not speaking here of art as some kind of clinical psychology; rather we seek to emphasize, as Longinus did, that "art is the echo of a great soul, and its value ultimately lies therein."

Art and Society. The creative artist is one who gives, that is the meaning of saying that one has a "gift"—it is given to him to do something with. This is why people have defined an artist as a selfish person who is liked, and a philanthropist an unselfish one who is not liked. The latter gives what is ultimately not his to give, and at no real cost to himself. Is the Alba Madonna, (Plate 19a) a gift of Andrew Mellon to the National Gallery in Washington, or is it a gift of Raphael to the world?

So we are faced with the role of art in society. Many social historians like to point to those periods of art as best which follow close upon periods of social accomplishment and expansion. But this is only a half truth; and it is true only of certain kinds of art (like decorative Venetian painting). But some of the world's leading art forms have appeared when society was bleakest, and we are tempted to agree with Véron's judgment, that *"Art, far from being the blossom and fruit of civilization, is rather its germ."*

Art and Truth. The difference between art and "truth"—or the difference between the functions of art and of science—have been elucidated by the philosopher, Croce, when he observed that knowledge is either "intuitive knowledge or logical knowledge, knowledge obtained through the imagination or through the intellect. . . . It is in fact productive either of images or concepts." The latter is the province of science.

A recognition of the intuitive "truth" which is the province of art is necessary—one may insist—not only for an appreciation of artistic values, but also of the artistic process. Croce has also pertinently remarked: "Often one hears people say that they have many great thoughts in their minds, but that they are not able to express them. But if they really had them, they would have coined them. . . ." And Michelangelo insisted that the artist "paints not with the hands but with the brains," a conviction echoed by other artists—e.g. Gauguin and Picasso, who have (separately) insisted that if their hands were cut off they would paint with their feet. Leonardo da Vinci, who remarked that "the minds of men of lofty genius are most active when they are doing the least external work," was criticized for spending entire days "just looking" at the Last Supper without lifting a brush.

If it is true, as Bertrand Russell has feared, that artists are on the average less happy than men of science, it is not simply because they are usually far worse paid, nor entirely because they are not interested in happiness, but because art is more demanding, there are fewer verifications: the original artist is alone in the world.

Freud on the Artist. One school of modern thought which has sometimes been more harmful than helpful in understanding art and its function is that of psychoanalysis, at any rate on the part of Freud himself, who described the artist as "one who is urged on by instinctual needs which are too clamorous; he longs to attain to honor, power, riches, fame, and the love of women; but he lacks the means of achieving these gratifications." The implication is that the artist is a frustrated man of action.

But the facts are that some artists, like Raphael or Rubens were notably successful in every one of these "clamoring needs" in addition to achieving thorough-going art. Indeed the critic is likely to feel that the social achievements if anything prevented them from attaining the profounder artistic achievements of such contemporaries, respectively, as Michelangelo or Rembrandt. And Rembrandt, it must be noted, had, at a relatively precocious age, attained those very "gratifications." That he later turned from them represents a choice which is essentially moral.

Freud's studies of artists are notoriously liable to error, partly because he did not know enough history of art to ascertain which factors belonged to the personality and which to the entire age, but partly also—one may suppose—because the principles of sublimation, ill-health or alienation can apply only to the periphery of that healthiest and most affirmative of human functions: the making of art. This does not mean that psychology has nothing to contribute to the understanding of art. Some concepts of the collective unconscious, for example, may prove quite fruitful.

Relative Values of Art. But "art" is not one thing only; a painting, for example, does different things. One way to consider the function or value of a painting is according to a series of levels. A painting can, we might say, accomplish the following functions in ascending order of value: it can observe, record, and comment; it can interpret, then evaluate; it can even justify, and, at the ultimate, create. Each of these seven stages can be called artistic.

Thus it is perfectly sensible to call photography an art. In doing so we need only remark that photography is capable of accomplishing the first two, or at most the first three of these steps. After this the painter takes over.

It is in part an awareness of this which inclines contemporary painters to forgo the first two or three steps and get immediately to what thus appears more purely to be the business of painting.

The level of "interpretation and evaluation" is nowhere stronger than in Van Gogh, where human joy and sorrow are poignantly rendered in tearful, agonized cypresses and in apple orchards of beatific bloom.

The level of "justification" might be represented in the work of Giotto or Velásquez or Vermeer or Cézanne, where the solutions to the strongest contrasts between on the one hand the complexities of nature and experience, and on the other the organizing will of the artist, are most consummate.

Creativity is part of any art worthy of discussing. But the level of the sheer "creation"—of unfathomable yet incontrovertible worlds—is left perhaps to the only two absolute artists the West has known: Michelangelo and Rembrandt. It is no accident that Creation is the underlying theme of Michelangelo's Sistine Ceiling, and is the vital implication in Rembrandt's portraits of human personality.

The difference between the more limited and the more far-reaching of art forms is not the same kind of difference as that between good and bad art. Good art is of a piece. Bad art can be bad in any number of ways.

Good and Bad Art. If the reader compares Ingres' Apotheosis of Homer (Plate 17b), for example, with Raphael's School of Athens (Plate 17a), he should be able to see even in the reproduction how the Ingres is flat, pasty, insipid, artificially staged, dully composed and almost offensive in quality. It contains elements borrowed without necessity and composed without creativity. Raphael's picture is solid, monumental, alertly intelligent, breathtakingly alive, and superbly inventive.

Now Ingres was, at certain other kinds of things, a very important and sometimes a very fine artist. But he could not paint a Raphael-kind of picture, much as he admired it and much as what he knew about it. The reasons why this particular kind of painting failed require some acquaintance with basic principles of the history of art; therefore, they cannot be considered here. This will be more clear, it is hoped, when the reader comes to the discussion of Ingres, and after he has looked at both Raphael and Poussin.

We can at this point indicate, however, that the "good" in art has no more to do with the "beautiful" than it has to do with morality. *Art creates its own values: to know them we must know art.*

Art and Beauty. The beautiful is an ideal which holds for certain kinds of art: the classic Greek (for example) in that the resolution sought was one of harmony, ease, grace, dignity, and purity. The beautiful would have meant nothing, however, to the designer of a Gothic cathedral or to Goethe who with that in mind said, "This characteristic art is the only true art. When it acts upon its surroundings out of a fervent, unified, personal, independent feeling, unconcerned and even ignorant of anything foreign, then this true art may be born out of coarse savagery or out of educated sensitivity—it is whole and alive." (From the translation of Goethe's "Of German Architecture," by Christiane Crasemann Collins.)

This suggests an old distinction between the beautiful and the characteristic in art, or as it is often called (stemming from the contrast long felt between Raphael and Michelangelo) the beautiful and the sublime. But even the concept beautiful will be applied, now to the bodies of Raphael's virgins, now to the inner spirit of El Greco's saints. It is better to leave the term beautiful either to the philosophy of art, or to the spontaneous description of a woman, or a tree.

We might urge instead that any genuine art must be an expression of the temperament—both of the race and of the individual. Art is a formal expression of considered human experience that can be conceived in no other way. Skill in rendering (which often gives rise to a "beautiful" passage) can to some extent be learned. But the artist is born. He can neither be forced to nor prevented from pursuing his role and his creation. Henry VIII rightly admitted that of ten peasants he could make ten lords, but that he could not make one Hans Holbein—even of ten lords.

Temper. The word "temperament" as used here refers to forceful vitality, to a life-urge and an art-form, quite as well as to honesty, strength, and purpose. It is the sap that makes the tree grow, that gives it character and unmistakable identity. Cézanne, who was in a position to know, emphasized that "with some temperament one can be very much of a painter. One can do good things without being very much of a harmonist or a colorist."

It is with such a motto that this book will seek to touch upon something of the force, the character, and the spirit of art forms as they reveal themselves to us.

PART TWO

PRIMITIVE, ANCIENT, AND ORIENTAL ART

THE ORIGIN OF ART

What we mean by art in this book is not something merely artful, but something of weight and significance to mankind. It is what Schopenhauer had in mind when he said, "You must treat a work of art like a great man: stand before it and wait patiently until it deigns to speak." A work of art in this sense means a work embodying values that reflect its time and place of origin, the society and the man that produced it, and beyond that a view of the world that is somehow essential, that tells us something we could not learn otherwise of reality and truth. The result in a work of art is the creation and perpetuation of life; it is here that a man does what a woman does in reproducing the race, for, as a Renaissance portrait-maker said, the aim of art is to conquer death.

We shall not refer, then, to the wonderful world of artifacts nor to merely decorative devices, no matter how masterful the skill invested in them, nor, say, to that marvelously disciplined medium of expression, the Dance, for none of these is creative. Nor shall we refer to what are usually considered the time-arts, such as literature or music, but only to the space-arts, namely architecture, sculpture, and painting.

Much has been thought and written of the ultimate natures of these three media and of the distinctions between them. Perhaps the most useful way to distinguish them is according to the civilization that produced them. The relation between architecture and sculpture is different in the Parthenon, built by the ancient Athenians, from what it is in the Cathedral of Chartres, built by the Gothic Frenchmen. With the former, the architecture itself approaches a piece of sculpture; with the latter the sculpture tends to embellish and further articulate the architecture.

To put it another way: whereas Michelangelo's architecture, painting, and sculpture are closely interwoven and intimately related to each other, Rembrandt's art is pure painting in that it must be seen only in terms of its coloring and drawing: a statue by Rembrandt is virtually inconceivable.

If we consider the disciplines throughout history regardless of particular culture or society, however, it may be noted that architecture on the one hand can basically be distinguished from sculpture and painting on the other, since the former is, in first conception, a functional art and the latter are representative. Or, we could further subdivide, and call architecture functional, sculpture figurative, and painting illusionary. But, as will be seen, each can take on qualities of each of the others. There are pieces of architecture that serve very little purpose, like Michelangelo's Laurentian stairs, or Bramante's Tempietto, but are pictorially or plastically expressive—the one of a stormy temperament, the other of a classical idealism—whereas there are sculptures like Brancusi's or paintings like many by Matisse, which represent very little while having notably decorative and therefore functional aims.

For these reasons it is far better not to consider works of art in the abstract, nor disciplines either, but to consider building or painting, marble or impasto in terms of the particular context in which it is used and the society that valued it. No one would attempt to apply the political techniques that worked in 5th century Athens to 20th century America: why assume that the stone images carved meaningfully by the hand of man could be any more timeless or pure than the manifestoes written with his pen? By this of course is meant only that the *way* in which genuine art can be produced changes. It is also true that—to the extent that a work touches an ultimate reality—Gautier was entirely right in asserting that high art is eternal, and the bust outlives the city.

THE ART OF THE CAVES

Art began when men first took the trouble to make something that satisfied more than an immediate need. The point at which a hut first became a work of architecture, or the markings inside a cave a

painting, will fortunately never be a field for debate, since evidence is lacking; nonetheless we must consider that men created cave paintings of an achievement and quality unreservedly saluted by the finest modern artists, at a time so long before any other evidence of civilization that we can only wonder.

These cave paintings are the first instances we have of the great attempts to coordinate architecture, sculpture and painting. Located on the walls and ceilings of some of the larger caves, away from the entrances, they are executed in line and color according to the undulating surface of the rock, which is so used and adapted that a physical third dimension becomes a part of the painted illusion. No photograph has yet been made that gives any idea of the immanence and immediacy that one feels on seeing them.

Since these "paintings" were made in the Ice Age —of the most famous, those at Altamira in northern Spain are around fifteen thousand years old, and those at Lascaux in southern France nearer thirty thousand years old—in other words at a time that we really know nothing about, it is impossible to be sure what their purpose or function was. But it is imperative to know the basic function of any work of art in order precisely to know what makes it art. For example, the George Washington bridge would lack meaning to an Australian aborigine *even as pure form* if he did not know what it was for: what its purpose is. By the same token, Picasso's *Guernica* loses something of its force if we do not know the circumstances of the war, the atrocity, and the motive for the painting.

With the cave paintings, since we are familiar neither with the way of life of the people who made them, nor with the circumstances under which they were made, we can only make conjecture. We find, first of all, that the paintings do not occur near the entrance, that is to say, they are far from the living quarters, where one would expect to find them if they functioned as decoration. Furthermore they occur in no ascertainable arrangement, being piled together without an eye to relationships, and sometimes even overlapping. From these two facts we must conclude that they were in no way intended to be decorative, but that they must have had some quite different purpose.

Even among the most sophisticated people there is a natural aversion to mutilating or destroying the portrait, whether painted or photographic, of a familiar person; or if the mutilation takes place, it

has meaning. The image is in some profound way taken as an equation of the real thing. The nature of this process is a problem for the psychologist of civilization. What concerns us is that this feeling, natural to any man, is crucial to the image-thinking of primitive peoples. By primitive we do not in any sense mean simple-minded, but rather we refer to people who stand at an early or an arrested stage of civilization.

It is very frequent among primitives to find a manufactured image of an enemy or of game attacked physically—in the hope, feeling, or belief that the real object will thus be injured or killed. It is not at all unreasonable, then, to interpret these cave paintings as images made for the purpose of increasing the hunting success of the tribe, a matter of vital importance to them, one that helps make us aware of the extraordinary immediacy of effect gained through the subtle interplay of the surface of the rock with the painted form. This supposition is furthered when we observe that the animals—which are the sole subject matter of these paintings (when men occur, which is very infrequent, they tend to be stick figures: this is truly "primitive," like the work of children)—are painted always at a side view and usually in motion, just as the hunter would see them. To observe closely the movements of wild animals so vividly depicted in such a film as Walt Disney's "The African Lion" is to be reminded of the extraordinary observation and rhythmic sense shown by the cave painters. And this observation extends to the detailed rendering of anatomy, skin and bone, such that a naturalist today would be hard put to improve upon these pictures for sheer accuracy.

"Inspiration." Yet all this does not tell us why these paintings amount to fine art. Up to this point we have simply shown the keen motivation and great care and knowledge that went into the work; but to explain why one thing is a work of art, and another with all the same apparent conditions is not, is something that the ablest critics have never succeeded in doing. Art's final realm is mystery.

Let us stop to consider instead that which all works of art seem to have in common. First, as suggested above, is a strong motivation, for no work of art was ever created idly, or casually, or in an off moment. A work of art always has some serious meaning, for, even if its effect is sheer delight, as in a painting by Fragonard, such was the sophisticated and highly considered meaning of life for the 18th

century French aristocracy. Next, of course, a real work of art requires genius on the part of the maker. Now genius is not so breathlessly rare as is sometimes supposed; indeed, an extraordinary number of genuine works of art have been made since the cave paintings; but the difference between a work of art and a non-work of art, between genius and non-genius is one of the few things that almost all competent critics will agree on. Beyond profound thought as to the meaning of the image, beyond deep, keen, and genuine emotion as to its object and value, beyond painstaking skill and endurance in its execution is something that has been referred to by such different peoples as Greeks, Hindus, Frenchmen or Chinese as the "breath," the inspiration: that which—through some process sometimes thought of as magical—succeeds in giving life. One of the Egyptian words for sculptor may be translated, "he who keeps alive."

This is a brief summary of what most artists and aestheticians would agree are required to produce a work of art. It still tells us nothing of the *nature* of art, nor is it any part of the intention here to try to do so. If we consider that the most thoughtful among the great artists—men like Titian and Delacroix—tell us that, after long years of hard work and consideration, only at the end of their careers do they begin to understand anything about their art, let us not seek that which is by definition unattainable; let us more humbly try instead to *experience* some works of art in themselves.

How to Look at a Picture. It is useful to point out that certain tests have been found more or less valid by artist and critic alike as aids in distinguishing good art from bad.

One device is to turn the object upside down, if it is a painting, or in some way to look at it from a novel angle, so as to separate its formal organization from the apprehension of what it represents, which because of immediate associations with life-experience provides a block to the grasp of its more permanent value. In employing such a device it is necessary to remember that some works suffer more from being turned upside down, or on end, than do others, because they make more specific reference to natural fact, disposition, or the force of gravity. Furthermore any painting has its own artistic gravity, and almost any painter, no matter how abstract his work, will be genuinely *upset* if his painting is hung the wrong way. Nonetheless, as a temporary expedient, the upside down test can be very useful.

Another device is to separate one aspect of the work from some of the others. With a building this may be done effectively by consulting different schemes such as the plan (what the building would look like from above if cut off at ankle-height), the section (a vertical view of the inner structure), or an elevation (a non-perspective view of the exterior). With sculpture, differing aspects of the work may be distinguished by controlling two key factors, the position of the spectator, and the source and condition of lighting. These are the outstanding advantages of the photography of sculpture, although there is a loss in three-dimensionality, which we may hope will be corrected soon through the development of stereoptical equipment. With painting there is less to be gained through light-control, since most paintings should be seen in moderately strong, even light from head on, though it should not be forgotten that the light conditions of the original making of a picture may vary from a candle-lit room to a bright sun at midday, and a painting should be seen as nearly as possible to its original light condition and environment.

It is nonetheless true that many pictures change their mood, so to speak, according not only to the mood of the spectator (there is a lot of difference between seeing something when buoyant upon a good night's sleep and a hearty breakfast, and seeing the same thing at the end of a long day—or many days—hungry, weary, and footsore) but also according to the light in the room, whether it is strong or dim, diffused or clear, warm or cool.

In addition to varying the light under which the picture is seen, one may also separate out certain artistic factors by varying the distance of the observer. An Impressionist picture, for example, may be seen quite close to, where the repetition and interweaving of the brushstrokes and the disposition of tones appear in abstract, vitally moving patterns; or it may be viewed from across the room, at which distance the objects and areas that seem fuzzy close to suddenly take focus, and the interpretation of nature becomes quite clear; or the picture may be seen at arm's length, as it was painted, at which distance it was really intended to be seen, and at which distance both of the earlier experiences come together, and a tension is maintained which helps give life to the image.

Another way to separate different aspects of a painting is to look at it from an angle. A few paintings (like Holbein's portrait of the Two Ambassa-

dors which contains a skull painted at a very sharp angle, so that it can only be seen correctly from the same angle, yet operates frontally as part of the design) require this; most pictures will only appear distorted if viewed from an angle, though something may be observed thereby of use of texture, or vertical disposition of form: for example, a painting by El Greco, which on first view from straight on will appear distorted in natural form, if seen from the side will carry the distortion so far that it is no longer apprehended as distortion, and may be experienced more nearly as pure rhythm while the same picture, hung high on a wall and seen from below will, through a foreshortening of the picture itself, present the figures in a more normal proportion (which was not, of course, the intent of the artist).

A very useful device in looking at a picture is to squint at it. This must be done intelligently and with care, but through practice it is possible by squinting to separate out the more important areas, the more important colors, or certain colors from others, or, most effectively of all, the black and white or "value" (this is further discussed at a later point) from the "hue" or pure color disposition.

The artistic factors in the cave paintings derive chiefly from relationships of line and of color. Thus, and especially since the total organization of the animal depictions is unimportant, they may be studied very well in some of the good color reproductions that have already been made, except of course for the sculptural factor provided by the face of the rock wall. In the caves themselves some attempts have been made by varying the color of electric light to reproduce the light of the torches by which they were originally made and seen.

PRIMITIVE ART

Now if these paintings were indeed used as an aid in killing game, then the ultimate purpose was to feed and thus preserve the life of the tribe, and we may note that the creation or preservation of life is a prime motive in much of what is considered to be primitive art.

"Primitive" is a widely abused term in art history, having no agreed meaning—or a considerable variety of meanings.

One of these refers to the pre-historic—that is, an early stage of civilization—which may actually be quite sophisticated (and thus not "primitive" at all).

Another refers to the art of a rudimentary or arrested society, as frequently found in Africa. But even here both the society and the art are sometimes surprisingly sophisticated. Whether elegant or severe, **African sculpture** at its best shows a peculiar sculptural sensitivity, an understanding of the object as experienced in the round, and composed of parts highly articulated in their own right (not subordinated so much to the whole, as in Gothic sculpture). Generally these works (usually figures) become more tangible than monumental.

Another kind of primitive is the backwoods of an advanced civilization (think of early America or provincial France).

Still different is the instinctively primitive personality within an advanced civilization, for example the Douanier Rousseau (Plate 51*a*) in late 19th century France.

Or primitive may refer to conscious elements adapted in a sophisticated art form (as in Matisse or Picasso).

Or it may be used to refer to a sort of primordial harkening back in the subconscious, as shown perhaps in the works of Odilon Redon, or the contemporary Willem deKooning (Plate 64*a*).

The earlier forms of primitive art have many common characteristics. Throughout Africa, the South Seas, and primitive North America archeologists have found all manner of effigies, generally carved in wood but sometimes of stone or metal and often with foreign materials representing costume or hair or other accoutrements. These effigies sometimes vary only in detail, but those details are completely meaningful to the native in distinguishing an image which is intended to promote fertility in women from one promoting the power of the owner, or an image to help children grow from one to protect against white men.

Some also are used as signs of mourning, but such are not to be confused with the widely found sacred mask made from the skull of an ancestor, which was made not only to perpetuate something of the life of that ancestor, but also might be used in rituals by a young man seeking a transmission of life force and potency from a vital forebear.

Since the work of art here is created under the narrow restrictions of working with a skull, or if an independent figure, one that yet is severely conventionalized, we would neither find nor look for in such works the inventiveness or freedom of expression characteristic of, say, a Rembrandt etching.

What we admire in such works is something quite different, something connected with the severity of the image and the seriousness of its purpose: an extraordinary economy (and of course we refer only to the good works, which are, as in any society a small minority of the total artistic production) in the selection of forms and rigorous subordination of the less important to the more important, an objective consistency of stylization and distortion to practical ends, and often a superb natural grasp of the problems of carving or moulding a figure in three dimensions (something not always found in more sophisticated sculptures), possibly heightened by the keen development of the sense of touch. Such qualities as these have become more highly cherished, for various reasons, during the past half century in the western world, and not a few outstanding modern artists have shown a serious excitement in the forms of primitive sculpture.

If we think of the cave paintings as representing the art production of a hunting community, and primitive sculpture as representing that of an agricultural community, we are still dealing with art that is unhistorical. In general use, unhistorical means simply that calendars or writing systems were not developed, so that *time* in the sense of one era measured against another was never conceived.

The importance for the art critic is that no significant development is undergone such that an art object for example could be dated according to its style derivation, as can be done very closely in classic Greece, say, or medieval Europe. Thus in primitive art one object is usually made by reproducing another quite like it, the variations being not in a time-style, but only in the talent or taste of the artist.

ORIENTAL ART

In this sense, the art of Central or West Africa or Madagascar or Australia, or the Islands of Oceania or the Philippines is quite a different thing from the art of ancient Egypt or Babylonia, Greece or Rome, medieval India or China, or modern Europe or America. It is also different from that art of Central and South America which was connected with the civilizations of Mexico and Peru.

But within these spheres of so-called civilized art, we must again distinguish between the old Americas, India, and China, where there was little influence from other civilizations, on the one hand, and Egypt, the ancient Near East, Greece, Rome, Byzantium, Europe and modern America, on the other, where there has been a chain of events that leads people to speak of the development of western civilization as something that began first in Egypt or in Greece.

For the purposes of art history, and possibly total human history as well, it is advantageous (though not the only truth) to think of each civilization as a separate entity, having its own values and inner development and in which the influence from some other civilization appears relatively superficial. Thus we shall be concerned in this book not with any continuing discussion of the use of the column or the art of fresco, but with the *differences*, in total style and purpose, between a pyramid and a cathedral, a Greek statue and a Gothic, a Chinese painting and a Dutch.

Nonetheless the chief emphasis is bound to be on works of art that fall in the European and American areas, in the broadest sense, and on objects made nearer to our time than those far removed. Although any given ancient work may be the equal of any given modern one, we are likely to know much less about it, as well as its being farther removed from us in interest and in specific value. Thus we are not primarily concerned with using art to illustrate cultural history, but rather with a study of the objects in themselves, with a view to understanding more about why they are meaningful and valuable.

INDIAN ART

The civilization of India is one of the important historical civilizations of mankind. But since it has had almost nothing to do with Western civilization, we must be content to analyze one example of its productions for the logic of its art.

An Indian Sculpture. From northern India in the 6th century comes a delightful statue of Ganesa with a Sakti (Plate 1*b*). Ganesa, the elephant-headed son of Siva and the Goddess, sits here with his Sakti, or consort, upon his left thigh. In one of his four hands he holds an ax, in another his attribute (identifying object) the tusk, in a third a lotus bud, and the fourth supports (perhaps needlessly) the breast of his Sakti. In the upper left corner is a seated figure of Brahma. The remaining tusk is broken off, while the other is missing, some say because he threw it once in anger at the mocking moon, others that he gave it to Vyasa wherewith to

write the Mahabharata. Around his belly girdles the snake that keeps it from bursting, and its full roundness pays tribute to the god's role as a transcendent gourmand while with his trunk he takes meats from a bowl held considerately by the Sakti.

Ganesa was one of the most immensely popular of Hindu gods. Variously known as Ganapati, the chief of the Ganas or little genii of Kailasa, the Lord of the Hosts of Siva, or the Lord and Master of Obstacles, Ganesa is full of humor and genial good will for the votary in his auspicious benevolent aspect, whereas to those for whom the ways of life remain closed he is a devouring monster. In this depiction he is of course the former—a god who is invoked at the onset of undertakings of every kind, and—paunchy and well plenished, is the bestower of earthly prosperity. His Sakti, or procreative power, is here perhaps simply his consort, returning the sly gaze in her lord's tiny eyes.

Although this piece is carved in rough stone it displays a subtle abundance and richness of expression through rhythmically repeated curves; these manage to combine a basic dignity with warmth of treatment in the swelling roundness of the belly, the sinuous yet full arc of the trunk, and the sweep of leg and torso. The result is a jaunty combination of majestic aspect with a jovial, earthly, and genial good humor that invigorates us no matter what our mood.

No one could fully appreciate the iconography of a given work of art unless it were a product of the very tradition in which he was educated or experienced life. Nevertheless, even if we cannot know all the details or all the ramifications of a work from places like India or China, Polynesia or Peru, we can greatly increase our appreciation of the artistic function of a work by apprehending something of its direction and range of meaning, for in any work its symbolic function and its interpretation of the world are crucial to its artistic form.

East and West. Of the great Indian culture which pervaded most of southeast Asia, the most important art forms were architecture (of an especially sensuous and sculptural nature) and sculpture itself. Of the equally venerable Chinese-Japanese culture of northeastern Asia, the leading art forms are sculpture and above all painting, both of a highly calligraphic spirit and character. A roughly similar difference in emphasis may be observed in European art as between northern and southern traditions.

At the same time we must distinguish—in the arts —a difference between all the West taken together as against all the East: a tendency towards masculine dominance in the West as against feminine (it has been said of the Indian male that he dominates the female by becoming even more feminine than she); or, in another aspect: a more abstract and rational tendency in the West as against a more intuitive approach in the East. These of course are very broad distinctions, and encompass wide variation within their own traditions, as does the general tendency toward greater individualism, exploration, or inventiveness in the West, as opposed to greater acquiescence with traditional forms in the East.

A Chinese Painting. This pervasive feeling of acquiescence is evident if we compare a landscape drawing by Bruegel (alternate spelling, Breughel), (Plate 15b) with one by a Chinese artist (Plate 15a). Bruegel is sometimes cited as comparable to the Chinese in the meandering pattern and vast spaces of his mountains, rivers, forests. But where the Chinese artist will intersperse his solid forms with discreet emptiness—voids of a metaphysical value— Bruegel with his western aggressive temperament will activate the entire surface and space. What tends to remain graciously decorative in the Chinese scene will be stirred with conflict in the western version, and a road by Bruegel or Dürer will often flow with more passionate vigor and strife than a towering waterfall of the Japanese or Chinese. Similarly, the fabulous Chinese monsters are strangely playful. And the human element—whether peasant or philosopher—will tend to be involved in the workings of nature, with a sense of issue and a clamor in the Western landscape, whereas the observer in the Eastern painting is passive: one who accepts what nature presents, who seeks to intuit its harmony.

The Chinese painting is closely related to literature, and often poems or comments are combined on the same page, even written by the same man and with the same brush. Then the calligraphy becomes part of the design of the page or scroll, and there is a relation between the two not only of meaning but of stylistic intimacy of a kind which is not really understood by the Westerner. For example, Wordsworth may "paint" pastoral pictures in words, or Constable at the same time effect lyrics in paint, but the two media are not interfused or merged, but seek to be distinctly their own selves. And herein lies the individualism of the western temperament.

The history of the civilization of China is not il-limitable (as is sometimes supposed in considera-tion of the ancientness of Chinese history and their reverence of it), but has had its great periods just as Europe has, and for a long time has been uncrea-tive, except in a derivative sense. In the Orient to-day much active painting is strongly influenced by the still creative Western traditions, while the im-portance of Eastern influence on contemporary American style, for example, is overrated. Or, with such a contemporary Italian artist as the sculptor Marino Marini, the oft-cited influence of the Chi-nese sculptured horse seems less vital than an old Etruscan plastic feeling—from the same soil as that in which Marini grew.

Commensurate with the difference in world atti-tudes of the Chinese and northern European is the choice of medium. The former prefers a scroll, which unrolls endlessly—as were felt to do the great rivers, the mountain ranges, or the seasons. The Westerner prefers a framed area within which no matter how vast the space depicted, it is always under control by the artist or by man himself. Simi-larly the Chinese or Japanese artist uses a brush from which the ink flows and dances. Bruegel uses pen or pencil: he *carves* his landscape out of nature; later Rembrandt *etches* his. Western man seeks con-flict and conquest: it was he, not the cooperative Asian, who insisted on climbing Everest.

EGYPTIAN ART

Civilized art, or art belonging to a civilization marked by historical development, had its earliest beginning in the Nile Valley late in the fourth mil-lennium B.C. This civilization developed and pro-duced, in the course of a thousand years, works of art of all kinds and at all levels, from stupendous pyramids and rock-cut tombs, to statues of human size, carved and painted reliefs and wall paintings, and a world of artifacts which, whether or not of precious stones or metals, attained such superb de-sign that they are admired today as the equal of anything of their kind.

The Pyramids. Perhaps the most extraordinary thing the Egyptians ever did was to conceive and execute the pyramids. These structures appeared at a time in Egyptian history which is comparable to the appearance of Gothic cathedrals early in Euro-pean history, representing the peak of religious building. For the pyramids were not simply monu-ments to the vanity of a king. Had they been so it is questionable whether anything requiring such effort by so many people over so long a period of time could have been accomplished. The value of the pyramid to the people who built it was as a monu-ment both to preserve the king's body and to aid it in its progress to the after-life; since the king was related to the sun-god, and ultimately identified with him, the progress of the king's body and soul were connected with the source of life itself.

Now these apparently simple triangular shaped mounds were erected by people who had already developed picture-writing, a calendar, irrigation and metallurgy. The pyramid is far more complex than it looks. Originally the Egyptian had marked his dead—or hid it, for the two processes took place at the same time—by digging a pit, over which he heaped sand, twigs, or stone. The next step was to build a **mastaba,** a low, flat, slab-like stone structure sloping in at the corners and resembling a truncated pyramid, containing a chapel with a false burial chamber, the true one hidden deep inside. Next was to build a step pyramid, which was in effect the pil-ing of mastabas on top of one another in descending size. The final development was the true pyramid, made by pointing off the top and filling in the steps. The greatest pyramids were built near Gaza in the Old Kingdom, and the central one, that of Cheops, the largest of all, is usually known as the Great Pyra-mid.

The scope of this building is almost beyond be-lief, when one considers that the transporting and cutting was done by foot and hand. The building is four-sided, 776 feet on a side, and 481 feet high (the top thirty feet are now missing). The ground area covered is over thirteen acres. To Europeans this would mean that the cathedrals of Florence and Milan, the basilica of St. Peter's in Rome, and West-minster Abbey and St. Paul's cathedral in London could be contained within its base with room left over. A story is told of Napoleon that while some of his officers climbed the pyramid, he stayed be-low, and when they returned he announced a cal-culation that the three pyramids taken together con-tained enough stone to build a wall a foot wide and ten feet high around the whole of France; this was subsequently confirmed by a mathematician.

The Great Pyramid is composed of over two mil-lion blocks of stone, averaging 2½ tons, and this is over a core of rock the size of which has not yet been determined. So far as we know these people

had only knotted ropes to use for measuring, yet the four sides are equal to each other within a matter of inches, and the orientation of the four sides is true to north, south, east and west within a fraction of a degree. We may wonder at such accuracy in a structure which is simplicity itself. For no broadly based monument could be less diversified unless it were a cone; but a cone is somehow amorphous, it has no sides, no direction, no orientation. And the four-sided pyramid is psychologically more stable than a triangular one—we ourselves use the word "four-square." Thus for simple permanence the pyramid could hardly be exceeded, so why did they bother to be so accurate? The answer lies in the fact that the pyramid is by no means a simple structure. For one thing, it contains within it a complex system of passageways and chambers, composed at angles and of varying dimensions, and constructed with great care and skill lest they be crushed by the weight of superimposed stone. Furthermore, outside the pyramid yet still organically parts of it are first a large chapel at the entrance for offerings and ceremonies, then a long causeway (sometimes over a mile) leading from the plateau on which the pyramid stands down over the cliffs to the Nile, at the edge of which stands the so-called valley temple, where the body of the king was first received after its trip on the barge from the place of death. The trip on the Nile and possibly the causeway too were symbolic of the voyage to the other world. Thus a number of very difficult feats of engineering are entailed in the vast pyramid complex, and it is no surprise that the same care was extended to the aligning of the mound proper.

The motivation or cultural "climate" for taking all this trouble appears when we are reminded of the actual climate and geology of the land: a stern country without curves or jags, but of strict verticals and horizontals of rock strata and parallel mountains, all lit in severe clarity by a brilliant sun. Through its center straight as a die (as rivers go) for a thousand miles, a narrow band of luxuriant soil is fed by the Nile, which is the source of recurrent life: in the annual floods the country is reborn. And in this process the Egyptian saw by analogy the possibility of his own rebirth, and in this belief he built a pyramid. It must be emphasized that geography never explains the development of cultural forms, but it is profoundly connected with their source.

The result is a structure which does not only astonish us in the near-impossibility of its engineering and the effort involved, nor for the amazing precision and consistency of stone cutting, but as well for the imposing monumentality of the original conception, and for the serene dignity of its final proportions.

Indeed we may question those who interpret the pyramid as an "aspiring" form. For its height is considerably less than its base; if we compare the over-all shape with that of a Gothic cathedral—a truly aspiring building—we find that the height of the latter may be several times its base. Furthermore the Gothic building seems to soar not only by its pointedness but also by the fact that it is all eaten out, giving it an airy quality in stark contrast to the solid simple planes of the pyramid. Our first impression of the pyramid is likely to be the enduring one: impressive grandeur that will never change, that could never fall or topple, that will not erode, that earthquakes could not move (though they have tried),—that is, in a word, timeless.

GREEK ART

Compared to this, the Greeks, who are sometimes thought to have been followers of the Egyptians, actually created a very different world in which time was not eternal but evanescent: all truths were of the moment. Classic Greek art strives, whether in a statue or in a building, to attain a moment of suspension in time, a balance between forces, a hovering quality which thus repudiates time itself,—time which the Egyptian had seen as an ultimate reality.

To compare a Greek figure (Plate 4b) with an Egyptian (Plate 4a) is to see a fundamental difference in *movement*. Actually of course, movement in sculpture does not occur except in a "mobile," but in the Greek we have—through the interworking of contour, axes, weights, and focus—a vivid sense of *fluctuation* but no sense of direction. In the Egyptian it is the other way around.

For the Greeks reality consisted in the here and now; death was for them merely a descent into the shades, the absence of life. The highest man could attain was to live life most perfectly on earth; and the gods were but human conceptions more completely fulfilled.

Similarly, when the Greeks erected a building, they shaped architectural members and processes suggestive of the human. The earliest Greek temples were of wood, and over a period of more than two

hundred years the stone temple was developed with only the slightest modifications of the original idea whether in size or in detail. This is particularly striking if we think of the extraordinary development of the pyramid-complex from the first mastabas. The Greeks' imagination and inventiveness appear not in vast structural systems—buildings or empires— but in **refinement and appropriateness.** Indeed, in the Parthenon—that building which marks the culmination of the Doric style and may actually stand as a symbol of all classic Greek civilization—there are no structural problems at all; among the world's noted monuments this is one of the smallest and simplest, yet it justly enjoys the reputation of being the most "perfect" building ever conceived. In other words, by the very act of self-limitation, by simplifying the problem to profound modesty, the Greek was able to carry his solution to a point more harmonious, more complete, more final than any created before or since, or likely to be.

THE PARTHENON

"If arithmetic, mensuration, and the weighing of things be taken away from art, there will be little left."—Plato

The Parthenon's simplicity begins with its function. Not a very religious people (think of the importance of the priesthood in Egypt or Byzantium as against the corresponding small size, lack of power, and secular nature of the priesthood in Greece), the Greeks did not build especially religious temples. The only altar, for example, is outside the building and not even contiguous with it. The function of the Greek temple was not much other than to provide a house for a god. The Parthenon is the house of Athena.

It contains only two rooms, the smaller a treasury, the larger containing the statue of the goddess, which to the physical- and immediate-minded Greek was identified with the goddess herself in a way that we could never share. And from this devolves the secret of the entire building—it attains a physical presence and reality more intense and more subtle than any monument we know. And this even in ruins. It seems ironic to speak about the most perfected buildings and statues ever produced when the buildings are in fragments (Plate 4) and the statues either lost (most of them) or without heads (Plate 1*a*). Yet we must and can reconstruct it imaginatively.

Part of the physical presence of this building has to do with its sculptural nature (Plate 2*b*). Unlike a Roman bath or a Gothic cathedral, the Greek temple does not deal with interior space; in fact it denies that by running a solid wall through the center: you can neither see nor proceed from one end to the other. The two rooms are filled with interior columns, more than are necessary to support the roof, and the one room was additionally filled with storage, the other by the statue of Athena which rose to the ceiling, forty feet high. Thus there is no sense of moving around, there are no voids; the building does not deal in volume but in mass. Yet, unlike the inert, eternally posed mass of the pyramid, the mass in a Greek work is all articulated.

Refinements. Far from being a simple shaft, the column contains important refinements in addition to the fluting which is its most noticeable articulation. The fluting gives an added vertical emphasis suggesting thrust; also, because seen from any point the flutings gather at the edge, the roundness of the column is further stressed. Other refinements are taper and entasis.

Taper simply means that the top diameter of the column is approximately one-sixth less than the bottom diameter. This effect, akin to the natural diminishing of mass at the top whether in a mountain or in a tree-trunk, gives a sense of greater stability. **Entasis** means that the sides of the column are not straight, in other words that the taper is not constant, but the sides are curved and the whole column actually bulges. Now this curvature or bulging is not quite noticeable to the naked eye but it is *sensed,* and here is the purport of all the refinements in a Greek building: imperceptible curves, displacements, angles and shiftings give the building a quiet sense of organic life. These refinements are at the same time calculated to correct optical illusions or tendencies of the naked eye. For example, if the column were straight and did not use entasis, it would appear concave in shape. What the Greek did was actually to give the column enough convexity to correct the illusion, and then a little bit more—the result being an imperceptible swelling that makes the form "breathe."

A comparable example is the curvature of the base. In the Parthenon—though not in all other temples where things were not worked out so far as in this veritable model—this curvature, which means that the entire floor is a low dome, several inches higher in the middle than at the ends, is repeated

in the parts above the columns, so that the whole building bends. This acts first of all to prevent it from sagging—for the naked eye would be unable to carry so long a straight line without its appearing to sag—but the curvature like the entasis is slightly exaggerated (the curvature becomes quite noticeable when sighted from the corner) to give a sensible swelling of life throughout.

Further refinements may be observed in the **Doric order,** that is, the organization of standard parts of the building as seen in profile. The column is part of the order, and also the bay—or space between— which in the Doric style is quite narrow, comparable to the width of the column, and creating a shape which when seen in outline is a positive thing, not just a space between objects as in the later orders.

The top of the column consists in the **necking,** that is, horizontal incisions designed to slow the eye and prepare it for a change in shape and direction, and the **capital,** or head (the shaft being the trunk), which consists in two parts, the **abacus** and the **echinus.** The latter word means "cushion" in Greek and in this architectural order consists in a round part broader at the top than at the bottom; it thus serves to cushion the abacus, a square member whose sides are tangent to the upper circumference of the echinus. The **architrave** or beam lies upon the abacus. The capital in its entirety then functions to make a transition from the round shape of the column or support to the rectilinear shape of the architrave or load, and from the verticality of the former to the horizontality of the latter.

The architrave is the lower horizontal part of the **entablature,** the term referring to the agglomeration of horizontal parts above the vertical columns and below the diagonal roof. The upper horizontal part of the entablature is the **cornice,** and the center part the **frieze,** which is in turn composed of an alternation of the **triglyph,** a group of three vertical stone slabs, and the **metope,** a bare slab which on the more ambitious temples like the Parthenon was filled with sculpture. The triglyph is thought to be a stone translation of the beam ends in earlier wood constructions in the Doric order. Whatever its source it acts as a repetition of the vertical theme established in the fluting of the columns; in other words, **column** and **architrave** are the major theme, **triglyph** and **cornice** the minor. The triglyphs appear to be located one over the center of each column, one over the center of each bay. But actually this is true only in the center; if it were carried all

the way across, the Greeks would have been left with half a metope over, a situation intolerable because it lacks conclusion and finality. Therefore the triglyphs are displaced so that the end one stands at the corner of the frieze. This also gives a stability to the corner of the building in a way that suited Greek logic. The displacement of the triglyphs is reduced, however, by the fact that the corner columns are closer to each other than the others. This also makes the building appear more secure at the corners, a fact that is even further suggested by the inclination or tipping inward of all the outside columns. Thus the corner columns tip inward in two directions, sharing the inclination of both the side and end columns. The axes of the columns, if continued, would meet in a tent-like form several thousand feet above the building. The column inclination, like the other refinements, is more than enough to prevent the building from seeming to spread at the top, and further adds to its feeling of being compact and smoothly knit.

The Significance of Numbers. Many aspects of the Parthenon are composed in groups of three. The entire building consists of base, columns, and roof. There are three steps at the base; the column is composed of three parts of distinct shape—**shaft, abacus, echinus;** there are three horizontal parts of the entablature, distinguished by the fact that the architrave is unadorned, the frieze alternates triglyph and metope, and the cornice projects notably out from the rest of the entablature. The triglyph itself is of three parts. The significance of this love of groups of three may come to light if we think of the Greek organization of plays into trilogies and also into three acts (think of the Shakespearean variation in number of Parts, and preference for five acts), or of the Greek traditions of Three Fates, the Three Graces, or of Aristotle's division of the work of art into three parts, the beginning, the middle, and the end.

This Greek conception of three consisted in equal, separate, and opposed parts (unlike the three-in-one of Christian doctrine, for example) and reminiscent of the separate, equal, and opposed nature of the Greek city state, its individual citizens, or the very nature of the landscape: small islands and isolated mountain valleys. Indeed much of Greek art and civilization can be understood from a knowledge of Greek climate and geography: the land forms are small, diversified, and moderate, the atmosphere very clear and sunny but slightly softened at the ex-

tremes by a haze. This is basically different from the extremes and contrasts that mark the Egyptian land, and helps account for the flavor of Greek art and life. It does not, of course, account for the particular genius of Greek civilization, which might be said to be its **anthropomorphism**—natural or supernatural concepts given human form.

The Greek visualization of their gods as more perfect humans is well-known, but their love of human reference extends even to their architecture. Thus the entasis in the column is like the bulging of a muscle, or we refer to the parts of the column as head, neck and shaft or trunk. Indeed, in a later style the column sometimes actually became a human figure, as in the Porch of the Maidens of the Erechtheum. This is not to say that the Greeks thought of the column as *representing* the human figure; rather the column (in the Parthenon) is a purely architectural form which because of its shape, function, and relationship to other forms carries certain unmistakable overtones of physical human activity and existence. (Plate 2*a*.)

Greek Sculpture. The present location of some of the best remnants of sculpture from the Parthenon in the British Museum is the result of their removal by Lord Elgin early in the nineteenth century by agreement with the Turkish government, which was not interested in them. Though the Greeks feel these masterpieces should be returned to their home, it is true that they are accessible to more people in London, and that Lord Elgin rendered a service by protecting them from the elements (other fragments have since been placed in the Athens Museum and replicas put in their place in certain instances on the pediments).

The building itself suffered successively from being made into a church in the fifth century, a mosque in the fifteenth century, and a shambles in 1687. The Turks, who had converted the building into a powder magazine, were besieged by Venetian artillery and it is said that it was a German gunner who landed a shell square in the middle. The entire center portion was blown out, and German archeologists ever since have tried to figure out how to put it back together. To date it has been restored so far as original remains permit.

The two pediments presented the Birth of Athena, and her contest with Poseidon for the patronage of Athens. The few fragments remaining are not only carved in the round, but show a use of 2-dimensional curves (around the knees, for example), which re-

enforces the suggestion of 3-dimensionality (Plate 2*c*).

The Metopes. Other sculpture on the building was contained in the metopes. These consisted in 92 slabs each with a scene carved in **high relief**, meaning that the figure emerges half-way or more from the stone, but may be somewhat compressed and is not free from the background. Each side of the temple had a separate theme, though all relate to each other. On the east were depicted struggles between Gods and Giants or Titans, on the west between Greeks and Amazons, on the north (probably) between Greeks and Trojans, and on the south Centaurs and Lapiths (men of a Greek tribe).

It will be seen that in each instance the victors (Gods, Greeks, or Lapiths) were morally superior to the defeated. The Trojans had been guilty of abducting a Greek queen; the Titans were unfit to rule the world; the Centaurs were half beast, a perversion of nature; and the Amazons were women warriors which to the Greeks was a sin against the appropriateness of place, position, and role. For the ultimate Greek sin was *hubris*—overweening pride —not the pride which is in our sense commendably connected with ambition, but the pride that goes before the fall, the pretension to a position for which the pretender is not entitled or fit.

If we remember that the Parthenon was originally proposed as a war memorial and that it was built on a surge of civic and national glory in the victory over the invading Persians (considered by the Greeks to be barbarians), the importance and meaning of the analogies in these metope themes becomes clear.

Unlike Egyptian sculpture, which often included complexes of figures with natural objects and settings, these depictions of war on the metopes are reduced to the most logical simplicity. There is no accompaniment—nothing that refers to a natural setting—only two opposed figures on each metope. Furthermore, Greek reasonableness is such that the winning side is not always winning: often enough it is the Centaur who has the Lapith by the throat.

It is only the metopes on the south side (Centaurs and Lapiths) that are sufficiently preserved for study (Plate 1*a*), partly because the Turks liked to use the metopes for target practice, for which the south side was relatively inaccessible. These eighteen extant metopes can tell us a great deal about principles of Greek sculpture. For one thing, we find a strong sense of repetition in design, in that nearly all these metopes are based on some counter-

diagonal movement, though where the diagonals cross may vary up and down or from left to right. When we consider that this scheme takes place within a square frame, alternating with the vertical accents in the triglyphs and bordered by horizontal lines above and below, the result is extraordinarily rich within the severe simplicity of elements used. In addition to the composition on diagonals, each metope has a basic design feature—a sinuous S-curve repeated throughout one, or a semicircular form in another. Throughout these metopes it is remarkable how the sculptor retains a pervasive feeling of dignity and composure despite the violence depicted.

Assyrian sculptors keenly depicted cruelty and violence, courage and strength for their own sakes; the Greek, no matter what the subject, moderates with a cool simplicity. For the Greek, one of the ways in which the god exceeded the man was in self-possession.

The Frieze. In better preservation because of its protected position on the inner entablature is the sculpture on the inner frieze, a band 3⅓ feet high running without break 520 feet around the building. This carving is in **low relief**, meaning that the represented planes are highly compressed, with a projection of 2¼ inches at the top as against 1¼ inches at the bottom. This angling outwards may be partly to provide a better angle of vision; it may also be an adjustment to the diminishing illumination towards the top of the frieze.

The subject presented in the frieze is the Panathenaic procession, a pageant and parade of cavalry (Plate 2d) and marshals, wine bearers, animals for slaughter and other members of the procession made each four years by the free citizenry of Athens through the city to the Acropolis, where the *peplos*, a robe for the statue woven by chosen maidens of Athens, was dedicated and placed upon the shoulders of the statue of Athena, protectress of her people.

Perhaps the most famous part of the frieze is the cavalry sequence, where the young Athenian knights are shown in various stages of mounting, gathering speed, reaching full gallop, then reining in and coming to a halt. Throughout, there is a close adjustment of the level of the horses' heads with those of the riders', a distortion referred to as *isocephalism*, a typically Greek device to keep the horse from superseding man, as well as to maintain uniformity. Some passages (Plate 2d) achieve an extraordinary fusion of variety of action with an almost geometric

ordering of rhythms—relaxed and controlled, but so alive that the resonance of the hoof beats resounds from pure stone.

Like the metopes and the pediments, the frieze was carved by the hands of many men, though all under the direction and control of PHIDIAS, the greatest name in Greek sculpture though known to us by reputation only. Phidias would indicate to the individual sculptor how far he was to cut along the frieze, what his section should contain and how it should lead to the next, but it is very plain that the style of the execution was left to the individual artist. These came from all parts of Greece to work at the Parthenon and they represent a spread of generations. If we compare two different sections from the cavalry part of the frieze, we can see not only the difference in "hands," that is, the individual style devolving from the personal temperament of the artist, but also the difference in generation.

The older artist creates a scheme closer to the archaic style, relying more on verticals and horizontals, more rigid, whether in the posture of horse and rider or in the carving of drapery and horses' tails and manes, so that a severe geometric pattern results. The younger artist appears more liberal, more "baroque"; he relies on sweeping S-curves, diagonals, and more continuously flowing lines; the action of horse and rider is more exuberant; there is a wind-swept quality that adds to the fluency of the composition. Now it must be emphasized for once and all that neither one is superior to the other artistically. If a later piece seems more "realistic" because of its greater insistence on details of anatomy or textures, this has nothing to do with its quality or effect as art. Any work of art deals with a stimulus from nature transvalued by the artist into a hierarchy of forms; the student of art investigates the peculiar nature of transvaluation insisted on by any given style. He may also observe differences of quality or success within a given style, but he is extremely wary of comparing the artistic quality of different styles. Since both pieces of the frieze are of high quality, we learn much more by asking, What is the *nature* of each style? than by asking, Which is better?

The frieze is composed so that the spectator sees the procession beginning at the west end of the building, then follows its progress up either the north or the south side, much as he would if taking part in the original procession. The culmination of the frieze is then at the east end of the building, and

here we come upon a curious fact. The figures depicted on the east end of the frieze (Plate 2*e*), though of high artistic quality, are far less active in composition than most other parts of the frieze. Part of the reason for this is that they represent gods, and gods were by Greek definition more sedate, more self-restrained or "composed" than men. Now these gods are sitting around talking in true Greek fashion, but also watching, as from a divine reviewing stand, the procession bearing the *peplos*. And the culmination of this procession is beneath their feet at the middle of the east end of the building for it is there that the spectator is faced, through the great doorway, with the imposing statue of Athena inside, the statue identified with the living reality of the goddess, upon whose shoulders the *peplos* will be placed. Thus the reason for the quietness of the frieze at the east end: the spectator's attention is the more readily transferred to the statue itself.

The Athena Parthenos. Reputed by the ancient world to be the masterwork of Phidias, the *Athena Parthenos* was a forty foot chryselephantine (gold and ivory) structure, the flesh being ivory and the drapery and accessories of gold and some semi-precious stones. Given such materials, it is not surprising that we know this work only through literary accounts, coins, and small ancient replicas. One of these ancient fragments seems to indicate that on the shield of Athena was carved a combat of Greeks and Amazons, and that two of the Greeks are represented as Pericles and Phidias. If so, this is the exception that proves the rule, for unlike the Egyptians, the Greeks repudiated the portrait as being an individualization, a study in peculiarities, whereas the chief aim of all Greek civilization was to find the ideal type, a conception of the most perfect values or features of all humanity that could be embodied in a single form.

GREEK VERSUS ROMAN

If we compare a Greek head (Plate 3*a*) with a Roman portrait (Plate 4*c*) bust, we observe a world of difference in the attitude towards the human being. The marble Greek head, though battered, is extraordinarily sensitive in surface quality and life. It originally belonged to a complete figure: the Greeks never detached parts of the anatomy, but sought the logic of the whole. The Roman bust, now in the Boston Museum of Fine Arts, is of terra cotta (the Greek is marble, therefore more permanent but less susceptible of detail) and is complete; the Roman felt that he could express the character of his subject best by focusing on the facial disposition.

Looking at the Greek head we cannot be sure of the age of the person: it seems to fall in a general category of youthful maturity that might be anywhere from 16 to 36. The Roman head, in contrast, is distinctly stated, we feel we could spot his age in the late 50's, indeed we feel we have seen him somewhere, and it is precisely this factor that renders the Roman bust a work of art, rather than its literal description of a particular being. The Roman head speaks of a class of men—this man is generally considered to have been a senator though no one knows for sure—in any case he is someone who by the firmness and articulation of forms about the mouth is accustomed to giving commands or directions, and by the lines about the eyes, nose and brow is accustomed to the perplexities of making decisions. The hair on the head is plastered with sweat. The man himself might be either politician, soldier, businessman, but he fits a type, and in today's America we might see him in Wall Street or on Capitol Hill.

The Greek conception of type is quite different. There is less differentiation as to age or occupation or specific character.

The Greek head is far more than an idealization of features. After all, the simple smoothing out of irregularities would be a rather negative process. The Greek head gains its power as a work of art from the forceful arrangement of the parts of the head into a readily apprehended geometric pattern and subtlety of execution. With the Greek head, if you look at it and then turn away, you will retain a cogent sense of its shape and configuration *as a piece of solid geometry*. With the Roman head, which is actually rather shapeless, you will retain instead a keen sense of the sum of the expression rendered by the shape of individual features and their connecting lines. The results are indeed so different that a final comparison is almost impossible—there remains so little to compare—but something of the difference between the Greek theoretical and the Roman practical mind will be appreciated.

FIGURE TYPES

It is not quite true that the Greeks never made portraits. Nothing is more typical or expressive of Greek culture in any field of activity than the statues of single athletic figures which were

mounted on pedestals on an Acropolis, in a market-place, or along a roadway. Typically these statues began as representations of victors at athletic contests, such as the Olympic games, men favored among all the Greeks, about whom poems were written, and for whom tributes ranged from laurel crowns to lifetime meal-tickets.

But if these statues began as portraits, by the time they were done little or no resemblance to an individual remained, for they stand as ideal representations of successful manhood. These men represented to the classic Greek far more than even the greatest baseball hero to an American today, for their games were not sport only but were derived from military preparations and conditioning, and were based directly on a religious ideal as represented by Achilles. In themselves they represent the fulfillment of the Greek philosophy of physical skill, conditioning, and accomplishment as being quite as necessary as music, literacy, or statecraft to the balanced, complete man which was the Greek ideal of civilization.

In these figures (Plate 4*b*) nothing is over-stressed. The anatomy and disposition of the figure are strong, efficient and vibrant but evenly regulated. Whereas modern athletes run to different physical development for different sports—one for basketball, another for football; one for pole-vaulting, another for boxing—the Greek ideal for all athletes was one, and their heroes were not the equivalents of our highly specialized athletes, but were the pentathlon and decathlon winners, the composite athletes who must do everything well.

By the same token, the action depicted in these figures is generalized rather than specified. For example, in the well known reconstruction of MYRON's famous Discobolos or Discus Thrower, the moment of the action chosen is precisely that of suspension between actions: the top of the backswing. The result is a remarkable absence of tension or strain. In different terms the same result is obtained in the Doryphoros or Spearman of Polyclitus (Plate 4*b*). Not only is this figure not in the process of throwing a spear, but it is impossible to say that he is doing much of anything. At first impression he may seem to be walking, but close observation shows such an equal shifting of weight front to back and side to side that the result is undirected equilibrium. In other words he is just standing around. And yet there is nothing at all static or frozen in the pose.

If we compare this figure with a standing Egyptian figure like that of Mycerinus in the Boston Museum (Plate 4*a*), we see that the latter implies a strong forward direction, emphasized by the direction of gaze, the position of the hands, and the striding forward of one leg. Despite this uncompromising force of direction, the figure remains severely static. Its weight is straight up and down, and the movement of the leg is actually impossible. Now when a figure walks, the process might be described as leaning forward and putting out a foot to stop the fall. Closer to the dynamics of walking would be, say, the striding figure of St. John in the Wilderness by the impressionist sculptor, Rodin, yet even here the stride is caught up so that balance is retained. In other words, it may be questioned whether the actual dynamics of walking, which require that the figure be off balance, could ever in itself become the subject of a work of art, which by basic response to perpetual human requirements seeks **the re-establishment of a sense of balance by one means or another.** Thus the Greek, the Egyptian, and the modern French sculptures deal with the problem of the potential weight shift of the standing figure in entirely different ways, each transforming a natural process into an artificial style expressive of the values of its society.

The rest or repose attained by the Egyptian style should never be confused with that of the Greek. The effect of the former, whether in pyramid or statue, is one of immutable steadfastness, an uncompromising permanence that is vastly immobile and silent. The effect of the latter, whether in the load and support relationships in the Doric order, or the *contrapposto* (the alternating back and forth of body weights) in the Doryphoros, is one of casualness and "hovering," of considered yet momentary balance. The Greek style is not a negation of action but rather a marvelous suggestion of different possibilities of action by a refusal to be committed to any given one at any given time. Think of the counterparts of this attitude in Greek politics, or the Socratic form of argument.

The Doryphoros stands as a final statement of the development of the Greek sculptural aesthetic, which was the latest of the classic Greek art forms to fulfill itself, superseding and ultimately replacing all other art forms as it did so, just as the art of music did in the culmination of the Baroque age in Europe. In doing so it developed **a canon of the relationship of parts to each other and to the whole,** and the canon of Polyclitus may be likened to that of the European development of the **sonata** form.

With the Polyclitan figure the relationship of finger to hand, of foot to stature, or of the precise disposition of contrapposto, is mathematical: the final result of the thought and experimentation of many generations, first cousin to the ratios finally worked out for the Doric order in the Parthenon.

This classic interest in reaching a perfect adjustment of parts is further illustrated in the popular anecdote of Pliny about Zeuxis, who could find no woman beautiful enough to stand as model for his painting of Helen of Troy. He thereupon inspected the maidens of Athens, and selected five whose particular beauties he proposed to abstract for reproduction in his picture of the ideal.

ROMAN ART

The question is not infrequent among critics and historians, Was there a Roman art? just as it is sometimes asked, Is there an American art? The asking of such questions is intended to draw attention to the fact that Rome produced no works of ultimate beauty like the Parthenon or the Winged Victory, and that America has produced no Shakespeare, no Rembrandt, no Beethoven.

The Roman and American peoples stand much the same in history as being practical builders of roads and empires, laws and housing developments (Plate 4c and 7a). Neither people is generally thought of as artistic, theoretical or spiritual in a creative sense like the Greeks and Europeans, but rather as materialistic, scientific, and matter-of-fact. Whether or not we conclude the existence of a Roman or American art depends simply on what we mean by art.

Where the Parthenon aimed at a pure metaphysical beauty; a Roman aqueduct or coliseum sought grandeur and efficacy. Each attained something that is stirring to behold, but in different ways, just as the George Washington Bridge leaves the spectator bowled over in quite a different way from a Gothic cathedral.

Both the aqueduct and the George Washington Bridge attain an undeniable and imperishable beauty, yet it is not the kind of beauty that elevates the soul, like that of temple or church, but the beauty attained by the imagination and articulation of the engineer.

In any epoch we think only of the leading art forms. For example we seldom pay attention to Elizabethan *painting* or Venetian *sculpture*. Thus, although the Romans did make countless statues and temples, these were for the most part lifeless imitations of the Greek, and when we think of candidates for Roman art we think of the portrait busts, or of secular buildings. Now the latter provide a very difficult problem in spatial concept.

We observed with the Egyptian an emphasis on spatial extension all in one line, whether it be the organization of buildings in the pyramid complex, or the direction in stance of the king. Egyptian paintings and reliefs were characteristically placed along the walls of endless narrow passageways: they fall into a natural focus best when the spectator walks along with them and apprehends them, so to speak, from the corner of his eye.

With the Greeks we observed a denial of any space whatever. Indeed the Greeks had no word for space as we know it, but referred only to location, distance, or extent. Now in a Roman basilica or bath we find no real spatial concept or organization, yet definitely a spaciousness, something in their architecture cognate with the spaciousness of empire, yet without insistent logic of measurement or direction.

To this effect the Romans conceived and executed stupendous arches and vaults such as the world had never seen. In the construction of the Roman **basilica**, a building commonly used as law court and business mart, the spatial effect was open, monumental, and clear, perfectly suited to function. This is most important when we regard what happened in the Early Christian basilica, designed as a church, and product of a civilization that we can no longer consider as belonging to the ancient world.

PART THREE

MEDIEVAL ART

EARLY CHRISTIAN AND BYZANTINE ARCHITECTURE

With the conversion of Constantine to Christianity it becomes clear that the ancient world has been transformed. No longer are law, engineering, and empire—the magnificent secular achievements of ancient Rome—vital nor able to defend themselves from the barbarian within and without. Instead of the concentrated gaze and imperious command of the statues of the emperors, the bust of Constantine has enormous eyes and a strange, inward and otherworldly gaze, like all human representations of that time, from the Roman catacombs to the Coptic (Christian Egypt) tombs. A thousand years of intensely religious civilization seems to have emerged with Christianity and the other Mediterranean religious cults, further developed with the Byzantine empire and civilization, and eventually with Islam. In a poem of great insight, W. B. Yeats speaks of leaving the West's "monuments of its own magnificence" and sailing to the "holy city of Byzantium" to be gathered "into the artifice of eternity."

Thus the difference between the Roman basilica and the Early Christian basilica is much more than that between secular and religious function, but depends on a radical difference in civilizations, in which the secular and religious orientations are of basic importance. The classical antique world of Greek and Roman and Etruscan was one of the least religious of all the world's civilizations; the medieval world of Hebrew, Early Christian, Byzantine and Moslem was one of the most intensely religious that we know or could imagine. The magnificent Byzantine Emperor, Justinian, turned in the end to a monastery.

The classical civilization was characteristically physical, frank, and extroverted, the medieval was spiritual, introverted, and mysterious. In an Early Christian basilica like S. Apollinare Nuovo in Ravenna (Plate 5b), which is only superficially a descendant of the Roman basilica, we find a relative darkness, a use of columns without a base and topped with arches so that they seem to float, a hypnotic repetition or lack of articulation in the colonnade, in the row of windows, and the saints in mosaic leading down to the altar, all of which produces a mesmerizing, single-minded concentration on the host and an air of mystery and suspense which are anything but appropriate to the spirit of ancient Rome.

Similarly in the great monument of Byzantine civilization, Hagia Sophia in Constantinople—the vast centrally planned church with its domes piled on domes, its dim lighting and richly glimmering interior surfaces—the feeling of the immaterial, of reality as a floating dream, achieves a consummation.

ROMANESQUE ARCHITECTURE

It is not unusual to group together all manner of cultural manifestations under the historical heading of "medieval"—the Early Christian, Byzantine, Moslem, Romanesque, Gothic (even sometimes the far-outlying contemporary civilizations of India, China or Central America) have been covered by this term. Now whatever unity there may be among the deeply religious civilizations flourishing in the first millennium A.D. and extending from Rome to Syria, taken together they have no more real relationship to the Romanesque and Gothic ages in western Europe than they had to the antique world.

By the end of the 10th century in Europe, from Tuscany to northern England the beginnings of what is usually considered western European civilization had taken form. The full development of the feudal system, the reform movements in the monasteries, and the Romanesque architectural style all appear at this time. The process of development of the particular features of the Romanesque style is an historical study. Let us be content with examining an instance or two of its fulfilment.

First should be pointed out the inadequacy of the term "Romanesque," which was a later invention made to distinguish what is really the early Gothic

38

style using rounded (thus "Roman") arches instead of the pointed arches of the full and late Gothic. Far better is the term used of the England of this time, namely "Norman." For the Northmen, who settled not only Normandy and England but went as far as Sicily and southern Italy, were the vitalizing force at the inception of this civilization. The qualities of ruthlessness, energy, massiveness, directedness, and total organization that characterize the policies of William the Conqueror would equally characterize a Romanesque building whether in England or the Rhineland.

As typical as any Romanesque monument is the island-town-fortress-church of Mont St. Michel, though it was finished in the Gothic age and parts of it belong to that style. Erected on a heap of natural rock at the end of a promontory into the Atlantic on the northwest coast of France, this famous conglomeration of architecture is topped by a statue of the warrior saint who was at that time tantamount to the patron saint of France: as G. K. Chesterton described in *Lepanto*, "Saint Michael on his mountain guards the sea-roads of the north. . . ."

The isolation of church or monastery—whether in so spectacular a way as this, or at or near the top of one of the many hills of central France, or on the banks of the Rhine—for protection, much as contemporary castles were mounted and fortified, was typical of this early feudal period.

And in this spirit it is typical for Romanesque walls to be blunt and massive, with windows small and high up, and with powerful buttressing and supports. But possible military exigencies did not really produce this style, rather it was a militant and vehemently aspiring Christianity—one that sent out Crusades, and saw high officers of the church leading troops on horseback. Structurally this spirit may be seen in some of the cellar vaulting at Mont St. Michel, where heavy arches rising from strong piers seem not merely to support a weight above (as in the Doric order the column neatly countered the weight of the lintel) but to thrust upward with superhuman force as if to raise a world.

The interior of a Romanesque church, such as that at Vézelay in Burgundy (Plate 6a), shows an entirely different conception of the use of space from that in the Early Christian basilica. Although both make use of the nave as a means of directed progression—whether actual or psychological—from the front door toward the altar, the progression invited by the architectural forms in the Early Christian building was a monotonous one, unrelieved by any stops or differentiated subdivisions.

Compare the interior of the nave at San' Apollinare Nuovo (Plate 5b) with that at Vézelay. In the latter we find strong clusters of columns running clear to the ceiling, powerfully dividing one bay from another, articulated with variations of round and square forms, and culminating in the massive arches of the roof vaults, arches that are themselves marked off with alternations of light and dark stones. Furthermore the building is more strongly lighted than the typical Byzantine building, so that the articulation of spatial organization is made both clear and emphatic.

GOTHIC ARCHITECTURE

If we compare this Romanesque interior with the interior of a Gothic cathedral, however, we are faced not only with a further development of these features, but a transformation of the meaning of the whole.

The Interior. The nave of the cathedral of Amiens—the most classic of the high Gothic cathedrals—is not only several times bigger and of greater absolute height than Vézelay but is of much larger proportions (Plate 10a). The feeling of height is further created by the continuity of the vertical accents; the colonnettes seem to rise continuously from the floor to the peak of the roof. It may be observed also that the colonnettes multiply as they rise, from one to three to five to a multiple spread in all directions as they run into the ceiling vaulting, like the branching out and flowering of a tall tree, and indeed what **the analogy of the human figure was to the Doric order, the analogy of tree and forest is to the Gothic.** Like leafage is the multifoliate effect of the variegated patterns in the enormous stained glass windows of the **clerestory** and like interwoven vines or branches, or the veins of leaves, is the vaulting itself (Plate 6b).

Beneath the clerestory is the **triforium gallery,** the only part of the entire wall surface that is backed with masonry rather than glass. What this did was to provide a small area between the great windows above and below for a passageway from which workmen could make repairs, although in a later cathedral, like that of Cologne, even the triforium gallery is backed with windows and virtually the entire wall becomes glass. The bottom level of the Gothic interior order is called the **nave arcade.** Parallel to it and equal to it in height are the side aisles,

providing further space for congregation. But when we stand in the nave itself and look down the aisle, the continuation of the piers with their multiples of colonnettes is such that we do not see into the side spaces—the bays and aisles—as we did in the Romanesque building, but our eye is led with a rush through the vast space of the building towards the choir.

Now this is quite different from the singleminded, confined, almost monotonous eastward movement in the Byzantine building, for it is richly articulated, brilliantly lit, and unbelievably spacious. But above all, this powerful eastward movement is inseparable from the drive upwards.

The object of movement in the Byzantine building was the low altar, often contained under a squat, dark dome in a shallow choir that gave an air of enclosure and mystery. The object of movement in the Gothic cathedral is the upper part of the choir, that part of the building which is most brilliantly lit of all and the most articulated, which stands above the altar, and which is the culmination of the two basic drives, eastward and upward, as if there were a vector running from the doors where one enters at the west end to the peak of the building at the east end to which the eye is drawn.

In modern photographs it is important to disregard all furniture—chairs, pulpits, even an occasional sculpture on the lower part of a pier—most of these are Baroque introductions: like the organ too, products of an equally elaborate but far more earthly style. **The Gothic was aggressively otherworldly;** nothing was permitted in the nave which would detract from the immensity of scale within which human size and location were completely and intentionally lost, or from the swift and overwhelming movement unequivocally onward and upward.

For the Gothic heaven was in the sky, above the clouds, through the high-arching leaves of the forest, beyond the mountain peaks: this is where God and the angels dwelt, to this man aspired and yearned with such burning energy that he built the most ingenious, complex, and intricate symbolic constructions ever conceived or ever likely to be, vast compilations for which the stone was hauled voluntarily by noble and workman alike, to which the riches of the community were dedicated, and for the building of which the most skilled architects and craftsmen were called the length and breadth of Europe.

As to who is responsible for the design of these unbelievable excelsiors, we do not know. Abbot Suger, an astonishing person and a vital force behind the building of the Gothic apse at St. Denis (often claimed to be the first truly Gothic structure), has left a proud and vigorous book on his role as promoter, but he could not have been responsible for the architectural ideas, which would have required professional training and architectural-imagination. The artist may have been some sort of combined engineer and master craftsman. Today all these functions are rather distinct. But even if there had been a single commanding genius on the scene we still would not know him. For in this respect the Middle Ages were anonymous, and those sublime works were achieved not for private fame but in a greater cause.

The Pointed Arch. Crucial to the expression of these deep feelings and cosmic predictions was the development of the pointed arch. Its advantages over the round arch are several. First, it attains a great actual height from the same springing point as the round arch. Second, it *seems* higher even than it is because of its arrow shape, or pointed effect. Furthermore, it permits a continuous, uninterrupted line the entire length of the ceiling. The reason for this may be seen if we remember that in round arch construction an arch which is the arc of a circle is more secure than one lower than that. In cross-vaulting (that is, where the weight of the roof is carried on ribs springing from four basic piers) if the piers are equidistant, then round arches from one pier to another nearest to it will reach the same height, but the necessary arches running diagonally across the vault, if they are kept round, will be higher than the side arches. This produces a dome effect, and some buildings were made this way. Indeed such a solution might be satisfactory to the Byzantine architect because of his fondness for domes. But to the Gothic this was intolerable because it broke up the continuous eastward drive, which to them was vital. Now with the pointed arch it is possible to vary the height with little effect on the strength, and a roof without domical divisions but with a continuous sequence of the meeting points of the ribs is possible. This provides not only a continuous line but possibly more important in the nature of the style, a continuous flow. We have already seen how colonnette flows into colonnette, across the orders—in stark contrast with the classic Greek division and opposition of function and level.

A great deal of thought and discussion has been

directed by historians to precisely what distinguishes the Gothic style. The pointed arch, the glass wall, the flying buttress, over-all verticality are only some of the features cited as being essential. Now it is true that all these features are characteristic of the Gothic, and when a building has all of them it is invariably a Gothic building. But it is also true that any one of these features may be found in a non-Gothic building. We must look then, not for a device, but for a pervading characteristic.

The Gothic Principle. If there is one thing that is true of any Gothic building and of no Romanesque building it is this principle of continuity, **of the essential merger** of one part into the next, of the perpetual flow of the unit throughout until it becomes indistinguishable from the whole. This principle may be found anywhere and from any view inside or outside the building. It gives the Gothic style an unparalleled feeling of growing, moving, and developing: an organic quality that is of a very different kind from that of the Greek. The Parthenon is organic in that its refinements give it an imperceptible but keenly sensed life, a breathing, hovering quality. It creates a feeling of life that is quiet, modest, self-contained, in perfect harmony. The cathedral creates feelings of the limitless procreative power of nature, of rushing, soaring movements, of the rustle and roar of forest, of the staggering splendor of the sunset, of land and ocean without rest.

A Gothic cathedral calls to mind Goethe's interpretation of nature and his finding there the eternal source and replenishment of life and vigor. So it is no accident that Goethe was himself one of the deepest appreciators of the Gothic style; he wrote, before the cathedral of Strasbourg, "It rises like a most sublime, broad-arching Tree of God, who with a thousand boughs, a million twigs, and leafage like the sands of the sea, proclaims to all the neighborhood the glory of the Lord, its master . . . everything is articulated, down to the minutest fibril, yet everything functions as a part of the whole. How the firmly grounded, stupendous building lightly rears itself high in the air! How quick with life, yet all for eternity. . . ."

And from the outside the forest-like feeling of infinite and continuous growth is all the more overwhelming. At first glance the building seems a morass of flickering elements, with filigrees and sculptures of all kinds over multifold surfaces which are already eaten in and out with light and air. And much of the surface is sheer decoration though all is ordered toward the feelings of verticality and growth. Yet underneath, on the exterior of the cathedral, is the mass of structural engineering which makes possible the incredible vaulting and vast walls of glass which seem, on the inside, impossible of support. **A Gothic building always seems to be turning itself inside out.** The choir stalls, for example, not only heighten the articulation of the interior but echo the forms of the exterior as well. This aspect of metamorphosis obtains equally in Southern England, Northern France, Western Germany, and the Lowlands, all of which compose the center of Gothic style. The looming, endlessly elaborated character of these mysterious yet articulate buildings is best experienced in the grey and misty atmosphere of the area, much as Greek and Roman buildings need and deserve a clear, bright and undisturbed empyrean.

The Open Wall. The support of such high vaulting requires an extraordinary amount of buttressing, and at the same time the opening of the walls into glass means that this buttressing cannot be done by the walls as such. A solution was indispensable to Gothic spiritual and metaphysical drives, and it came with the development of the flying buttress. The use of ribs in the vaulting meant that the weight could be carried to piers so that in between, in the bays, the wall could be opened up into windows. To carry the lateral thrust in such lofty vaulting, the piers themselves had to be very deep and at right angles to the building. This would mean blocking a good deal of the light.

At this point we have the effect of breaking the wall into many sections and turning each one at right angles to the building. The next step, in order to gain more light, was, in effect, to remove each of these sections clear of the wall. The pier thus removed becomes what is called a **tower buttress.** The outward and downward thrust of the vaulting is then carried from the inner pier to the tower buttress by means of the **flying buttress,** which is no more than a small course of stone running at an angle counter to the thrust and doing its work through the compressive strength of stone. This buttress is held in place by a slender arch formation beneath it, usually called the **flying arch** (Plate 7c). Since the chief weight carried in this way is exerted horizontally from the vaulting (much of the vertical component of the thrust being carried by the inner piers), the pinnacles atop the tower buttresses, which add to the sense of vertical aspiration on the

exterior, also add weight to the buttress working horizontally.

At the west end this work is done by the gigantic façade tower, but at the east end, where the choir is rounded and there are no towers, the system of flying arches and tower buttresses circles right around the building. The whole effect taken together with the use of the round rose windows on the west, north, and south façades—which inside the building provide a note of mild repose in the midst of all the forceful upward action—with their multifoliate tracery radiating dynamically out, is that of a gigantic spider web, all sinuous and infinitely complex, yet all organized to a monumentally structural purpose, richer than that of any other major building style, and partly for that reason yet also by the very nature of its aims always imperfect, unfulfilled, incomplete, and striving for the infinite.

Growth and Infinity. No Gothic building was ever completed. We have some idea of how one of them might have looked if it had been: with long pinnacles topping every tower. But even then what is there to prevent adding a tower here or there, bigger or smaller; what is to prevent adding a chapel or chapter house, porch, stair or belfry, statue, pinnacle, or cross?

Unlike a Greek temple—which had to be complete to be anything at all—which was planned to the last detail before it was begun, which is so perfectly logical that the viewer standing at one corner knows what every other view of the building must be—the Gothic cathedral, growing slowly out of a cluster of houses around its base and interwoven almost with them, might go on indefinitely. Of the great cathedrals of the Ile de France—Paris, Reims, Beauvais, Amiens and Chartres—only Chartres can boast completed pinnacles on the great west towers (Plate 11*a*), and these were built two centuries apart and are of entirely different shapes literally from the ground up. The one on the right is Romanesque (and by reputation one of the most beautiful and successful towers ever built), while the one on the left is late Gothic, yet their styles are harmonious, not in the Greek sense of being the same, but in the sense of being compatible, of complementing each other. The façade at Chartres is Romanesque, the south portal high Gothic. Reims was built from the east end to the west end, Amiens from the west end to the east end, Cologne from the two ends meeting in the middle. Only one of the towers at Strasbourg was completed; the single tower at Ulm, highest of any in the world, was completed (from Gothic plans) only in the 19th century. Beauvais remains only choir and transept, yet she ranks among the great cathedrals.

The point is that the logic of these buildings lies partly in their sense of growth. No two civilizations seek the same qualities. The Egyptian pyramid and the Greek temple were constructed with the most astonishing care and precision. Hagia Sophia, the glory of Byzantium and one of the great buildings of the world, was constructed somewhat hastily and roughly by men who cared little for perfect joints but a great deal for the organization of all architectural factors in such a way as to produce an effect of glorious dematerialization.

In contrast to these, the quality of **variety** is one of the characteristics of the Gothic style. All Doric temples approach the same ideal: the Parthenon is the most classic and also the finest. Amiens is the most classic of Gothic cathedrals but this only means it is the most consistent and attains the greatest internal balance. Since these are more important to our understanding of Gothic structure than they are to the nature of the Gothic style, Amiens—though certainly one of the finest—is not necessarily more beautiful than any one of half a dozen other cathedrals, all strikingly different.

Variety extends as well to the national styles. Italian Gothic style is unimportant except perhaps for the cathedral of Milan (in northern Italy) since the Gothic spirit itself is a northern one and always had trouble expressing itself near the Mediterranean. Spanish Gothic (e.g., Burgos) always seems to engender Moorish undercurrents. The Gothic style began in France and found there its most balanced and possibly its finest expression, though we can never ignore the Lowlands, nor especially England and Germany.

England is a broad, low country, and her people have covered more of the surface of the globe than any other. Her cathedrals extend out horizontally, their naves are very long but not wide nor high, their towers either low or slender, their transepts sometimes repeated alongside, their chapels and cloisters connected to the outside of the building which meanders over the landscape. The English cathedral is characteristically surrounded with a close, or system of vast lawns frequently containing streams and other buildings. We may think of Addison's remark, after seeing the Alps: "You can't imagine how glad I am with the sight of a plain."

With the narrower, more idealistic and theoretically inclined Germans, the Gothic style achieved its furthest expression of the vertical, and also the most extensive development of that logic of transforming the stone wall into light-filled glass.

The spire at Ulm is the tallest of any Gothic building in the world. But equally Germanic is the militant rise and frontal assertion of such a cathedral as Worms—it seems to compose itself, to march and clang as if made of iron.

Compared with this the façade at Chartres (Plate 11a)—the most French of all Gothic buildings in its simplicity, variety and taste—seems to charm the very sky with a lovely reasonableness and intimacy.

GOTHIC SCULPTURE

The term "Gothic" was first applied in the later Renaissance as a term of disapproval. Indeed, most historical terms seem astonishingly ill-fitting, being the products either of malice—like the terms Gothic and Baroque—or of misunderstanding—like the terms Romanesque and Renaissance. "Gothic" registered the repudiation, by a later and more worldly age, of the lean and ascetic, unreally attenuated saints who people Gothic sculpture, and of the seemingly barbarous emotive force in riotous representations of hell and damnation, which today are more justly appreciated as masterpieces of expressionist art.

The Gothic cathedral was both covered and filled with sculpture. Inside, although the nave was kept clear for purposes described above, the side aisles and ambulatory, with their rows of chapels, were filled with sculptures of local saints, and the choir screen was a favorite background for carved elaborations of the Passion, the life of Christ or the Virgin. Elsewhere sculpture was created on moldings, capitals, and tombs. It should not be forgotten that these sculptures were generally polychromed, and thus all the more vivid and colorful, adding to the already rich and tumultuous effect of thousands of churchgoers in variegated garb moving in an atmosphere filled with colored smoke and incense, and lit by vast areas of colored glass—now mostly gone.

Outside sculpture was even more in evidence (Plate 7d). At the top of faraway pinnacles stood angels, on the roof-lines demons and gargoyles, high across the façade rows of saints, or kings, and at every corner or point of emphasis the elaboration of some sculptured form, whether representational or abstract, all combining with the deep architectural recesses and variations to provide that multifoliate flicker and movement essential to the whole.

But these sculptures were not limited to decoration or even to emotional expression. The most important had strict and literal biblical meanings, warnings, encouragements, lessons, and encyclopedic illustrations from the life of the time. These cathedrals stood at the heart of society, yet they were made at a time when only a small proportion of that society was literate. The entire cathedral has therefore been called a sermon, an epic, and an encyclopedia in stone. The purpose was to teach not only by the exaltation of the architecture but also literally through the representation of stories and images.

FAÇADE DECORATION

At the west façade of Amiens are three great portals, the largest in the center. Each portal is a deep cavern, drawing the churchgoer into the interior and especially the nave. Each portal has two gigantic doors, so large that the six-foot doors cut within them which are used today are only a small fraction of the whole. In the thirteenth century the large doors were left open at all times, and tens of thousands of people thronged in and out. The cathedral was in the center of the town, facing the market place (a far cry from the Romanesque Mont St. Michel), and no small amount of business and politics took place within the building itself. At night thousands of pilgrims might sleep inside, and doubtless it was shelter too for people who now must use doorways and park benches. Today, at any given time, these great cathedrals seldom contain more than a handful of people, possibly churchgoers, more likely sightseers. It is questionable whether we can really envision these extraordinary buildings as originally experienced when central to the life of the community.

Between the two great doors in each portal at Amiens is a supporting post called a **trumeau**. On the left hand trumeau stands a figure identifiable by the crosier he is holding and the miter he is wearing as a bishop; this is St. Firmin, an earlier bishop of Amiens (a cathedral is by definition the seat of a bishopric) and virtually a patron saint of the town, but not in the sense that Athena was patron saint of Athens and the Parthenon, for the latter was felt to be her home and hers exclusively. The church is not the home of any god (though the cathedrals were

dedicated to Our Lady), for God dwells everywhere; it is rather a house of worship, a place where an experience is undergone whereby the churchgoer associates himself with a higher life.

On the central trumeau at Amiens stands the Beau Dieu (Plate 4e), a figure of Christ triumphant over four grotesque animals under his feet: the lion (here a symbol of the antichrist), the dragon (devil), the adder (sin), and the basilisk (death)—in other words, the Powers of Darkness. In one hand he holds a book, suggestive of teaching, the other is raised in a gesture suggestive of benediction. Yet the severity of his expression and the angularity of posture and of the cutting of the costume suggest a more pointed interpretation, and when we consider that this figure stands at the center of the central portal, over the head of the churchgoer, we may experience something of the force of the Biblical injunction understood by anyone of the time to be expressed by the Beau Dieu: "I am the door . . ."

Now the interpretation of such figures, which to us is practically a problem in archeology, was in the 13th century largely a question of common understanding. François Villon (writing late in the Middle Ages) described something of this process in verses written for his mother:

> I am a woman, poor and old,
> Quite ignorant, I cannot read;
> They showed me at my village church
> A painted Paradise with harps
> And hell where damned souls are boiled;
> One gave me joy, the other frightened me . . .

One way in which figures could be "read" was by the use of *attributes:* objects carried by or near the figure associated with its position, its function, or its martyrdom.

For example, on a level with the trumeau but on the sides of the portal (Plate 7d) are ranged full length figures (but a little smaller than the Beau Dieu because of lesser importance) of saints and apostles holding various attributes. St. John holds the cup from which he drank poison, St. Peter holds the key (to heaven), St. Paul the sword of his leadership, St. James the Greater wears the cockle shells of a medieval pilgrim to his own shrine in Galicia, and St. Bartholomew the axe with which he was flayed.

Beneath these figures, in basement strips, are the sequences of quatrefoils, carved in low relief and representing more secular ideas. At one place the Virtues are ranged above the corresponding Vices (the figure of Courage sits erect and firmly composed, sword in hand, the figure of Vice turns in consternation, dropping the sword). In another (Plate 8b) place the signs of the Zodiac are ranged above the appropriate Labors of the Months (cultivating the vine, hawking, or blissfully drunk on May wine). Elsewhere are parables, further biblical illustrations and teachings, and allusions to all aspects of life, for as Victor Hugo observed, "in the middle ages men had no great thought that they did not write down in stone."

GOTHIC NUMBERS

Great metaphysical epochs seem to develop vital cosmic systems of number relationships and meanings, and the Gothic was no exception. The classic Greeks, whether in drama, sculpture, philosophy, or architecture chose to think in terms of the trilogy, or in clear geometric multiples of one-two-four-eight (for example, one column, two triglyphs and metopes, four mutules and lions' heads, eight rows of roofing). Gothic numerology was extremely complex, and open even amongst themselves to a variety of interpretations, but this takes nothing from the significance that such number relationships were felt to have. Three signified the Trinity, not the Greek trilogy, but a three-in-one and sacred, as opposed to four (the elements) which was secular or mundane (thus the earthly-subject quatrefoils are foursided, "four-leaf"). The addition of three and four signified man (his seven ages, or the seven deadly sins), and the multiplication of three and four (the twelve Apostles, the twelve days of Christmas) referred to the Church.

The object was to represent, express, and make clear and meaningful a universe compounded of the Sacred and Profane, wherein everything tended to be a symbol of something else, so that there were many layers of meaning affecting all, from farmhand or prince to recondite clergyman or prelate. Even the mortar consisted of lime, which was love, and sand which was earthly toil, and water that united heavenly love and the earthly world. So that in all this multiplicity, variegation, and enthusiasm nothing was really haphazard—everything was, as St. Thomas said, ordered towards God: where lay the sole source of truth and finality of meaning.

But if God was the beginning and the end, Nature was the medium. The natural world had been

repudiated by the Greeks—their metopes excluded it entirely—but in the quatrefoils we find earth, foliage, trees and vines and on the string courses inside the cathedral—we find forms of vine leaves that blow and vines that grow, a marvelously organic device.

In contrast, when the Greeks did occasionally use a botanical motif they preferred to render it as an abstract shape, part of a geometric pattern, and static, whereas in the cathedral, this deep association with the life of nature, along with the driving sensations and conceptions of the existence and meaningfulness of space and time, are qualities that emerge in the Gothic and already distinguish the civilization of western Europe from any other.

In the tympanum, or flat, pointed area above the door and at the back of the portal, is represented at Amiens typically a scene of the Last Judgment, or really four scenes, with God appearing over the heavenly city (represented in medieval symbolic fashion by a single tower); next the figure of Christ sitting in Judgment, with Mary and John—the intercessors for humanity—kneeling entreatingly beside him, and angels displaying the cross and the spear (of Longinus), symbols of the Passion; next, a section showing clothed, erect, dignified smiling figures on the left half and facing towards the left, in contrast with the naked, awkward, unhappy figures on the right, moving to the right where gapes the mouth of hell—so these are the blessed and the damned—and the latter include bishops and monks, queens and princes as well as the run of mankind. Finally, on the bottom tier stand four large angels, blowing the Last Day, flanking the center figure of Justice with her scales, and including a number of naked figures struggling with stones: the Dead rising from the grave.

Throughout the tympanum as throughout the portal itself we find that the size given a figure varies a great deal according to its importance. This is a conception of physical relationships remote from the Greek, for in the pediment of the Parthenon there was only a slight shift in size of figures as one approached the more important, standing figures in the center, and all were closely related to the size of the human being itself. The Gothic aim was, both in the ascetic treatment of its figures and in the expressive distortion of their size, to transcend the mortal frame.

The famous figure of Moses at Chartres (Plate 4*d*) shows ascetic elongation not only in the body but even in the head. There is nothing here of Greek solid geometry, yet at the same time this head is unlike the Roman in that there is a gripping formal organization, based chiefly on the elongated S-curve and continuing endlessly so as to encompass not only forehead and cheekbone but the hair on the top of the head, down the side, moustache and beard, back and forth. Ordinarily when the Greeks wished to indicate an old man, they simply carved a youth and put a beard on him. Such was the typical representation of Zeus, to give him dignity. But Moses, and the other figures of saints and prophets, are *aged*—bowed and wizened, drawn and incised with the torment of experience.

The Western Character. This has to do with a conception of man's fate common to all Western civilization and alien to the Classical. For the latter a man's fate was something he inherited, his character something he was born with, full-blown, his career at the whim of the gods, his duty but resignation toward that which was stronger than he.

For Western man, his fate is in his own hands, his duty is to struggle, his character is the result of time and suffering and inner change: Shakespeare says, "Think not I am the man I was." This attitude of the soul toward the world may be seen in any Gothic sculpture (so that even a young saint looks aged and experienced in a way that the placid and externalized Greek never does) but also in Renaissance or modern work, and it is precisely these qualities of will, determination, and inner consciousness that distinguish Italian Renaissance sculptured portraits from the ancient Roman (Classical) work which they otherwise so much resemble.

But if this attitude prevails, not all Gothic sculpture is necessarily concerned with heaven and hell, and it should never be forgotten that some of the loveliest women ever carved are those in the high Gothic choir at Naumberg, whether fresh and smiling and intimate or poignantly withdrawn like the unforgettable Uta (Plate 3*e*). Together with them are princes and knights in various human characterizations, truculent or craven. One, who hides behind his shield, grips a broadsword which would have to curve right around his figure if it were conceived entire: always in Gothic sculpture the figure is subordinated to the architecture.

Gothic versus Renaissance. This principle is nowhere more clear than in the Bamberg Rider, especially if we contrast it with a Renaissance mounted portrait like DONATELLO's Gattamelatta (Plate 9*a*). The Gothic statue is smaller; it is attached to a wall

inside the cathedral. The Renaissance statue is very large, larger than life; it stands on a large pedestal outside the cathedral at Padua, but not connected with it in any way: it looks on the square. The Gothic statue is subservient to architecture. The Renaissance statue is independent, indeed the pedestal is actually in itself a piece of architecture, with doors and orders, so that in a sense architecture is here subordinate to sculpture.

The Gothic figure is all oriented upward, in gesture, in the lines of the horse and its proportions and in the background. The Renaissance figure is displayed horizontally, the body of the horse is thick, the man looks outward with a sweeping gesture of the hand, as if to survey the world and act upon it, whereas the Gothic figure relates head and hands in a withdrawing gesture, and his expression (even though he is a secular figure, a warrior) is otherworldly.

THE MEANING OF RENAISSANCE

We are faced in this comparison with one of the profound changes that took place in the western world around 1400 A.D. The word "Renaissance" is most unfortunate, first because it suggests that this aspect of civilization was in its basic nature a rebirth or copying of something else, but also because its glorious outburst in Italy tends to make us think that a Renaissance either did not happen in the north or came, as some say, a century later.

Whatever word is used, the fact remains that in the late 14th and early 15th centuries, everywhere in Europe, a shift occurred that meant a different kind of interest in life, a different attitude toward present and future, God and man, the material and the immaterial. The age that followed was still a devout one, but it did not subordinate everything in this life to the life to come. Instead it found much to relish and enjoy here on earth, as the blossoming trade and industry from Florence to Bruges will testify. A love of consumption goods was equalled by a new ideal of the human body: full and physically energetic.

One of the outstanding sculptors of the early Renaissance was the French CLAUS SLUTER whose masterpiece is the Well of Moses at Dijon. If we compare his head of Moses (Plate 13a) with the Chartres version and again with Michelangelo's (Plate 13b), we are struck with the vivid presence of the Renaissance work. Although far-seeing and authoritative

according to the Moses tradition, the expression is more of *man* in momentary intensity than of *saint* as in the Gothic, or of *philosopher-soldier* concept as in the Michelangelo.

This interest in the reality and life of the present world, here and now, is further shown in the farflung explorations, covering the surface of the globe and made possible by new instruments of navigation, cartography, and scientific exploration itself.

Just so, the Gattamelata (Plate 9a), soldier of fortune and savior of the city, commands the field and surveys the world in one gesture, magnificently healthy, vigorous, and worldly-knowing, holding the baton of command rather more as a pointer than an abstract symbol, astride a stupendous charger whose foot is raised, neck swollen with energy and anticipation, veins distended, nostril expanded and eye aflame, so that the whole breathes with a particularized vitality that contrasts strikingly with such a truly classical work as the horse of Selene from the Parthenon, where there is no less life but rather one subdued, severely generalized, calmly stated. The magnificent—and highly efficient, as contrasted with the Gothic—saddle, armor, and material equipage of the Gattamelata, with its lavishness, articulation and vibrant touch contrast both with the material rejection of the Gothic and the more abstract formulation of the Greek.

Now the interest in the earthly life, the mancentered world, sounds very much like the Greek, and rightly so, but there the resemblance ends. Consider that the Gattamelata is a *portrait*, in itself an approach to life that the Greeks consistently repudiated. Think of the assertion of will, and of dominion, where the Greeks taught resignation. Think of its great size and scope, where the Greeks sought modesty and self-restraint. Unlike the Phoenicians and the Egyptians, the Greeks had travelled and explored very little, touching only the borders of Africa and then withdrawing. It would not have occurred to them to venture beyond the Gates of Hercules any more than to trace the stars or to dissect the human figure, as the Egyptians and Mesopotamians had done. The worst punishment that could befall an Athenian was exile, and Socrates chose death instead. To a European of the Renaissance, home was a place to return to after a venture —until the next.

The word—"*rinascita*"—was devised later in the 16th century to celebrate the revival of ancient art forms, especially letters, that pervaded forms of ex-

pression as the 15th century developed. Yet in fact this revival did not occur until after, and was thus a product rather than cause of that change in the whole world outlook which then made the long-familiar works of a human-centered Antiquity more interesting and palatable. And at that it was generally Roman works (those that lay about in Italy) rather than Greek that were chosen, though the latter far more purely expressed the classical civilization.

This is not to say that the interest in the Antique was not genuine nor that it can be dismissed as a mere stimulus, for it was a vital source in Renaissance civilization. But it is important to remember that the same shift of interest towards the life of this world, and with it a tremendous outburst in the realms of economics, science, and art alike, in contrast with the spent forms and activity of the late Gothic, took place in the north quite as soon and quite as emphatically as in the south.

Renaissance versus Antique. Let us consider once more the metope from the Parthenon (Plate 1*b*), and contrast it with a similarly architectural-decorative plaque like one of those on LORENZO GHIBERTI's doors (Plate 12*a*) of the Baptistry in Florence, done early in the 15th century and later adjudged by Michelangelo as worthy of being called the Gates of Paradise. The Greek work is in marble, which wants to be carved in clear simple planes (the more involved Gothic sculptures were carved in wood or in limestone, which are far more malleable). Ghiberti's relief is cast in bronze from a clay model, a medium readily worked with the fingers and variegated tools, and susceptible of far more supple and pictorial effect. The Greek relief is plainly bordered by simple architectural lines, the Renaissance panel by a rich development of decorative devices, figures, and emblems.

Both are battle scenes, yet the Greek image is reduced to two near-naked figures representing the two sides, while the Renaissance one is filled with throngs, of people in all guises, in many parts of the landscape, which itself is rich in architectural detail and natural—and all within a narrow plaque.

In the Renaissance work we see developments in time, in scene, and in role. The Greek ideal was a unity of time, of scene, of action. In fact, to look at Ghiberti's doors entire is to see a vast Gothic elaboration in terms of a clearer light, more balanced architecture, and appreciation of the human figure as a breathing, athletic entity.

But if this is to insist on the continuing unity of the western world, it is not to minimize the difference between the Gothic and the Renaissance ages, as generally understood, in the broadest terms. We have already noted a shift from architecture to sculpture as a basic clue. The leading art of the Gothic age is unquestionably architecture, though this is not to underrate sculpture, glass windows, manuscripts, or panel paintings, all of which are significant. The leading art of the Renaissance is painting—clearly so in the north, but true even in Italy, where sculpture is merely a strong element, and where, significantly, sculpture reaches its highest point in the history of western European civilization. In Greece sculpture was the final and supreme medium; it is interesting that Frank Lloyd Wright has difficulty in accepting the Parthenon other than as a piece of sculpture.

Gothic and Renaissance Architecture. But since it is difficult to compare one medium with another, we may more profitably turn to comparing Gothic architecture with that of the Renaissance, for the latter is important. But before we begin, there must be one more amendment. The important architecture of the Romanesque and Gothic ages is incontrovertibly religious. The most striking and characteristic buildings of the Renaissance and Baroque ages, the most vital if not always the most famous, are not religious but secular, and it should be added, aristocratic. Although the castle is crucial to the Gothic age, and so also is the church to the Renaissance, still if we think of the most genuine and energetic buildings of the period roughly 1400-1800 A.D. we think of palaces, chateaux, country estates, hotels de villes.

But let us compare what can best be compared. Sto. Spirito (Plate 10*b*) by FILIPPE BRUNELLESCHI looks almost like a return to the Roman basilica. Light, clear, close to the ground, self-limited, composed of straight lines and circles—all in contrast with the Gothic—it looks Roman in its use of Corinthian columns and parts of an entablature above, as well as in its clarity of shape. Here however we find something the Romans would never have been interested in: an organization of space according to the numbers. The height of the nave is exactly twice its width. The aisle bays are square and exactly twice as high as they are wide. The apprehension of such simple relationships contributes to the quiet, orderly feeling in such buildings of the early Renaissance, but the application of mathematical laws

to the organization of space was a matter of positive excitement to the people of this time who were —in quite the same spirit—experimenting with the laws of perspective.

At about the time this building was completed, so also was the invention of printing, another conquest of geographic space, though it may be suggested that it was the Italians who were especially interested in *measuring* space, the northerners primarily interested in pursuing its limitless extensions. The Italian, with the classical undercurrent always a part of his nature, is also concerned with balance, a quality markedly shown in Sto. Spirito where Brunelleschi made the apse identical with the transepts, so that from the crossing the building is exactly the same in all directions except down the nave. The result is very close to the centrally planned churches that were favored in the Byzantine style, but the feeling that results in this building is nothing like that inside the mystery-domed Byzantine structure—dark, floating, and enclosed. Here all is expounded in the clear light of day, each part simply but articulately measured against the next and the whole. The final experience of its tendency towards centrality is for one to stand in the center of the crossing, from which point the building has its most complete effect. There man becomes the measure of the world, and the church is no longer the scene of transcendental experience but a house of devotion for man on this earth, centered in his present life.

But if a building such as this tells philosophically of the ideals and conceptual attitudes of the time, and creates a very real beauty, there is another kind of building of the Renaissance which seems equally connected with the spirit of the time and even more alive—the palace of the merchant prince (and in a sense of the entire community). The Palazzo Riccardi was built in Florence by DI BARTOLOMMEO MICHELOZZO in the 15th century, and may stand for the others.

We are at once confronted with broad wall surfaces, of which the windows are the lesser part, and a static conception of space. What is it, then, that distinguishes this style from that of the Romanesque? First we notice that the windows are carefully organized: a large one on the bottom story, twin windows on the second story on the same axis, and the same repeated with variations on the third story. The windows on each story are the same, except on the bottom story, where they alternate. The windows on the upper stories are divided by a column and round arches. In other words, the windows which are the basic articulation of the wall are measured and balanced, and could not be moved without destroying the effect of the whole. This, however, was not true of the Romanesque, which like the Gothic gave the effect that things could grow and alter indefinitely (though this is not to be confused with the fact that *space* in the Romanesque was static, while that of the Gothic was organic, ever-flowing).

Further articulation of the wall of the Palazzo Riccardi may be seen in the size and cutting of the stones used. In each story they are uniform, and each story is separated by a small but clear cornice which extends all the way around the building. The bottom story is heavily rusticated—the stones are massive in size and left rough. This, taken together with the bars on the windows, reminds us that even in the middle of Florence a house had to defend itself if only against thieves; in Europe there were no police as we know them until Sir Robert Peel's Bobbies early in the 19th century. The second story employs a stone that is smaller, more evenly cut, and smoother, and uniform except for the courses that meet the arc of stones at the top of the windows, where they become narrower in compensation. In the top story the stones are smaller and smoother still so as to give, very nearly, the effect of an even surface.

Not only does the building show these Renaissance qualities of measurement and gradation, but like most Renaissance buildings it shows specifically the choice of Antique motifs, if only for decoration. Thus the pediments over the first-story windows, the medallions on the upper ones, or the deep Roman cornice that tops the building.

But this is only the outside, that relatively grim front that the palace gives to the everyday world. The important part was the inside, for the whole center of the building was open ground, sometimes as an entrance-way for carriages, sometimes with formal gardens and pools, and surrounded by graceful arcades almost resembling a cloister, yet where people lived the full and active lives of which we read in so many Renaissance memoirs—hardly a cloister for self-seclusion and other-worldly thought.

One of the most impressive examples of the development of the Renaissance palace-symbol is the Castle of Blenheim (Plate 9*b*), gift of the realm to the Duke of Marlborough in commemoration of the victory in that German town. A private home, a

public showpiece, but more than that a place for important state and diplomatic functions, it was drawn up as if in military formation, and capped with stone cannon balls and bursts of flame.

In America a genuine representative of this style of architecture and form of life may be seen in the Gardner Museum on the Fenway in Boston, an original Venetian palace brought over stone by stone by Mrs. Jack Gardner who filled it with pictures largely chosen by Bernard Berenson, the venerable authority on Renaissance painting. Here because of the Massachusetts climate the courtyard has been roofed over, with the result that in the middle of winter one can enjoy a wealth of flowers in a springlike atmosphere, genuine enough in contrast with such an imitative and out-of-place Gothic building as St. Patrick's cathedral, burrowed among skyscrapers in the midst of Manhattan.

Subsequent Architecture. Renaissance architecture developed, in the later 16th and in the 17th century, into a grandiose order, the outstanding monument of which is beyond comparison the apse of St. Peter's in Rome, where Michelangelo, violently thrusting against the limitations of his time and prognosticating the giantism of the Baroque, piled up colossal masses beyond human scale.

In the 18th century, architecture—especially in south Germany—took its cue from music, the dominant art form of the age. It is of this kind of art that Goethe said, "Architecture is frozen music" (a concept much misapplied in recent years).

Since then architecture has no longer been a symbolic art (as it had been in Egypt and Greece) but a building—or engineering—art (as in Crete and in ancient Rome).

Modern American architecture—notably that of Richardson, Sullivan, and above all Frank Lloyd Wright, is one of the outstanding achievements of the modern world. Wright's buildings are art, but they do not require theoretical analysis. Their imaginative and pertinent use of space, volume, mass, line, color, light, texture, not to mention terrain, can be understood directly by people of our time.

GOTHIC PAINTING

Long before the Renaissance reached a fulfillment in such buildings as these, a sense of the real world found expression in the first hero of western painting, GIOTTO. The Gothic age was not incapable of presenting reality, as we have seen in the figures of the Founders at Naumberg. It is simply that what the Gothic usually sought was something that transcended reality. A man's life here on earth was nothing to them, and so the facts of perspective or foreshortening, of psychology or likeness, of movement or gesture, of geology or meteorology rarely drew their attention. In ordained power of expression and ingenuous glory of decoration the stained glass windows of the cathedrals and the illustrated manuscripts of the monasteries are quite unexceeded. Yet we must admit a history to the art of painting, at least from Giotto to Picasso. Within this development we do not find an artist of the 18th century necessarily superior to one of the fifteenth, but, apart from individual artistic achievement, we can pursue a development in the command and rendering of natural phenomena. There is no greater observer, for example, than Rembrandt, and one of the things at which he was consummate was the handling of light. Nonetheless the Impressionists, two centuries later, knew more and depicted more of certain light-effects than Rembrandt did.

By the same token, Giotto endures as one of the most powerful painters whose work we know, yet some of his renditions of nature would in the light of subsequent developments seem crude—were they not so effective. Also it should be emphasized that Giotto's contemporaries and followers found his work so realistic—in contrast with the highly stylized painting that preceded him—that it seemed to man more convincing than nature herself. In the beginning and the end we must take the artist on his own terms.

Duccio (1260?-1339?). It is possible, however, to compare two contemporaries in the same land who represent different schools. In Siena a Byzantine tradition of painting—sumptuous, decorative, and abstract—had persisted throughout the Gothic period and reached its finest expression in the work of DUCCIO DI BUONINSEGNA. His masterpiece, the *Maesta* (Madonna in Majesty) originally stood facing the nave from the high altar. The panels are now dismounted from their Gothic frames and placed in a room elsewhere in Siena for safe-keeping and to facilitate cleaning, some of which has been done. Like the façade sculpture and the stained glass windows in the north, this great sequence of panels told a story. Its extensive use of gold in backgrounds and traceries calls to mind the gold-ground mosaics of Byzantium. But the medium is less abstract, less other-worldly.

The medium here is tempera (see Appendix A), usually used on wooden panels superimposed by a thin coat of glue called gesso and finished very smooth. The pigments were mixed with egg, resulting in a smooth, firm, and opaque finish, capable of considerable subtlety in handling, but conducive neither to breadth (as in fresco painting) nor translucence and reworking (as in oil on canvas). Duccio made particularly effective use of this medium in emphasizing jewelled tones, gold backgrounds, and the movement of a bright outline throughout that takes on an electric quality (Plate 16*a*).

The narrative scenes on the back of the Maesta depict the life of Christ and of the Virgin in the greatest possible detail. Humanized in feeling they are a documentation of life in the contemporary Franciscan terms of poverty, in contrast with the more severe and hierarchic attitudes of earlier Gothic painting. There is even a beginning interest in spatial projection, but unlike the Renaissance it is intuitive rather than scientific.

Duccio gives to his figures, rocks and trees a coherent shape and form, one that is built, however, not upon the analysis of planes as we have already seen in Renaissance architecture, but on his manipulation of lines, especially outlines, so that the result (particularly if you squint at it) is vitally moving, yet still abstract, like the vaulting in a Gothic cathedral. Similarly he uses clear, rainbow-like colors in arbitrary schemes which seem—again like the cathedrals —at once infinitely complex and naively simple.

Nevertheless, abstract and remote as these paintings seem when we first look at them, Duccio's work stands **among the first in western painting wherein the forms are dominated by an individual human feeling, and where the artist's expression becomes autonomous.** And indeed we may view the entire subsequent course of western art, up to the Expressionism of the 20th century, as the gradual development of these qualities until they become the very subject of the work of art. For in Duccio's paintings it must not be forgotten that the subject remains a sacred one; painting was meant to be materialized theology, as much a part of the liturgy as music. It is still true in these paintings that *what* was said was more important than *who* said it.

By the same token, it was not the actors who counted, but the action. Duccio looked closely at fellow humans to take from them not specific heads or gestures but universal types. Since it was the theological significance of a given Biblical act that counted, there was no reason not to include several in one scene: thus in one panel depicting the Agony in the Garden we see three different groups, the disciples sleeping, Christ in discourse with them, and Christ and the angel.

In the Frick collection in New York is a superb panel from the Maesta: the temptation of Christ (Plate 16*a*). Each figure takes a different moment in the drama. Despite some loss to the surface we feel the sensuous Sienese textural detail working from highly articulated flat patterns. The figures are typically attenuated, as were Gothic sculptured figures, and with a peculiar linear animation. The cities of the world are shown as miniature groups of Gothic buildings, actual reflections of contemporary Sienese architecture.

Another panel from the Maesta, the Betrayal, shows a distribution and variety of gestures and expressions adding up to a keen psychological melodrama that contrasts strongly with the more congealed, monumental drama in a painting of Giotto, the Tuscan (Plate 16*b*).

Giotto (1276?-1337?). For whatever reasons, and certainly part of it had to do with centuries of the Etruscan-Roman sculptural tradition, Tuscany was a stronghold throughout the Gothic age and the Renaissance of a tendency in painting to emphasize monumental simplicity, a severe concentration of attention, and a restrained but full-blown sculptural conception of the human figure. We see this first in Giotto, later in Masaccio and Donatello, and ultimately in Michelangelo.

To compare Giotto with Duccio is not to identify the latter with the Byzantine world. In Duccio there is a keen human quality and above all a frenetic excitement and anguish starkly opposed to the Byzantine frozen calm and final peace—thus in the Byzantine a finality, in Duccio a Gothic feeling of endless undulation.

Nonetheless Giotto seems more modern, more western to us than Duccio because of his thrust into the world of space and time. Giotto's contemporaries in Florence were that wonderful family of sculptors, the Pisani, makers of firm, solid, and psychologically-grounded images that render the human being convincing as a thing in itself. What Giotto did was to render such images in painting, to suggest by the illusions of light and dark, of line and color *that which is a given in sculpture: the solidity, density, and weight of the human figure;* and to locate it in a scenic world which if still arbitrary and

symbolic, is far more real and tangible than anything preceding him in the Middle Ages.

Where Duccio's skies were gold, Giotto's were bright blue; where Duccio combined several actions in time within the same frame, Giotto preferred a unity of time; where Duccio made of his landscape a dynamic movement that reinforced the emotive quality of his picture, Giotto rendered his landscape as architecture, commensurate with and as a setting for his human actors.

If Duccio began the process of the revelation of the beyond in the terms of this world, Giotto carried it to the point where we feel that the religious context is a starting point for the creation of human emotions and relationships in themselves. With Duccio, still, an abstract beauty is sought and found; with Giotto the beauty is rather a product of his aiming to realize an extraordinarily congealed drama of human realities.

We are able to interpret Duccio as using a pictorial language to translate the work of the religious poets, and showing a return to nature equivalent to that found in the contemporary songs of the troubadours, with an ecstatic mysticism combining piety and brutality with courtliness and luxuriance. In this sense Duccio and the Sienese school belong to the past, and **Giotto is virtually the father of all later dramatic painting in Italy.**

St. Francis. The twenty-eight scenes of St. Francis' life in the Upper Church at Assisi (generally acknowledged to be by Giotto's hand, though with assistance) are early works that already show a devotion to serenity and gravity in contrast with the emotional excitement and drama of Duccio's work. Already too we see a reliance on natural fact and observation rather than on canonical receipts: the landscape depicts actual parts of the countryside (Duccio relied more on the well-established method of drawing mountains, for example, from rocks aligned on a table in his studio).

The didactic motivation is still basic: here in the church of San Francesco stands the first complete account of Francis' career; if Giotto did not invent all the iconographic devices, he did work out a definitive statement. The scene of Francis addressing the birds is justly one of the best known (there is a small panel version in the Louvre), achieving remarkably fresh detail in the rendition of the tree and of the birds. These are still what we call conceptual (the outline of the tree is emphasized, and the leaves are oversized the more readily to be grasped), yet there is a breathing quality, a tense vividness that is new in western art.

Giotto must be interpreted not only in the light of Francis himself—who inspired freshness, immediacy, and a direct response to nature, but also of Dante, his friend and contemporary (Giotto is mentioned in the *Divine Comedy*), with whom he is allied in developing the solemn grandeur of nature through economy in the use of small detail, or of color. The barrenness of so much of Giotto's landscapes thus depends partly on the nature of the Umbrian landscape (whose magnificence withal we shall see again in the paintings of Piero della Francesco), but partly on a deep urge to formalization shared with Dante.

The development within the work of a period style or of an individual artist's style is particularly worthy of study since an understanding of the direction of a work of art, whence it came and whither it leads, tells us a great deal about the most significant nature of that isolated work. If we compare the façades of the cathedrals of—in turn—Paris, Amiens, and Reims, we see a developing verticality, airiness, and elaboration that reveals precisely what the aim of Gothic style was: what it *sought to be.* This has nothing to do with the quality or effectiveness of a single monument—that depends on the success of the particular design, and also to a considerable extent on the temperament of the particular spectator (many people prefer the façade of the cathedral of Paris, though it is the least Gothic of the three).

The development within Giotto's work reveals not only the basic direction of that work and thus its inner nature, but at the same time a sure progress towards generalization and expressive freedom which characterize the careers of all of the very greatest of the artists of the west—Titian, Michelangelo, Rembrandt, Cézanne.

For example during his lifetime, Giotto painted several versions of the scene in which St. Francis received the Stigmata from the vision of Christ. In the version at Assisi, the artist makes a positive connection between the vision and the saint, who bends backward under the impact. The figure is of a massive, rock-like solidity, set within a landscape which is hollowed out to receive it. In a late version in Santa Croce in Florence, the setting is more spacious, the rendering broader and looser, and the gestures and dramatic relationship between the figures freer. Where the modelling in the early version is hard and tight, that in the later is more pic-

torial. The early haloes are round, the later ones foreshortened. The freer, airier, more naturalistic and yet simpler effect of the late style represents not only the breadth and ease of the maturer grasp of life, but also a development in the logic of the medium.

Wall Painting. Where Duccio chose tempera on small wooden panels mounted in an altarpiece, Giotto painted in fresco to decorate the wall surfaces of chapels. Now fresco (see Appendix A) is a painting technique in which the material used to bind the pigment (equivalent to the egg in tempera) is wet plaster, which when dry renders the color a part of the very wall. Since the plaster dries quickly (in less than twenty-four hours) and since the painting is done on wall areas designed to be seen from a distance, the application must be done broadly, simply, without hesitation. The colors tend to be of a pastel, chalky freshness (tempera was usually done over dark green background and the surface colors were correspondingly darker and richer). We have seen that precisely these qualities were developed by Giotto in his late style, which thus reflects not only a maturity of expression but a further understanding of the limits and potentialities of the medium. It must never be forgotten, in considering the relevance of style to medium, that the choice of medium in the first place is the result of an inner-felt need for stylistic fulfillment.

The Arena Chapel. As with Michelangelo, Titian, and Rembrandt, Giotto's most famous works, however, are not those of his latest style, but those of what might be called his mature style. These are in a chapel in Padua sometimes called the Arena Chapel because it was the site of a former Roman amphitheatre, sometimes the Scrovegni chapel for Enrico Scrovegni, son of a Paduan so avaricious that Dante put him among the usurers in Hell: if Enrico's building of the chapel was to atone for the reputation of the family, this is not the first time nor the last that art owes a debt to avarice.

The opportunity for Giotto was ideal, since he had the whole chapel to himself, and since the building contained relatively large wall space to small windows so that the artist could determine the panel size. Now Giotto was one of the outstanding Italian architects as well as painters—responsible for, among other things, the campanile (bell tower) of the cathedral of Florence. In this chapel he shows himself an architect as well in the designing of the panels both in relationship to the building forms and to each other, and in the organization of the iconography. Thus the upper tier is a single unit depicting the life of the Virgin and properly not related to the scenes below, which in turn depict the life of Christ in two tiers. The scenes are so co-ordinated that the childhood episodes are related to those of the passion: the total logic of the wall is thus from Mother to Child to Man to God, a more involved program than the standard medieval analogies of Old and New Testament scenes or figures.

The result of this was virtually a new religious iconography for Italian painting, much as Dante's style had inaugurated a literary idiom. Like Dante too is the plasticity of rendering, and the attainment of an exalted pathos combined with firm composure (Plate 16b). Gone completely is the calligraphic idiom of Duccio (Plate 16a), and the ornately picturesque detail.

If these works seem to us at times to embody an almost excessive insistence on solidity, without space or air, we must remember that this is still the Gothic age, that no matter how keenly human the emotions, they are in the service of religious experience, in which terms the things of lesser importance are subordinated in size and position to the greater, and of which the metaphysical aim is to render everything of one universal material.

These things should be remembered when it is urged that Giotto is the first Renaissance artist. **More accurately he is proto-Renaissance.** He re-establishes in painting an ancient Tuscan demand for sculptural weight and restrained, profound human feeling, and it is because such elements were among the first to express themselves in the Renaissance that Giotto is looked on as the father of Italian Renaissance painting. But there is a gap of an entire (late Gothic) century between his work and that of Masaccio, on whom it is more sensible to confer such a title.

Let us consider one of these Paduan frescoes as a dramatic achievement. The Flight into Egypt (Plate 16b) is established upon a rocky stage, where enormously solid figures—which would look like sacks of cement were it not for the profound emotion in every contour—are grouped with eloquence yet restraint. There is also a remarkable integration between figures and landscape: observe the repetition of individual shapes and of groupings. In this way the movement in the entire picture is enhanced and made into one deep rhythm. Between the figures themselves a psychic relationship is

established by the intimate yet quiet gestures and the strangely intense, almost hypnotic eyes. Despite particular religious apparatus the general character of these scenes remains visual. The modern abstract artist Matisse said, "A work of art must carry in itself its complete significance and impose it upon the beholder even before he can identify the subject matter. When I see the Giotto frescoes at Padua I do not trouble to recognize which scene of the life of Christ I have before me, but I perceive instantly the feeling which radiates from it and which is instinct in the composition in every line and color. The title will only serve to confirm my impression."

Unlike the occasional fussiness in the earlier works, the heads, arms and drapery here are established in broad planes. All distracting detail is eliminated. The faces appear as intensely tragic masks, the sense of dignity contributing at once to the expression of the intrinsic significance of the event, and to the realizing of some of the most monumental and imposing wall decorations in all art.

If Giotto brought art back to earth in ways from which later masters of the Renaissance could take inspiration, this is only one aspect of Renaissance painting. For others we must turn to the north.

RENAISSANCE ART

EARLY FLEMISH AND FRENCH PAINTING

At about the beginning of the 15th century, notably in Flanders and northern France, there occurred an outburst of an entirely new kind of painting. The change in iconography can be seen first in certain forward-looking manuscripts.

Among the most interesting of these manuscripts are the famous miniatures made for the Duke of Berri by the brothers Limbourg (Plate 20*a*). Like some of the quatrefoils on the cathedral, these are encyclopedic in nature, depicting seasons of the years and their activities. But the most advanced of these miniatures belong entirely to the Renaissance in that **they establish the space of nature, and their scenes take place in the real world.** Here we find most charming depictions of hunting and hawking, reaping and sowing, in the clear fresh light of day, situated in luxuriant nature, and often against the background of one of the chateaux owned by the Duke. If the small scale and certain stylistic artificialities of these works are Gothic continuities, their spirit is quite that of **the new age that centers its interest in the events, space, and time of life here on earth.**

Even more extraordinary in the history of art, though they could hardly exceed the former in fresh beauty, are another set of manuscripts also done very early in the 15th century, the so-called Lost Turin Hours. In these the entrance of man into nature seems complete and uninhibited—there is no barrier between the foreground of man and the background of nature, and the immediacy of wind and wave, cloud and atmosphere rank these works high in all the art of landscape painting. Here we see wind-swept waters, salty beaches, stirring clouds, sunsets and storms. Here is a **microcosm of what was to come to be one of the outstanding fields of expression of western Europe: landscape and seascape, the drama of the elements.**

The Van Eycks. There is endless controversy about HUBERT VAN EYCK (1370?-1426) and JAN VAN EYCK (1390?-1440), the men usually credited with the invention of oil painting. Without entering into this controversy, we may very likely attribute these marvels of landscape as those of the Turin Hours to Hubert. To Jan probably belong paintings in which the still-life element above all others draws our attention. Still-life is what the French call "nature morte" (non-living nature)—the world of objects with which men live.

Crucial to the rendition of these still-life objects and their world of surfaces, shapes, and textures was the medium of representation, **oil painting on panel** (see Appendix A). Mention had been made in documents of the use of oil as early as the 12th century, but use of oil as the predominant vehicle for distribution of the pigment was a development of the early 15th century. An unfinished picture, the Saint Barbara of Jan van Eyck, shows this procedure. First, a wooden panel is coated with gesso, as in preparation for tempera painting. The next step, in place of the Italian practice of underpainting, was to make a brush drawing. The color was then applied in thin, almost transparent washes, working up to a great brilliancy (from the white showing through —a feature not possible in tempera painting). Small brushes were used, sometimes composed of as few as two hairs (one hair, contrary to popular suspicion, would be impossible, since the oil must be carried between two as on tracks). The result tends to be an enamel-like finish, with no visible brushstroking.

In a painting like Jan van Eyck's portrait of John Arnolfini and his Wife the resulting natural detail is shown at its height. Apparently represented here is the old northern practice of marriage without clergy but by holding hands and taking the oath. The painting amounts to a pictorial marriage certificate, emphasizing the intimacy with everyday life in much northern painting.

The space in these Flemish pictures is not, as it was in the contemporary Italian pictures, completely consistent or rationally organized according to a one-point perspective. Rather it was empirical— developing within itself, and built along rising lines, so that the physical space of the represented world

seems to extend as you move through the picture. This can take place not only in a landscape, but even in an interior scene as in this picture. And on the back wall is an elaborate mirror showing the reflections not only of the wedding couple that we see in the painting from the front, but also of figures in front of the picture plane—that is, where the spectator might himself be so that the space extends by implication actually out of the picture. And throughout the scene all objects, all details are painted with equally devoted care so that *we are reminded, despite the interest in the material splendor of the real and present world, of the persistence of a profound religious conviction that everything in the universe, every nail, every blade of grass, every person great or small, was equal in God's love.*

The Altarpiece of the Lamb. The grandest and best known monument in early Flemish painting is the Ghent Altarpiece, or Altarpiece of the Lamb. Whether this painting should be attributed to Hubert or to Jan van Eyck or to both, or whether parts of it belong to still others are questions for the experts, and do not affect the wealth of images contained here, nor the many and peculiar aspects of early Flemish painting presented at the highest level. It should not be missed by travelers in Belgium.

Like the Gothic altarpieces of the north—whether carved or painted or a combination of the two—this altarpiece is made to fold together, so that normally were presented the more symbolic and decorative parts, often in grisaille (black, white and grey), but on special occasions the altar would be unfolded and the glories within exposed to the churchgoer.

Thus the scene of the Annunciation shows hierarchic scaling and subdued coloring, only partly naturalistic (compared with the humans in the lower zone), though the realism is intense, down to the shadows of the frame. Included as still-life are the implements of cleanliness, referring to the purity of the Virgin. The portrait of the patron, Jodoc Vyd, exhibits the utmost realism, and somehow does not feel cramped for space despite its small niche. John the Baptist and John the Evangelist are presented in grisaille to represent statuary.

The figures in the upper zones with their hierarchic scale would seem to render the entire effect top-heavy were it not for the wonderful depth in overlapping spatial layers and the multitudes of human figures of all kinds in the lower zones, with their earthly implications. Above are God the Father, God the Son, and God the Holy Ghost with John the Baptist, a precursor of Christ, and Angels singing to the glory thereof; also Cain and Abel paired off with Adam and Eve—the parallels of Old and New Testaments—representing the sins of our ancestors, purified by the Pelican (who pierces Eve's breast in order to feed with her life's blood). The figures above are large, symbols to be apprehended from a distance, though rendered in meticulous detail, for metaphysical reasons as given above.

The Adoration of the Lamb in the part below, though a scene of humans in outdoor nature, is also filled with symbolism. The Adoration itself was linked with the coming of the Messiah. As rendered it shows an earthly paradise, with Jerusalem in the background, the fountain of life, and the four rivers of paradise.

The varying groups of people arriving to present themselves in adoration show a marked variety in treatment, from the courtly figures of the ladies to the sturdy kneelers; and the landscape itself shows Italian vegetation brought in amongst the northern. The richness and splendor of the setting, the profuse variety of characterization, the sprightliness yet objectivity of interpretation, the pervading concentration of devotion, and the serene dignity throughout this complex harmony (there are well over two hundred figures) render this a contestant for the chief glory of Flemish painting and one of the most remarkable pictures in the world.

In New York, the Frick Collection has recently purchased (at a figure reputed to be in the vicinity of three-quarters of a million dollars) a superb small panel, important parts of which were painted by van Eyck, the rest by an estimable Flemish painter of the period. Such a painting is invaluable for the American who cannot get to Bruges or Ghent, and deserves an investment of time and consideration, both of the whole composition, the spatial construction, and in close detail for the study of which the use of a magnifying glass is strongly recommended.

Van der Weyden (ab. 1400-1464). Jan van Eyck's great contemporary, ROGIER VAN DER WEYDEN, was an enormously popular painter who virtually tyrannized over the first large painting workshop of the north, a factory-like establishment responsible for many fine works, using (as the Italians already had for some time through acquaintance with the Byzantine procedures) a system of apprentices and assistants, each doing work for which he qualified, stage

by stage, from grinding colors on up to the final touches of the masters.

If we compare a painting by Rogier with one by Jan van Eyck, for example two madonnas, we find in the former a tendency for the figure to stand closer to the picture plane, within a thoroughly defined space that admits of almost no continuity beyond. By the same token, the figure is less plastic and more decorative, the drapery shallow and broken up into smaller parts, a more irregular silhouette consisting in a remarkably rhythmic arabesque. The result is a more decorative, less dramatic presentation, more enclosed and concerned with still-life motifs, just as Jan van Eyck's style was in contrast with Hubert's. *The three men encompass three great emphases in northern Renaissance painting: the atmospheric wonder of the great world (Hubert), the solidity and splendor of material objects (Jan), and the decorative tracery (Plate 21b) that unites the whole in a continuous calligraphic rhythm (Rogier).*

In Rogier's painting of the Deposition from the Cross, in Philadelphia, we see again this perhaps more obvious human drama but high decorative coherence, suggesting that Rogier is more effective at the gentler, more domestic themes. Here the complicated grouping in shallow space gives no resulting sense of crowding, but turns in on itself, with an endless repetition of minor curves musically alternated with angular shapes. One of the most important of these, the angularity of the figure of Christ, suggests the "breaking" in death, and is echoed in the position of the swooning madonna, who is likewise deathly pale.

Rogier's works can have an extraordinary grace, as in such a masterwork as the panel of St. Luke painting the Virgin, found in the Museum of Fine Arts, Boston. (Plate 21a) St. Luke is actually making a silverpoint drawing, a practice of the time, whereby the artist would render a careful drawing from life, but paint his portrait back in the studio. Despite the extension of space behind, the foreground figures are kept down and in to a considerable extent by the post and lintel above and the canopy. Throughout there is very little plastic emphasis, but a constant movement and ballet-like weightlessness—especially in the drapery, where are worked out the purest rhythmic patterns. A detail from the painting (Plate 21b) shows the extraordinary penetration of the microscopic world.

A comparably microscopic view, this time of the entire object, is shown in a painting by the Master of Flemalle (Plate 22a), certainly one of the most vivid portraits in existence. A gentle human, rather than theological flavor persists, in contrast with the more austere paintings of the slightly earlier Van Eycks. This human quality, approaching the psychological, looks forward to much that is important in subsequent northern painting, and may be seen again in an important recent acquisition at the Cloisters in New York, the Merode Altarpiece.

Hugo van der Goes (?-1482). Yet Rogier was not really a psychologist, at least when compared with a master like HUGO VAN DER GOES, who worked in the second half of the 15th century. Any art gains in one realm by surrendering in another. If Rogier's rhythmic compositions required the subordination of psychological exploitation, perhaps the opposite might be said for Hugo.

Hugo's most famous painting—perhaps his greatest and certainly one of the important paintings in European history because of its commission to Italy and its influence there on late 15th century painting—is now in the Uffizi in Florence and is called the Portinari Altarpiece. The exterior shows an Annunciation in grisaille, full of deep mysterious shadows containing emaciated, introverted figures. The Virgin does not display the conventional surprise but seems to have an inner vision. The angel is more physical, rushing down so that the knees give and the drapery flutters.

On the inside, the spectator is invited to a cool space of subdued coloring, where the light and shade is more naturalistic than dramatic. Within the quiet mood, centered by the helpless child, are remarkable contrasts in expression between the earthy, clumsy eagerness of the shepherds, and the demure, restrained loveliness of the kneeling angels. The quality of Hugo's portraiture too is shown here, and the skill with which he sets the lively undulations of a face against a more abstract background feature.

Hugo's Portrait of a Man in New York's Metropolitan Museum of Art (Plate 22b) shows the kind of intense spiritual inner life that has led some to speculate on the painter's possible insanity, especially in view of his retreat to a cloister late in life. That he had a breakdown is possible, but it seems more to the point to attribute such knowing intensity to a religious fanaticism, an analogy for which might easily be found in the contemporary mysticism of Savonarola in Florence, which had profound but

hardly accidental influence on Botticelli, and which lay, we are beginning to suspect, deeply behind many events of the Renaissance.

Bosch (1462-1516). The culmination of this growing expressionism in 15th century Flemish painting may be seen in the works of HIERONYMUS (JEROME) BOSCH, who has attained a sudden and deserved popularity and interest in the mid-20th century. No one has yet fully interpreted the messages, symbols, and potential meanings in these paintings, which were first taken to be an oddity, next taken as social satire, later interpreted according to Freudian symbolism (in many ways he anticipates Freud) and latterly analyzed historically in terms of the magical beliefs, astrology, and heretical cults flourishing in his day.

Bosch painted in the latter part of the 15th century and on into the early 16th century. Now the year 1500, like the year 500, seems to have been very nearly as much a chiliastic year as the year 1000. Evidently anticipations and fears of the millennium, to judge from manifestations in all cultural forms, appear each five hundred years. There are those who suspect that we are beginning now to feel the chaos which threatens in the year 2000.

These facts alone would not account for the extraordinary expressionism that developed with Bosch, for that is also connected with a freedom of human expression that develops steadily throughout the 15th century, being almost lacking in Jan van Eyck, definitely in evidence in Rogier van der Weyden, straining almost to the breaking point in Hugo van der Goes, and bursting out into entirely new forms with Hieronymus Bosch.

Basically, Bosch's theme was a perennially Flemish one: **the variety and extent of human error.** An early picture like the Ship of Fools displays this theme with misleading restraint, and depicts clergymen among the revellers. The Temptation of St. Anthony (Plate 23*a*) is more characteristically a nightmare, to which the extraordinarily vivid shapes and accents contribute quite as much as the literary caricature.

The Hay Wagon in the Prado in Madrid develops this further, showing the way to Hell. Musical instruments are a sign of carnality as nuns indulge in the sin of avarice. Medicine is satirized, and the sins of humanity and its inevitable doom, confirming the text given from Isaiah, "All flesh is grass, and all the goodliness thereof is as the flower of the field. The grass withereth, the flower fadeth: because the Spirit of the Lord bloweth upon it: surely the people is grass."

Bosch's greatest paintings are in Madrid and Lisbon: let the traveler take note of this.

Also in the Prado is an even stranger painting, the Garden of Earthly Delight, or as the Spanish call it, Lust. The egg-shaped or spherical forms refer to sexual creation. Included are tiny nude figures demonstrating not only Lust but the other of the seven deadly sins, Pride, Envy, Sloth, Gluttony, Anger, Greed. Symbolic beasts, strange architectural and landscape forms, and some things that are hard to define by any concept catch up the human figures in all manner of ridiculous postures. Yet through all there is an astonishing decorative unity and dynamic pattern which extends to the shutters with their depictions of the Garden of Eden and Hell, where a great stomach is ruptured to show the gluttons inside.

Bosch's Role. The use of caricature to denote evil as against idealization of the good as in the Temptation of St. Anthony (Plate 23*a*) was a common convention in northern art throughout the Middle Ages. We have seen it in the contrast between the saved and sinners in the tympanum at Amiens, or between the Beau Dieu and the monsters under his feet. Paintings by Bosch of Christ carrying the cross, or crowned with thorns use this interplay of caricature to develop a frightening psychological intensity; at the same time Bosch's landscapes take on a spectacular inventiveness, equally removed from the keen, restrained objectivity of the Van Eycks.

The strangeness of Bosch's personality is partly explained by the strangeness of the period in which he lived—a period that encouraged individuality. Giving pictorial form to the fears inflaming people of the time that their follies and sins might momentarily meet everlasting judgment and punishment, Bosch directly reflects the spirit of an age that produced new heresies, new attacks on the church, and new excesses in a vicious circle. It is quite possible that Bosch belonged to and took his iconography from a pre-Reformation sectarian group, such as the Brethren of the Free Spirit.

But all the time he retains a vigorous Flemish humor, and interprets the devil not as the Prince of Hell but in the many disguises of the buffoon. Fascinated with the dramatic moral, Bosch runs a gamut of sorcery that makes us feel that evil has reached its peak.

With such stark and imaginative expressions of

the themes of folly and damnation, it is no surprise that his works were sought in Spain. And this may remind us that Spain has little enough to do with the classical Mediterranean tradition that underlies everything Italian and that has come in turn to stand for the Renaissance. Painted at exactly the same time as the height of the Renaissance in Italy, Bosch's works, of a very high artistic quality and historic significance, might make us ask what ever he could share with Raphael. But let us return to this later.

The French school of the early Renaissance was not so extensive or important as the Flemish, but it did produce a few impressive masters and some wonderful pictures. One of these is among the best known in all the annals of painting.

Usually called the Villeneuve Pietà, now in the Louvre, this picture is also among the most controversial of all European masterworks. Given by some to Italian, by others to Spanish art, it is probably actually French, with some important Flemish aspects. It has been dated everywhere from 1425 to 1475, and was most likely painted about in the middle of that period. It therefore contains aspects that look forward to the new world of nature, others that look back to the Gothic world of abstract symbolism. A dark, brooding quality of Provence contributes to the moving sorrow of this scene, composed at once of suffering and nobility. There are few paintings that accomplish such stark, vivid, yet reticent expression through the economical use of contours and body angles. The sky remains gold, as of the Middle Ages, but is cool and spacious, and the breadth and openness of the composition is of the Renaissance. Still, compared with the Renaissance exuberance in Flemish paintings of everyday life, this picture is sparse death and tragedy.

GERMANIC PAINTING

Painting was to flower in the Germanic countries somewhat later than in France and Flanders. The term painting we use to include watercolors, wash drawings, all other drawings, and also graphic works, that is, works in which the original is a print —not to be confused with a reproduction—whether in black and white or color. Now the Germanic tradition in painting has always been a calligraphic, rather than a painterly one. In this sense there is a direct continuity from German Gothic manuscripts and woodcarvings to the "carved" wood and steel

plates of German graphic art of the 15th, 16th, and 20th centuries. These are the great stages of Germanic art, and in these centuries it is graphics that dominate.

The Emergence of Graphic Art. The significance of the flourishing of graphic art in the 15th century is more however, than that attributable to a national temperament. It also has deep social and economic importance. European manufactured paper was not in general use until the 15th century. It is not necessary to ask as between the development of printing, the availability of paper, and the widespread habit of reading, which came first or which caused which. Actually they all came together, so that as a cultural manifestation the printed book, the illustration, the printed drawing or painting, and the reading and artistically oriented public are the sign of a new age. Involved too, of course, are increases in the standard of living and changes in the distribution of wealth. All that concerns us is that a broad public comes into existence for the consumption and appreciation of graphic work, so that the nature of communication in the work of art is different from that in the Middle Ages; also that one artist more readily influences another, especially in another country, not only through original graphic works but also through graphic reproductions of paintings.

The first graphic medium to attain its height of expression was the woodcut (see Appendix A), and the first woodcuts were still Gothic in function, that is, devotional. For example in the famous Saint Dorothy print from Bavaria early in the 15th century, fifteen inches high, the content is of supreme importance. This was a popular saint of the time, revered as a helper in poverty and a protection against false accusation, especially valued by women in childbirth. The style is mostly abstract, with relatively few realistic forms. The purpose of such prints was as a substitute for paintings, that is, devotional images for home consumption, and their strikingly vigorous and primitive qualities may call to mind the style of stained glass windows. In such works it was felt by the makers that too much naturalism in the depiction would have destroyed the spiritual power of the image.

As the period progressed, woodcuts tended to be used primarily for book illustrations, for which the process was admirably suited. Engraving in metal was a later development but one of more possibilities, and the greater artists and the more independent tended to choose it. Originating in the gold-

smith shops (socially a more elevated origin than the carpenter source of the woodcut), the art of **engraving** (see Appendix A) in the latter 15th century reached great heights.

Compared with woodcutting, the art of engraving is both harder and more refined. Control of the medium is more precise, and fine outlines and subtle tones are produced in contrast with the more primitively forceful distribution of broad tones in a woodcut. In woodcutting the wood is cut away on both sides from a ridge which becomes the line that takes the ink. In engraving, an **intaglio** (see Appendix A) process, the line itself is incised and the ink subsequently forced into it. Thus the engraving is entirely by the hand of the master, whereas usually with the woodcut the master would design the block, but leave the cutting to a skilled technician.

Schongauer (1445?-1491). Consummate at the art of engraving was MARTIN SCHONGAUER, who lived in the second half of the 15th century. In technical perfection and quality of design he stands almost without superior in the history of the art, and for a long time was preferred as an artist by many people even to that emperor of engravers, Albrecht Dürer.

Schongauer's Temptations of St. Anthony (Plate 26a) might be compared with Bosch's. Schongauer creates that line at once incisive in expression and ornate in decoration for which he is famous. This work shows the flamboyant crowding of early Gothic works, an extraordinary inventive capacity, and a multiplicity of forms which although recalling contemporary Flemish painting in its general range, shows more of Germanic clash and violence.

The superb balance of effect and fine nervous quality of works like this can very well be appreciated if we make a scrupulous attempt to reproduce them ourselves: to make a careful pen drawing from a Schongauer or Dürer engraving is to suffer great disappointment and frustration, but at the same time to appreciate all the more fully how much of form and idea originally went into the work.

To compare Schongauer with a contemporary Italian engraver (on the whole the Italians went in very little for the graphic arts, but there are a few magnificent exceptions) we might invoke the northern Italian painter and graphic artist, ANDREA MANTEGNA. Where Schongauer's work shows a continuation of the Gothic spirit in its ornamental, flamboyant drapery, which tends to conceal the anatomy, Mantegna is more interested in revealing the form,

structure, and action of the human figure, in rendering it monumentally, with human dignity, warmth, even tenderness, while Schongauer's figure conceptions (think of Gothic architecture) remind us more of luxuriant plant forms, and although richer are also cooler. Furthermore there is a simplicity and uniformity in the Mantegna (aided by the use of even, parallel strokes) that contrasts with the more varied handling of Schongauer, who might be said to exploit the metallic medium more fully.

Dürer (1471-1528). The greatest of German artists and the only European artist of absolutely top rank to devote himself primarily to graphics, ALBRECHT DÜRER was born the son of a goldsmith in 1471. From an early trip to Italy Dürer was somewhat influenced by Mantegna, but basically his art, like that of Schongauer, was indigenous, and only later in his career did he attempt a classical synthesis. Undoubtedly the training as a goldsmith was a valuable discipline, though it can hardly be held to account for the fact that—although Dürer produced a number of impressive oil paintings, and some even finer water-colors—the artist never attained a very painterly style: despite his avowed ambition to exceed the Venetians in coloring, it is questionable whether he ever really meant to. Because of his exploitation of the graphic media of woodcuts and engravings with their broad dissemination, because of the wealth of ideas both philosophic and artistic that he produced, and because of his theoretical treatises and expositions (reminiscent of Leonardo's), Dürer has long been held the teacher of his people.

An early Dürer woodcut like the Vision of St. John from the monumental Apocalypse series, with its famous seven candlesticks, seems almost Gothic in its verticality and flamboyance, but at the same time its breadth of conception, vigorous plasticity and majestic vitality mark it of the newer spirit, taking life from the experiences of the present world. Though not anatomical in an Italian sense, the function can be felt beneath the drapery, and despite the elaboration of style there is a substantial elimination of detail. As with Schongauer, a rounded stroke is used that follows the form and establishes a vigorous relief with expressive contours. We see here the beginning of the use of the white of the paper for spatial expression where Schongauer had used it for decorative power. There are fourteen other woodcuts of Apocalyptic scenes from Revelation, all reflecting in one way or another the fatefulness of that generation shared by Bosch.

The Four Horsemen. The life-giving line that marks Dürer's best work is nowhere more vividly in evidence than in the Four Horsemen of the Apocalypse (Plate 27a) one of the best known pictures of all Europe. The powerful, clanging rhythms of the riders and their victims, and the haunting sense of impending doom are as difficult to analyze as the rich sensations of color and "sound," but they ring on relentlessly as if to the end of the world.

As Dürer's style progressed he became more and more cognizant of the challenge of classic Italian art, and sought to synthesize these ideals with his own northern, Gothic nature. His later works show greater economy, simplicity, clarity, and balance, but always solicit a sense of air and atmosphere not to be found in the south. For example, a late woodcut of the Last Supper, showing the influence of Leonardo in its peace, calm, and restraint, remains distinctively a work of northern art in the subtlety of its tonal grading, its unifying light.

No one has ever exceeded Dürer's accomplishments in woodcutting, yet for the fulfillment of his genius we must turn to his engravings. For it was only in this more variable medium that Dürer's consummate command of the shapes, textures, lines, and lights of the real world could find full expression. The Vision of Saint Eustace (who when hunting came upon a deer with a cross on its forehead) shows almost miraculous textural variations, extending into a wonderfully romantic landscape filled with details of life that require close study lest they be missed. At the same time the plastic forms and actions of the dogs are finely realized: **once again, try to draw them,** and see how much thought has gone into their disposition. The result is far too subtle and too intense to justify its being termed a dry depiction of reality: what gives it infinite vitality is an earnest love and feeling for all the creatures and the creations of God.

In the three so-called Master Engravings Dürer went further, introducing elaborate schemes of intellectual symbols to render religious and social ideas of his time. The first, The Knight, Death, and the Devil (Plate 27b) is an allegory of the Christian in the world of action. Riding bravely forward, he never deviates from the Christian path, and sustains fortitude and dignity despite the horrendous entanglements pressing on him. He further represents Dürer's attempt to synthesize the northern with the southern or more classical Renaissance in that he stands for the "Vita Activa" (the Active Life) in a fusion of humanism (the pose of the knight) and Gothic religion (the tangled wilderness).

The second Master Engraving is certainly one of the astonishing moments in the history of all printmaking. Entitled the Melancholia, it represents the secular genius in the rational world. The wings suggest the capacity of the human mind to soar, yet the figure sits in the clouded light of despair and can find no solution to the dilemma of the meaning and function of life; the symbols of the liberal and industrial arts remain untouched. The result is a profound expression of the tragic limitations of the mind and spirit of man, within an age keyed to humanistic optimism, rendered through the mysterious creation of a light that never was on sea or land.

The third, the Saint Jerome, represents the sacred contemplation of the Christian saint in the spiritual world. In the Melancholia, which dealt with the rational world, Dürer created so eerie and unearthly an atmosphere and psychological drama that he is partly responsible for the equation of "melancholy" with madness and thus with genius. Here, dealing with the sacred theme, Dürer gives a cosy, secure interior, with the symbolic lion on the hearthrug, looking like a large woolly dog. Through the warmth of this atmosphere, with its light radiating in all parts each of which is in its appropriate place, we feel the beatitude of the inference that only the Christian saint can attain true happiness.

Lucas van Leyden (1494-1533). If the quality of light in a Dürer is one of its most important unifying, conditioning, and expressive aspects, still the light does not so dominate the creation of form and of line as it does in the work of Dürer's brilliant Dutch contemporary, LUCAS VAN LEYDEN. The Dutch evidently had always been more sensitive to Nature's lights than to her lines (as with the Germans) or textures (as with the Flemish). The distinction may be seen earlier in the 15th century in the paintings of the Dutchman GEERTGEN TOT SINT JANS. Dutch painting of the 15th century suffered greatly from the iconoclastic riots in the 16th century, but we may assume that basically it resembled its Flemish counterparts. Therefore it is very much to the point when we find in Geertgen's works an almost amused detachment from the event, and an involvement instead in the creation of intensely felt landscape atmosphere, in comparison with the contemporary work of, for example, Hugo van der Goes.

By the same token, the work of Lucas van Leyden, in contrast to that of Dürer, shows a certain naive

freshness as against an incisive sureness. The extraordinary refinement in tonal gradations in Lucas' work creates a luministic effect, which in place of Dürer's emphasis on form and contour is used to bring out the fullness of his figures, and more than that a feeling of movement, flicker, life and substance as belonging in the atmosphere itself. Lucas sometimes combined etching with engraving, and in any event his use of engraving for these purposes (Dürer tried etching once or twice and rejected it as conflicting with his style needs) shows a yearning for the techniques of etching that were to be developed to their eternal height, a century and a half later, by another Dutchman—Rembrandt.

For all the emphasis on the graphic arts in the Germanic countries, it is not to be inferred that the Germans produced no important painting. As a sort of strong if minor theme there developed in German Renaissance art a tradition of an exuberant and richly expressive painterly style that has seen a most valuable revival in the 20th century.

Grünewald (fl. 1500-1530). The outstanding exemplar of this painterly style, and the greatest of all German *painters*, is MATTHIAS GRÜNEWALD. We know almost nothing of his life, indeed we are not sure of his real name, so it is hard to tell how he felt about the Reformation. But this in no way detracts from the extraordinary spiritual intensity in his pictures.

Like all Germans Grünewald was a master draftsman, but unlike Dürer, who drew with a pen, Grünewald drew with soft pencil or charcoal—that is, he drew as a painter. Some of his sketches for figures in paintings are among the masterpieces of draftsmanship available to us.

Despite these, and despite a number of smaller paintings, Grünewald's reputation stands primarily with one of the most spectacular and astonishing painting constructions in existence, the Isenheimer Altar, now in Colmar. Like the medieval altarpieces this one is a complex compilation of painting, sculpture (not by Grünewald) and frame. Originally it was put together of two fixed shutters and two pairs of wings so that there were three entirely different presentations to the church-going public: first for ordinary occasions, the whole thing was closed, showing a crucifixion; second, with one pair of shutters opened, on certain feast days, the three great joys, the Annunciation, the Madonna and Child, and the Resurrection; and third, on a special holiday—especially St. Anthony's—the visit of Saints Anthony and Paul, and the Temptation of Anthony (Plate 26*b*), for it was this saint to whom the whole altar was dedicated. Comparison with both the Bosch and the Schongauer is suggested.

The crucifixion scene is one of the grimmest and most powerfully moving that has ever been conceived. Taking its text from a widespread 15th century interest in vivid literary descriptions of the gruesome suffering, its detail and emphasis on wounds, rendings, flesh turned green, limbs bent in pain or sorrow are all gathered together in deep pervasive rhythms and a high style that produces not disgust but infinite pity and gloom.

To compare this scene with a contemporary rendition of the Crucifixion by the Italian painter PERUGINO (the teacher of Raphael) is to see the difference between the northern persistence of a Gothic spirit, though rendered in terms of the real world, and the clear, sunlit, quiet and relatively cheerful world of the Renaissance where even the figure of Christ suffering on the cross is rendered in terms of a gracious and composed athlete, the decorative center of a harmoniously disposed and balanced composition, where whatever emotion there is is held in discreet restraint. In the Grünewald the expression of the deepest and most intense emotions is the final purpose of the picture, and is effected by the participation of all elements of the picture, including the landscape. We are reminded here of Goethe's comment on the nature of Germanic culture: "Gefühl ist Alles"—feeling is everything.

In the predella (a smaller painting on the altarpiece below the main part) we see Christ by the tomb, a scene in which grief has spent itself. Christ gains nobility in repose, and the Magdalen is rendered in one of the famous passages of emotional exhaustion in all art.

The Annunciation, Madonna, and Resurrection are likewise organized pictorially into one total rhythm, but here the tone is warm, rich, and varied in keeping with its suggestion of natural and supernatural joys. The Virgin of the Annunciation is a simple peasant girl, in the tradition of the time, reflecting a keen human interest and close attention to reality that help distinguish Grünewald's from properly Gothic art. Just as she withdraws from this momentous apprehension, so in the Madonna scene she bends with love and sympathy towards the Child, while kneeling angels render choirs of colorful music.

The Christ of the Resurrection, representing the most supernatural joy, comes soaring from the tomb in a blaze of color and cosmic light, in which his face and features are so energetically blended that a critic once took it on himself to conclude that Christ was painted this way because the artist (held today one of the great draftsmen of all time) didn't know how to draw. But this is a criticism that has been applied at one time or another to many of the first-rank "painterly" painters—Titian or Rembrandt, Turner or Cézanne. It is a reminder that we must take a great work the way it is given us: it is we who have something to learn.

In the visit of Paul to Anthony in the wilderness, the entire scene, each rock and branch, contributes to the feeling of desolation and decay; a wealth of imagined forms is used to create what is in a way more of a desert than a waste of Sahara sands. The companion piece, the Temptation of Saint Anthony (St. Anthony tormented by Demons, Plate 26*b*) is as phenomenal as any painting of the first rank. Its inventiveness in color and form, its exaggerations and distortions, its weirdness of subject, the horror and fascination and utter originality carry the art of expressionism to its furthest limits. At first glance we may be reminded of Walt Disney—and it was a German-Swiss (Töpffer) who invented the animated cartoon. The difference however is between the conventional and commonplace or the repetition of familiar forms and situations on the one hand, and the height of imaginative power given specific form through a ceaseless inventive skill and inexhaustible vigor, on the other. Running virtually the entire gamut of human emotions, the Isenheimer Altar is not only Grünewald's most important painting but one of the monuments of western art.

Altdorfer (1480-1538). Usually more modest in scope but little less rich in the imaginative life he created is ALBRECHT ALTDORFER, remarkable not only for an astonishing graphic art, more spontaneous and less propagandized or conceptualized than Dürer's, but also for paintings that contain at once the incisively realized formal growths of the graphic art and at the same time something of the pictorial splendor of painting of Grünewald's kind.

Perhaps no one, whether in etching or in painting, has given more luxuriant life to trees and foliage, the inexhaustible vegetable world than Altdorfer—his only equal is Van Gogh. But where the former renders a natural world of optimism and wealth, the latter's is of poverty and tragedy (the one coming near the beginning, the other toward the end of the most splendid epoch of European painting). And both men must be thought of in terms of Rembrandt, whose ultimately balanced and cognizant world of landscape makes each of the others appear somehow overwrought.

Where Rembrandt was to develop the technique of successive "baths" in etching—whereby the amount of time any given part of the plate is immersed in acid determines how deep it will bite, thus how much ink it will take, thus how dark it will print—to elaborate spatial or atmospheric perspective, Altdorfer either did not know or did not choose to employ this technique, but nonetheless achieved keen aerial perspective and vast depth through the elaboration and suppression of detail.

Altdorfer's most fabulous painting is the Battle of Alexander and Darius (Plate 28), a vast panorama of armies and cities, mountains, oceans, and sunsets, that was commissioned by William IV of Bavaria. Its splendor and splash as well as its sense of cosmic clamor made it a favorite in due time of Napoleon, who hung it over his bed.

A more typical Altdorfer is the St. George and the Dragon, a conception of vast importance for art history, because it comes close to being a **pure landscape** (i.e., without figures). St. George is almost lost in an unbelievably rich vegetation covering almost the entire picture surface, a forest in which one senses rather than sees depicted the restless drama of knights and dragons, with whispers, melodies, and rhythms that could only be further expressed in music itself.

Baldung (1476?-1545). HANS BALDUNG was a superb draftsman who exemplified the German tradition of the graphic arts, though he was also a painter. In accord with a significant tradition of the time, he would make wonderfully observant drawings or studies from nature, and then returning to the studio would create from imagination his more abstract and inventive woodcuts. In these the light seems to take on a form of its own, shapes that light could never have but that render it all the more substantial and energetic, a force and actor in nature's drama. Indeed, much as the history of Greek art could be told in terms of the development of shape and interval, or that of Italian Renaissance art in terms of perspective, the story of Venetian and Northern art could be told in terms of the conception, interpretation, and rendering of light. But this verges on the history of culture, and

we must confine ourselves to the investigation of the art object in itself. For that, however, comparisons are always helpful.

Cranach (1472-1553). For example, to compare Grünewald and LUCAS CRANACH is to illuminate the art of each. Where Grünewald was utterly serious—his caricature, if it can be so-called, was in the service not of humor but expressive power—Cranach often reflected a lighter, more relaxed side of life. His painting in the Metropolitan Museum of Art entitled The Judgment of Paris shows all the figures in contemporary costume, armor for the men (who are probably portraits of local prince and adviser) and hats for the women, who have a courtesan air. The Rhineland landscape, in the background, which clearly interested Cranach as much as anything else in the picture, is separated from the foreground figures by a wall of greenery against which the figures stand in a striking translation of the classical myth. The Wittenberg court, to which he was painter, put a great deal into the trappings of humanism, but the Germanic idiom which must have resulted is revealed all too well by Cranach, whose love for nature and the swinging contours of a nude young woman dominate any mythical overtones.

Cranach's was a sunny disposition and a worldly one. A picture entitled the Marriage of St. Catherine shows a group of Saxon court ladies in contemporary high-waisted costumes and fashionable coiffeurs, almost like fashion dummies except for the lively attenuation of the figures. Or again this courtly mannerism will show itself in his several renditions of Adam and Eve, where the girls are brightly adolescent, and the men a bit fatigued.

Holbein (1497?-1543). Cranach was also a notable portraitist, of considerable charm, elegance and incisiveness, but not of the weight or depth of the most formidable name in German portraiture, HANS HOLBEIN THE YOUNGER. Holbein comes closest among German artists to the forms and ideas of the High Renaissance, but he remains essentially a northern artist. His extraordinarily perceptive and expressive portrait drawings have been a source and inspiration to no small number of artists including Ingres and Degas. In the United States Holbein's best known portrait drawings are those in the Windsor Castle collection, but many of these have been tampered with (worked over with a gross, heavy line in certain points, destroying both the solidity of form and delicacy of expression in the total effect). Those

in the collection in Basel (where Holbein alternated periods with London) are better.

Not only are the drawings themselves among the masterpieces of their kind in European art, but Holbein's painted portraits are much like painted drawings, especially if compared with such painterly work as Grünewald's. No more incisive portrayal was ever made of Erasmus than some of those by Holbein, wherein every aspect, not just the proportions of the head or the features of the face, but the disposition of the figure, action of neck, shoulder, and wrist, and psychological play of expression blend into the expression not of a single temperament only, but of an age.

The well-known portrait of Sir Thomas More in the Frick Collection, though it has suffered from a good deal of restoration, still shows Holbein's combination of simplicity with grandeur through a bold surface design in which the three-dimensional shapes, though solid and sure, are carefully retained within a relatively narrow range, so that the result is rather like a medallion.

The painting called the Ambassadors (actually representing an ambassador and a bishop) is filled, as many of Holbein's portraits were, with a wealth of identifying detail, whether of profession, location, or personal temperament. Some of these are a little tricky, like the lute which refers to Luther (a pun typical of the age: think of Shakespeare) or the skull in the foreground which can be apprehended only if the picture is seen from a sharp angle, and all the more effective in a typically frontal Holbein composition.

But portraits were not Holbein's only claim to a high rank in European art. His religious and historical pictures have largely been lost, through fire and other accidents. But in the graphic arts, as with so many Germans, Holbein also shone. Few book illustrations are vigorous and knowing at the same time as his drawings for Erasmus' Praise of Folly. Better known are the series of woodcuts of the Dance of Death, tiny but unbelievably expansive in spatial suggestion, monumental in scale (which means apparent size—such that they can be reproduced very large without loss of effect), and vigorous in movement.

If some weight seems to be given here to the Germanic schools at the possible expense of the Italian, this is only partly because so many books are imbalanced in the other direction and correction is indicated. Also, Germanic art has in our time

provided some of the strongest infusions of energy into painting and graphics. By this is meant not only modern Expressionism itself, but also the fact that, in various ways, the three towering painters of the past century have paid especial tribute to the old Germans: Cézanne toward the end of his life bestowed extravagant praise on Holbein. Picasso still decorates the walls of his home with color reproductions of Cranach. And Van Gogh's instinctive style, wildly and incessantly infused with northern lights and forest fears, seems virtually to take up where the old German expressionists left off. As for Americans, it is too soon to tell what may be the ultimate contribution of such energy and imaginative power for our own art; but we may note the remark of Justice Holmes: that Dürer's works were dearer to him, and more valued instructors, than any book or any other art.

THE HIGH RENAISSANCE

To think of the work of Dürer and of Bosch around the year 1500, and to turn then to the work of Raphael in Italy is to see what disparate manifestations the Renaissance could take. For in Italy at this time, and above all in Rome, there developed what is usually called the **High Renaissance**, meaning the classic moment in the development of Renaissance style, the culminating achievement, before which everything seems archaic or uncertain, and everything afterwards attenuated or mannered. Such a point might be represented by the Parthenon in the history of Greek architecture, or by the cathedral at Amiens in the Gothic. It must be emphasized that this classic moment (not to be confused with *classical*, which refers to the ancient world only) does not necessarily suggest the peak of quality. It indicates the most logical exposition of the nature of the style, when all elements are in the most perfect balance or harmony. Artistic quality or achievement, however, depends on the individual artist.

RAPHAEL (1483-1520)

There are many people richly experienced in painting who prefer the Renaissance pictures of many others—of Masaccio, of Piero Della Francesca, of Leonardo, of Michelangelo, or of the wonderful Venetian school (which flowered from the late 15th to the late 16th centuries)—to the art of RAPHAEL. On the other hand, there are those who still feel that Raphael is the Prince of Painters, the

man who could accomplish everything. Such controversy is idle. Actually Raphael's reputation is neither as high today as it has been nor as it deserves to be. He was, after all, the favorite painter of Poussin, upon whose form Cézanne depended, and Cézanne is widely considered the father of modern art. Raphael was also the favorite painter of Ingres, from whom Picasso has taken so much. But Raphael's personality was too harmonious, too balanced, too moderate and graciously disposed to be appreciated in a day such as ours: to us he too often appears cloyingly sweet.

As a matter of fact he is not that, any more than Mozart is, but is rather extraordinarily subtle and unsentimental. It is sometimes said that Raphael's work would be better if he had suffered more. But he would not have wanted to be like Michelangelo or Van Gogh; he did not want to express the anguish and strain and hopelessness of life, but instead its potential peace, clarity, and quiet joy. It remains true that Michelangelo—in the interpretation and expression of the depths of human experience—is greater than Raphael, as Bach is than Handel, Van Gogh than Renoir. But this should not mislead us when we are examining their art. For the fact remains that Raphael, not exclusively but more comprehensively than anyone else, expressed the ideals of the High Renaissance.

The Stanze. It is worthwhile to examine in detail Raphael's masterpiece, the fresco decoration of the Camera della Segnatura in the Vatican's Stanze. Stanze in Italian simply means rooms, but *the Stanze* mean Raphael's. Camera indicates chamber, and this series of chambers, connected not by halls but by doors at their corners (a more open arrangement), served as papal offices. Here the pope signed documents and presumably held audiences of a secular nature. We see at once that the art of the High Renaissance tended to be secular and aristocratic: Raphael's paintings would be less available to the public than either Dürer's woodcuts or the sculpture on a cathedral façade. By the same token, their iconography is more recondite, to be understood by the well-educated courtier, the humanist.

In the succeeding rooms of the Stanze some of the paintings were done by Raphael, but more of them simply under his direction, although that alone renders them worth looking at. But in the first room, the Camera della Segnatura, all of the execution is by the master himself. ("Master," incidentally, is a term applied to any leader of a workshop or any

artist of note: there are *little* masters as well as great ones. "Masterpiece" originally meant the qualifying work of the apprentice.)

This room is dedicated to four "faculties," or as we might say, capacities of man or aspects of the world and its orientation. These were—typically for the time—Religion, Philosophy, Poetry and Justice. On the ceiling of the room stands a round medallion containing an allegorical figure of each of these faculties, plus diamond-shaped medallions in between each containing a scene or figures that represent something appropriately connected with the two that it stands between—for example, Adam and Eve with the forbidden fruit between the medallions of Religion and Justice. The theme of reconciliation was important in the Renaissance.

Since two of the walls have windows in them, the paintings on those walls are smaller and less important; these are the Poetry and the Justice. On the two large walls, opposite each other, are the major theme of the room, and in a way of the Renaissance: **The opposition and reconciliation of Philosophy and Religion.**

For the Italians of the Renaissance felt themselves the inheritors of two vital traditions, that of **medieval Christianity,** and that of **classical pagan philosophy.** To create a world that would reconcile these two seemingly opposed traditions was their great vision. In point of fact it was never done, for the living spirit and basic orientation of the ancient world was never revived. The western world of time and space, expressing itself in portrait and landscape, persisted through the Renaissance following without pause on its beginnings in the Gothic.

When it is said that for a brief moment in the beginning of the 16th century Italy recaptured the antique, what is meant—the only possible meaning—is that momentarily there was reached a balance of forces, a resolution of tensions, and a reconciliation of aims. Nowhere is this more perfectly expressed than in the Camera della Segnatura, above all in the two supreme pictures of Raphael's career: the School of Athens (Plate 17*a*) and the Disputa.

The harmony between medieval religion and antique philosophy is first established by a subtle interplay in the spatial constructions of the two settings. Each is built on a grid plan, faced head-on by the spectator, who must stand not only in the center of the picture but in the center of the room in order best to apprehend the space. In other words, he stands in the same point for both pictures, so that the space of the two becomes interchangeable. Each composition builds up in a few broad steps, with figures concentrated at the edges and the space opening out at the center. In each scene the perspective lines converge on an implied horizon point—that is, it is obscured but we know exactly where it lies, and in each case it is on the central axis—giving balance and harmony, and a little below the middle—giving stability and peace.

The School of Athens. The space in the School of Athens (Plate 17*a*) is measured by the unfinished structure of a great church in high Renaissance style: this is a conception of how St. Peter's would have looked if built according to the plans made for it at this time. Actually only the cornerstone had been laid: this is shown at the right in the Disputa.

Now if we recall that one of the keynotes of the antique world was a finality, a demand for completion, as expressed in every measurement, every detail of the Parthenon, it is very interesting that in the High Renaissance, which was supposed to recapture the antique, possibly the grandest architecture conceived was never built at all but is rendered in Raphael's painting. Such a tendency—that of the grandiose scheme existing only in sketch or partial completion—is a strong one among the giants of the High Renaissance: Leonardo, Michelangelo, and Raphael.

The title given the painting derives from the presence of key positions of certain Greek philosophers. Plato and Aristotle stand in the center on the top step. We can tell which is which not only because Plato appears older, but also by all the ways in which he is depicted suggesting an idealistic, self-contained, and transcendental system of philosophy as distinguished from the open, expansive, naturalistic, encyclopedic philosophy of Aristotle. Plato's robe is red (a color which must be abstracted from nature: thus an abstract color); Aristotle's is blue, the pervasive color of sea and sky. Plato gestures upward with his right hand, holding the book in his left hand straight down and close to his body. Aristotle points outward toward the spectator with an open right hand (closer to the spectator's world, less withdrawn), the book in his left hand extending horizontally.

Similarly the organization of Aristotle's robe is horizontal wherever possible, including the brocaded hem. Plato's is vertical (all the folds) and comes together at the bottom, as do the feet; Aris-

totle's point outwards. The verticality in the style of the Plato figure, and the way in which all is contained within a single contour, suggests the way in which Plato's philosophy built upon itself, unconcerned with variety of experience. The horizontality, expansiveness, and relatively broken contour in the Aristotle figure suggest the wide-ranging investigation of his more natural philosophy. It is true there are words for identification (*Timaus* and *Ethics*, written in Latin on the books they hold), but these are neither legible from a distance nor are they necessary to intrepret the figures.

Plato was chosen in the place of honor over Socrates because Plato was the schoolman, the system builder. Socrates, thought of more as a questioner and less as an idealist is shown in the center of the left hand side of the top row, gesticulating in vehement argument, and recognizable by his traditional bald pate and pug nose. To the far right on the top row is a figure in a dark red robe who isolates himself and stands severe: is this Zeno, the Stoic? In the center, sprawled across the steps and important to the composition in providing a contact between lower left and upper right and vise versa is the only ancient philosopher who could be so depicted: here in rags, if without his lantern, is Diogenes. In the lower right are ancient and contemporary mathematicians, grouped over a slate on which are markings which appear to represent intervals and relationships pertaining to contemporary music.

The large figure leaning on the stone at left center of the foreground is taken directly from the Sistine ceiling, Michelangelo's thunderous composition which Raphael saw in mid-progress and by which he was overwhelmed. But this figure again is necessary to fill a space. Elsewhere spaces are filled and the rhythm of gestures and postures elaborated and fulfilled by figures which are portraits of contemporaries (for example in the lower right we find Raphael himself and Perugino his teacher) and also by figures which have no meaning whatever (which is usually the case if you can't see the face) but are there merely as part of the group composition.

Yet in a way these figures are as important as any others. For centuries Raphael has been cited as the consummate master of **figure composition, that is, the organization of figures in groups and the groups themselves into an entire composition that accounts for spatial relationships in depth and height, and is a perfectly resolved complex of glances, gestures, and postures.** If one were to diagram the relationships in such a painting as this, one would actually need an overlay of a number of diagrams, and would still lack the subtle unity of the whole. But let the reader make the experiment. Let him analyze the ground plan; the architectural organization from side to side, and up and down; the color organization, that is, the placing of the reds, then the blues, and so on, and then how they are all inter-related; the organization of the glances (directions of gaze); the organization of hand gestures; the rhythm of the body postures, the way they work against each other. This is the essence of the painting, and one may learn as much from a serious attempt to analyze it as from an attempt to reproduce the calligraphic forms in a Schongauer engraving. Then one may compare all this with the weakness of Ingres' Apotheosis (Plate 17*b*), though reproductions are hard to work with in matters of quality.

A vital quality in the School of Athens is the indescribably fresh, airy light in which building and figures are bathed and vitalized. This atmospheric quality is derived from consummate exploitation of the chalkiness of the fresco medium; it gives a breath and a life to the entire scheme which is one of the first things that strikes the spectator, and which cannot be reproduced.

Raphael's Madonnas. Compared to the aristocratic if not actually recondite character of the Stanze, Raphael's Madonna paintings were a relatively popular art form, constituting perhaps the central focus of his fame in his own time as well as the chief target in criticism of Raphael's "sweetness" in the less harmonious world of today. As eternal symbols of motherhood, of maternal devotion perfectly complemented by childlike trust, these pictures are without equal of their kind. For some people today the religious accoutrements in these paintings form an obstacle to the apprehension of their true sentiment. But it should not be forgotten that in an age which sought ideals the Madonna was appropriate and meaningful as the supreme ideal of motherhood. Perhaps this is not really so much of a block as the sentiment of motherhood itself: in a century in which conflicts between the generations are crucial, people are apt to find such a sentiment cloying if not false. Also it should be noted that these pictures are better appreciated, even today, among Italians, for

whom family life has an intensity and intimacy less often found in northern countries.

The spectator must find for himself the weight and significance of the emotion expressed in these pictures. To analyze them is to explore not so much the emotion as the composition. And if we compare the composition of one of Raphael's classic Madonnas with such a late one as the Sistine Madonna (in Dresden) we may be startled at the difference. It is as if they belonged to different ages.

The Alba Madonna. The Alba Madonna in the National Gallery in Washington (Plate 19a) fetched what may be the biggest price in history for a detached painting when Andrew Mellon reputedly paid a million dollars for it. It is worthy of consideration not only because of its superb quality and condition, but also because it is, very likely, the most classical easel painting of Europe's most classical painter. Composed in a circle within a square frame —each of them perfect geometric figures, complete, final, and without direction—it also approaches perfect stillness and detachment, for all its tenderness in human relationships. Not only is the framing composed of simple geometric forms, but everything within the composition repeats this emphasis. Looking only at the group of Madonna, Christ child, and St. John, we perceive an extraordinary compilation of squares, circles, and equilateral triangles, varied to some extent by ovals, rectangles, and unequal triangles, depending on whether we follow gestures or glances, contours or lines made by the shift from light to dark. But these geometric patterns are not confined to the figure grouping, they extend also to the relation of the figures to landscape and to the organization of the landscape itself.

The three nodal points in the landscape are the figure group in center foreground, and the clusters of building, hill, or tree forms at distant left and at distant right. This in itself forms a triangle, and one that is particularly expressive of the Renaissance outlook on the world of nature, for it is as if the human element, represented either by the figure group or by the spectator himself reached out almost literally with his two arms toward those distant yet tangible points.

The world depicted here is clear, open, unequivocal. The time of day is that of high noon; there are no uncertainties. We see this world as through a hole in the fence—that is, the participants are unaware of our observation.

The Sistine Madonna. This general approach is typical of the bulk of Raphael Madonna pictures. But one look at the Sistine Madonna (Dresden), (Plate 18c) the most famous of them all, and we are in a different world. To begin with, there is no outdoors. The only suggestion of landscape is in the cloud forms, and if we look closely we perceive that these are filled with the faces of cherubs. The setting is not a section of the extensive natural world, as in the Alba Madonna, but seems to be that of a stage. Curtains and a curtain rod are actually painted in at the top, and the bottom edge of the picture is rendered in the form of a window sill or stage floor, on which two impish putti lean their elbows, an element of the unexpected, even the incongruous that is totally lacking in the Alba.

This incongruity is re-enforced by the spatial relationships of the figures. In the Alba these were clear, coherent, even geometric upon a ground plan. In the Sistine the figures all seem—according to size—to be about the same distance from the spectator even though the positioning and implied positioning of their feet would put some in back of others. By the same token the contours of robes and limbs look as if they were going to overlap but seldom actually do so. Again, the direction of gaze with each of the figures is ambiguous. We are not sure whether St. Sixtus (whose papal hat stands below) is looking at the Child, the Virgin, or past them both. We cannot be sure whether St. Barbara (her tower is behind her) is looking at her shoulder, her elbow, her knee, or the cherubs, who seem in turn to be looking back over their shoulders, a physical impossibility repeated in the absence of a wing on one of them for purposes of composition: this is so skillfully worked out that this omission is often ignored until pointed out. The Virgin and Child seem to be looking out at the spectator—or do they look beyond him?

These qualities of ambiguity and self-consciousness, though appearing in a work of the year 1515, anticipate the entire state of affairs in the art world in the second half of the sixteenth century—a style falling between the Renaissance and Baroque that is usually referred to as **Mannerism.** The function of this and other qualities is a problem that belongs to the historian. What we may note with more general interest and greater relevance is one of the first appearances of the stage presentation, a conception of the world that was to lie behind all Baroque art.

The Castiglione. If this enigmatic picture takes us far from the Renaissance—of which Raphael is often cited as the clearest exemplar—one of the master's great portraits may remind us of the classic Raphael of the School of Athens or the Alba Madonna—the portrait of Castiglione (Plate 18*a*). Count Castiglione was a good friend of Raphael and the well known author of the *Courtier*, one of the most typical of Renaissance books, developing an ideal of the universal man. Such a person —and there were such (among the famous being Alberti, Bramante, Leonardo)—was to be agreeable, graceful, witty and harmonious, yet at the same time strong, healthy, and skilled in vigorous forms of athletics. Furthermore he should be learned in the sciences and a practitioner of the arts: an intellectual, aesthetic, social, and athletic ideal combined, and one that nearly but not quite takes us back to 5th century Greece.

No one could have been better suited to portray the author of such an ideal than Raphael. All the qualities of harmony, balance, formality, grace, objectivity and composure that characterized Castiglione's life and thought were congenial to Raphael personally, and could be called on without conflict between sitter and portraitist in a pose so striking that two of the greatest Baroque painters, Rubens and Rembrandt, copied it; so convincing that we recognize almost at once that we are confronted with the portrait not of an individual only but of a society.

LEONARDO DA VINCI (1452-1519)

From the contemplation of such a classic ideal we may be all the more astonished in turning to a contemporary work of the High Renaissance—the most publicized painting of all Europe—the Mona Lisa.

The Mona Lisa. Though actually preceding Raphael as an artist of the High Renaissance, LEONARDO DA VINCI at an early stage seems to have reacted against its ideals of clarity and simplicity (as in the Castiglione portrait), for in his *Treatise on Painting*, while establishing theoretical canons, at the same time he warned against them in the name of "the immense variety of nature." Such a phrase is a clue quite as much to Leonardo's art as it is to his life. In the Mona Lisa this sense of the variety of experience comes out less in a multiplicity of forms, although the rich landscape background shows that too (in comparison, say, with the voided background in the Castiglione) than in the constant play and shifting of the fitful light: nervous and mysterious. It is this changing, unreal light that creates the air of inscrutability quite as much as the well known cryptic smile. As a factor which operates at once to activate and to unify the entire picture, such a quality of light looks forward to the fabulous stagings of Baroque landscape painting, and beyond that even to Impressionism.

The Last Supper. Yet at the same time the Mona Lisa remains a truly Renaissance picture in its composure, its quietness, its serenity, and in the (at least apparent) simplicity of its formal structure. If the reader at this point wonders what the Renaissance is all about—if he finds it not made simple but instead almost contradictory, then he is at least on the right track. What, for example, of Leonardo's Last Supper (Plate 18*b*), reputedly his greatest painting—revealed somewhat better after a recent cleaning but still so deteriorated that we can best decipher it from contemporary copies. Here is a truly classic composition. The architecture of the room is simple, the long table at right angles to the wall and frontal to the spectator, the central figure of Christ in repose, the twelve disciples perfectly balanced side to side in gesture, pose, and expression, all signifying the reaction to Christ's announcement: "One of you will betray me."

Christ is relatively isolated from the others, who are grouped intricately in twos, threes and fours. Similarly the central window in the back wall is larger than the two flanking windows and has an arch above it that echoes the halo over Christ: this is the only curved line in all the architecture, the receding lines of which would meet at the horizon line in the center of the picture if that point on the surface were not occupied by Christ's right eye.

Both the spatial and dramatic structure, then, is highly intellectual, worked out with great subtlety yet clarity. But another condition imposed by the classical ideal is that of completion of perfect finish. No great painting was ever less perfectly finished. Leonardo experimented with conflicting media upon a dubiously prepared surface with the result that even within his lifetime the work began to fall to pieces.

The Experimental in the Renaissance. We must, then, observe that the drive to experimentation of

all kinds, like the exploration of nature, represents a key Renaissance attitude and further separates it from the true classical world. Indeed with Leonardo this urge went so far that he has—with justification—been called the Faust of the Renaissance. It is common knowledge that Leonardo was not only one of the great painters of all time, but also a formidable sculptor, ingenious architect, outstanding engineer and at the top level of creative thought in all the sciences of his time, writer and musician to boot. Here truly was a man for whom all the world was his province. Such wide-flung activities each at so prophetic a level were not seen before, nor since in Western man until Goethe.

The Role of the Artist. It is characteristic of the Renaissance that the activity for which Leonardo most highly valued himself was painting: this was probably the highest ranking field of human endeavor in Italy in the 15th and 16th centuries, and marks a profound change in the role of the artist in culture. In the Gothic age the artist had been typically a professional stonecutter who made statues on the side (this refers of course only to the social position of the work of art, not its quality), or a monk who illuminated manuscripts. The Renaissance saw first a secularization of general artistic activity, then a rise in social rank of the artist, from craftsman to intellectual and eventually to something of a gentleman. *Leonardo developed a theory of the arts not as trades but as liberal arts attaining an ideal value, the realm of law and truth.*

The Artist and the Scientist. Leonardo's notebooks are filled not only with formulations of artistic ideals, but with observations, experiments, and analyses of all kinds. In the presence of such work we may be reminded that art and science far from being antithetical are actually parallel approaches to the same ends: further grasp of the order and variety of the universe. Leonardo's extraordinary drawings (qualitatively often of the very highest rank) range from sketches of ideal cities and buildings to observations of foundries and all manner of engineering processes, ideas for bridges and naval vessels, artillery and the predecessors of tanks, submarines, and aircraft. Where does the scientific imagination leave off and the artistic begin? Perhaps most deeply felt of all are the drawings of geologic and meteorologic formations—expressions (like Goethe's) of the prime forces of nature experienceable by man. Shown in these are not only forces of formation but as well of disruption. One called

Mountain Falling on a Town shows a cataclysm reminiscent of the chiliastic fears and disasters in the contemporary work of Bosch and Dürer.

MICHELANGELO (1475-1564)

In contrast with Leonardo's wide range and constant interaction of art with other activities, the third great artist of the High Renaissance in Italy, MICHELANGELO BUONARROTI, was an ascetic. Known to this day as the Titan, no man ever put more sheer energy into an artistic career. Where Leonardo was painter and writer, philosopher, courtier, and scientist and outstanding in each, Michelangelo was an artist only, but at that he was supreme. The greatest sculptor of the west, he was also one of its greatest painters, draftsmen, architects, and—what is less well known—one of Italy's outstanding poets.

The Tuscan. In all these activities Michelangelo's work shows with unparalleled force the strain of the period in which he lived: that which saw the Renaissance fulfilled, overcome, and transformed into the Baroque. But this strain was compounded with another: that of being temperamentally a sculptor in an age in which painting had come to be the dominant medium. Apart from his individually sculptural nature, Michelango was a Tuscan. The rhythm in his blood and the form in his thinking derived ultimately from a keenly sculptural people, the Etruscans. To oversimplify, we might say of the Etruscans that they were as profoundly sculptural in nature as the Romans were architectural, or the Venetians musical. Such basic dispositions are clearly manifested in the painting of each school, and carry so far that one tends to reject the other. Michelangelo lived during the period when the weight of artistic creation in Italy shifted from Florence to Rome. He did not live for the next shift, which was to Venice, but his work was directly carried on there by Tintoretto.

Michelangelo, the Sculptor. It is not surprising that Michelangelo's most important work in Rome was in architecture and painting, that his most important work in Florence, to which he always returned, was in sculpture. To be temperamentally a sculptor is to think naturally and inevitably in terms of mass, or solid form. Architecture, at least in the western world, deals in space, or opened form. Painting deals in what we call pictorial form which is expressed in terms of light, color, and line. One can perfectly well be a painterly architect or a sculptural painter. Also one can be a sculptural

architect as Michelangelo was late in life at St. Peter's, or in the wonderfully classical bridge over the Arno in Florence, destroyed in the war and recently reconstructed after extraordinary planning and effort to reproduce its apparently simple but powerfully "incalculable" curves.

Since the future of the plastic arts of the west was to lie with painting Michelangelo's sculptural painting had far greater influence than his actual sculpture. All the same, his sculpture was a more perfect accomplishment. Perhaps the frustration of these situations helps explain why Michelangelo was such a fanatical worker that he taught himself to do without food or sleep. When he was dead the footgear had to be cut off him, and the flesh came with the socks.

The Sistine Ceiling. The painting for which he is famous was a commission that Michelangelo originally tried to avoid: the decoration of the ceiling of the Sistine chapel. Its walls had been decorated over a period of generations by outstanding Italian painters. The ceiling remained, challenging. For whatever reason, some said through the influence of other painters—possibly including Raphael himself—jealous of Michelangelo's growing fame as a sculptor, who wanted to show him up as a painter, the Pope forced this commission on Michelangelo. The latter resisted as long as he could and accepted only on the terms that he was to make his own design. The original plan had been simply for a decoration of figures on the lower part of the ceiling and a geometric design down the center; Michelangelo insisted on a vast figural composition—the key action of which would be in the center—such that if the Pope were to have his ceiling he would have to strain his neck to see it.

During four years Michelangelo worked on his back at this painting; for he would not—though such was the usual practice of the day on large commissions—accept assistants. When it was over he said he never could stand up straight again.

Leonardo's Conception of the Deluge. The theme of the ceiling is that of Creation, starting with the Deluge. Now Leonardo's conception of the Deluge had been expressed in landscape terms. He described it—and how it should be painted—in his notebooks. First, he said, let there be presented the summit of a rugged mountain with valleys around the base and a surface of shrubs and roots. This surface then begins to slide, laying bare the rock and descending in devastation, in its headlong course ruining great

trees, opening deep fissures, covering the base with debris and swelling the rivers so that they rush in enormous waves down the valleys destroying farms and cities, the ruins of which throw great clouds of dust and smoke against the descending rains which are also countered by vast lakes of water thrown up by the debris from the mountains. Whirling eddies and muddy foam develop in the swollen waters setting up contrary cyclical movements and piling up and down, tearing open the surface of the water, recoiling, and merging with the tormented air. The falling rain is the same color as the clouds except where the sun strikes through. Debris striking the water will cause a rebound in the opposite direction: the angle of reflection will be equal to the angle of incidence. Rain descending through the air will form transparent clouds according to the density of the wind and will be seen through the lines of driving rain near the eye of the spectator. The waves of the sea will crash upon the mountain slopes, to fall back upon the onset of the next wave.

Lastly will be represented the myriad scenes of animal and human devastation. The essential divisions of the scene will be first darkness, winds, tempests, deluges, forestfires, rains, thunderbolts, earthquakes to destroy mountains and level cities; next whirlwinds carrying branches, trees, and people through the air, crashing together at the meeting of the winds; next ships broken to pieces and dashed upon the rocks; the flocking of sheep; hailstones, thunderbolts, whirlwinds; people on trees that cannot support them—rocks, towers, and hills crowded with people and all contrivances for floating; the landscape covered with people and animals, and lit with lightning from the clouds.

Such was the conception of a scientist, a naturalist, a painter. In its dynamic complexity, its attempt to express the eternal flux, its riot of conflicting forces it reminds us of the sagas of the North. Nothing could be further from the Greek, from the classical, from the human-centered. Although Leonardo never painted such a scene—no man could—he did render aspects of it in some of the most wonderful drawings of all western art (Plate 18*d*). Corot, much later, looked back to Leonardo as embodying the initiation of landscape.

Michelangelo's Deluge. It was not the same with Michelangelo. His sculptural preoccupation, based on his intense feeling in the human form, caused him to present the Deluge in relative simplicity. In place of Leonardo's multitudes, Michelangelo uses three

rather isolated groups of figures, the Ark, one wind-swept tree. This tree is so powerful in its twisting shape supplemented by the writhing figure wrapped around its base, and the figures struggling up the hillside are so forceful that a vast tormented movement piles through the scene and compels us to accept it as complete and sufficient. Leonardo's drama was of the elements; Michelangelo's is expressed primarily in the human figure.

Yet a final synthesis of Leonardo's extensive and Michelangelo's intensive concepts could be said to take place in Rubens' torrential Fall of the Damned (Plate 62*a*). For there is a common feeling in that Michelangelo's is seldom the ideal, composed, harmonious figure conception of the Greeks or even of Raphael. Michelangelo's figures tend toward the gigantic, the strained, the tormented. Even the idealized figure of Adam in the Creation of Man panel on the Sistine Ceiling is outsize, awkwardly lethargic, and presented in a strange alternation of profile and front view that twists the physical presence. The left arm must rest upon the knee and the finger droop as it is about to receive the spark of life from God.

As with Gothic art, the awkwardness is only apparent. Bernini observed: "When a painting by Baroccio, who used bright colors and gave agreeable looks to his figures, is seen for the first time, even by a connoisseur, it will please him perhaps better than a painting by Michelangelo, which at first glance looks so rude and unpleasant that it makes you turn your eyes away from it. Nevertheless, even while you are turning to leave the room, Michelangelo's painting seems to detain you, to call you back. And then when you have looked at it for a while you are forced to say: Ah! but it is fine! At length it excites you insensibly, and so deeply that you are reluctant to depart. And each time you behold it again it looks finer and finer."

The panel of the Temptation and Expulsion shows the serpent become female form, and the female forms become almost masculine. In other words, if Michelangelo tends to treat everything in terms of the human form, he also tends to make that form border on the grotesque. There was in this man an extraordinary fusion of classical and Gothic forces. This is not to be confused with the classic phase of the Gothic style as seen in the cathedral at Amiens, most notably in the form of the Beau Dieu. There it was a question of the Gothic finding a sort of standard form, and there is no strain involved.

Michelangelo's Conflict. What is in conflict in Michelangelo is something quite else: the force of the classical Mediterranean search to express its view of the world in terms of the typified, intensely physical human form, as opposed to the force of the northern European (in the broadest sense "Gothic") search to express its restless, anti-physical, endlessly energized and—we may say it—unhappy spirit and interpretation of the world. Think of the Nordic myths, of the sculptured Last Judgments, of Dürer's woodcuts and Bosch's paintings. This is the source of meaning and energy in western civilization, as the Doric was in the Greek, and it was strong in Michelangelo, strong enough eventually to overwhelm his Tuscan predisposition.

In the long run Michelangelo and Leonardo were to point towards the same thing: the dynamism of the Baroque. Raphael on the other hand is like Mozart: he died too soon for us to tell where his work might have led, though as with Mozart there is cause to suspect a potential change in direction.

An Artist's Career. An important artist dies. Apart from pure accident—which is perhaps rather rare—there are several possible historical accountings for the cessation of his activity. He may be, like Raphael and Mozart, an artist of classic temperament who comes at such a time that he can work up to an harmonious solution, after which he is either incapable of or deeply unwilling to proceed to the next historic step (which would be represented in these instances by Michelangelo and Beethoven).

Or he may come at the inception of an important artistic movement and do work of such revolutionary significance and suggestive power that he seems to burn himself out at a very early age. Possible examples of this phenomenon would be Masaccio at the beginning of the Renaissance in Florence, Giorgione in Venice, or Géricault in revolutionary France.

Or an artist may outlive his work. Even Shakespeare stopped writing. Michelangelo spent the last 18 years of his life in general renunciation of creative work, permitting himself only a handful of sculptures, drawings, and architectural plans of a most highly spiritualized nature. This was essentially meditation: his work had been done, as much as any man could do. After Rembrandt attained his final artistic statement there remained only one or two years of obviously declining power before death. Possibly Beethoven, possibly Cézanne died at

the right moment (Nietzsche implied how difficult yet important this was for a man of consummate ambition)—the power undiminished, and the work fulfilled.

There are of course other possibilities in this question of the work and death of the artist. One is the Romantic phenomenon. Keats, Byron, and Shelley died young, and there are those who feel that the reputations of Coleridge and Wordsworth would be enhanced had they done so. This may be another area where the genius burns itself out at high intensity, and must be considered in relationship to Géricault and perhaps even Napoleon.

Or the artistic death can take the form of a change in role. Marcel Duchamp, a 20th century French painter of outstanding promise and early achievement renounced painting many years ago and has been playing chess ever since. This man's intelligence being of the highest order and his family prolific in artistic creativity, his career may actually represent an awareness that painting in his country is pretty well exhausted.

Or it may be a question of the orientation of the culture itself. Both Leonardo da Vinci and Samuel F. B. Morse were painters and inventors combined. The former stayed with art, the latter turned to the world of mechanics. This may represent a fundamental difference in their societies. There is and was a valid school of American painting, but it has never carried the emphasis or volume in our society as has the field of mechanics or engineering.

A man may—like Rembrandt or Shakespeare—live at a time when his best abilities are perfectly suited to the needs of his culture. He may, like Morse, find it both possible and necessary to renounce a higher activity for a less high but more effective one. Or he may, like Michelangelo, find himself both in and out of the stream. A sculptor in an age of painting, Michelangelo's inner conflict was so intense and his own energy and conscience so unrelenting as to result in several of the most forceful individual monuments of western art, perhaps of all carvings anywhere. We think above all of the sculpture. But the paintings too are unparalleled.

Much of their power is based upon economy. For example, the Temptation and Expulsion are included in one simple panel, Adam and Eve appearing in the Garden on the left. In the middle is the tree from the top of which the serpent hands them the apple and from the other side of which

the angel brandishes the sword over the two figures who appear again at the right. The Landscape background is restricted to the tree which has leaves only on the Garden side, a few rocks and a little greenery to indicate the Garden, and desert for the rest. The few forms presented in the landscape are made to echo and re-enforce the gestures and postures established in the drama of the human figures: the relationship between the figure of Adam and the rocks at left, the great branch of the tree and the serpent, the silhouetted branch below that echoes the hands of Adam and Eve, or the base of the tree at right which echoes the accent combining the angel, the sword, and the figures at right.

Elsewhere down the center of the ceiling follow tumultuous scenes of God hovering over the waters; separating light and dark; or creating the sun and moon (Plate 19b). In the latter panel He appears twice. The larger figure hurtles toward the spectator, the two orbs appearing at either hand. At left is a comparable figure roaring away in the opposite direction. This is God creating the plant world, which is indicated by one small shrub in the corner. Such a backward, faceless, diminutive attitude towards external nature is no accident. For Michelangelo in his own words had dismissed the entire school of Flemish painting—which dealt above all with the phenomena of nature, living and still—as fit only for old people and schoolgirls.

The Prophets and Sibyls. This hypermasculinity and emphasis on the human image is expressed particularly in the gigantic figures of prophets and sibyls at the base of the shallow vaulting, that flank the central panels of the Creation. These figures, whether male or female, are taken primarily from studies of the male. This may be seen in the drawing for the Libyan Sibyl in the Metropolitan Museum, a tradition perhaps comparable to the use of males for female roles on the Elizabethan stage. But Michelangelo in any case tended toward the masculine physical type as being much more expressive of amplitude of frame and vigor of torsion. These seated figures invoke a physical force— the motor sensations of weights, balances, directions and gestures in the human body—to a degree of intensity and grandeur hardly attained in any other art. And each expresses, through the action of the body alone (the accoutrements are unimportant as are for the most part the expressions of the faces), a profound conception of the nature of the

particular prophet. The Delphic Sibyl is all grace and balance; the Libyan Sibyl playful and lightly charming; the prophet Isaiah is a study in introspection and a voice calling in the wind. Jonah leans furiously backwards, expressing in gesture the Biblical words, "I do well to be angry even unto death." The profound sadness in the Jeremiah suggests a self-portrait—a device unusual neither for the times nor in the works of this master.

The Last Judgment. Years later Michelangelo was commissioned to paint the end wall of the Sistine chapel. Just as the ceiling should not be investigated by the spectator until he has inspected the early paintings on the side walls beneath,—since the latter would be robbed of the slender grace and charm by the raw power of the ceiling—so the end wall depicting the Last Judgment should be ignored until the ceiling has been experienced, since the painting in the later style with its greater fluidity and more abstract expression may render the ceiling itself a little slow and stolid by forced comparison, though the latter is the more famous and—perhaps?—the greater painting.

The Last Judgment comes with the period of the Counter-Reformation. Michelangelo was thereby required by the church to clothe some of the nudes, but the spirit of the painting itself is that of a Gothic revival. Although Michelangelo retains a sense of the fullness of the human figure that he derived from the Renaissance, he calls here upon a number of Gothic devices, such as hierarchical scaling, spatial ambiguity, and continuous rhythms both of line and of light and shade (not limited to the contours of the figure or form as was typical of the Renaissance), in the service of greater emotional intensity, and at the expense of clarity and reason. Also he indulges more in the grotesque and the monstrous. The figure of Bartholomew to the right of Christ is shown with the knife of his flaying in one hand and his own skin in the other. The head belonging to this pelt is a possible self-portrait. Another demonic head from the painting was used as an entire poster—one of the most effective ever made. It advertised, several years ago in Rome, an exhibition of the Grotesque in European painting.

The ways in which Michelangelo's Last Judgment belongs in some aspects to the Renaissance, in others to Mannerism, in still others to the coming Baroque age is a problem for the style historian. We will miss something in the appreciation of this master, however, if we ignore the fact that, like

Shakespeare and Beethoven, he is one of those few among the great masters big enough and strong enough to straddle the ages. This means the jump not only from Renaissance to Baroque but also to modern expressionism: his figure drawing at once goes back to Giotto and forward to the verve of such 20th century artists as Marini and Cremonini.

MICHELANGELO'S SCULPTURE

The artist signed the Sistine Ceiling with the legend *"Michelangelo, Sculptor."* And advisedly it would seem for if his most noticeable influence lay in these vast paintings, his furthest attainment remained in the field of his calling.

It can only be evidence of the primacy of the art of painting in his age that Michelangelo's great painting projects were completed and that his great sculptural projects remained fragments, compromises, or unfulfilled plans.

The Julius Tomb. When Michelangelo first went to Rome, Pope Julius was attracted not only by his already great reputation but also by his tumultuous and independent personality (for he came to treat the Pope as no private citizen nor even, it was said, the king of France might have dared). The Pope commissioned him to design and execute the Pope's own tomb. They planned a monument detached from architecture to be three stories high, covered with three dozen colossal (larger than life) figures, to stand in the new church of St. Peter's which was to be the largest church in Christendom. Such a project would have taken any one man several lifetimes, not to mention more patience and funds than the Pope could provide.

The project in due time was amended to a wall tomb, much reduced, but still of ample proportions. Finally it was excommunicated from St. Peter's altogether, to end up as a small tomb, flat against the wall in the little church of St. Peter in Chains, and executed by other artists—with the sole exception of the figure of Moses. The only remnants from the original scheme by the original hand are the Moses here and several figures of bound slaves in various other places, some of them done quite late in Michelangelo's career, so that they have the appearance of separate studies, and belong to a much later style.

Moses. The Moses (Plate 13*b*) is one of the best known monuments in European sculpture. The seated figure, over eight feet high, has the power

almost literally to bowl over strong and sober men. Originally it was to have stood freely on a corner of the second story of the tomb. Now it is half obscured by a niche and undoubtedly loses something of the spatial twisting of head, neck, and beard against arms, knees, and feet. Because of this twisting, and because of the forcefulness of expression throughout the figure, the standard interpretation for generations was that Moses was here depicted as rising in wrath at witnessing the worship of the Golden Calf.

One difficulty with such an interpretation becomes evident if we consult the plaster cast of the statue owned by the Metropolitan Museum in New York. Freed of its niche, this cast shows the position of back and feet behind, where the weights are such that the figure if anything inclines backward rather than forward, and makes us reinterpret the function of the drawn-back left foot.

Next, if we examine the expression in the face more closely and under differing light conditions, we find it possible to read an entire range of expressions into the face that include wrath, indignation, apprehension, attention, perplexity, and awe.

We then note that while the left arm is tensed and strained in muscle, sinew, and position so that it could express everything from anger to fear, the right hand, firmly holding a book, also holds the end of the beard. The beard then twists markedly to reach the chin. It is the head that has turned, not the hand. Has something caught the ear or the eye of the prophet? Is this the moment when Moses is startled and awed to hear the voice of the Lord?

We do not have to answer this question so much as to note the powerful range of expressive possibilities, all stemming from Moses' character and career, that the artist has infused in one figure. Thus it is his total character, loaded with tensions, even contradictions but resolved in homogeneity and integrity—as with Hamlet or Faust.

Whatever the depiction may or may not be, this sculpture is more than a depiction, it is in the end symbolic: an expression of more than what pertains to Moses. *It is no less than the eternal problem of the leader in relation to history and to the divine.* And not through generalization only, but so intensely and keenly is this rendered that in a recent motion picture the part of Moses was given to that actor who most resembled Michelangelo's image.

The Medici Tombs. Such a rendering of the individual as an intensely realized type rather than as an attempt at strict portraiture also characterizes the Medici tombs in Florence. This mortuary chapel of the Medici in San Lorenzo, like the Julius tomb, exists only as a meagre remnant. The original plan would have made of this room one of the remarkable monuments of history: a total organization of architecture, sculpture, and pictorial decoration all by a single organizing and executing hand. A large four-sided tomb would have stood in the center of the room, a square chapel with a dome overhead, and the motifs of this sculptured tomb would have been repeated by and played off against the architectural structure and decoration of the walls. Knowing as we do Michelangelo's unequalled capacity to load, energize, and integrate situations involved with mass and space in all dimensions, we can only wonder at what might have been the result. Surely it is one of the great losses in the annals of art. And yet, like the Julius tomb, it could never have been finished by one man alone.

What we see today is only the basic architecture of the room, with two opposed wall tombs (an intermediary plan had called for four wall tombs). On each is the portrait figure of a son of the Medici, with two allegorical figures beneath (Plate 14). The two tombs are opposed in every sense, not only geographically but in the symbols and forms through which they are worked out. For these portrait figures are not really portraits at all but expressions of the two aspects of a dichotomy particularly meaningful to the Renaissance: **the Active versus the Contemplative Life.**

Now this dichotomy was in no sense a mere intellectual or academic one. To us it is not an issue. But we have our own issues, some of which are comparable: for example today a great many artistic, social, psychological, even philosophical and religious problems present themselves constantly in terms of objective versus subjective values; of introverted versus extroverted attitudes; of conscious versus unconscious activities; or, as a contemporary American artist has put it, "the conflict between spontaneous and deliberate behavior." It is such oppositions and the need to resolve them which are vital to *our* age and may shed light on the meaning of Michelangelo's.

Lorenzo and Giuliano. Giuliano de' Medici had been a soldier and a man of action, and Lorenzo a thinker and poet. There the portraits end. Indeed, when it was objected by a contemporary critic that

these visages did not especially resemble the men in question, that Giuliano who wore a beard in life appeared beardless upon his tomb, Michelangelo is reputed to have replied: who in a thousand years will care for what he looked like? The corollary implication that in a thousand years people would care very much what the *statue* looked like has so far held good.

The style with which each category—Active or Contemplative—is worked out is so coherent that we can identify the figures immediately with no need for labels or identifying devices. Thus we are not deceived by the fact that Lorenzo (Plate 14*b*), the thinker, wears a hat, and that Giuliano (Plate 14*a*), does not. For the function of Lorenzo's hat, which is not actually a helmet but a softer, more informal cap, is to shade the eyes and thus cast a veil of thought over the expression, whereas the hatless, free, unencumbered head of Giuliano turns actively upon a tall, strong neck, so that the clarity of vision, the attaching of the active gaze upon the immediate world is unhindered. Lorenzo's neck, by contrast, is obscured by the larger, brooding head— symbol of cerebration—and by the hand raised to the mouth with finger upon the lips in a time-honored gesture of the intellectual conscious that his expression is in words.

Giuliano unself-consciously expresses himself in actions, symbolized above all in the hands. These are extraordinarily articulated both in detail of bone and sinew, and in gesture. They hold, lightly but firmly, the two ends of the baton of command. The muscles of the arms are similarly emphasized, and amplified by the formations of the sleeves, whereas the costume formations in the Lorenzo figure are looser and do not re-enforce the anatomy but fall generally in broad, drooping curves echoing the more abstract idea of the weight of thought.

This is carried into the drapery about the feet, which it encumbers. With the Giuliano the drapery is kept back leaving the feet clear for action; unlike the Moses this figure is truly ready to rise. With Lorenzo the feet are crossed such that if he were to try to stand, which he seems to have no inclination to do, he would fall on his face.

Between Lorenzo's left elbow, and left knee, that is, held closely to the person, is a Florentine money box. The Contemplative life is indrawn. Giuliano, on the other hand, holds between forefinger and thumb of his left hand a coin. The wrist is drawn back in the gesture of the extrovert, the expansive man of action about to flip a coin on the bar—See what the boys in the back room will have.

But these profound and intricate characterizations of types are not the only factors determining Michelangelo's composition of the two figures. Also important is the interplay between the two. If you cannot compare the originals, which stand of course opposite to each other in a square room small enough so that the two walls feel each other's weight, then take photographs of the two tombs entire and look back and forth from one to another. The contrast and interplay of accents and rhythms on the surface may then be experienced even if the plastic relationships of the massing in the originals be lost.

The Allegorical Figures. This factor is particularly enhanced by the allegorical figures, two upon each sarcophagus lid. These represent the four times of day: Evening and Dawn, Day and Night. The latter, representing concepts of fullness, clarity, distinctness, and decisiveness represent the world of action. The two twilight times, characterized by grey rather than black and white, are in nature composed of multiple changing shades and represent the world of thought.

Day and Evening are male, the others female. On the one tomb the female is on the left, on the other the right. The interplay then is complete. Not so the execution. The figure of Night, done first, is the most technically finished. We shall see in later works how Michelangelo, as his style developed, tended less and less to finish the carving and polishing of his stone, more and more to leave off execution—at the point where the native grain of the material and the quality of the chisel marks could still express themselves and become part of the total aesthetic.

Thus the figure of Day is left with a hand half embedded in the stone, from which the figure strains to rise, and the same for the upper part of the head, which—it has more than once been observed—rises up over the shoulders like the sun over a mountain.

The figure of Night is self-enclosed. The left leg bends back over the right, and the left elbow back across the right thigh, the hand then rising to shade the head which is cast in darkness. Under the left foot is an owl symbolizing night, and under the left shoulder a grotesque mask almost Gothic in spirit (one may think of the meaning of night in the Middle Ages, as against the clear light of day

in classic Greece, or with Raphael). Rodin, the 19th century sculptor, was to observe: "Michelangelo . . . is the culmination of all Gothic thought. . . . He is manifestly the descendant of the image makers of the 13th and 14th centuries. You constantly find in the sculpture of the Middle Ages this form of the console . . . this same restriction of the chest, these limbs glued to the body, and this attitude of effort. There you find above all a melancholy which regards life as a transitory thing to which we must not cling." Compare this with our discussion of Michelangelo's "Slaves." In the figure of Day the axes of the body and limbs also cross each other, but with quite a different effect, for here everything tends to open up and out, though as always in Michelangelo, not without strain.

Day and Night are both dominated by more upward, pyramidal, vertical, and active accents than the figures of Evening and Dawn which are more horizontal, closer to the supine. Compared to the figure of Day, everything in the figure of Evening tends to droop or sag. Or again, compared to Day, the figure of Dawn also aspires upward but with less success: it is all she can do to pull the veil of dawn sleepily from a face so fresh with girlish charm as to restore a feeling of womanhood in a figure which, typically of the master, is so heavily articulated in frame and musculature as to appear almost masculine.

In the intricate opposition of the motives of one wall to those of the other, in their play of statement and counterstatement, and in their ultimate synthesis, the spectator may be reminded of the opposition of the School of Athens and the Disputa in Raphael's Camera della Segnatura. And so, in its Renaissance-like search for balanced logic and expression through types, it is. But where Raphael's mode was one of harmony, sweetness, and light, Michelangelo's is one of dissonance, passion, violence, and despair.

Some of the reasons for this despair have been suggested before. They come under the studies of psychology and history, even ethnology. What concerns us is more purely the operation of one of the profoundest and most powerfully experienced of individual emotions ever to be transvalued into the world of art.

The Bound Slaves. Around the chest of the figure of Dawn in the Medici tombs is a ribbon which appears to act as a constricting bond. On one of the earlier slaves, originally intended for the Julius tomb, we find the same thing. These bound slaves, of which there were to be many on the tomb, represented an attitude common to Michelangelo's time: **the attempt of man to free himself from his earthly fetters and attain freedom of the soul.**

In Michelangelo's statue this bond is hardly sufficient to restrain so powerful and straining a physique; this fact taken together with the closed eyes and strange lethargy of the figure suggest that man is struggling against no external bond but the baseness of his own nature. An ape-like figure encumbering the feet of one of these slaves suggests this baseness in pre-Darwinian terms.

"Unfinished" Statues. Soon the pretext of a literal bond is discarded, and the slave figure is plainly struggling with himself. But in the latest slaves (Plate 23*b*), done towards the end of his life, Michelangelo develops a further symbolism. These statues are often thought to be unfinished. This is not so. They were finished to precisely the point the sculptor wanted. The result is an indescribable feeling of effort and tragedy as the figure seeks to extricate itself from the stone, by analogy the soul from the flesh which Shakespeare (born the year Michelangelo died) was to call "this muddy vesture of decay." A hand is held down by a vast weight of stone from which it cannot free itself, a foot only half emerges, the stone, or Shakespearean "mud" or Biblical "clay" still upon it, a head is bowed and blinded by the vast weight of the recalcitrant earth. Or was it history and destiny against which Michelangelo felt man to be doomed in futile, endless struggle. When we think of his situation we are tempted by such an interpretation. But this would be a mistake in the general interpretation of art. **No first-rate art form has ever sought purely to illustrate a specific human situation: that comes under the heading of propaganda.** One thing that characterizes art is the universality in its expression of a persistent human attitude, emotion, quality, or truth. In this sense, although it is very interesting to know something about the artist and his career, that is not really necessary: all that is really required is an attentive and patient study of the work itself, in all its moods—and in all the moods of the spectator.

Spiritual Development of the Artist. Such a development from a more material to a more spiritual form of expression may be set down as a general rule applying to the most profound artists: Giotto, Titian, Rembrandt, Goya, Cézanne. It may be seen again with Michelangelo in his development of the

Pietà theme (the mourning of Christ by the Virgin). In the early rendition in St. Peter's, the artist actually intensifies the physical problem by placing the figure of the dead Christ across the lap of the Virgin. This means that the latter must be larger than the former, an impossibility in life. So the artist must in turn make the figure of Christ appear as large or extensive as possible and do the opposite for the Virgin.

This he accomplishes first by having the figure of Christ nude and that of the Virgin heavily clothed: this emphasizes the specific continuity of the Christ figure—the measurement from limb to limb, and at the same time helps to conceal the actual scope of the Virgin figure and aids us in deluding ourselves—as our understanding of the story demands that we do—or as Coleridge would say, helps us to suspend disbelief. Next, the figure of the Virgin is bowed over, hunched into itself, at least in comparison with the Christ figure which is carried on a long diagonal, the head thrown back in one direction, the foot thrown out in another. The high polish of this sculpture, notably in areas like the hands of Christ, sets up a gleam in the air immediately around it that adds something specifically to a sense of mystery and awe, but basically we may be more inclined to wonder than to be deeply moved at the tender expression on the face of the youngly depicted Virgin, the subtlety of represented textures, or the ingenious solution of the intellectual problem involved in the discrepancy of size.

In a later version in the cathedral in Florence—actually a Deposition, but close enough for comparison—we see a change from the material to the emotional. The figure at left may be ignored as not by Michelangelo. Otherwise the figures, even though there are more of them than in the early Pietà, are more economically grouped, and this compactness adds something to the compactness of the drama. The unfinished carving of the Virgin's head is handled to produce an abstract expression of grief, all the more powerful in that it goes beyond nature at the same time as it falls short of finished carving. The angular twisting of the Christ figure is similarly a straining of nature this time to suggest pain and the perversion of nature itself. Overhead glowers the despairing face of Nicodemus, whose features and expression must indicate another self-portrait.

Lastly, in a very late Pietà (Plate 12*b*), the artist develops the theme beyond even such powerful emotion and virtually into the realm of the spirit. All materiality is now gone. Specific parts are undeveloped, the stone is left rough-hewn. An extraordinary sense of clinging in the abstract, unforgettable gesture of the Virgin and the merging of the two figures in the same material combined with the sharply rising accents throughout the group to suggest the final spiritual transmutation implied in the first physical event.

If the reader finds this latest work difficult to grasp, he may remind himself that he is in good company. Such works were hardly understood at all by Michelangelo's contemporaries. Like Rembrandt he travelled beyond his age, and it took a century or two for the world to catch up. But many of the most experienced critics of our time feel that in these works, the last Pietàs and figures of slaves (Plate 23*b*), Michelangelo attained not only the most remote and secret stage of his work, but also the most powerful, purest, and furthest imaginative.

Quality versus Invention. The most important artists must be considered in two very different ways at the same time: for the quality attained in a given work, and for their contribution to history, their power to change things. These two factors go together in that **you could never find work of truly high quality in an artist whose style was reactionary, and by the same token no artist whose work was of true revolutionary importance could do this at an inferior level of quality.** One thing that art implies is the creation, in greater or lesser extent, of a new world. Inventiveness in itself is neither a cause nor a result of quality or importance, but in one way or another they all go together.

Nevertheless there are vast differences in the way quality and inventiveness may mingle with a given artist. Raphael, for example, invented relatively little for an artist of the first rank. He stands as the highest form of the eclectic, organizing with extraordinary taste, sureness, grace, and judgment ideas which came chiefly from others. On the other hand, Leonardo invented all sorts of things and completed very few.

Something of this contrast can be seen in the difference between the classic Greek temple and the Gothic cathedral: the one extraordinarily complete, finished or "perfect," but not particularly inventive or ambitious, the other endlessly inventive, incomparably ambitious, never completed. We might conclude that the qualities of the Gothic

cathedral are more proper to western art as a whole than the opposite qualities.

Nevertheless we have had at least a few outstanding figures like Michelangelo and Titian, Velásquez and Rembrandt, who not only revolutionized the forms that they took up and set in motion entire new worlds of art, but also made single works of which we can say that the expression is total, that we look at, not so much in appreciation of their originality or the direction in which they lead, as for completed beings who speak to us direct.

Such are Michelangelo's slaves, and the late Pietàs. With other works we may be somewhat more impelled to think of their historic significance—their relation to the world of styles. In the self-immobilizing figures of the Medici tombs we are constantly reminded of that profound aspect of Mannerism, the period of uncertainty between Renaissance and Baroque.

In the flatness, stability, and eternal dignity of Michelangelo's statue of David we feel the quiet, composed assertion of the Renaissance. This statue is nearly fifteen feet high. It originally stood in front of the Palazzo Vecchio or town hall of Florence. It was then and still is a civic monument, symbolizing individualism and defiance of the enemy, of which at the time there were many (Michelangelo is also famous for the fortifications he built to defend his city).

The later figure of David is so generalized, so clearly a pure study of the human figure that we find the allegory in it only a pretext, and indeed it is often thought to be not David but Apollo. In this we are reminded of the far more self-consistent Baroque age, which continued the use of allegory typical of the Renaissance but used it as pretext to its own ends. We are equally reminded of the Baroque in the formal structure of this later figure of Michelangelo's. Where the early statue of David is meant to be seen only from the front—the dimensions are full, but there is no action in space except from side to side—the later figure must be considered as rotating, and the spectator with it. Here there is no single viewpoint which is indicated more than another. From any given view we are impelled to move around the figure. The axes and the inner structure as well as the movement of the limbs provide this rotation.

Later Development. Such complete three-dimensionality was to become characteristic of the Baroque. It develops from the Gothic, where the sculptured figure was flat upon a wall, to the deeper, more spatially varied reliefs of Ghiberti in the early Renaissance, then the fully developed figure, detached from architecture, of Donatello, then the figures involving spatial play and tension of Michelangelo's Medici tombs, where the allegorical figures have been taken from the niches beside the portrait figures and moved violently into a new dimension in front.

But those very allegorical figures, although involving a new spatial dimension by their placement, are still meant to be seen only from the front. From the side they make sense as sculptural organization but not as human figures.

The final step was to destroy frontality and to keep the mass of the statue moving around on its own axis, to break up the isolatable contour and make the spectator himself move around the statue in search of it. **Such a sense of rotation, of incessant movement, provided a terrific vitality and motive power to Baroque art.** At the same time, in destroying the assertion of plane, of contour, and of the permanence of massiveness it attacked the very nature of sculpture.

Baroque Mass. It is often said that the Baroque style may be defined as "masses moving in space." This is a fruitful definition of a style and we can see why Michelangelo is often called a Father of the Baroque. But we may also see that when a mass gets to moving in space on all its axes it loses its massive quality, its static weight and solidity as defined by contours. These are qualities that pertain to Egyptian and Greek and Mexican sculpture and make them truly massive, truly sculptural. It seems as if western sculpture was always trying to become something else: architecture with the Gothic, painting with Michelangelo, or music with the Baroque.

VENETIAN PAINTING

In contrast with the artists of Florence and Rome who were ever oriented toward the antique, toward the ancient Etruscan and Roman monuments which they still saw around them and the pulse of which they still felt in their blood, the orientation of Venice was towards the east, meaning Byzantium.

The Byzantine Heritage. Byzantine mosaics, with their broad decorative simplicity and splendor of

pure color, used not as a mere embellishment but as an essential mode of doctrinal expression, had for centuries adorned the interior of the cathedral of St. Mark in Venice. The influence of such wonders on Venetian painting from the very beginning (in the Gothic age) is no accident, for the entire Venetian economy and culture nourished itself on what Wordsworth called the "gorgeous east" that Venice held "in fee." This Byzantine east had not sought a world made clear in terms of plastic relations—the organization of solid bodies—as did ancient Greece, or Renaissance Florence, but sought instead a world of richly variegated surfaces, which, denying the illusion of specific physical objects, established an unreal, fabulous world of splendid, continuous substance, enchanting the eye, deepening the emotions, and transporting the spirit.

Venetian Traditions. The Venetian culture took these ideas of color and surface organization, originally devised for religious purposes to overwhelm the spectator, and filled them instead with the vigorous physical reality of the Renaissance. The love of festivals and beautiful women, of money and gems and fabrics, of instrumental music and song—in other words of all facets of material splendor and delight that illumined Venice from the 11th through the 18th centuries—found its highest and furthest expression in the painting of the Bellinis, of Giorgione, Titian, Veronese, Tintoretto, Guardi and Tiepolo: in the greatest school of color and of pure painting that Europe has produced. Perhaps because this school appeals so directly to the eye and to the sensuous emotions it has received far less discussion and analysis than the Florentine, say, or the Flemish schools.

The Anti-Plastic. The art of sculpture—that art of the tangible, immediate reality and kinesthetic grasp—was non-existent in Venice, and the art of architecture—dealing with the measurement of space and volume—though enchanting was of minor creative importance there. Music on the other hand played a far greater role in Venice than in central Italy, and we must keep in mind that there is something in all Venetian painting that tends towards music.

Florentine art is more readily analyzable than Venetian partly because it contained a greater intellectual quality (this is not a mark of superiority but a chosen element or emphasis); its forms, proportions, and relationships were more explicitly thought-out. Florentine art is more tangible: it can be taken up and handled so to speak. It can be measured and charted: one may profitably draw a diagram of Leonardo's Last Judgment, or the School of Athens, or even the Sistine ceiling. But one is not tempted to make a diagram of a Titian, at least, not a linear diagram. With a Titian what one would analyze instead would be the color organization.

Aspects of Color. To do this we need other equipment. For one thing there are different kinds of color. There is color-matter, or pigment, which involves qualities of depth, surface, and texture and is the province of chemistry. There is the color of light-rays as studied by the physicist. There is the phenomenon of color response as studied by the psychologist. There is the phenomenon of color relationships as one tone of paint is placed next to or on top of another on the canvas, which is the particular concern of the artist.

In analyzing color it is helpful to distinguish **primary** from **secondary** factors. The latter refer to suggested qualities of **mood, temperature, weight, distance, or tangibility.** They are apparent rather than implicit; they result from the total organization of primary factors; and they cannot be measured as such, unless some day by psychologists.

The Primary Factors. The primary factors are usually referred to as **hue, value, and intensity (or saturation).** Any given tone of paint is the result of a peculiar admixture of these three factors, and can be so closely measured that it could be reproduced according to a number system. This is the sense in which "tone" should be used: **a specific phenomenon of color,** rather than more generally in several loose senses deriving from the concept of "tonality" as is all too frequent. A tone is a color *fact*, not a quality. For this specific fact the word "color" should not strictly be used, since color properly is a concept involving all three factors. Thus we speak of a whole complex of things when we speak of Titian's or Delacroix' or Matisse's "color." In daily life we may speak of a fabric of green color, but **in painting color means an organization, and green is not a color but a hue.**

Hue. A hue refers to **a distinguishable part of the** spectrum: such as purple, green-blue, or orange. The **primary hues are red, blue, and yellow**—these are defined simply as being **mutually exclusive**—that is, red contains no blue or yellow, etc. Any other hue is produced by a mixture of these: red and

blue make purple, yellow and blue make green. Black and white are not hues but values.

Value. Value means the lightness or darkness of a tone. White is the highest possible value, black the lowest. This is not at all the same as physical light, in which white light or sunlight contains all the hues of the spectrum, and black means the absence of light. The whitest paint or canvas represents the highest value available to the painter and contains no hue. By mixing black with white paint in varying proportions he obtains middle values. Value may be also thought of in terms of incident light. If a painting is moved from a darker part of a room to a lighter part, the value of every tone in the painting will be raised.

Intensity. It is important to distinguish **value from intensity.** The latter is sometimes referred to as saturation and means the **strength or richness of the hue.** Where there is no hue there can be no intensity but only higher or lower value.

Imagine a canvas covered evenly with grey paint, that is, made of black and white with no hue. Then imagine adding a certain number of dots of red paint which is at the same value as the background grey. (Relationships of values among contrasting hues can be more readily distinguished by squinting, which helps reduce the visual element of hue.) If the canvas is now viewed from a sufficient distance a certain red tone will be fused. This tone will have an intensity dependent upon the quantity of red dots. If more red dots are added the value will be unchanged because the red dot is of the same value as the background grey that it replaces. But the intensity will increase because there is a greater quantity of hue in the given area.

Both the value and the intensity, however, will change with the distance of the spectator from the object because of the filtering effect of dust and moisture in the atmosphere. With increased distance values become higher and intensities weaker.

Furthermore, because of the nature of light waves, each hue will attain its optimum intensity at a given value and no other. The optimum intensity of yellow appears at a relatively high value, those of red and blue much lower. This fact makes it possible for us to construct a color wheel (see Appendix A) against a value scale.

The Complementaries. Another phenomenon with which we must be acquainted is that of **complementary hues.** The complement of a given hue is to be found two-thirds opposite it on the color circle.

Thus the complement of yellow is violet, of red is green. If complementary hues are mixed the result will be grey, or the cancellation of hue. If complementary hues are juxtaposed, the most intense contrast results: one seems to vibrate against the other. Or to put it another way, a yellowness can be emphasized more strongly by contrast with a little blue. A hue seems to invoke or demand its complement. If you stare at yellow and then close your eyes you will see blue; or if you stare at a yellow area against a grey background a blue halo will emerge around the edge.

Secondary Factors. We are at this point confronted not with pure or primary intensity but with **apparent intensity,** a secondary factor. Another secondary factor is **apparent warmth or coolness.** The warm hues are on the yellow-red side of the color wheel, the cool hues on the blue-green. Whether these are simple natural associations stemming from the colors of sunlights or flames as against those of water or woodland shade, or whether such associations are more complex does not concern the artist and it need not concern us. We must note however that generally speaking an object takes on a cooler hue as it recedes in atmospheric distance. This does not mean that a painter will invariably render the more distant object cooler in hue than the nearer: he may simply alternate warm and cool hues to suggest successive layers, for example, just as he may alternate high and low values (light and dark accents) to express spatial superposition.

Mood. Another secondary factor of importance is **color mood.** No painter establishes the mood of a picture by a single hue but rather by a **combination of hues** which according to the way they are organized and integrated with other elements of representation and design all together create a mood situation. Nonetheless among the painter's tools in doing so are normative **emotional reactions** to various isolated hues. Thus it is generally agreed that yellow suggests activity or energy while blue opposes a passive internalness and red stands somehow between with a deep potency. Pure orange can have the effect of adding the potent activity of red to the excitability of yellow resulting in fulfilled activity (is it accidental that this is the color of fire?) or the passiveness of blue combined with the energy of yellow produces the subdued stirring of green (is it accidental that this is the color of growing verdure?).

Hue Environment. We are accustomed to the

overall effect of a yellow bedroom as against a green dining room. Here the hue has become virtually an environment—such as that referred to by R. L. Stevenson in the line "green days in forests and blue days at sea." But the art of painting is —among other things—the art of color relationships, so that the isolated hue has less significance than the way in which it is used: the tones with which it is mixed, to which it is opposed, in which it is outlined, and so on. Much the same is true of music. A single note on the piano creates a certain vague emotional response, but this is not made explicit, coherent, and directed until organized within a chord, or more fully, within a sequence of notes and chords.

Florentine Color. Now the basic concept of color in Florentine and Roman painting was that of colored drawing, that is, the **embellishment or enlivening of an art form that was essentially plastic,** that could be understood quite well in black and white. This does not mean that a painting by Raphael (Color Plate) or Michelangelo is just as effective in a good black and white reproduction as in a good color reproduction. The color most definitely adds something. The emphasis is on the word "added." The composition was established first, in terms of line, massing, spatial position, and so on. Color thereupon helps to clarify, enrich, or further express relationships, but it was never a primary or conditioning element in the composition.

Venetian Color. In a painting by Titian, on the other hand, **line is partially done away with** (this is closer to the phenomena of vision, since there are no lines in nature); **masses are not solid but diffuse** (the weight and self-containment of masses that is expressed in Florentine painting refers to our experience of touch and physical movement, not of *vision* which presents only areas); and **spatial relations, though strongly suggested, are not so clearly emphasized** as in the Florentine mode (the relation of objects in space is something that we learn, not something immediately apparent), with a greater emphasis on the **continuous texture of the surface.** Above all, the **design of the picture relies on color,** for example, a large area of one tone may be required to balance a small area of another which may be more intense or may be more isolated by contrasting tones. Without color then the picture not only loses a great deal in dimension and expressiveness, but it doesn't "work"—as painters say

in referring to the total effectiveness of a composition.

Intellect vs. Sensation. We see immediately that where the Florentine painter was more interested in the operation of the intellect and of physical apprehensions, the Venetian to a large extent repudiated these in favor of more emotional and visual sensations. The two modes and their components are by no means mutually exclusive—it is a question of emphasis, of the realm of human experience pursued.

The Color Mode. We see also for the Venetian painter a greater interest in color as a medium, just as some modes of music work far more with melody than do others, Mozart as opposed to Bach for example. This is not to say that Titian's color is better than Raphael's so much as it is more interesting, more moving: there is infinitely more to it. Within Raphael's own terms he is a very fine colorist, but restrained. He would have repudiated Titian's richness and variety of color as misleading to the things emphasized in his own style and he would have been right. A whole school of painters known as the **Eclectics,** in Rome in the 16th century, made the serious mistake of supposing that if the glories of Venetian coloring were added to those of Florentine drawing a still more effective art would ensue. Their failure was partly due to the fact that Venetian coloring and Florentine drawing were not processes that led in the same or even parallel directions. Such things are neither ordinarily compatible nor mutually exclusive, they simply refer to different areas of human experience.

Raphael's Color. With Raphael (Color Plate) the color belongs to the object. With Titian color belongs to the atmosphere. In Raphael a blue robe is all blue, and the area next to it is all some other color which clearly contrasts with it. Basically the means used to suggest modelling is to change the value of the blue, to add black or white to indicate highlight or shadow. By this means the consistency of the hue appropriate to the object remains almost complete, with some variation in intensity.

Light as Color. But when Titian (Color Plate) wishes to indicate light or shadow he may change not only the value intensity but also the hue itself. We are today well aware that the actual color of a given object depends not only on its own inherent hue but even more upon the kind of light reflected on it. Thus a green tree may appear gold in sunset light. We are also aware that a strong change in

value, as from sharp light to deep shadow, can make the same surface appear to change in hue. Add to this reflected lights from various sources and directions and the color world becomes extremely complex and fluid. Part of our awareness of these facts depends ultimately on the investigations and expressions in paint of Titian and Venetian painting in general. **Color has thus become something conditioned by atmosphere, and no longer a property of the object, as with the Florentines.** All this corresponds to other areas of metaphysics, since classical thought generally associated properties with objects.

Venetian Color Dynamics. Another metaphysical difference between the more classical Florentine and the more dynamic Venetian lies in the **static quality of Raphael's color, the fluid quality of Titian's.** Raphael's robe is blue and no other hue. Titian's blue robe, though its total effect remains bluish, changes within from blue to purple to green to orange. In other words the hue transforms itself. But it moves in another sense also, for it continues beyond the boundaries of the object whereat it originates, and travels in and out across the picture surface, and back and forward in depth, thus becoming part of the dynamism of the composition.

Transparency and Fluidity. And Titian's color moves in still another sense. Raphael's paint surface is smooth and opaque. Titian's is composed of an intricate system of textures such that color seems to float back and forward within the paint surface itself. This is effected by darker underlayers of thick pigment overlaid with varying numbers of pigment diluted with oil and thus more or less transparent. These glazes will contain pigments of different hues to suggest the fluid quality of cross-reflections within natural atmosphere. However the entire color composition will at the last be unified by an overall glazing of a characteristic tonality: with Titian this is blond and warm and has caused his name to be invoked to describe a type of color in women's hair.

Activity of Light. Color in Venetian painting was not only decorative and dynamic. It also involved an **interpretation of the world in terms of light.** In Florentine painting light was conceived as a quality that helped reveal and clarify the plastic object. Raphael's light falls with basic consistency but casts relatively few shadows. Rather we might say that objects are shaded, especially at the edges, or if an edge is light, then the area behind it is shaded. In other words specific light effects are minimized to begin with, and when used are made to play up the contours and thus define the plasticity of the objects.

Contour. But with Titian the outlines are a little fuzzy, as if to prevent the isolation of the object from the continuous play of light. Shadows fall not simply around the edges or at the base, but entirely across parts of one object and on to another, such that if we squint at the picture we see not so much a pattern of light and dark areas each representing a self-contained form, as more abstract areas, including a part of an object here or several objects there, broader areas that fit into a coherent surface pattern.

Vibration. Furthermore, within a given area of light notice the flicker, the constant change, the feeling of vibration, where in the Raphael all is still. Raphael's light has the perfect, static quality of high noon; Titian's though serene has a sort of afternoon stirring: whispering movements fill the air and give an animation to flesh and foliage alike.

GIOVANNI BELLINI (1426?-1516)

Such an emphasis on the quality of light as part of the subject matter of the picture was not new in painting. We have seen it a century earlier in Hubert van Eyck, and it was developed notably in the work of GIOVANNI BELLINI, the virtual author of the great development of Venetian painting, in whose workshop Titian began to learn his art as a young man. In pictures like the famous Allegory in the Uffizi the spectator is so entranced at the magic light moving in and out, not merely enhancing but actually creating the mood, that he may care far less than in a Florentine picture what the intellectual significance of the actual subject is (it may have to do with the pilgrimage of the soul).

St. Francis. Visitors to Naples are urged not to miss Bellini's extraordinary painting of the Transfiguration, with its keen realization of the unreality of early morning light. Or in the picture of St. Francis in Ecstasy in the Frick Collection in New York, we find again a dominance of landscape, and within that ever-variegated structure of rock and vegetable forms such a weird shifting of light sources and tonalities that we are forced to conclude that the scene must represent the false dawn when Francis was supposed to have received the stigmata.

Bellini's Contribution. Through his subordination of all other natural phenomena to the unifying influence of light and color Bellini began a tradition in painting that was to lead through Giorgione and Titian to Velásquez and Rubens, Delacroix and Goya, Constable and Turner, and ultimately the impressionists and the Fauves. This is not to ignore the creative power of light in the early Flemings, in Grünewald or Dürer. But in the northern schools the light generally tends towards exploitation as **expression** rather than **impression.** The Venetian mode worked itself logically in the direction of **a world seen as spots of color,** organized frequently to suggest religious or classic pastoral or portrait themes, but organized in terms far closer to the natural vision than the more literal painting of either Flanders or Florence that had been the glories of the preceding century.

GIORGIONE (1478?-1511)

Successor to Giovanni Bellini in the 16th century Venetian school was GIORGIONE DA CASTELFRANCO, one of those supreme figures in art who died so young that we wonder what he might further have accomplished. Paintings attributable to Giorgione are so rare that they often outprice the works of Titian himself, although the latter's reputation is, in the end, greater. But rarity operates in the art market as anywhere else. Furthermore when we note that although Titian painted fine pictures all his life, those for which he is best known—his most ambitious and transcending accomplishments— came late in his long career (he lived to be either 89 or 99 before succumbing to the Plague), we have to ask what his reputation might have been had he died at Giorgione's age. On the other hand it is possible that Giorgione was one of those who had already said most of what he had to say. At any rate before he died he had basically transformed the thematic quality of Renaissance art.

The Tempest. The only picture universally agreed to be entirely by the hand of Giorgione is the so-called Tempest in the Academy in Venice (Plate 32*a*). This is one of those paintings that no color reproduction yet made can really represent. The sensation of fitful light, of the approaching storm of glimmerings, flashings and iridescent tones, playing upon strangely opaque and wonderfully luminous surfaces and textures, and keynoted by Giorgione's superlative creation of white and cream hues, is the true subject of the picture. The apparent subject is a city in the background and a woman with child and a soldier in the foreground. The two adults seem to have no relation to each other nor particularly to the landscape, nor do they seem interested in the approaching storm. Whether or not this situation refers to some classical allegory, as was popular at the time, does not matter. The point is that any possible human meaning has been subordinated to the intense aliveness of the atmospheric theme, and to an imaginative orchestration in colors and textures of paint. Small wonder that this painting is so referred to as a touchstone of modern art.

Giorgione's best known painting however (whether or not it is entirely by his own hand need not concern us much because of the superb quality throughout) is the Pastoral Concert in the Louvre. Two nude ladies join two clothed gentlemen with musical instruments in an aristocratic picnic. Although the tenor of the situation is clearly one of love and beauty, the specific situation is not clear: there are no particularly meaningful relationships between the figures, and the theme seems to vibrate between figures and landscape, atmosphere and musical sound. Few works in all art have a more profound, composed, yet reverberating charm.

This accomplishment of the transforming of all nature and human entities into one unifying atmosphere and mood was a development from Bellini's work wherein the specific human situation remained clear and dominant, and it paved the way for Titian's extension of this light and color analysis to the total fabric of the picture. But there are other differences between Giorgione and Titian.

The Venus. There is still an ideal, remote air to Giorgione. His painting of the reclining Venus in the Dresden Gallery lies asleep in a landscape of which the commanding features are remote as are her dreams. With her discrete head and elegantly uplifted elbow she is a goddess. Titian's reclining Venus of the Uffizi—the pose and pictorial organization of which are clearly based on Giorgione's—lies on a couch, close to the spectator, in a room which extends deeply into the background, includes ladies in waiting, and shows only a man-made landscape through a window. Her elbow is down upon the pillow and her hand moves forward with flowers toward the spectator, at whom she looks directly. A small furry dog curls up near her feet at the end of the couch. Her hair tumbles invitingly across her

shoulder. The curtain behind her falls to the pelvis, thus isolating, screening, and emphasizing the feminine parts. The background rock which acts as a curtain in the Giorgione falls so as to isolate only the head, or cerebral and dream-like aspect. Giorgione's nude is a goddess suspended in reverie; Titian's is a woman, wide-awake, modestly presenting herself in gracious reality.

TITIAN (1477-1576)

"If one were to live for one hundred and twenty years one would prefer Titian to everything."
—Delacroix

TITIAN's art is fully human. While he painted countless religious and mythological pictures in addition to his more strictly human-oriented portraits and nudes, all have a strongly human flavor, a heartiness, a vitality, and a glorying in the flesh that never becomes heavy but remains always vibrant.

Rape of Europa. It is worth a trip to Boston alone to see the finest Titian in this country and one of the best preserved in the world: the Rape of Europa at Fenway Court (Color Plate). The painting is protected by glass and one must move about to obviate the reflections. Even so the extraordinary richness and fluidity of paint texture may remind the spectator to pay little heed to the average color reproduction of a Titian. The perspective of the landscape shifts as we move back in it attaining a wonderfully romantic haze and glimmer which reverberates from, and the more strongly emphasizes the superb figure of Europa, floating through water, spray and air on a diaphanous bull, no more a goddess than the Venus, but a woman in all her flesh and gesture.

Titian's Contribution. Such a picture, with its chords of color echoing into the elusive, imaginative background takes us close to the realm of music and of the Baroque. Embodied here is a great deal of Titian's contribution to the coming age: **the orchestration of color and light, the pictorial mode as against the sculptural mode of Michelangelo or the architectural mode of Raphael, the opening up of the potentialities of visible paint handling and decorative organization** that were to count so much with Rubens, El Greco, Hals, Velásquez, and Rembrandt.

The Late Development. But this is not the end of Titian. There was to be a final, emotionally transcendent stage of his art that elevates him to the rank of the very greatest. In paintings towards the end of his long life, such as the Entombment in the Prado (Madrid) or the Pietà in the Academy in Venice, there is a transformation from gay, cheerful, sensuous themes into a genuinely tragic passion, a profound *expression* of the significance of grievous and sublime events.

An earlier painting of the Entombment stands in the Louvre. It is a handsome picture, striking in gesture, exciting in color, compelling in total organization. Only in comparison with the later Entombment do the gestures begin to seem histrionic, the colors material, the composition artificial or at least conscious rather than deeply inevitable. In the later picture the upraised hand and outstretched fingers of the only figure who actually gestures fuse electrically with sky, cloud, and air. All other figures, even the independent draperies, bend with the weight of the corpse and its destiny. But the color can only be referred to in the presence of the painting. It does not merely create a mood profoundly harmonious with the subject but goes beyond that to create a world of its own which once seen is never forgotten, and cannot possibly be described.

Venetian Quality. Whether in these last paintings of Titian, or in his earlier ones, or in the paintings of Giorgione or Giovanni Bellini, it is very important to note that the color when compared generally to that of a non-coloristic school like the Florentine *is not necessarily brighter or stronger*. Actually Raphael's paintings are clearer in color contrasts and often more intense in single tones than Titian's. The Venetian mode works primarily from **muted colors,** and its incomparable richness and fascination comes from its **variety, mobility, and subtlety.** The tradition of coloristic painting developed in Venice was later to be restimulated by fusion with the color traditions of the northern schools and was to flower in the extraordinary coloring of Velásquez, Rubens, Vermeer, Delacroix, Turner, Manet, Renoir, and Matisse. But as an achievement in itself, as the creation of glowing fire, excitement, harmony, radiation, and—let us not always fear to use the word—pure beauty, the Venetian School stands unexcelled.

VERONESE (1528-1588)

PAUL VERONESE, one of the five great names of Venice and one of the leading painters of all Europe is hardly to be seen in this country. The Metro-

politan Museum in New York has a fair representative in the Mars and Venus, and there is a fine small picture in the Boston Museum. Otherwise one must travel to Paris but above all to Venice itself to see this grandest of all decorative painting for what it was. Nowhere is the fullness, ambition yet serenity and dignity of the Renaissance more completely expressed than in the gigantic canvas purposing to represent the Marriage at Cana (in the Louvre) (Plate 33*a*) but actually depicting a 16th century Venetian feast, with several of the leading Venetian painters in center foreground in the roles of musicians, a keenly significant allegory; or in the vast painting called the Feast in the House of Levi in the Academy in Venice. It had been a Last Supper but Veronese was brought before the Inquisition and charged with representing various profanities and irrelevancies such as a dwarf, a parrot, a man with a bloody nose, a dog, and some Germans with halberds eating and drinking. Unwilling to change the painting, he changed the title. It is typical of the Counter Reformation that the Inquisition sought to control such matters that involved seriousness and religious dignity if not doctrine itself. It is equally typical of the individualism and social importance of the Renaissance artist that Veronese made only verbal deferment to this august body.

Veronese is what we might loosely call the Raphael of Venetian painting. He established, within the Venetian mode, a norm of balance and clarity, of **eloquence and decorative coherence** that provided a readily communicable base for future painting in the given school. Nor does this mean academic painting only, though a good deal of that. Some first class painters have followed directly in such traditions: Poussin and ultimately Cézanne from Raphael, and Tiepolo and ultimately Goya from Veronese.

TINTORETTO (1518-1594)

Of contrasting significance was the last great Venetian of the 16th century, TINTORETTO, a vehement and tempestuous figure whose professed aim was no less than **to combine the drawing of Michelangelo with the color of Titian.** Naturally any attempt to combine such antithetical things would have to surrender a great deal of each: the wonder is that Tintoretto succeeded at all, and indeed he accomplished a titanic style which represents a genuine fusion of important aspects of the two, though his line tends to flash rather than to mould

as with Michelangelo, and his color is less pure and more expressive of the movement of forms and of areas of light and shade than was Titian's.

In thus providing a meeting ground for the prophetic styles of two divergent titans of the Renaissance, Tintoretto made an incalculable contribution to the development of European painting. The basic style of the most characteristic of all Baroque artists, Rubens, depends directly upon Tintoretto's tentative fusion of Michelangelo's principle of "masses moving in space" with Titian's pictorial form, color orchestration, and organization according to an overall pattern of light and shade.

As with Veronese one hesitates to discuss Tintoretto from the works visible in this country, which although many in number are few in importance. One or two pictures in the Metropolitan and a portrait in the Frick gallery will give some idea of the agitation in Tintoretto's style but little of its scope. For this one must see his chief monument, the Scuola di San Rocco in Venice. This large roomed building of two floors is filled with gigantic canvases of Biblical subjects, culminating in the Crucifixion or Calvary. The largest and one of the most impressive of all depictions of the scene, Tintoretto's Crucifixion is melodramatic in the best sense of the word. Filled almost but not quite to a redundance of figures and details, it is organized into a vast stormy movement of light and shade, over and undercast with lurid tones and flashes of fitful light.

Mannerism. Such a forceful unreality with its denial of human health, solidity, or composure is another typification of this latter part of the 16th century that we have already alluded to as **Mannerism.** The precise nature of the Mannerist movement is a problem for the student of history, but we cannot ignore such features as these when we look at an individual painting by Tintoretto, or by the very strange painter whose work at some points so much resembles his, by name Domenikos Theotokopoulos whom the Spanish call EL GRECO.

EL GRECO (1548?-1625)

We have met something called an **eclectic artist** before in Raphael. That meant that he recombined in unique form artistic ideas that he found amongst his nearby contemporaries and some older civilizations from the same area in which he was born and always lived. In Greco we have a different kind of eclectic.

Born in Crete amongst a people whom we would call Grecian, his heredity had nothing to do with the ancient civilizations of Crete or of Greece, but with the medieval civilization of Byzantium, whose forms were all about him in his infancy and from whose blood and spirit he derived.

Immersed in this hierarchic, otherworldly, and abstractly stylized background, Greco went to Venice in the day of Titian and Tintoretto, where he absorbed the essence of their pictorial conception of painting, and the stimulation of variegated color, which in itself had partly derived from Byzantine mosaics. From Venice he went to Rome where he was overwhelmed by the late work of Michelangelo —the painting of the Last Judgment or the sculpture of the Deposition—composed of abstractly agitated forms and severely spiritual in feeling. From Italy, whether because he felt that he would be better off as a painter outside of Italy or whether more likely that he felt a deep identity with the growing political power and religious intensity of the Counter Reformation in Spain, he went to the city of Toledo, its citadel.

Greco's Personal Style. With such an heredity and such an odyssey one might expect Greco to evince some kind of conglomerate style, made up of many different elements that would not agree with each other. As a matter of fact, the reverse is true. Greco developed a personal style which both in subject and pictorial form is so homogeneous that it almost runs the danger of being repetitive, and by the same token has been an inspiration to modern painters with their interest in self-consistent abstract form.

The fully developed features of this style may be seen in many respects in the Orgaz (Plate 29), though more consistently in works like the Resurrection of Christ in the Prado. The unearthly hues have a common element and are overcast by a sort of ashen white which further unifies them. The human limbs are all rendered with a peculiar twist and flow that becomes the handwriting of the author. No form ever gets very far from the surface without being pulled back toward it.

Throughout the picture we see continuous rhythms and accents of light and dark all weaving in and about close to the surface, transforming the literal anatomy into parts that flow within themselves and also into their neighbors. The negative spaces are nearly as active with abstract shapes and light flickerings as are the solids. Furthermore there are basic overall shapes and patterns that not only unify the entire scheme but recur in smaller editions throughout so that the unit is related not only to the next unit but also to the whole. Among these basic forms are sharp diagonals, S-curves, and variations on the diamond shape.

The qualities of elongation and attenuation in the figures, of ambiguity in the spatial relationships, of a kind of deathly pallor and fitful light, and of constant nervous tension and, indeed, of a self-conscious style in all, are qualities more or less common with Tintoretto and others of the Mannerist age.

Distance from the Renaissance. Such pictures do not sit firmly and quietly on the ground as did a Raphael or a Giorgione, and it lacks their objectivity, stability, and clarity. Take the Alba Madonna (Plate 19a). There the basic geometric shape is an equilateral triangle on a horizontal base. The basic geometric shape in the Resurrection is an elongated diamond, both axes of which are on diagonals. Now as we saw with the pyramid, nothing could be more stable than the kind of weight disposition to be found in Raphael's Madonna. Few things could be less stable than the towering, teetering diamond shape in Greco's Resurrection. Furthermore this contributes a strong feeling of levitation such as Raphael would never have abided (except in a late work like the Sistine Madonna which has already many Mannerist qualities). It must be reaffirmed that although the resulting feeling in the Greco is one of precariousness, the final effect is not unbalanced or the picture would be unsatisfactory. The upward emphases are countered by the host of light and dark accents that vigorously fill the bottom half of the picture. The picture *is* balanced, both up and down and from side to side. But it is not balanced in a chosen calm and repose, rather like the Raphael, but tensely, nervously, and with disquieting agitation. Pictorially—abstractly—the picture works, it satisfies. But people without sympathy for the denial of flesh and bone, people without an urge toward self-agitated spirituality will always have trouble approaching this or any other fully developed image of Greco's style.

Greco's Approach. This spirituality was so intense that it is said Greco could never be got out into the streets by daylight, that he painted by candlelight behind closed blinds. Anyone who has seen Greco's handsome villa in the middle of Toledo, one of the most striking cities of Europe, will appreciate this denial (Plate 30a). We are now far

from the clear, midday light sought by the High Renaissance. This is a world of shadows and flickering light, of mystery and transubstantiation and the glowing realities of another world. It takes us back to Byzantine church and mosaic though it belongs to European painting.

The Burial of Count Orgaz. Nowhere is this unearthly light and sense of transformation from the material to the passionate spirit more richly or completely expressed than in Greco's masterpiece, the large (14′ 9″ by 11′ 9″) canvas mounted on a wall of the church of San Tomé in Toledo (Plate 29).

The story referred to is that of a knight who, before Greco's time, had died in battle. When he was taken from the field for burial in this church it is said that two saints, Stephen and Augustine, miraculously appeared to lift him into the tomb. This is the moment depicted in the bottom half of the picture. We identify Augustine by his hat, Stephen by the plaque woven near the bottom of his robe showing a man being stoned: Stephen's martyrdom. Although some of the attendant nobles and clergy seem to look in the general direction of the event, upon close inspection we find that actually they pay it no particular heed, and though all contribute to the severe piety of the theme, each seems strangely withdrawn. The two monks at left who seem in disputation are actually unconnected: one gazes into space, the other turns his gaze inward in contemplation. The boy in the foreground points mysteriously at an abstract emblem on St. Stephen's sleeve, a gesture reminiscent of medieval manuscripts. The range of nobles' heads include some marvellous portraits, sensual in paint-handling, spiritual in expression, and perhaps include a portrait of the artist himself in the head directly above that of Stephen. The languorously gesticulating hands, a trademark of Greco, serve not only as spots of light to maintain a nervous accentuation in the dark areas but also to carry the pictorial direction towards the figure of Orgaz. The hand directly over the head of the boy takes on a peculiarly flamelike shape—another Greco trademark—and echoes the actual flames in the torches above. The hand above the head of Stephen repeats the shape and orientation of Augustine's hat and like the torch flames; and the gaze of the figure continuous with that hand leads upward and almost touches the down-swerving wing and draperies of the angel suspended in the center.

This figure is the contact between the bottom earthly sphere and the upper celestial realm of the scene. From the deep-sagging figure of Orgaz echoed in the drooping drapery beneath him (and strongly reminiscent of the figure and drapery of Christ in Titian's Entombment now in the Prado, which Greco must have known) a widespread movement sweeps upward through the figure of Augustine up into the air and thence into the aperture between wing and cloak of the angel. This open passage is blocked by her elbow, but opens again above it. And emerging therefrom is a phosphorescent form, infantile in shape and size, and almost transparent, without substance: an ectoplasm. This is the soul of Orgaz reborn into the kingdom of Heaven, aspiring upwards through the bright-lit passage between Mary and John towards the receiving figure of Christ Himself at the top.

The bottom of the picture is sober, dominated by horizontals and even downward movements, and basically restrained. The upper part is built on diagonals, S—and Z—shaped forms, greater distortions and more unreal light and color. In other words the pictorial style distinguishes between the weight of burial, the firmness of the earth bound world, and the ecstasy and airy spiritual nature of the heavenly realm. Yet at the same time the two parts are unified by connecting links and gestures, by tones and transparencies in the bottom layer that refer to those above, by repetition of shape character in all parts, and by a surprisingly substantial treatment of celestial figures and clouds, considering that they are celestial. So that in a way the earthly emphasizes contemplation and withdrawal, the celestial action and reality.

Toledo in a Storm. Greco's depiction of Toledo in the Metropolitan Museum is the only important landscape painting of the Spanish school, and of course it is not actually by a Spaniard. Velásquez did two fine small landscape paintings in Rome. There is an occasional bit of landscape in the backgrounds of some of Velásquez and Goya's paintings. Otherwise this is it. And the more we look at this picture the more we are likely to be impressed by its symbolic overtones.

The Toledo has sometimes been cited as an early instance of pure landscape, but as a matter of fact it contains a number of tiny figures. Actually some paintings a century earlier in the north, like Altdorfer's are probably the first pure landscapes in European painting. Still, the figures here are of no

account, and there are three dominant elements: the sky; the buildings, roads and bridges all connected in a network and of a continuous tonality; and the landscape itself. Toledo is an extraordinary city, built upon a rock fortress edged by the steep valley of the river Tagus, its roads and buildings piling up steeply and compounded together. Anyone who has tried the experiment of drawing the city from the same point as Greco will see at once several things: that the countryside was evidently far more fertile at the beginning of the 17th century than the middle of the 20th, that Greco has exaggerated the steepness of the hills and the jumbled quality of the rock-like buildings, (Plate 30*a*), and that nevertheless the picture is emotionally so true and pictorially so compelling that one tends to remember it rather as Greco saw and expressed it than as any camera or more literal painting could do.

For a city whose climate is incomparably dry and clear (for example Greco's paintings that have remained in that city stand virtually without need of cleaning or restoration) this is a most strange atmosphere. It is so dark as almost to seem night, and the cloud formations, lit weirdly from behind, are precisely what one may see on a summer night in northern Spain. But the light on the grasses is too strong and too warm for night. The light comes at a lower than 45 degree angle from the right, and since we are looking at the city from the north, the time described must be mid-afternoon. The darkness of land and sky combined with the wetness of the vegetation finally indicate the middle or end of a storm, and the picture has sometimes been called Toledo in a Storm.

Possible Symbolism. The great mass of the city on the right is counter-balanced by a smaller but strikingly isolated and theatrically lit group of buildings in the character of a fortress. It cannot fail to remind us of the fortress-like character of the piled-up city itself, with its abnormally grey walls.

We must recall that Toledo was at this time a center of the Counter-Reformation. Most likely it would seem that the city here upon its fortress rock stands for the citadel of the Church itself, beset by the storms of Reformation. Or does it, as others have proposed, recall the stony land of Gethsemane, where it is said that at Christ's death the curtain was rent much as the curtain of the sky is here? Or is it even that prime symbol of western

religious art from Romanesque Tympanums to Michelangelo and Rubens (Plate 63*a*): the universal crisis of the Last Day?

Our appreciation of this painting may be intensified by the contemplation of such possibilities. But it is probably the case, as it was with Michelangelo's Moses, that no such specific symbol was intended, that we are presented with an image that is not individual but characteristic, in which essences of the place, the time, and the spirit of the man who was the artist are vividly enshrined.

PIETER BRUEGEL (1525?-1569)

If Greco was a Spaniard only by adoption, PIETER BRUEGEL, his near contemporary in the north, was a Fleming to the soles of his earthy feet. Both figures stand **between the Renaissance proper and the Baroque**, yet where Greco called backward in some ways to the Byzantine and forward in others to modern art, straddling and partly skipping the development of the next three centuries, Bruegel stood directly in line with his Flemish forebears, and in turn set the stage for Rubens.

It is not that Bruegel was unacquainted with southern art. He studied under (and married the daughter of) Pieter Coeck who, like Titian, had been painter to Charles V. The greatest influence in connection with Italy was from the Alpine landscape seen on his trips there, and this is of course not Italian at all but northern. These mountain panoramas appear in greater or less fusion with broad elements of Flemish landscape throughout a great deal of his drawing and painting (these were his chief media: although a great many engravings were made from his work, Bruegel himself made only one print, a landscape etching).

The Triumph of Death. An important source for Bruegel's work was the cataclysmic style of Bosch. Bruegel's painting of the Triumph of Death (in the Prado) displays the grotesquerie of humanity in disaster and a world in flames. The spirit reminds us of Bosch in particular and of the entire northern theme of the conquest of Death from Gothic sculpture to the works of Dürer and Holbein.

Bruegel's use of an extremely high horizon permits him as it were to scoop out the surface of the earth so as to include as much of it as possible in a single painting. Countless figures of humans and skeletons (representing death) depict destruction and the grave in all variety from resignation

to defiance: note the magnificent figure of a soldier in the lower right: inebriated and dauntless he is willing to take on the army of death itself, which is ranged in ranks so as to force humanity into a passageway between bearing the shape of a coffin.

In the background flames, gallows, and torture wheels reflect not merely the theme of destruction inherited from Bosch and his generation (including Leonardo) but also the specific horrors of the Spanish Inquisition. Here is another aspect of an historical institution which Greco, on the other hand, painted with sympathy at least as to its dignity and seriousness. (cf. Greco's portrait of the Grand Inquisitor, Cardinal Fernando Nino de Geuvara, in the Metropolitan Museum).

Bruegel's Themes. Bruegel painted no portraits. He saw the world as infused with natural forces—ravishing, in both senses: overwheming, devouring, enslaving, but ineffably exciting, stirring, and beautiful. Such basic force dominates even a religious picture. The painting of Christ Bearing the Cross (Vienna) does contain a few purely religious figures in the foreground (though actually these are in the painting style and costume of 15th century Flanders). Otherwise one has to look hard to find the cross, or Christ, or Gethsemane. The cross is in the middle of the picture—that is, technically it is centrally located and thus given importance, but actually since the middle of such a vast landscape is far away the cross is barely discernible. Christ is even harder to find, underneath it. Gethsemane is in the far upper right corner, where a circle of spectators has formed about the other two crosses, and towards which people run and walk, dogs bark and an informal festive spirit against the background of a small northern town makes us think more of a local Flemish hockey match—or a football game in a small New England town—than the climactic event in the life of Christ.

By the same token, the depiction of soldiers holding back peasants from the road in the left nearground reminds us more of a tavern brawl, and the cross itself is far more evident in the windmill atop the crag than in the literal cross.

Bruegel was not alone in his day in the **rendition of religious themes mostly in contemporary terms** so that qualities of **genre** (meaning the habits and activities of people) and landscape dominate the picture. He did however carry the convictive force of these contemporary elements so far as to help set the stage for the following century's development of whole schools of pure genre and landscape and even still-life painting.

Other "Religious" Pictures. In a painting like the Massacre of the Innocents (Vienna) we can see all too clearly the Biblical theme, although it has been rendered in terms of an atrocity by Spanish soldiery. Such after all is the meaning of Biblical or mythological themes to people living in periods other than the historical-scientific age which is ours. We prefer to re-create the setting in which we conceive the theme to have had its inception. But to Bruegel, as to a Gothic sculptor, the significance of the theme was that it expressed a recurrent and typical human situation. Bruegel cared little for ancient Israel: he cared a great deal for the people and the land of his own experience.

Sometimes, however, Bruegel's Biblical themes appear as pretexts for the exploitation of genre and landscape themes. For example in the Conversion of Saul we have to look hard to find the subject (he has fallen off his horse a little to the right and above the center of the picture amidst a maelstrom of figures). The real subject (though here again possible allegories have been suggested) is the majesty and infinity of the Alpine landscape, cut off at the top to show it never ends, and the faceless, anonymous surge of soldiery under the weight of their equipment up the steep hillside to be swallowed up in the very clouds.

In a painting of the Census at Bethlehem we could scarcely distinguish the subject from a local census or tax collecting scene, and concentrate instead on the varieties of pure genre and the wintry lowland landscape. In a picture of the Nativity we are again barely able to distinguish the subject, and the chief interest in the picture is the marvelous rendition of a snowfall—slow, steady, chilling yet almost comforting in its silence, uniformity, and blanketing effect. Predominating in the townscape is a church perhaps significantly in ruins.

Not really religious in theme but instead a kind of encyclopedic genre painting (think of the quatrefoils on the cathedral at Amiens) is the Battle between Carnival and Lent symbolizing the contrast between the last fling and the lean season in a combat between a hearty rollicker mounted on a keg and using a spit festooned with meats for a lance, and a lean and ancient hag armed with a shovel sporting two slim herring. Elsewhere all manner of revelry on the one hand and pious

scenes on the other are included in an extraordinarily rich conglomeration.

Games and Proverbs. Similar in interest and construction is the picture of Children's Games. Occupying an entire town, the vista of whose main street opens to the very top of the picture without adults or any activity other than playful, these children (hundreds of them) take part in an enormous assortment of games, many of which can be identified and many of which or their descendants and variants are in use today. Such a scene ought to be given over to gaiety. And indeed in the richness of its color and the sparkle of pictorial shapes and accents a generally gay mood prevails. But if we look closely at the children's expressions—take the group playing at some sort of queenly procession just at the corner of the fence in the middle of the picture—we see that they are anything but carefree. They move—according to the laws of nature and of society—like puppets. Or do they now look like old people, or dwarfs, or even thoughtless primates? We might say that instead of life being in them, they are in life; they take their life only from nature itself.

The furthest development of this encyclopedic, almost didactic kind of painting is in the picture usually known as Flemish Proverbs, into which something like a hundred different proverbs, sayings, foibles, or common situations are woven.

Many of these are readily identifiable, indeed for many there are present-day English equivalents. Some are locally Flemish, some are even puns in the language (like one which depends upon the Flemish word for pretzel).

We find a man shooting one arrow directly after another (throwing good money after bad); a couple kissing in an attic (love in an attic is uncomfortable but convenient) under a broomstick (the equivalent of our shotgun). We find a man butting his head against a stone wall, and against the whole length of it. We find another stretching his arms in either direction for pies beyond his reach (the donkey starving of indecision between two haystacks). We find a man crawling on his hands and knees through a world-symbol (a globe with a cross attached), and a fop (Italian costume) holding the world on his thumb (or as we would say in the palm of his hand). At the upper left we see pies out to cool on a roof—is this our pie in the sky?

The same motive appears in another proverbial painting of Bruegel's, but this one is entirely given over to one idea: the Land of Cockayne. The theme here is satiation, or gluttony. Three men in the garb of soldier, farmer, and clerk—to show that such folly occurs without discrimination—are fed to the gills and spread out beneath a tree, near which an egg with a spoon in it walks about on legs to facilitate its own consumption. In the background a pig with a tranchê cut in his back and a knife tucked through a slice of his side similarly moves. On the tree overhead is a circular tray with vessels for food and a bottle the mouth of which opens directly over the clerk's.

Everything in the picture is rounded. Not only the pies, and the porker, the egg and the dishes, but the table on the tree and landscape itself, and lastly the organization of the chief figures, in a giant oval, within which their arms and legs and accompanying instruments work back and forth like the spokes of a wheel. This roundness is clearly indicative of satiation, of the round belly. But it also, along with the breathless, stifled atmosphere suggests the nature of the kind of existence satirized: a round of eating, drinking, sleeping, endless and pointless, without purpose or direction.

One of the best known Bruegel pictures is that representing the Blind Leading the Blind (Naples Museum). Here the figures dominate the scene and stretching out across the foreground stand for different and successive stages of their fall. The first walks unconcernedly, the second hesitates, the third grows apprehensive, the fourth stumbles, but remains upright—and here, as in the basic action comes the basic break in the picture, the opening into the background—the next man has lost his balance, and the last is in the ditch. Each too represents a different variety of blindness. We have then an allegory not only of the inevitable outcome of human folly but of its many aspects.

Bruegel and Folly. People speculate widely on Bruegel's attitude toward human folly—for not only in this picture but throughout his proverbial pictures and even the religious ones folly is the dominant human theme, much as sin was for Jerome Bosch—asking did Bruegel condemn, satirize, hold in contempt, overlook, sympathize with, or glory in this profound aspect of mankind. What does it matter? Perhaps these are the wrong questions to ask. What did Shakespeare think of Hamlet or of Falstaff? The answer is both simpler and richer than any overt interpretation allows. Kipling had his finger on the problem:

When all the world would keep a matter hid,
 Since truth is seldom friend to any crowd,
Men write in fable as old Aesop did,
 Jesting at that which none will name aloud.
And this they needs must do, or it will fall
 Unless they please they are not heard at all.

Something is created, using human experience for its medium, which is so rich and compelling that our own experience of it works to transform our own interpretation of the world. Let the spectator of Bruegel's pictures not arrogantly or with dispassionate intellect try to "solve" these pictures or psychoanalyze the artist. *The great artist is a great man: he is bigger than most of the people who experience his work.* Let the spectator more innocently and humbly immerse himself in these pictures, not just once but time after time, and he will not only discover more and more things going on—both in subject and design—but he will in time come away a different person.

The Seasons. Bruegel's best known pictures are also in a way didactic: these are the series of the Seasons. Probably the original intention was that there should be six, but whether the last was accomplished we do not know. Today there are five, four in Vienna, and one in New York, the Harvesters. This picture represents July or August and is the most serene and restrained of the series, as befits that time of year when nature's temper is at its most even, the time between growth and harvest in which man can sit in the shade of a tree and simply contemplate the limitless bounty and sheer sunny existence of nature, as expressed not only in wheatfields and orchards but in a broad distant vista extending in a silvery haze ultimately to the sea.

The so-called Hay Harvest stands for May or June. Full of swelling, rolling rhythms, its greater heartiness and activity suggest the fecundity of nature at that first moment when its fruits are plucked and taken by the hand of man for consumption. Buoyant women, yet with that enigmatic facial expression to be found in all Bruegel, march with rakes; others—back to us so we do not see their faces at all—stride with rolling gait over the hill to the village with full baskets on their heads. In a corner a man pounds out his scythe rather than waste steel in sharpening it—is this the thin edge by which man exists in the midst of nature's profligacy? Overhead a few small clouds appear—in no way obscuring the clear, strong atmosphere, but giving a breezy note.

Autumn. In the painting of Autumn (September-October) these clouds have grown in starkness and in extent to cover half the sky. They become sharp, poignant reminders of the rending of the seasons, and similar sharp accents and configurations are picked up in hills, mountains, and the course of the great river. Against this dominant scheme the roundness of the fatted cattle (many of which are brought around and presented from the rear to accentuate this quality) serve as a lesser theme to emphasize the major aspect of autumn. Mediating between these two divergent shape-characters are the meadows—in the middle ground so that geographically and pictorially they come between the foreground cattle and background mountains and sky—with a sort of elongated roundness verging at points on straightness and sharpness. Even the trees respond to this expressive theme: at the left they are more swelling and rounded whereas the tree at the right twists angularly in sympathy with the mountain form behind it, and at the top, where it is silhouetted against the storm-impending sky, becomes harshly brittle and austere. As for the colors we might only say briefly that nothing in painting more purely expresses, against the background of russet overtones, that which was indicated in Shakespeare's phrase—the sere, the yellow leaf.

Winter. One of the most popular paintings ever reproduced (and hung in countless parlors in this country alone) is the Winter, or Hunters in the Snow (Plate 24). It is also—strictly from a formal and critical point of view—one of the finest landscapes ever painted. As the Harvesters portrayed the quiet life of summer, this picture—January-February—portrays the loud dead of winter. Once again the sky is cloudless, the branches of the trees are still, and there is no wind. A bird with wings outspread, and the hunters moving into the landscape suggest, the idea of setting out—we feel this is the beginning of the year, not the end.

The picture can be distinguished from one by Norman Rockwell or Grandma Moses by the power and subtlety of pictorial organization, which is of interest both in itself and as it re-enforces and clarifies the literary and natural scene.

The foreground is a near-two-dimensional arabesque of the dark profiles of dogs and hunters against the snow at the bottom and the tracery of deciduous branches and twigs at the top. Against this chill a roaring flame—almost the only dynamic

note in the picture; its thrust is parallel to that of the geologic thrust of the mountains in the upper right—is fed by women and children. Throughout the middle distance people work transporting burdens on their backs and on carts while others skate and play at curling on the dark ice. Behind them is an entire village in the middle distance, a wondrous detail itself, the incessantly active shapes of snow-laden roofs against dark walls picking up those to be seen on the roofs in the foreground, and lending transition, through a somewhat increased quality of flow, to the mountain shapes in the background.

Countering this vast transformation expressive of distance are such devices as the use of the birds to tie it all together. On the nearest tree in left foreground sits a large dark bird silhouetted by the removal of twigs at that point. He faces left, that is toward the inward or closed part of the composition. Directly above the center of the picture, three trees out, sits a similar bird, the difference being that he is slightly smaller by virtue of distance and that he faces outward toward the open part of the picture where there are no trees but only a distant view. On the same diagonal that connects these two, but midway in the open half of the picture on the right is a third bird emphasized (there are also others that we do not immediately notice). He faces the same way as the second one, but instead of sitting is in full wing. The shape-character thus keenly emphasized (the crossing of his wings with his body also crosses the distant meeting point of snow ridge and sky) is repeated in the shape-character of the dark walls of the building directly beneath him. In this way, the foreground (for he is the same size as the other birds) is related to the middle ground. But the birds lead to the upper left, and this pivotal bird is also related to the lower left by the phenomenon that he and the dogs at lower left are the most strikingly active silhouettes in the picture. Again the bird is tied to the lower right by the sharp triangular shape of the house walls there. And lastly he is tied to the upper right and also the far distance by the repetition of his shape in the remote mountain crags, of which there are three predominant ones, so arranged that if they themselves be connected with the figure of the bird—and they and the bird are all of equivalent size on the picture surface—they will together form a cross-like shape which

exactly repeats that of the bird himself. And in still another sense the bird has a crucial function in the picture, for he connects—on a diagonal across the surface—the line of physical motion begun by the dogs and the hunters but which is interrupted by the counter diagonal of the hill, yet at the ultimate end of which are the fabulously romantic mountain peaks, so that we have a deep urge to take flight in order somehow to reach them. By his action and position the bird strikes the note that fulfills this spatial yearning. (We can only conclude, in returning to the ground of criticism and analysis, that there could hardly be a more important bird in all the art of landscape painting.)

The Dark Day. The most exciting picture of the series is also in Vienna and is best known as the Dark Day (Plate 25). It would seem to represent March-April, the time of break-up and promise. Once again the round of nature has begun, but only as feeble shoots amongst the stormy force of the March that comes in like a lion. The sky is the stormiest of all the paintings of the seasons, and the distant landscape the most stirring. In the foreground a warmer note is struck, men prune trees, and one excitedly reads—what, a love letter?—to another, and dropping down to the left foreground we see people stirring. But as we move back into space, which is all the deeper from its beginning well below the foreground corner (the basic structure is very much like, but the reverse of that in the Winter), the warmer notes of human activity become obliterated in the sweep and surge of nature, above all in the wide tempestuous river that roars out into an angry ocean, belit with whitecaps and dotted with ships in distress. The rhythm of this great arabesque of river and ocean is set in the foreground by two twisting tree-trunks, which is one way of uniting the surface pattern with the depth structure. As usual there are many others.

For example, on the distant beach, toward the right where the river becomes ocean bay, several ships are piled up in various stages of destruction. Above them whirl broken twigs in the wind, accents that pick up the shapes and rhythms in the brittle bones of the ships. But these twigs have nothing to do with the area to which the ships belong—they come from the trees in the foreground, whose intact branches further carry this staccato pattern and unite the two spaces. These trees further act, by their grouping all the way up the

center of the picture, to break up the sweep of grandiose landscape from the sunlit Alpine mountains at distant left to the open sea climaxed by a minute but miraculously romantic, wind- and spray-swept lighthouse in the furthest distance, above the derelicts. This most fascinating landscape is kept in place by the interruptive function of these trees and also by their reference to the contiguous background, on the right by their reference to the derelict motif, on the left by the blending of the rhythms of the branches with those of the clouds.

As we gaze into this and the other paintings of the seasons we become more and more impressed with the landscape elements. They are always loaded with life, not just on the surface, but deep within, showing forces of growth, of dynamic swell and strain, of the subtle harmonies between meteor-ological and geological formations, of the running of rivers and the surge of the ocean.

More than any man who ever painted Bruegel expresses the deep changes over the physiognomy of earth as the seasons roll. Somehow in this process the straining of humanity and the all-powerful rhythms of nature are seen as one, with a direction and a life force that sublimates the aimless, chaotic follies and grotesqueries of his early painting into a more complete unity, but without loss of variety or vitality. These paintings must stand as the most comprehensive landscape achievement of all time, and cause Bruegel to take rank among that handful of painters whose works take us beyond ourselves into a vast, vital world of new wonders. Out of the most intense subjective experience, they create an objective truth.

BAROQUE ART

RUBENS (1577-1640)

"That fellow mixes blood with his colors."
—Guido Reni

The culminating glory of Flemish painting is the work of PETER PAUL RUBENS, who perhaps more than Raphael deserves to be called the Prince of Painters, for he was in fact a nobleman, rich and of vast social weight, but in addition one of Europe's leading ambassadors and gentlemen-at-large. His was one of the largest and most productive workshops in European history, and his own work was likewise prodigious, especially considering his many other activities. Where Bruegel had been a man of the middle class who entered spiritually into the life of the peasantry, Rubens belonged, in the healthiest sense, to the aristocracy, and his paintings ranged from themes of local genre and landscape derived from Bruegel to the heights of Europe's formal political and religious life. Yet when all is said, much of his best work is that sprung from the homeland; here his expression becomes complete, and his debt to Bruegel all the more clear.

Rubens vs. Bruegel. To get at the nature of Rubens' art it is helpful to see how it differs from that of Bruegel, who still belonged in most ways to the Renaissance. Rubens is often taken as the avatar of the Baroque. Although there are many Baroque features that his work does not include, still the central frame of his style and the temper of his expressive techniques stand for his age with a completeness remarkable for the work of a single artist.

Line. If we compare any Bruegel with a comparable Rubens—a Kermesse (peasant dance, Plate 33b), a return from the fields, or any Flemish landscape or peasant scene in general—we notice perhaps first of all that the Bruegel is made of component parts where in the Rubens the parts seem fused into a continuous whole. This is partly the result of Bruegel's use of contour lines and Rubens' disavowal of them (a development of Titian's pictorial mode), partly by Bruegel's restriction of light and shade fairly close to the object and Rubens' extension of light and shade into a fluid continuum, partly by Bruegel's restriction of color more to specific area and keeping the colors more simple, fewer in number, more clear and distinct.

Color. The remarkable thing in a Bruegel painting is the extraordinary range of suggested tones while relatively few tones are actually used. With Rubens it is almost the other way around: amid one of the richest, most complete and most active palettes ever created, Rubens, by a systematic abstracting or keynoting of relationships that all have something in common, manages to produce a color result which is basically simple, once we have thoroughly experienced it.

For example Bruegel's tonal scheme seems at its richest when he portrays marginal seasons like November and March: to do this he uses a few basic tones which are clear enough in themselves but which by their peculiar juxtaposition become capable of rich suggestion. Rubens' seasons tend toward full summer, the agglomeration of all the warm, hearty, sunny tones of full activity and fruition. Yet if we look closely at a Rubens we will often find that an effect of blue amongst a passage of red and yellow is created not by blue paint at all but a more economical dash of neutral grey which has the power to suggest blue by juxtaposition with its complements.

The Simple and Complex. In any painting worthy of the name there is a tension between the suggestion of the complex forces and facts of nature on the one hand and the clarity and simplicity of the artist's organization for the purpose of making this interpretation coherent, on the other. In a sense two different masters like Bruegel and Rubens do the same thing, for in each style we find the complexity of color sensation exceeds the complexity of elements used. But there is a difference too, and this is what we are talking about whenever we try to shed more light on one style by comparing it with another. In the Bruegel we are immediately aware of the basic simplicity of the elements, and as we

study the painting we gradually become aware of and wonder at the richness of suggestion which never seems to stop. In the Rubens we are immediately struck with the rich variety of elements, and come to wonder instead at the simplicity and unity which ultimately emerge.

Differences of this kind are sometimes characterized as **unity** (what we have seen in Greco and Rubens) as against **multiplicity** (Raphael or Bruegel). This does not mean that one style is necessarily *more* unified than another but rather that the *kind* of unity or process of organization is different. In Bruegel we are especially aware of object, linear accents, and planes. In Rubens we are more aware of spots, color accents, and above all continuous rhythms involving shapes, tones, and planes that are continually becoming transformed into something else.

Rubens' Baroque. Furthermore, where Bruegel's world seems well-grounded, though displaying certain tensions and ambiguities, Rubens' world has attained complete suspension: everything is caught up, it floats (Plate 62a). But not in the mysterious, dematerialized floating sensation of a Byzantine mosaic, rather in continuous, vigorous activity. Such a description of Rubens' style may also remind us of the Gothic style. In many ways it should, for the Baroque may for convenience be considered as a translation of the spiritual Gothic form into a three-dimensional, material world. With Rubens this infinitely-energized world attained the greatest height of sensual stimulation, physical vigor and psychological health. Rubens painted many religious pictures, and always Christ or the saints appear as dynamic athletes. We may suspect the artist of preferring pagan subjects, like the Rape of the Daughters of Leucippus (Munich), or the Judgment of Paris (London), or the Venus and Adonis in the Metropolitan Museum in New York, wherein the action of the healthy nude human figure is more appropriate.

The Nudes. But the figures need not be idealized, and this is important to remember when trying to appreciate Rubens' nudes, which are famous for repelling people at the first glance. What Rubens really renders is an exorbitantly healthy, physical and basically peasant ideal. His paintings of Flemish peasants (widely recognized for their prowess at farming and hunting, eating and drinking) never bother people. The blood and earthiness from the Flemish soil invigorates Rubens' paintings and in his most completely effective work he returns to such themes. But he was also a genuine courtier and aristocrat living near the center of a world of highly rational ideals.

What makes a unification of these two apparently diverse directions possible is Rubens' unexampled extroversion. In this sense he is the opposite of Greco or Tintoretto whose work is full of problems and tensions. Since Rubens' world is untroubled, everything can somehow be included in his gigantic rhythms. An analogy might be the plant world of nature where despite the most extraordinary diversity of forms everything is united in its unthinking, unceasing growth.

If the modern reader, influenced in his taste for women by contemporary Paris, New York, and Hollywood emaciation—can approach Rubens' nudes as burgeoning products of the abundance of nature, like the blossoming fruits and vegetables, or even the swelling fields and clouds that abound in Rubens' landscapes, it may be easier to see how wonderful they are even today.

The Glowing Flesh. For Rubens' figures do not represent an ideal of proportions and shapes, as did Raphael's, or Phidias's. They seek instead an ideal of physical, fleshly health, and energetic, glowing activity. Thus Rubens' portrait of his second wife (who was half his age when he married her) as nude in a fur robe recalls the Titian classic nudes with textural backgrounds on which it in part depends. But Titian always retained a certain grandeur and distance, compared with which the Rubens seems fleshier, more immediate, and sensual, and though standing still somehow more active.

Hunting Pictures. It should not be surprising that Rubens did not stop with rendering the human figure on the one hand and the plant world on the other but merged them with the painting of animals in the hunting scene. Although hunting scenes had appeared long before Rubens in northern prints and miniatures, he was the first to develop them into a major theme. Nor did any after him achieve such ambitious scale, compelling action, or convincing array, despite the inclusion of the most exotic elements, lions and crocodiles as well as more native deer, wolves, and boar. Sometimes these hunting scenes are actually given mythological titles, like the Death of Adonis. It hardly matters: all genuine Rubens pictures stand for the same thing, a world of incredibly vital

force and motion produced out of the most real and tangible structures and materials of nature.

Composite Painting. To say "genuine" Rubens pictures is to refer to the fact that the majority of canvases that go under the master's name were not executed by his own hand. From his letters we gather that there were several distinct kinds of Rubens paintings turned out by his workshop. Some were begun by Rubens but had certain parts filled in by specialists—for example in the hunting pictures certain kinds of animals were often rendered by Frans Snyders, an animal specialist (one of these is in the Metropolitan Museum).

In others the painting was begun by Rubens, worked on by followers, and then had the final touches put on it by the master. Still others were complete replicas of Rubens originals by his pupils. Only a small minority were conceived and executed by Rubens alone.

If complete finished pictures are relatively few, the oil sketches that Rubens made for workshop "machines" or even for tapestries are perhaps more readily found and provide one of the best approaches to the art of such a master for an age like ours which generally responds to briefer and more segmented entities.

Sketches. In this country, sketches like the Triumph of Henry IV in the Metropolitan Museum or the Quos Ego in the Fogg Museum show in small, unfinished versions the same expansiveness of larger pictures, and an extraordinarily pregnant use of color, which being rendered more in some parts than others thus the more clearly shows how Rubens typically employs pure color relationships to establish spatial depth and movement. Volumes seem to flow and ebb in this color notation like the volumes of sound in musical orchestration. And above all we experience in these sketches the qualities that perhaps most purely express Rubens' natural subject matter: the immediacy of deeply felt materials and sensations in a constant process of transformation into fluid energy.

The Baroque World. Such a conception of a world of countless and intensely experienced facts and sensations caught up in an all-encompassing dynamism of perfect harmony and infinite energy was no idle or personal invention of Rubens'. It was a **characteristic metaphysical achievement of the Baroque age,** especially in the north. Let the reader think of Milton or of Donne, of Galileo, Bruno, Kep-

ler, or of its clearest and furthest elaborated forms in Newton and Leibnitz.

The Baroque was essentially the same in the south, for everywhere—from Holland to Spain—it built upon **an intense reality of material experience toward an exalted ideality of thought and/or feeling of subject and effect, of which the theme itself, then, was transformation.** This sounds like a simple key, but it is central, and applies as well to Bernini in Italy as to the very different Vermeer in Holland.

POUSSIN (1594-1665)

With Rubens the vital materials are earth and flesh, and in the process or aesthetic of his painting they are transformed into pure light and color. With NICOLAS POUSSIN the vital materials are human gestures and postures, and the shapes, made by the way light falls on them, of buildings and trees. The former are transformed into a musical counterpoint, the latter into a dynamic architecture. It is misleading to call Poussin a typical example of French rationalism, which would emphasize qualities of balance, clarity, and repose. But that sounds like Raphael and the High Renaissance, from which Poussin is far removed.

Actually Poussin—although both French and rational—belongs completely to the Baroque age. This must be understood before we can appreciate the motive force in his painting. Raphael—in the School of Athens or the Alba Madonna—actually did attain the High Renaissance ideal of repose, harmony, perfection, and utter stillness. To do this Raphael based his designs on verticals and especially horizontal accents, and preferred shapes that tended toward squares and circles.

Poussin vs. Raphael. Now the antithesis of this disposition may be found in such a Rubens painting as the Rape of the Daughters of Leucippus where the basic design is that of a swastika on a diagonal, in other words a rotating diamond shape. Compared with such a composition, those of Poussin at first appear static and reposed like Raphael's. But this is deceiving. Actually they show French restraint, composure, and economy just as do the contemporary works of Corneille and Racine, but their essential mode of organization remains dynamic. The verticals are actually on a slant, working against and into each other. And the basic structure, as in any Baroque picture, depends upon **chiaroscuro or an abstract pattern of light and shade** which is in

itself a transformation, since it refers not to the object but to something that comes from objects, and interrelates them. In color, too, Poussin is Baroque, deriving from the muted, chromatic color conceptions of Titian rather than the "colored drawing" conceptions of Raphael. The fact that Poussin himself said that color was an added element to charm the eye does not alter this fact, for restrained though it is, his color operates according to the *mode* of Titian rather than that of Raphael.

The confusion arises because, after looking at Rubens, any aspect of Poussin's work appears static. But the difference between Rubens and Poussin is one of temperament, of emphasis, and of approach. Poussin may be considered, like Velásquez, to belong to a later, more classical, phase of the Baroque, but the clue to his work is still to be found in conceptions that are fundamentally akin to Rubens'.

Indeed if we consult Poussin's drawings or sketches we find that they are far more dynamic than the final paintings, and also that they are more dynamic than Rubens' preparatory drawings (not to be confused with his sketches in paint). In other words Rubens worked from a rather detailed and factual analysis of nature towards a more and more energetic fusion of elements. Poussin worked from a dynamic concept of action towards a form that would congeal that action: but the action remains dynamic.

Modern Dynamics. This must be understood if we are to understand the stylistic significance of the art of Poussin. To Cézanne the painting that mattered was that of Poussin, of Rubens, and of the Venetians. We have seen the connection between the Venetians and Rubens: both deal with **the dynamics of color and of pictorial form.** Poussin deals with **the dynamics of architecture.** Raphael's architecture—of unsurpassed beauty in its own terms—was static. Cézanne never referred to Raphael, and the reason was that the whole history of western painting since 1500 has been toward some kind of dynamic realization, whether of color, light, shape, line or of spatial expression.

If we looked at Poussin, as would be easy to do, merely as a builder of static designs we could only conclude that he was a dry rationalist and clearly inferior to Raphael himself. As to whether he was greater or less than Raphael in total quality we need not concern ourselves, but certainly he was second only to Cézanne among French painters,

and deserves our careful attention, the more so in that so many other 19th century French painters depended on him also.

The Intellectual. Where Rubens painted—we might say—from his heart and hands and stomach, it is quite true that—as Bernini said—*Poussin painted from his head.* When Poussin said, "I have neglected nothing" he was not making an idle or fatuous boast: he meant that he had worked out, in a given picture, every possible relationship that he found significant. Relative to Rubens' pulsating approach, this throws an emphasis on the intellect, for worked-out means thought-out.

Procedure. Like Racine, Poussin set his stage with infinite care and patience (not so Rubens or Milton). He applied himself to geometry, perspective, and optics, to anatomy and drawing after the antique and the nude, and to modelling from the living model and from sculpture. He never painted outdoors, although he made numerous studies from outdoor nature, especially vibrant wash drawings which are justly popular today. He used no assistants, and painted very slowly and carefully, often being satisfied if he completed only one head in a day.

Poussin's subject matter was often inspired by what he read, but its disposition would take place only upon great thought and cerebral tension. First he would make sketches denoting movement, searching the streets for convenient human documents. Slowly, with constant corrections including written indications, his work took form. The distance travelled by Poussin between the first conception and finished painting is as far as with any known artist. His aim was to discipline original ideas and impulses until a frozen essence emerged: a sort of pictorial rationale of a dramatic situation.

Modes. This entailed the congealing of all dramatic situations into five basic "modes" (ultimately derived from musical forms): the **Doric,** denoting that which is stable, grave, severe; the **Phrygian** for the furious and dramatic; the **Lydian** for the lamentable, sad, and elegiac; **Ionic** for the gay, festive, jocund; and **Hypolidian** for the religious, sweet, divine. This mode of setting became in effect a mood, to which all expressions, gestures, accents, and color relationships were subordinated, thus contributing to psychological as well as formal unity.

The results of so rigorous a process, in the hands of a genius, demand close investigation. Connois-

seurs would sometimes spend days in examining pictures of this order, so complex are all the significant relationships.

Achilles on Skyros. In spite of this painstaking process Poussin was surprisingly prolific. There are good paintings to be found in several American cities. Of high quality, and especially apt for illustrating the choice of stage setting and the congealing of the action, is the picture Achilles on Skyros, in the Museum of Fine Arts, Boston (Plate 31).

Theme. Legend had it that Calchas the soothsayer told when Achilles was nine years of age that Troy could not be conquered without him. When his mother Thetis heard this prophecy, knowing that the campaign, did he enter it, would bring death to her son, rose from the depths of the sea and stole the boy in girl's attire from her husband's palace, and took him to King Lycomedes on the island of Skyros. There he was brought up as if a maiden, but when he reached the age when the first down appeared on his lip, he fell in love with Deidamia, the lovely daughter of Lycomedes, and became her husband, while the islanders continued to mistake him for a kinswoman of the king. But now Calchas the soothsayer told where he was, and Odysseus and Diomedes went to Skyros to enlist him in the war.

They arrived in the guise of foreign merchants, bringing merchandise, especially things of appeal for women, for the daughters of Lycomedes. But among these things were a sword and helmet, and when Achilles turned these over he fell to handling them, as the shrewd Ulysses noted. Thereupon Achilles was prevailed upon to come to Troy where, as prophesied, he lost his life in saving the Greeks.

The Dramatic Moment. The artist decided to render this entire story as of the moment of revelation. Six figures are closely grouped in the foreground. At the left is Ulysses on one knee, with one hand on his chest of treasures, and the other in a gesture of suspension, perhaps about to nudge his comrade Diomedes (to his left and behind him) who offers a mirror to one of the daughters of Lycomedes standing at rear center. On her right, and between her and Diomedes, stands another daughter pointing into a second chest at something she wishes to see. Below the two standing daughters kneels Deidamia, her right hand in the first chest, fingering its contents, her left hand raised in a gesture of astonishment as she turns to see Achilles, at the far right, raise himself upon one knee

and draw from its scabbard the sword that betrays his identity.

In the foreground at Ulysses' feet, lies a splendid helmet. Behind Ulysses and Diomedes, at the left, stands a stone monument on which is draped a robe, and behind which stands a grove of trees. At the right, behind Achilles, the entrance to a portico is in evidence, with a wall and post and column rising out of the picture at top, and behind the pillar and against the wall stands another tree. The elements, then, are simple enough, but their organization is complex.

Color Drama. Color is used to create a sequence of excitement through the high intensities of Achilles' mantle, Deidamia's dress, and Ulysses' hat and mantle. It is not by accident that these are the fullest intensities in the picture. The helmet being half in shadow is thereby emphasized in color contrast—to counteract the general pull of colors to the right toward Achilles—and at the same time kept subordinate to the light and shadow pattern and prevented from becoming obtrusive as a shape.

There is a spot of excitement in the high intensity of Deidamia's hand—significant in the story—and similarly in the high intensity of the sword blade particularly at the point where it emerges from the scabbard. A glow of high intensity in the sky among the trees at left helps counter the general movement toward Achilles; it is reached by a diagonal emphasized by the light and shade in the pattern of the drapery on the wall and concluded by the arms of Ulysses, thus suggesting the distant place whence he came.

The colors in the three background figures are given lesser intensities, thus uniting them in the minor roles and setting them off from the major participants who occupy the foreground. A bright red is the predominant tone in the front group, except that the red for Achilles appears not on him but on the helmet at his feet. This emphasizes the connection between Achilles and Deidamia and the fact that when Ulysses and Achilles are to be united it will be in connection with the helmet. But for the moment there is a basic opposition between Ulysses on the one hand and Deidamia and Achilles on the other, and this is symbolized by the opposition of the red in the latter two and the predominant blue (perhaps also suggestive of distance?) of the former figure.

Achilles and Ulysses are however united by the repetition of blue in their garments. These blues

are repeated in the two girls at rear center but with the two areas together so that there is less tension and the figures are smaller so that there is less attraction: the two are not distinguished in their roles and thus are not distinguished pictorially.

Red is the dominant accent in the front plane, and blue in the secondary, but there is a transition through the great blue area of Ulysses' mantle. Achilles, the most important figure, is given the most striking tones: red, blue, and gold. Deidamia and Ulysses, the next most important, are given the next most striking combinations, approximately equal in effect.

The Secondary Figures. The attraction of the rear figures in the secondary plane is further reduced by showing each figure only in part; by placing relatively greater areas of their garments in shade; and by reducing the intensities generally as well as the values. For example, the blue in the dress of the woman at right, although equal in intensity to the foreground blues, is reduced in total effect by so much of it being in shadow: at a lower value. The red chemise, in full light and thus having a high value, is reduced in intensity, the result being a pink. Diomedes' mantle picks up this tone connecting the two figures. The olive drab tone of her shirt is repeated in the bank of earth behind Achilles' sword, thus reconnecting the two figures at the same time that they are separated by the sword.

High value whites appear only in the front plane, being distributed among Ulysses' hat, the helmet crest, Deidamia's cap and chemise, and Achilles' sword. The large gold drapery on the wall behind is kept in secondary position by its low value and intensity. This, with the darkened foreground (a theatrical tendency of all Baroque painting), helps emphasize the front row of actors with whom all the significance of the drama rests.

Balance. The occult balance of the Baroque, as against the more symmetrical balance sought in the Renaissance, is achieved by giving the mass of green trees at left a dark green; the tree and column at the right are smaller but of more variegated shape and higher value.

Reds do not appear in nature but only among the humans, further knitting them dramatically. Blue and gold, however, appear everywhere serving the quite different function of uniting the entire picture, and with a kind of melody, since they are near complements. As a final touch, each of the key colors of the human group—red, blue, gold, and white—is repeated in the contents of the boxes, the material foci of the drama.

Color and Emotion. The colors are also carefully chosen for emotive power. The red and gold in Achilles' garments are highly exciting, all the more for being set off by the blue. Even the hair is gold. The capability of red to suggest love enhances the relationship between Achilles and Deidamia. In contrast, Ulysses is clothed almost entirely in blue, a cool color, in keeping with his proverbial craftiness which is one of the key elements in this story. His hat is a cool white against which the neck and cheek are brought up in ruddiness: the flesh of arms and legs is less so—it is the cerebral Ulysses who figures in this story. To further balance the cool tones there is some gold in Ulysses' sleeve and leg drap, but this is cooler than its counterpart in Achilles' skirt, and the real countering of Ulysses' cool tones is in the warm red and gold accents in the helmet at his feet, which returns us again to Achilles. The warm tones of the latter are countered by the cool tones of the pillar.

The color, then, is crucial to the composition—whereas it was only a heightening with Raphael. Without it the constantly operating occult balances would be lost, not to mention a good deal of expression. The basic tones are striking in themselves, as befits the dramatic mode.

Light and Shade. It is by change in tone that one area is distinguished from its neighbor, not by actual contour lines as in Raphael or even so late a Renaissance painter as Bruegel. This produces a feeling of atmosphere, of air moving around and across the objects, which again is a tendency of the Baroque. A broad chiaroscuro organizes the entire picture so that the figures are not so isolated as they appear when we examine them independently. Within this pattern arbitrary devices are used for particular effect, such as the darkening of the shadows cast by Ulysses' right leg upon the box so as to set off the strip of light at its corner, which establishes it clearly in the front plane. This accent is repeated in the sword as it is drawn from the sheath, which in turn was drawn from the box. Compared with such sharp contrast of light and dark, the left forearm of Deidamia (the arm with which she makes her gesture) is very softly modelled, as is appropriate. Further adjustments within the abstract pattern of light and shade (which in true Baroque fashion **emphasizes** diagonal con-

tinuities and groupings) are made for psychological expression. Most of Ulysses is in shadow, including his crafty face, but the bright turban, literally suggestive of dawning recognition, the tense arms and the legs poised as if to spring—all these catch the light. Deidamia's arms and face are illuminated, and the hands and arms form a diagonal that leads to the hand of Achilles that draws the sword. Achilles' left leg, the one that rises, is highly lit, not only accentuating that action but also acting as a foil for the dark scabbard.

There is generally more light on the right side of the picture—where are Achilles and the daughters of Lycomedes—which represents peace and happiness, than on the left, out of which Ulysses and Diomedes emerge, representing dark conspiracy. The girl to the rear however had to be darkened to prevent disbalance. The arm of the girl holding the mirror exactly parallels and thus re-enforces the curve of Achilles' body, and the former at the same time seems to point to Deidamia's apprehending face.

Organization by Subject. In addition to the incidence of light, the picture is organized by the relationships of represented parts. It is divided into two basic parts by a central axis running down the edge of the mass of trees, through the head of Deidamia, the edge of the front box, and the knee of Deidamia. On one side of this line are the two merchants, their boxes, and the darkness whence they came. On the other side are the three women and Achilles, all as of the moment associated with the untroubled court of Lycomedes, symbolized by the stable, sunlit pillar. This makes it four to two, and the apparent disbalance is furthered by the fact that the action reads from left to right. **Only through light and color is a final balance achieved.**

The picture is also divided into top and bottom by a line a little above the middle running along the wall at left across the tops of the heads of Achilles and Diomedes, the horizon, and reiterated in the mirror, the landscape at right, the sword hilt, and the head and hand of Achilles. **Above this line the secondary themes of the story dominate, below it the primary.** The latter is larger in order to provide not only dramatic but also gravitational weight. But the top is saved from dissipation of formal strength by the operation of the two standing figures as the apex of a broad triangle that unites all the figures.

Or we may regard the composition of the figures as a broad ellipse, pulled out at the ends to heighten the tension between Ulysses and Achilles. This ellipse is composed of the heads and hands (the evocative members) of the six actors, and its center is the mirror, which repeats the shape of the ellipse and is itself the symbol of transformation, the theme of the story.

An entire complex of inner accents—straight or curved—sets up a musical rhythm. The most striking of these are diagonals, and we note that the diagonal, suggestive of movement, is found only with the figures, not with the landscape or architecture. Among these, the basic motif is the countering of the literal diagonal of the sword held by Achilles (the most important object in the story) with a longer but only implied diagonal of Achilles' left hand, the elbow and head of Deidamia, the hand of Diomedes and the head of Ulysses: this is the line of response to the act of hand and sword. These two most important diagonals form a cross, but whether Poussin meant in an undertone to suggest the self-sacrifice of a man for his people must remain a matter for speculation.

The use of the Phrygian or serious and dramatic mode is appropriate for the setting of a surprise which is pregnant with history. Even the size of the picture (38 by 51 inches) seems to have been carefully thought out. So concentrated and timely an action would lose impact if diffused over a large area, for example a ceiling decoration, or even an oil painting too large to be seen all at once. On the other hand its broad classic character and grand theme would never permit a miniature or even a small panel.

Poussin's Position. The painting of course must be experienced in itself, and it is for that reason that some space has been given to its analysis. But any art style can be more readily approached by comparing it with another more familiar one. The differences between Poussin's style and Rubens' are strongly marked, and emphasize the classicality of Poussin. But such classicality has little association with the Renaissance, and for that reason some differences between Poussin and Raphael have been emphasized. Poussin belongs to the Baroque age of drama and dynamics.

But it remains true that compared with the superbly emotional and energetic Rubens, **Poussin is restrained, severe, intellectual.** His style can be interpreted as the final austere, formalized stage of the Baroque, like that of Vermeer, Velásquez, and

the late Rembrandt and Hals, and opposed to the flamboyant or "full" Baroque of Bernini, Rubens, and early Hals and Rembrandt. Still it is significant that although of Norman origin, Poussin's temperament took him to Rome, where he did almost all his work. His temperament is genuinely a southern one and represents one of the two poles between which France has historically swung: northern and southern, Flemish and Latin: crude energy and distilled form. Small wonder that throughout the 18th and 19th centuries French attitudes in art were to be torn between the "Rubensists" and the "Poussinists," a dichotomy often erroneously described as that between form and color.

For the difficulty is that color can be functional as in Poussin, and is therefore part of the form. At the same time the northern tradition, though playing up color activity and playing down lines and shapes, could hardly be considered formless. Let us consider a vital work by a Fleming-Dutchman of more informal personality.

BROUWER (1605-1638)

A roisterous vagabond who died of unknown causes at the age of 33 is one of the underrated painters of all Europe. ADRIAEN BROUWER's small paintings of low-life themes were bought and prized by Rubens and Rembrandt, and the latter even sought his drawings, something of a tribute from the greatest draftsman of all time. It would be hard to find a personality or a style of painting more remote from his contemporary Poussin.

"Form." Compared to the latter, both subject and form in Brouwer appear literally "informal" or even formless. Such words should be used with care. The difference between formal and informal in social manners is clearly understood. In this sense Brouwer's painting is informal. But it is very far from being formless.

Poussin's painting attained formal order through a host of readable relationships in color, light and dark areas and accents, lines and shapes which became particularly meaningful in relation to the story being told, and which—more abstractly—established rhythms and patterns analogous to musical composition or architectural construction.

Against such highly articulated composition, Brouwer's picture at first seems hardly more than an illustration of human interest. Only as we look into it do we find that it, too, is superbly organ-

ized, and therefore, if the word means anything, formal. In part this is effected by basic groupings (for example the diamond shape). But these are played down, or overcome, by the rich variety of detail. The most important organizing force is the light and atmosphere, which entails both the physical nature of the scene and the human mood and expression.

Social Background. To fully appreciate this it is well to remember that in the Low Countries in the 17th century the tavern did not represent a backwash of society so much as a key institution. It has been said that the Dutch housewife kept her house so clean and herself so disagreeable that man was obliged to seek warmth and humanity with his fellows in the pub. Here was a place not only where he could shout or put his feet up and quench the vaunted Lowland thirst, but could as well smoke tobacco, in those days a genuinely intoxicating medium (Plate 32b).

A tradition of rendering such scenes in their joy and vigor—and ultimately with an eye to creating a process of transfiguration which is somehow connected with all high art—was virtually begun by Brouwer, although we can see in some ways how Bruegel was a precursor.

This form of art has nothing to do with social criticism, although Brouwer was later to be considered one of its pioneers. But his art is at once less conscious and more pure than social criticism. Brouwer's approach is one of absorbing human curiosity and keen artistic interest.

Dissipation or Spirituality. These pothouses and subterranean taprooms were re-created in his art in a mysterious atmosphere, flickering and glowing, and always alive—never, even in the most obscure parts, gone flat. It is an atmosphere that reverberates, as do its enveloped actors. For their movement is not arrested, as it would be in a snapshot, but achieves instead an astonishing momentary intensity. Hands and feet seem to vibrate, smoke curls from an open mouth, the very accent of song and talk echo with the picture's mood. No gesture is stiff, but each springs spontaneously from an inner force which all the figures share. This force is somehow echoed in the energized light of the scene, just as the mood established in the expressions is echoed in the muted, resonant colors. It is to the exultation of these mutual intoxications that we refer in suggesting that the drunkenness and bawdiness in Brouwer's

pictures are transfigured into a more spiritual realm.

Yet this does not mean a dissipation of pictorial force, any more than the imbibers or smokers themselves are dissipated. On the contrary these pictures attain an extraordinary condensation of power, as befits the poignancy of their subjects.

FRANS HALS (1581?-1666)

Quite a different aspect of the social psychology of eating and drinking is reflected in the works of FRANS HALS. Here are the burghers, the members of shooting clubs and other upper middle class social organizations presented in dazzling decorative displays that remind one of the lavish Venetian pageants of, say, Veronese. These scenes are upstairs, clearly lit, filled with fresh air and sparkling gestures. Just as the scene has changed from Brouwer's, so do the compositions. Hals' paintings are large and loose, though the organization is always clearly maintained through sweeping diagonals established in grandiloquent gestures, draperies, or flags.

Such paintings were commissioned as group portraits, and much of the skill in composing lies in giving each man his due without being tedious or dull in the alignment. These portraits were not only keen individual documents, but vivid representations of types. Famous individual portraits as those of the Bohemian girl of robust innocence or the Laughing Cavalier are tremendously compelling.

Yet Hals too attained a transfiguration, though later in life than the precocious Brouwer. In his latest pictures, like the Halle Babbe (Plate 34a), or Women Governors of the Haarlem Almshouse, a pictorial economy that spotlights only heads and collars, cuffs and hands suspended in a dark atmosphere contributes to a poignantly quiet expression, and strikes cool yet intense chords on the themes of human suffering and dignity.

REMBRANDT (1606-1669)

Such a development was a parallel to rather than a cause of the development of the most believable and unbelievable painter whose works we know. No one has carried the media of painting and drawing so far or so deep into human experience as REMBRANDT VAN RIJN, and possibly only Beethoven has gone so far in any other medium.

When confronted with such a phenomenon we are apt to do what people have done when they contemplated the marvel of 5th century Greece and were compelled to ask, whence came the Greeks? Whence came Rembrandt? About the only helpful answer is out of the ground—or a miller's loins. This is to signify that there is no artistic precedent for Rembrandt's work.

At the same time it must be noted that Rembrandt's career comes at the very peak of European painting, in the full maturity of its ripest period. This is the Baroque age, the time of Poussin, of Velásquez and the Spanish school, the culmination of Flemish painting in Rubens, and the only great flowering of the Dutch. The 17th century was for painting what the 18th century was for music.

Rembrandt's Sources. In this sense Rembrandt grew up immersed in the mutual insemination and flowering of several traditions: the colorism and dramatic splendor of the Venetians, the vitality and realism of the Flemings, the draftsmanlike probity and expressionism of the Germans, and the atmospheric sensitivity and vision of the Dutch themselves. Only the Florentine-Roman plastic tradition exemplified in Michelangelo remained apart: this enjoyed its final achievement of creative importance in 17th century Roman sculpture and architecture, which is closer in style to Rubens than to other painters of the time.

The music of color, the dance of brushwork, the drama of light: these are what characterize the central spirit of Baroque painting in the north and in Spain, and are the most striking qualities that underlie the work of Velásquez, Hals, Vermeer. But we must seek a metaphysical characterization of the Baroque age, an age that emphasizes quite at the same time an unassumingly objective realism, and a transcendent symbolism. As we have said, it is as if meaning lay in a sort of process: the spiritualizing of the material—but always returning to the spectator and glorying in the world and man's experience; not, like the Gothic, seeking another world that denies this one.

Baroque Technique. Such an age saw technical mastery of a level and of an inborn ease that far exceeds anything before or since. Infinite credit is due Titian for the development of oil painting capable of handling all at once considerations of color and form, texture and light within a brushwork so unified and still so alive that we take excitement both in the represented aspects and in the experi-

ence of the paint itself. Yet this took Titian a lifetime to develop. The great Baroque painters picked up these tools and worked their wonders without apparent effort.

So remarkable is the result that there are reputable schools of aesthetic thought (including painters and critics) which claim in turn that Velásquez, Frans Hals, Rubens or Rembrandt is the greatest paint-handler of all time. Vermeer's technique is probably the most wondered at and least understood in all painting. Even in sculpture, a declining art, Bernini attained a technical *tour de force* unequalled before or since (and here we must ask of the debt to Michelangelo, who stood to later sculptural technique as did Titian to the painters).

In the incomparably skilled hands of each of these masters such technique is not merely passive but operates to create a world of observation and sensation, thought and feeling, and—at the optimum—spiritual experience. Since the world that Rembrandt created is wider, deeper, more complex and powerful of vision than any other, he is not only the supreme but the most typical Baroque painter.

Rembrandt and Shakespeare. We have permitted the word "unbelievable" to attach to Rembrandt. This is partly because he outshines the greatest of his contemporaries in the qualities in which they themselves were surpassing masters. He exceeded Rubens in vitality, Poussin in dramatic power, Velásquez in dignity and assurance, Hals in virtuosity, Vermeer in the analysis of light. Add to this that in each of the three major fields in which he worked— painting, etching, and drawing—Rembrandt went further and accomplished more than anyone who has ever worked in any of those fields (much less all three) and we have a phenomenon something like that of Shakespeare in European literature. It is not fair to Milton to compare him with Shakespeare. It is not fair to Rubens to compare him with Rembrandt. It has often been observed that to see a painting by Hals is to be seized with a desire to paint, but on seeing a Rembrandt any such desire evaporates.

A process of transformation from the experience of the material to that of the spiritual has been offered not as an aesthetic definition but simply as a help toward understanding the nature and purpose of Baroque works. Such a process occurs not only within a given work but is also a con-

stant tendency throughout an artist's career. It is necessary to keep this in mind in looking at Rembrandt; more than that, the most fruitful approach to the quality and accomplishment in any given work may lie in an analysis of Rembrandt's development.

Early and Late Phases. We can grasp this development at once in comparing two etchings only a few years apart. An etching like Christ Presented to the People exists in different states. This means that the plate itself was altered so that a different printing produced a different picture; yet because the basic scene remains the same these changes are carefully controlled and we can observe precisely what Rembrandt felt it necessary to alter as the result of his own internal development.

In an earlier version we are presented with architecture reminiscent of the contemporary outdoor stage. Christ is on a platform in the center being presented literally to the people who cluster in the square. These include a wonderful assortment of characters across the middle of the picture, one of the richest passages of genre in all art for its variety of costume, shape, attitude, and temper. In a later version this group has been obliterated. Why?

Not only the group of people but the foreground itself is gone. The stone platform is darkened at the bottom and openings are suggested—like those of a subway tunnel—which remove from it any remaining base in the material world and cause it to float spiritually above a dark, prophetic abyss. The people to whom Christ is presented are no longer the townsmen within the picture, but the very spectators of the picture itself.

The Dramatic Change. The drama is no longer a literal one, seen from outside in the clear light of day, but a transfigured one in which we ourselves partake. The clearly articulated lines of costume or of masonry in the early version have been obscured. The shadows which in the early version were sharp and localized have become enriched, velvety, and diffused. Light seems to emanate from within objects rather than fall upon them from without. Lines that formerly symbolized the shapes and locations of objects and materials have been obliterated in favor of moving light and shadow which becomes the chief element in the drama.

Now a distinction must be made. It has sometimes been said that light ultimately becomes the real subject of Rembrandt's art. This is closer to be-

ing true of Impressionism, two centuries later, but even there the real subject is outdoor nature, of which light has become the dominant element. Rembrandt's true subjects are the people of Leyden and Amsterdam, the things with which they live, and the land about them. In Rembrandt's later work light operates more and more to envelop these people, dissolve their material settings, and dominate the life of the landscape. Rembrandt's world—both that of his own experience and that which he gives to our experience through his art—is one in which light is the ultimate reality in physical nature, and the richest and highest symbol of that which lies beyond. For the Greeks such a reality and such a symbol lay in the human body.

The Significance of Light. Rembrandt stands not alone but within a striking and powerful tradition in art, one including among many others Grünewald before him and Turner and Van Gogh who were to come after, a tradition that is sometimes called that of the Northern Lights. Furthermore Rembrandt's transformation of the world into a diapason of light that attained the spiritual has parallels within his own age. Milton said, "Since light so necessary is to life, And almost life itself, if it be true That light is in the soul." In no work is this more fully expressed than in the last state of the Three Crosses (Plate 37a).

But this does not mean that light can be taken as a secret of or a single clue to Rembrandt's art. It is simply the most important element of his natural world and his most expressive tool in creating spiritual conviction. Otherwise his world is filled with gestures and accents, wonderfully stimulating shapes and unheard of colors, sweeping rhythms and musical harmonies, all of which render pain, joy, sorrow, peace, conflict, terror, confidence, faith, disaster and—now and then a laugh at the world and at himself.

THE ETCHINGS

In an etching of himself drawing at a window we see the peculiarly frozen head and shoulders of the artist controlling all possible elements so as to "capture" a visual sensation, the brow unconsciously furrowed, the mouth even and slightly open, the eyes exaggeratedly apart suggesting the objectiveness of analytical vision. The hands—which move—are left barely indicated and amount to a flare of light in the midst of darker areas.

The famous etching of Faust in his study watching a magic disk shows the peculiar humility—in the hunched shoulder and sensitive face—of a man of vision confronted with these dazzling circles of light that transform his environment in a phantasmagoria of supernatural emanations.

In a portrait etching of Jan Six (his friend and the mayor of Amsterdam) leaning on a window sill, the black and white medium has been developed to the point where it suggests painting, not only in its variety of color-tones, but in textures, surfaces and depths. In another etching (Plate 38b) at the opposite extreme, actually a dry point (see Appendix A), the master shows what can be done in a few minutes work out of doors towards the economic but vivid indication of a rich world of spatial relations, elegant vegetation that is highly imaginative yet beautifully organized, the play of light and even the movement of the air.

Compared with this the great etching of the Three Trees is less objective but more dramatic. We might say that compared with the small dry point there is more space but no more spaciousness, the landscape of the Three Trees being filled with a wealth of detail and activity of man and nature.

The Hundred Guilder Print or Christ Healing the Sick is a sublimely Protestant representation of the individual's direct contact with God, and of the Biblical compassion: Suffer little children to come unto Me. The excitement and exuberance of Rubens and of the Counter Reformation is replaced by seriousness, humility, and tragic individualization.

Early Vigor. This is a matter of style as much as religion, for an earlier Rembrandt etching, such as the Christ Before Pilate, done in the spirit of the full Baroque of Rubens, Hals, and Bernini shows a vigorous dynamism, sweeping curves and diagonals with an emphasis on height and a more physical drama. Some of these early works, like the Sacrifice of Abraham among the paintings, are almost disconcertingly obvious, and were it not for their tremendous energy and substance might provide a block to their proper appreciation, especially after we have seen the later, more transported works. But even if Rembrandt had died at 35 we would be forced to consider him a strong, bold, and promising artist.

The mature master occasionally did studies from the nude, but as we would expect these are not really studies of anatomy or of posture, in which regards they appear almost ungainly and inarticu-

late, but instead are studies in texture and color, and as Renoir was to say, they take the light beautifully.

Range of Light. In some of the landscape etchings the quality of light—created partly by variation in stroking and partly by variation in the time of immersion in acid of different parts producing a darker or lighter "bite"—is such as not only to establish distance with perfect firmness and clarity but to indicate the very condition of the atmosphere—its tone, its weight, its movement. Rembrandt's handling of vegetation, though less explicit than Altdorfer's and less agitated than Van Gogh's is in the end more richly imaginative and compelling than either.

In such works Rembrandt's light is more purely a function of the real world for all that it helps towards a transporting in feeling. In etchings of religious themes like the Incredulity of Thomas or the Blindness of Tobit light attains a plainly symbolic value. Thomas does not touch the wound of Christ, he kneels apart, looking down with his hands raised to help shield his face from strong beams of light from the head of Christ which not only illuminate but actually provide the basic composition of the entire scene. In the Blindness of Tobit the contrast between light and dark is extreme, with few middle values, and with the only modulation taking place in the darks, thus rendering the lights all the more stark. Tobit stumbles over a dog, groping toward nothingness, his whirling, undirected motion reiterated in the wheel on the floor adjoining his wheeling right foot, and the revolving accents in the fireplace at rear.

The Nature of the Etchings. Rembrandt's etching has been taken up before either his painting or drawing because it is *the most public, the most readily graspable form of his art*. The drawings are frequently sketches or even if fully developed employ a kind of shorthand the deepest appreciation of which requires time, experience, and perhaps some attempts at drawing itself. Rembrandt's painting on the other hand is very difficult. It must be seen in the original since the deep glazes seem to be impossible of reproduction in photography apart from the complexity of color tones themselves which have never been reproduced accurately by any process (the reproduction of painting seems at the moment far behind that of music). This is also true of Velásquez and Vermeer whose color not only loses but is invariably falsified in reproduction.

Rembrandt's etchings are more readily communicable to the public not only because they are restricted to black and white and to an instrument producing a uniform stroke (in contrast with the highly variable stroke of pen or brush), but also because they were originally produced with an eye to widespread production. The drawings were intended for the master himself or possibly for a fellow artist or connoisseur. The paintings were for those few who could afford to commission them, and were either hung in private homes, or if in public places were invariably badly hung and overlooked or misunderstood by the public who could have seen them. But the etchings were meant for dissemination, for the enlightenment of anyone at home or abroad who could afford a print, which in those days went many times cheaper than it goes today.

Furthermore, the etchings stand more completely for Rembrandt's style than would be the case with many painters because the two factors that are perhaps in all the most important in Rembrandt's painting—light and line—are perfectly suited to etching. Just as the operation of light and dark are basic to any Rembrandt work, and so is the quality of drawing.

REMBRANDT'S PAINTING

In a black and white reproduction of a Rembrandt painting a good deal of the quality of light must be lost, but the drawing remains. A black and white reproduction of a Velásquez or a Vermeer suffers much more. Some painters simply do not draw but render purely in terms of areas and accents. This is neither good nor bad but only a difference in mode. Titian seldom made drawings, Vermeer and Velásquez never. At the opposite pole is Dürer, whose paintings are few and—in the opinion of this writer—sometimes actually look better in black and white.

To understand Rembrandt one might well begin by studying the etchings. One may then proceed, if still not without trepidation, to the larger, more comprehensive, more difficult sphere of the paintings.

Here the development too is crucial to the fuller grasp of any given work. If we follow through a series of Rembrandt's painted self-portraits, we may assimilate something of the style development as we appreciate the difference in physiognomy and personality that Rembrandt saw before him in the mirror.

Self-Portraiture. One of the earliest self-portraits (about 1629) shows a touch of the vanity and an overtone of the romantic youth. A lock of hair falls Byronically over the forehead, and the face is dramatically lit on one side, the other mostly obscured. The mouth, with the assurance and extroversion of youth, gets more attention than the eyes, and seems more alive.

In a painting of about 1634 Rembrandt portrays himself as an officer, with breastplate and plumed hat. In addition to the drama of the lighting is the drama of the twist of the head back over the shoulder, the swirl of the fancy hat, and the almost condescending glance of the eagle-eyed mustachioed face. This is the period of his prosperity. He has married well, has been successful financially, has a fine collection of Italian and Dutch paintings, eastern carpets, tapestries, armors, weapons, and exotic materials of all sorts which he uses to surround and clothe himself or his wife or others who sit for his pictures. He paints himself as an active, extroverted man of the world—which he never really was.

Maturity. By 1640 he has sobered down, but still poses himself with a certain elegance if not condescension. But by 1656 all is changed (Plate 35*a*). His wife is dead, his popularity and success gone, and he is a bankrupt. Never was his spirit finer, his (now shabby) costume more glorious. The figure here expands to fill the frame. The splendor of the trappings is not that of light falling from outside upon costly material but of light glowing from within, giving the clothing an inner radiance that reflects the soul. The face is neither happy nor troubled, but completely composed and self-aware. This introversion and personal quality are expressed in the more vibrant, subjectively handled brushstrokes just as the amplitude of Rembrandt's composure is expressed in the fullness of the figure within the frame, but without crowding, for air is left to circulate around the sad visage swimming in thought—or in washes of glowing paint. Not even the fabulous Moses of Michelangelo is more imposing than this figure—except physically, and in spirit the Rembrandt seems to look back and forward into time. Where the Moses is tense and thunderous, the Rembrandt is relaxed and infinitely knowing. Had he seen this contemporary work, Milton might have said of such a man: His state is kingly.

But the magnificence itself becomes unnecessary. As the man ages he strips himself of everything that might represent vanity, anything that might distract from the frank expression of the soul. Such frankness required a relentless application of values. A contemporary (Baldinucci) observed, "When Rembrandt worked he would not have granted an audience to the first monarch in the world, who would have had to return again and again until he found him no longer engaged." In 1659 only a face and hands are left, the rest is a dark unobtrusive coat and cap—and atmosphere. The eyes now come more and more to dominate the mouth—the mouth that made loud noise surrenders to the eye that is the window of the soul. Now all is humble and a surprising objectivity takes over from the self-interest of the earlier approaches. It is as if Rembrandt is no longer looking at himself, but trying to see the world, the truth in his mirror. And out of the honesty and intelligence of this pursuit comes an inner pride and self-assertion. Humble still, never boasting, no glorying in the flesh. But an assertion of the value of a self-experience which exists only at the end of a long and searing inner development. It is pictures like this that have reminded people of Shakespeare in their capacity to give at a glance the entire history of a soul.

The Final Stage. In the very last portraits there are signs of debility. The shoulders are not quite firm, the flesh of the face grows nearly flabby. The fire has abated but the honesty remains. Only in the last one of all (Munich) is there a final flareup: a complete response to terrible implications of what a dying man saw in a mirror.

Of all man's burden on earth that which seems hardest to accept or to understand is suffering. A man can spend a lifetime devoted to assuaging pain, as Dr. Schweitzer does today. Or like Mr. Churchill he can defend as many people as possible from systems that promote it. He can seek to overcome it in himself, like a Joan of Arc or an American Indian smiling triumphant at the stake.

He can fight the burden of an intolerable and momentous inner conflict, gloomily and with titanic force, and lose, like Michelangelo. Or he can ignore suffering and almost get away with it, like Raphael. Perhaps he may find beauty in its aftermath, like Titian, or in the greater natural forces that produce it, like Bruegel.

What no man can do completely is accept and understand the suffering that is the lot of anyone who would face the world. But he can face himself. And what he finds there of the grotesque and the sublime, the beauty and the horror, the transi-

tory and the eternal, of suffering in the void, so immense and so ridiculous that he knows not whether to laugh or to cry but in the need of asserting life itself does both—what a man sees in that final look at himself, beyond judgment, beyond pride and pity, beyond curiosity—the closest he can get at a glimpse of naked human experience —is in Rembrandt's last picture of himself.

We do not recognize such a creature when we look back at the early picture of the groom as a cavalier with Saskia (his first wife) on his knee. But when Saskia is dead and Hendrickje, his housekeeper and common law wife, leans simply in a window sill, we see that the difference is not between the two women but between Rembrandt young and Rembrandt grown spiritually mature. The breadth, the compassion, the inward vision—those belonged to the artist.

A portrait of Titus, Rembrandt's only son, leaning on a desk at an age that could not exceed ten or eleven, shows the composure and profound contemplation of a grown and inward looking man. And we are not surprised to find in some of the paintings of saints and philosophers—or down-and-outers from the street—for the distinction is a near one—the thought and character of the self-portraits. For in a sense all Rembrandt's work verges on self-portraiture: even the landscapes seem to mirror the vigor, the nobility, the sensitivity, the vision of that incomparable personality.

Group Portraits. In the group portraits, to be sure, the nature of one man is characterized by contrast with his neighbor. This is almost purely physical in an early work like the Anatomy Lesson of Dr. Tulp: the heads are compacted together and energetically grouped around the corpse, but if we investigate the gazes we find that none actually follows what the famous surgeon demonstrates. These men are a little self-conscious, which is a long way from being self-aware.

The Night Watch. The best known and certainly the most phenomenal of all Rembrandt works and indeed equalled in this respect perhaps only by the Sistine Ceiling and the Isenheimer altarpiece is the Night Watch (Plate 36a). It was cleaned a few years ago and discovered not to be a night scene at all but a morning one—the sortie of the militia company (which did not stand watches) of Captain Frans Banning Cocq to greet Marie de Medici (it is said) on a visit to the Netherlands—but the world may as well continue to call it the Night Watch. It is shorter, and it gives a better idea of the indescribable mysteriousness of this very worldly scene.

The captain and his lieutenant are boldly illuminated in front center, and several other figures receive prominent positions and attention. But among these are a drummer and a young woman, whereas many of the men whose portraits must have been commissioned are submerged in shadow, hidden behind another person or a flag, or sketched in transparently in the floating background. The quality of lighting in any case seems arbitrary and this is partly why it has been taken for a night scene. Spots of light in strong impasto emerge from shadowy mists to smite the eye; strange forms appear as shadowed shapes, interrupting a light from farther back. Of three objects (lance, gun, and sword) parallel and one above another on the picture plane, one turns out to be parallel to the picture plane, the next at a 45 degree angle advancing, the next at a 45 degree angle retreating. The left hand of the captain extending out toward the spectator casts a shadow at 90 degrees across the tunic of the lieutenant to whom the hand does not belong. This pictorial situation is repeated in the silhouette of dark weapons on the lighted girl at left.

A banner swirls. A musket is loaded. A dog barks at a drummer. Lances clatter and clang in the air. And the color orchestration fulfills the last possible dimension of this pictorial symphony.

The Change in Style. It was always said that many of the sitters for this portrait, indignant at relegation to the shades, refused to pay up and that the picture itself was rejected. There is no evidence for this. But even so it could hardly have accounted for the change in the artist. Rembrandt's turning from a style that was popularly acceptable to one that satisfied him alone—the inception of which has sometimes been attributed to the social failure of this picture—could no more have been caused by such an event than by the death of his wife, or his bankruptcy. Each of these had their effect. But it is only lesser artists who reflect life's external situations in their work. The direction of Rembrandt's art was a product of inner necessity. His self-sought loneliness is symbolized in the Polish Rider (Plate 37b), a work of the furthest imaginable yearnings.

The Syndics. We may indeed question whether Rembrandt's alienation from society (he wound up in a poor back apartment by the ghetto) was one-

sided. For in 1662 Rembrandt was commissioned to paint a portrait of the board of directors of the Cloth Guild of Amsterdam, known as the Syndics (Plate 36b). The result is the most serene and at the same time evocative group portrait ever painted. The cloth trade was crucial to the city and had the aspect of a public service. These men are thus joined in more than self-interest. The portrait aspect—the contrast of individual temperaments which also represent types—is astonishing. Each is a different type of the executive, recognizable at once. Yet the unity within the group is more comprehensive than could be in life. This is achieved both through abstract composition and psychological play. The center of the picture—its pivot—is a void, tensely surrounded by the figure most to the rear above and by the object most to the front—the book and table corner—below; to the left is the chairman or leader of the group, and to the right is the figure made most interesting of all by the fact that he is the only one leaning forward and by the concentration of his gaze.

The massive attraction of the red tablecloth, low, to the right, and horizontal, is subtly countered by the vertical height and the rising force in the figure on the left. This figure sets the key of gracious response and serious attention which is the theme of the picture. They all turn, soberly, keenly, but not unkindly to an apparent questioner in front of the picture and just to the left of the spectator. This sets up a tension between the focus of attention of the picture and the spectator himself, but does not become embarrassing by actually confusing the two, so that the picture retains its own position in space and time which poignantly reverberates with the spectator's.

One of the most extraordinary ways in which these individualized figures are unified is through the organization of the hats. X-rays show that Rembrandt painted each hat in the neighborhood of ten times in order to attain the precise arrangement of shape, attitude, and position which would establish the overall rhythm and individual intervals which are the meeting ground of the psychological drama and the abstract pattern. This pattern reverberates across the horizontal plane. Such a pervasive movement is prevented from destroying the rectangularity of the picture, however, by the countering chords of color orchestration—red, yellow, orange, golden brown and tan—which echo between the tablecloth and chair in the foreground, and the background wall and wainscotting. The chord formed by the individual notes of the figures and that formed by the selected color tones thus intermingle and produce a chord that operates in all dimensions accessible to pictorial creation. The result may remind some of the final chords in a late Beethoven quartet: an intricately conditioned yet inordinately unified chord that reverberates long after the cessation of exposure to the work.

Other Portraits. Something very much like this happens again in the famous portrait of Jan Six with a coat over his shoulder, pulling on a glove. The abstract pattern of buttons and stripes reverberates in the vertical plane, countering with their slight diagonal the diagonal of the head, within which the expression reverberates horizontally from side to side "to the last syllable of recorded time." Out of the richly congealed unity in this intensely masculine, sublimely dignified expression—compiled out of every gesture of head, feature, hand, elbow, shoulder and even costume—emerges a power of suggested and purposeful life that has given birth to countless pages of interpretation: what this man has been doing, what he is about to do, what he has been thinking, the direction of his thoughts, his spiritual state itself. We are reminded of the observation of that congenital art-hater Thomas Carlyle: "Often I have found a portrait superior in real instruction to half a dozen biographies."

Out of the creation of such spiritual states comes a grace and beauty which though less immediately apparent is more profound and everlasting than any creation of the more physically-oriented Italian school. The portrait of Nicholas Bruyningh (Plate 35b)—with no sacrifice whatever in physical masculinity and presence—attains a male beauty and grace unsuspected even by Raphael.

At the same time the picture of Hendrickje in the National Gallery, London, called A Woman Bathing, with its incredible vibration sympathetic to the physical beauty and inner purity of nature, is a song to unpretentious womanhood. The portrait of Hendrickje in the Metropolitan Museum of Art (Plate 34b) carries this sympathy both through the pose and the handling of textures as they interplay between shawl and flesh. We are reminded of one of the most eloquent comments ever made on Rembrandt, by his fellow countryman and artist, Van Gogh:

"And so Rembrandt has alone, or almost alone among painters, that tenderness in the gaze which

we see in the Pilgrims of Emmaus, or in the Jewish Bride . . . *that heartbroken tenderness, that glimpse of a superhuman infinite that seems so natural there.*"

The astonishing portrait of Margaretha de Geer, showing the fleshy decrepitude of age so keenly that the face is almost a ghastly skull, yet with a keen, objective dignity and sparkle that remains in the eyes and the upright carriage—such pictorial creations anticipate Goethe's "eternal womanhood" by a hundred and fifty years, and in contrast with Raphael's abstract idealizations of womanhood, touch us at every level of our experience. Yet despite their indescribable richness, these later pictures of Rembrandt are so unprepossessing, so lacking in artifice, pose or obtrusion of any sort as to have barely caught the attention of the contemporary world; and not until the middle of the 19th century when Delacroix said it did the notion really catch hold that Rembrandt might be equal in stature to Raphael. Today most people who have really looked at their works cannot deny to Rembrandt the status of the richest and most mature painter of all time; and to Raphael the attribution of the wonderful genius of a boy: graceful, superb, even prophetic, but a youth only.

The Drawings. From such a many-dimensional world as that of Rembrandt's painting, verging, through chiaroscuro and paint structure itself into space and time, creating here chamber music, there full orchestra of sound, alive with glowing reds, flaming yellows, and mellow golden browns that echo the tones of the contemporary violin, creating psychological incisions and spiritual states so compelling that we are left quite speechless—from such a world it is an abrupt step to that of Rembrandt's drawings. Where in the paintings all was wealth, here all is economy (the two are not antithetical in art, they simply have different purposes). Here is a world of near-spontaneous notations, of shorthand renderings of the fleeting expression of a face, the strain of a movement, the eloquence of the unconscious gesture, the pictorial accent struck by fleeting light and shade. Let the reader obtain the best reproductions he can of these drawings and thumb through them, now quickly to see the range of things they investigate and the consistency and ingenuity of the system of representation; now more slowly to grasp the superb composition even among the most loosely scattered elements, the unequivocal solidity ob-

tained in a few gradations of wash, the eloquence of location and of skeletal construction in the most briefly indicated knee, ankle, or skull, the ever-fresh, never conventional interpretation of a visual experience, and the overall consistency in the expressive dash, swirl, hook, and jag of the stroking of pen and brush which, along with a sure unity of light and shade, render these drawings not just incisive sketches but full-fledged works of art, capable of hanging indefinitely upon your wall without loss of interest or command.

In a brief charcoal drawing of a lioness eating a bird we find the keenest and most sympathetic expressions of felinity, never surpassed even in full oil paintings by the avid and knowing renditions by Rubens, Géricault or Delacroix despite their more explicit interest in the subject.

Or in a brief pen and wash drawing of Saskia carrying Rumbartus (their first son, who died in infancy) downstairs an astonishing empathy of the weight of the child on the mother's hip as she swings it forward underneath, both the weight and the movement echoed in the pendulum-like sash that swings heavily below.

Or in another pen and wash, evidently of the same subject, called The Naughty Boy, is congealed the vigor of the struggle of recalcitrant babyhood awkwardly in all directions against the mother's equally awkward and not quite successful counter-movements, while the nurse or granny interjects pointed face and forefinger in quite useless admonition or advice, and two intently interested, slightly older children follow the scene from the doorway, showing a discretion which prohibits involvement—a product of their "superior" age.

A watchdog sleeping in his hutch is caninity incarnate: the grizzled muzzle, the brow furrowed in a cramped, wakeful slumber, the projection of the head and neck from the dark shadow of the hutch so that we feel the imminence of potential action. Or a small drawing consisting of a handful of strokes of the pen and two or three delicate washes creates a vast landscape of houses, trees, fences, and snowfields in the glare of a midwinter day under a leaden sky.

The Prodigal Son. At an opposite pole, is the magnificent drawing in the Teyler Museum, Haarlem, of the Return of the Prodigal Son (Plate 38*a*). If we were to restrict the study of Rembrandt to one work alone, this would do as well as any. The subject is central to his attitude: a profound

and all embracing yet manly and marvelously *unsentimental* compassion.

The scene is unlocalized, being cast mostly in misty washes, suggestive of the recesses of time, leading up to the action. A doorway and a piece of wall suggest the home to which the Prodigal returns, and the step upon which he kneels (which is indicated only at that point) symbolizes the step he must remount to grace, while the father meets him halfway by kneeling upon the same step from above. In the darker parts of the background pen stroking is used from time to time to lend articulation, but chiefly the pen is reserved for the figures themselves, which occupy the center of stage. Here the accents that establish the mutual gestures are reiterated in vigorous strokes of the pen, and include lines that indicate bone and muscles with those that indicate clothing and purely abstract lines—all entering into a total, involuting rhythm which unites all elements of this pyramidal group like twisted wire which has somehow come to life. Here the age-old northern tradition of endless, vital emotional expression through abstract line unites with the Baroque vision of the establishment of human drama through the incidence and fusion of light. The latter unifies the entire scene, giving it emotional as well as spatial tone. Line is used to invigorate and specify the action, sometimes in the most arbitrary way, as in the use of the cane, projecting sharply downward to the left in a counter-diagonal to the Prodigal's legs and trailing cloak with their severe parallelism which establishes such a powerful thrust that it requires for absorption not only the entire figure of the father but also the witnessing child leaning on the wall. The cloak, the two feet, and the stick all end in a vigorous reverse twist or hook, which is repeated still again in an abstract line midway between them, like a final signature from the master's hand.

VERMEER (1632-1675)

If the ultimate achievement of Rembrandt's development is—like Titian's before him and Cézanne's to follow—a **controlled and objective but profoundly expressive agitation**, the achievement of the purest painters of the Baroque age, Vermeer and Velásquez, was **perfect and breathless peace.**

While Rembrandt's gaze penetrated keenly and poignantly into the visible world, Velásquez and Vermeer stood back, so to speak, and took in the coherent phenomena of vision with a breadth, accuracy, and dispassion unexampled before or since.

Perhaps none of the great painters is more difficult to analyze in words than JAN VERMEER of Delft. His rendering of the reflections of light from colored objects inside a room from daylight outside—for this was almost exclusively the world that Vermeer portrayed—can be analyzed in terms of hue, value, and intensity to show the sheer accuracy of his tonal analysis. Furthermore his peculiar ability to distinguish different kinds of edges as seen under the different conditions in which light passes around them and the differing circumstances in which one object stands before another may profitably be investigated for visual experience. Or it may be shown how Vermeer tends to exaggerate slightly the lines of recession (Plate 40*a*) within a room so that in perspective—which is the suggestion of three-dimensional space on a two-dimensional surface—as well, he heightens the sense of visual presence. Or we may note his historical importance as the first painter accurately to determine within the measurements possible to human vision the phenomena of color tones within shadows: which is where color counts most in vision.

But none of these observations—which the reader who has a penchant for this kind of painting will find endlessly fascinating and rewarding—accounts for artistic or qualitative achievement of Vermeer's art: they merely testify to his acuity and objectivity as an observer. To appreciate the art of it, we must find what unifies these vastly differentiated visual phenomena into a single style, and what kind of pictorial expression is, in the end, achieved.

Light. One means of unification is the consistency of the character of the light which comes predominantly from a single source (in contrast with the variety of light sources in Rembrandt). Thus each reflection, though varying greatly in warmth or coolness, roughness or smoothness, and so on depending on the object of incidence, is **unified with each other reflection through the common character of the originating light,** which becomes in turn a kind of energy permeating the scene. Light and color are further unified by the technique of **rendering,** that is, the application of the paint. This is in short squarish strokes, not invisible as with Van Eyck, but unobtrusive. We are just enough aware of the brushstrokes to feel their continuity or their presence at once everywhere in the picture (Plate 40*b*).

Color. The colors also organize the picture far more arbitrarily than at first appears. Although Vermeer tends to establish a deep and immediate sense of depth through placing high intensity reds and yellows in the foreground against which the blues and greens of the background appear all the more distant, still those same reds and yellows do reappear throughout the picture and thus unify it. Often their intensity is so low that they appear as browns, tans or even grays and thus create an atmospheric haze in themselves; yet in spite of that we apprehend subconsciously that their hues repeat others that appear more recognizably in the picture.

Objectivity. Such unobtrusiveness is typical of Vermeer's entire mode of painting and contrasts strongly with Rembrandt's, where forceful personal touches inform all aspects of his art, be it choice of hue, twist of line, or accent of light and dark. Unlike Rembrandt, Vermeer is not known to have painted a self-portrait. Perhaps the closest he ever came to it is in the picture usually known as the Artist's Studio. Here we see the back of the painter in the foreground and largely in shadow, while the model and the back of the room receive the fuller light, frontality, and articulation. Once again, this is in no way a qualitative distinction, but rather one of temperament. **Vermeer carried objective vision to a height never surpassed; Rembrandt in exploring his inner life rendered the subjective sublime.**

Landscape. Rembrandt's landscapes are extraordinary renditions of the sense of life, energy, and character within the forms of nature. Vermeer's only two landscapes, the Street in Delft, and the View of Delft across the harbor (Plate 39*b*) are cool, like still life, and contrast equally with the fine but overt drama in Ruisdael (Plate 30*b*). They must be seen in the original, since no color reproduction possible to contemporary processes can show the unerring and flawless justness of all tones, the rich yet objectified evenness of textures through a still atmosphere which itself has texture, and the absolute scale which depends on intensity as well as size. There are many similar landscapes of high quality by other Dutch painters of the great age, but none approach these in their setting forth of eternally rich patterns of shapes and colors without a single disturbing element. The result demonstrates the expressive quality finally attained by Vermeer's art: nowhere in painting (perhaps only in classic Greek sculpture) is the sensation of the immediate more effectively transformed into universal and immutable stillness and peace.

VELÁSQUEZ (1599-1660)

"To tell the truth, I don't like Raphael at all."

Equally objective, but of a more expansive, less modest temperament was the greatest of Spanish painters, who served and portrayed the King and court of Spain. Vermeer was a burgher, a stay-at-home, with a large family which he had difficulty supporting because of the extraordinary slowness of his work. Yet style predominates over circumstance, and if there is anything that never shows with Vermeer it is struggle.

Nor is there any strain in the art of DIEGO VELÁSQUEZ. Considering that much of his time was spent in irksome court duties and that the society of the Hapsburgs could hardly have been entirely congenial to him, people sometimes mistakenly conclude that Velásquez succeeded as a painter only through subservience, that is, by subordinating individual assertion or soulful expression to a noncommittal objectivity. Such critique is out of place and misapprehends the nature of Velásquez' style.

One of the supreme and, incidentally, most forward-looking achievements of both Vermeer and Velásquez is their ability to create worlds of glorious colors, textures, and lights based upon apparently unexciting subjects.

Painting without Content. With Brouwer—who represented the generation before Vermeer's of genre painting in the Lowlands—or with El Greco —a generation before Velásquez' of aristocratic painting in Spain—the objects and figures chosen and portrayed are charged with meaning. The figures and objects of Vermeer and Velásquez stand impassively before us, asserting nothing in themselves, everything in the way in which they are rendered. Such strides towards what is usually called **pure painting** were of inestimable inspiration to many key artists of the 19th and 20th centuries, and thus while they consummate one age, they bear within them the inception of another.

Yet Vermeer with his darkened foregrounds and sharp spatial recessions and above all his dramas of color and light remains a Baroque artist. Velásquez shared these qualities and in addition sometimes entered upon the drama of human action that was so crucial an element in the Baroque art of Rubens, Poussin, and Rembrandt.

The Surrender at Breda. Velásquez' famous painting of the Surrender at Breda, known to his countrymen as The Lances for obvious reasons, surprisingly calls to mind such a painting as the Night Watch. Both paintings are large group portraits of the military in formal array. In each case upraised lances act as a sort of stage curtain on the right, and banners on the left. The principal figures are centered on the stage not only through their positions but by bright spots of light (spotlights, as it were, though they are both outdoors and in daylight). In each there is a highly lit figure of relative inconsequence to the story but of key importance in the composition placed in the middleground halfway to the left. In each case marginal figures do not bother to follow the central action but gaze beyond the space of the picture out toward the spectator.

Now such features are in no way peculiar and are cited to show the unities of Baroque conceptions all the way across Europe. Granted these similarities in the setting of the stage, we then become aware of the contrast between the unfettered exuberance of the northern middle class defender of his country, and the dignity and grace of the superbly formal aristocracy of the south, shown not just in the postures and gestures of the figures or the magnificently groomed horse but in the dispositions of the lances themselves which lend an abstract "formality" so in keeping with the represented theme as to render the picture unforgettable.

Dignity through Detachment. This was an earlier work of Velásquez in which the drama is more overt. The later works are more like Vermeer's, with the drama expressed more quietly, with less formality, and with a greater role for the accidental, especially in the world of appearances. But this extraordinary sense of dignity remains. It has to do not only with the mode of painting, in which it is comparable to Vermeer's, but also with the peculiar Spanish development of the quality called *Sosiego*, and referring not merely to a social but actually a spiritual elevation through detachment based on a sense of inherent grandeur. This quality appears throughout Velásquez' work, whether it is called for in the subject or not, whether he portrays the commander of legions consoling the defeated general, or an infant prince on horseback, or a clown or a dwarf (Plate 41*a*), a beggar, a toper, or a hunting dog. It is as pure in a small oil painting done in the Medici gardens in Rome as in a full dress portrait of the Queen in her drawing room in Madrid.

This is not to say that there is no specific expression at all in Velásquez' work. One has only to see the superb orchestration in reds of the portrait of Innocent X in the Doria Gallery in Rome to see as incisive a study in objective psychology as may be found in all painting, and achieved not only by the development of red tones from the costume into the face but by specific posture, gesture, and delineation of feature. In this sense Velásquez is far from Vermeer, for where the former painted true if often distant portraits of people, the latter rendered portraits virtually into still-lifes, painting a face almost like an apple, with the modelling adjusted more to the abstract shape (cf. the Head of a Girl, in the Hague) than to specific bone structure or flesh arrangement.

With Vermeer, in other words, the expression is carried through the light and color—he is more interested in interiors, still-life, and to some extent landscape. Velásquez had more interest in people, but not in the penetrating, re-creative way of Rembrandt, rather in a detached, surprisingly objective view of what they were, just as they stood there, unobtrusive yet unforgettably real.

Yet Velásquez' figures are never lifeless. One might also say that the astonishing thing in Velásquez' art is the way in which such stillness, such naturalness of gesture that it seems motionless can at the same time be so full of palpable reality, immediacy, and the vibration of life. It is as though each figure were about to do something, yet no one actually moves to disturb that absolute serenity. In the famous Venus with Mirror in the National Gallery, London, the nude, whose lovely back is to us, is about to turn toward us, yet she is perfectly at ease.

In Velásquez' masterpiece, The Maids of Honor (Plate 41*a*), an absolute hush prevails, nothing jars, yet the entire scene is so pregnant with natural activity that for more than three hundred years critics and viewers have offered conjectures as to what is really going on. The princess stands at the center, surrounded by attendant ladies, a dwarf, and the most superb dog in all painting. To our left is the back of a gigantic painting, of the same size as this one itself if we account for its distance back from the picture plane. Looking at it from the middleground, with brush in hand, is the artist himself, on whose tunic shows the red cross of the order of Santiago, fabled to have been painted there by the

king's own hand. In the background, directly opposite us, is a mirror, wherein the features of the king and queen appear. To the right of that, through an open door, appears a figure on a step, holding back a curtain through which streams a rich palpable light, the true protagonist of the painting. The figures, allowing for their distance from the picture plane, are life size. The painting is given a room in the Prado all to itself, illuminated by a window as tall as it is, letting in light upon it at precisely the angle of the painted light in the scene. Opposite the painting is a tall mirror, so that if you stand between the mirror and the painting and look back and forth you are soon lost in the illusion of that particular space created by the artist. Never has specific illusion been carried further in so many dimensions.

For we cannot really tell what is going on. Is Velásquez painting the king and queen while the girls watch, or is he painting the girls in a mirror while the king and queen watch? What is the significance of the figure in the furthest background? It really doesn't matter. The final result, whatever the literal process inferred, is so convincingly involved between canvas, sitters, and painter that we may remark, with Ortega y Gasset, that *this is a portrait of the artist portraying portraiture.*

MODERN ART

GOYA (1746-1828)

Goya, a nightmare full of things unknown;
 The foetus witches broil on Sabbath night;
Old women at the mirror; children lone,
 Who tempt old demons with their limbs' delight.

—BAUDELAIRE

At the very end of Baroque painting and at the beginning of modern stands the elemental figure of FRANCISCO GOYA. To compare his portrait of the family of Charles IV (Plate 41*b*) with Velásquez' Maids of Honor is to see at once a shift in the painter's attitude towards his environment. Velásquez' world was one of harmony throughout, in which he could pursue at one and the same time the professions of painter and of grandee, in which soldier, painter, king and doctor were on terms of respect and communication. The Baroque world, for all its vigorous conflicts and many-sided directions was one which sought a unity. Thus Velásquez could paint the Spanish court with total dispassion, rendering figures and faces as they appeared, dignifying them with perfect grace and naturalness and with the splendor of the color and light in which he bathed them.

Modern Tendencies. Goya's painting shows the beginning divergence of the modern world, prophesied as well by his contemporary Goethe, who warned of specialization of function and implicitly of the atomization of society which we have learned today. In modern times the artist has come to work more and more on his own terms, more and more at odds with others. The Family of Charles IV displays the imbecility of the king—who retained the wit and honesty to confess that his only pursuits were hunting and the table—the grasping ambition of the queen, or the reddened face of the old battle-ax peering out at the left. Others show only their weakness or unimpressiveness, except for the lovely young mother with her infant at the right. These specimens are shown not *as* they were but *for what* they were—although without evident bitterness. Goya may paint them, but he does not

have to accept their world. This is modern, moreover, in representing psychological analysis for its own sake. The analysis in Velásquez' portrait of the Pope had contributed to the magnificence of the portrait. The analysis in any of Rembrandt's later portraits had marked the beginning of a process toward a spiritual state. But in Goya we are reminded of a more purely scientific dissection.

Yet it is precisely these two, Velásquez and Rembrandt, whom Goya proclaimed as his teachers. Along with Nature. Perhaps the latter is the real clue to modern art.

Where Gothic art imaged God and the saints, and Baroque art man and society, **modern art seems consistently more oriented toward the world of nature.** If it looks at man or society, it does so not as the humanist but as the scientist. This is neither better nor worse—so far as we can tell—than earlier periods, but it is basically different.

For one thing, it meant with Goya a disillusioned attitude toward man's most ancient activity, war. In Velásquez' great painting of the Surrender of Breda, destruction and conflict are not ignored, but they occupy the background: the foreground is a stage filled with the protagonists meeting as gentlemen—which they were—in a moment of historical significance.

Goya's most famous painting, The Executions of the Third of May (in the Prado), represents a scene such as he witnessed from his balcony in Madrid when the French took that city. Spanish resisters—civilians and even clergymen—are lined up and shot by lantern light. The very fact that this is a night scene emphasizes that it is "extra"— beyond the day's work. The central target is a figure dressed in white (a tone repeated only in the face of the lantern) and with arms upraised in a gesture unmistakably suggestive of the Crucifixion. This in other words is martyrdom: translated into terms of momentary suffering. Ghost-like the pale buildings of Madrid stand behind the hill hot with blood. Grey and silver they are, and call to mind that other-worldly city in Greco's epochal image of

Toledo (Plate 30*a*). The professional assassins lean into their work, pointing their bayonetted rifles like lances, their hatchet-hats in staccato cutting through the atmosphere, their faces hidden from us in the anonymity of terror.

For Goya war was not the splendor of formations, the brilliancy of tactics, the gallantry of defeat or the gracious condescension of victory. The French invasion of Spain was seen not as a logical extension of diplomacy, but as an uncalled-for act, involving the mutilation of civilians and the destruction of civilization.

Other artists of earlier ages—like Bruegel—had depicted the horrors of war, but as marginal themes, or as interpretations of mythological or Biblical legends, such as the Massacre of the Innocents. With Goya such themes had become central.

The Etchings. In his etchings the savagery and purposelessness of war were shown with the greatest range and incisiveness ever attained (Plate 42*a*). Goya rendered four major series of etchings, the Caprices, the Disasters of the War, the Art of Bullfighting, and the Proverbs. The Disasters of the War, although done afterward (and not published until years after Goya's death) showed scenes that he had witnessed. These etchings have made people sick to the stomach, yet they are not gory simply for effect but because they are truthful: there is no exaggeration where exaggeration is impossible.

To experience their art it is only necessary to have one of these etchings hanging on the wall in daily view. To experience their thematic power it is best to page through the series, which are available in book form in a number of more or less adequate reproductions. Doing so, we find French soldiery mowing down Spanish guerrillas armed with knives and pitchforks, or occasionally, when the tables are turned, guerrillas despatching the invaders with equal mercy.

Even women with babes under their arms enter the fray, and there is an heroic etching in which a woman rises from the dead around her to light a cannon pointing downward into the dark hills.

Soldiers attack the women, and are stabbed in return by women and clergymen; women are dragged from their infants, or tackled as in a football game. The rebels are executed in all ways—shot, garrotted, hanged even horizontally by tugging if there isn't height enough from the tree. Clothes are stripped from the stinking dead, and living relatives hold their noses as they search among the heaps. And all is rendered in bold, abstract patterns of coherent jagged shapes and strong sweeping contrast of light and dark that attends the mark of carnage.

Perhaps most evocative are the mutilated corpses of the violated women and dismembered men, strewn like broken furniture (Plate 42*a*), or tied in pieces to the shattered trees, with captions like Great Heroism—Against the Dead!

And finally there is the war's remainder—the lost children, the starving survivors witnessing the burials and ignored by their own aristocratic countrymen, somehow of another world. For it is now the aristocracy, which had been so real in Velásquez, that has dissociated itself from the responsible life around it. Social consciousness was to grow in the modern age precisely as the upper classes, which in variable measure had truly led during earlier ages, ran out of energy and abdicated that leadership.

Other Aspects. Goya did not take sides. He was almost certainly a lover of the Duchess of Alba, and he painted the famous pair of paintings (now in the Prado) called the Maja Nude and the Maja Clothed in such manner as to invite controversy as to the model. Legend has it that these two paintings were owned by a nobleman who hung the painting of the nude behind that of the clothed figure, to be revealed by the pulling of a cord—in an appropriate moment for his male guests at brandy and cigars. Yet, in accordance with a principle practiced popularly in burlesque through all ages, it is the clothed figure which emerges the more enticing.

Such an art really belongs to the 18th century, to the old way of life referred to by Talleyrand in his remark that whoever had not been around before 1789 could not know the enchantment of living. And it was here of course that Goya took his start.

Goya's Early Work. His early works closely resemble the style of TIEPOLO, the 18th century Venetian decorative painter who followed imaginatively in the tradition of Veronese. Goya's designs for tapestries belong to the 18th century. They show graceful members of the aristocracy finely attired and engaged in non-strenuous vintage, dancing, or hunting scenes, humorous interplays such as the two paintings entitled the Wounded Mason and the Drunken Mason, in which the import of the scene is transformed by a slight shift in facial ex-

pressions. Even the Coach Attacked by Bandits is a rather decorous affair, and the same is true of a great many of the Goya portraits which really belong to the older tradition, although more incisive than most 18th century portraiture.

The Change. But Goya the modern artist seems to have been born when modern war reached his province. These overpowering events of the outside world, in which human values seemed to reach an end, were transformed in Goya's art into a premonition of the entire modern age, expressed in the famous 20th century essay by Goya's countryman, Ortega y Gasset, entitled "The Dehumanization of Art."

Goya is still a man of his age, however: a romantic quite like Beethoven. They died within a year of each other, and both had endured the long culminating years of deafness and isolation. The result in each was a final style of surpassing inner richness, fantastic imaginative power, and rare profundity as statements of personal experience. With Beethoven we think of the late piano sonatas and the last quartets. With Goya it is a few large canvases like the Witches' Sabbath, and the strange etching-series called the Proverbs, filled with specters and titans, flying horses and giant bats, monsters, human deformities, and an eerie light that asks nothing of reality. Something of the ancient Gothic sense of the torment and incongruity that lies at the heart of things seems invoked here, and we may think of Bosch or the hell-fires of the Last Judgments of medieval times. *Indeed it seems that the vital tradition in Spanish art is not a southern or classical one at all, but profoundly kin to the old Flemish and German traditions from which, in the Renaissance, it emerged.*

The Quixotic Spanish character is shown too in the combination in Goya of the strongest visionary in pictorial art between Rembrandt and Van Gogh, with the man of action, the man of the world: lover, courtier, and—his own greatest pride—bullfighter in his youth.

Goya the Bullfighter. The bullfight (in which Goya had participated) seems to have undergone a transformation in or just before Goya's time that shifted the emphasis from the aristocratic protagonist on horseback—a knightly heritage—to the democratic engagement on foot. The variations of combat (Plate 56a) and acrobatics that characterized this early chaotic state of what has since become a highly formalized and ritualistic ballet of death are better seen in Goya's bullfighting prints than described in words. Although these must come under the heading of documentary art—which always runs the danger of the exigencies of subject matter overcoming aesthetic organization—a number of them are masterful in their off-beat patterning and positioning, and dramatic disposition of broad, sharp areas of light and shade. It is hardly a surprise that it was in order more fully and richly to portray his magnificent bulls that Goya learned—close to the age of eighty and near the very end of his life—the newly invented and pregnant technique of **lithography** (see Appendix A) that was to be the leading graphic art of the 19th century. Goya's etching plates have long since been bought up and steel-faced by the Spanish government and the impressions generally to be found on the market today are inferior. Nonetheless they are original works of art, and among the most instructive and rewarding objects available to the modest collector—for their inventiveness, their modernity, and their unfailing authority.

One of them, the Colossus (Plate 42b) has been variously interpreted as Prometheus or Napoleon, but also embodies prophetically the attitude of the artist in the modern age to come: his strength, his range, his inward questioning gaze, and the limitless universe which is his realm. We see in this work

> The prophetic soul of the wide world
> Dreaming on things to come.

CHARACTERISTICS OF MODERN ART

One aspect of modern art is its tendency to split in different directions, quite like professional trends in science or learning. Although it is not until the 20th century that we are inundated with "isms," they find their inception close on the beginning of 19th century art. Classicism, Romanticism, Realism, Impressionism, Post-Impressionism, Symbolism—such are the terms generally given to the dominant trends or movements in painting from 1800 to 1900. One may note that we say "painting." In the 19th century, sculpture was either an exception (Rodin); the side-line work of painters themselves (Géricault, Daumier, Degas, Renoir); or provincial or academic. Architecture was either revivalism (sometimes interesting as in Jefferson's Monticello) or in an embryonic state of new searchings in the realm of engineering (sometimes powerful as with Richardson and Sullivan). But painting enjoyed one of its

greatest ages. Its outstanding figures—Goya, Turner, Cézanne, Van Gogh—would need apologize to no age, and the century boasted as well a vast number of first-class masters of the art.

Nationalities. It will be noticed that of the four outstanding figures cited, only one was a Frenchman, the others being Spanish, English, and Dutch. This is worth remembering when one hears it said that the 19th century belongs to France.

For in the sense of a vital tradition this is largely true. There was no Spanish tradition at all, only Goya. There was, early in the century, an outstanding English school of landscape painting in oil and watercolor, blossoming in the two greatest of all English painters, Constable and Turner, but this was soon over, and the English painting of the second half of the century—notably that of the Pre-Raphaelite Brotherhood—was atrocious (with the exception of Whistler, who was an American). Flemish painting did not revive until Ensor, at the end of the century. Dutch painting was handsomely represented in Jongkind and Van Gogh, but these are only two. German painting and graphics were profuse, yet they were insignificant in comparison with either French painting or German music.

The French Tradition. The bulk of the 19th century tradition was developed in France and by Frenchmen. At the beginning foreigners like Goya, Constable, Bonington and Turner had great influence on the French, and in mid-century the Pre-Impressionist Jongkind as well, but generally speaking by that time French forms and ideas were paramount. The English-born Impressionist Sisley worked entirely in France, as did the American Mary Cassatt, and that profoundly northern-oriented Dutchman, Van Gogh.

Such a dominance of one nation had not been seen in European art heretofore. The outburst of 15th century painting was hardly more important in Tuscany than in Flanders. In the 16th century the outstanding masters and schools were Roman, Venetian, Flemish, and German. The 17th century saw the culmination of Baroque painting at once in Flanders, France, Holland, and Spain. 18th century painting flowered in Venice, France, and England.

This unprecedented centering of painting in one country during the past century and a half is better explained when we observe that it really centers on a single city: Paris.

The shift of European society and economics from country to city and above all to a few megalopolitan centers like Paris, London, Berlin, and Vienna was paralleled in the arts. This does not mean that artists now exclusively lived and worked in Paris. Many did so—Delacroix, Daumier, Manet, Degas, Toulouse-Lautrec. Others like Corot, Courbet, Monet, Van Gogh, Cézanne—artists who dealt primarily in landscape—lived and worked in the country, but Paris was always their base, their center of communication and intercourse, their market when they had one. Apparently, as this is written the weight of artistic creativity has shifted to New York. But the great bulk of European painting from Napoleon's age to Hitler's belongs to what we may broadly call the School of Paris.

That is to ignore the glories of neither the 19th century English landscapists nor the 20th century German Expressionists, but to indicate instead a central thread during a century and a half which is so frequently cited as impossibly confused and variable.

Further order may be seen amid the chaos if we note certain basic tendencies among the "isms," which at first seem to have little to do with each other.

If we keep in mind that there may be observed two parallel tendencies throughout the course of nineteenth century and twentieth century art, then the sequence of phases and of apparently divergent movements and "isms" can be more readily grasped.

One of these could be described as the drive towards expressionism, the other towards pure painting or abstractionism. In other words, modern art tends to pursue in divergent directions the two basic aspects of the art of painting, form and content. *If a painting carries nothing derived from life experiences it is sheer decoration. If on the other hand it merely copies life without translating such experiences into forms proper to its medium, it is nothing more than illustration, paler than life, and without the impact or the new experience implicit in any work to which we give the name of art.*

Nonetheless some kinds of art deal far more with the representational element, others preeminently with the formal. The end result of this tendency in the nineteenth century is the dual culmination in the twentieth century of actual schools of Abstract art on the one hand and Expressionism on the other.

JACQUES LOUIS DAVID (1748-1825)

Although Goya is the larger figure, his contribution to modern art was actually anticipated by an astonishing figure in the history of the painter's role in society: JACQUES LOUIS DAVID, key painter of the French Revolution, and virtual dictator of the French School under Napoleon's regime.

David's early paintings were quite in the manner of the 18th century Rococo style, just as Goya's early paintings had been. And as with Goya, the revolution in art preceded that in the social and political world. Before the Revolution David painted one of the most starkly revolutionary works in European history: the Oath of the Horatii.

Revolutionary Style. Preliminary studies show how an originally Baroque theatrical conception was reduced to a severely frontal, spare, and direct presentation of that timely and precipitous theme in which a severe Roman father asks an all-sacrificing oath of his sons. The call of public duty is sounded in as cold, stalwart, and masculine a form of drama as is possible within the bounds of the ancient, classical trappings, which have a tendency to be resurrected whenever a political or artistic crisis arrives in the European tradition, perhaps because the simplicity of the classic stance endows it with stability, clarity or directness.

In this painting, the theme was evidently sincerely felt by the artist, for the artistic result is one of strong, slashing diagonals accentuating the gestures of legs (the stance), arms (the gesture), and swords (the issue), against a background of horizontal masonry, vertical columns, and severely simple arches. The sorrowing women at right are somewhat contrived, but remain subordinated to the main drama and do little to detract from the marvelous flaying effect of the sharp cold flames of hands and swords at the vital center of the picture.

Compared to a Renaissance or Baroque composition this strong picture seems to lack style. There is an illogical if more or less satisfactory principle of balance, and there are large areas—which serve only as negative foils to the highly specified action which is the sole subject of the picture. The resulting composition must be called in large measure reportorial, for it sacrifices many formal considerations to the description of an event. Nonetheless its clarity and solidity, in those parts which are rendered explicit, and the imaginative invention

of the strikingly expressive central motif of diagonals and flaring shapes help to dignify it as a genuine work of art and without doubt help account for its enormous influence in its own time.

As is characteristic of most of the important painters of the first half of the nineteenth century, David's work is of disturbingly uneven quality. The Death of Marat assassinated is, like the Oath of the Horatii, a fine strong image which gains unforgettable power through the simplicity of its positive areas, treated again in terms of severe geometrical forms with a few striking diagonals standing expressively against the cold, sober predominance of vertical and horizontal forms solidly based on the very bottom of the picture, and rendered the more stark by the complete emptiness of the entire upper half of the picture. In a 17th century picture such an "empty" area will be full of reverberations, and comings and goings in space. It was a scene that the author had witnessed, and the martyr had been his friend. Thus the dedication, inscribed in large Roman letters "To Marat" with David written smaller beneath are not superfluous but belong to a frankly propagandist painting of protestation.

Stylistic Confusion. But when the revolutionary painter became overinvolved with elaborate dramatic settings or with literary or otherwise contrived meanings, his work tended to become cluttered, insincere, or vacuous. Thus the Coronation of Napoleon, although it boasts a number of fine and striking passages, is monotonous and unimpressive as a total composition, especially if we compare it with the grand scenes of Titian or Tintoretto or Raphael, of Rembrandt or Rubens or Velásquez, or even the broad decorations of the 18th century painters of admittedly lighter works such as Fragonard or Tiepolo. Already the grand style of the Renaissance and Baroque ages is no longer possible of success for the modern painter.

Such a picture as the Lictors Returning to Brutus the Bodies of His Sons carries a certain dramatic conviction due presumably to the contemporary allusive value of the subject, although it is over-contrived, and the focal points of the composition are uncertain. When David painted a classical theme which was meaningless for his time, like the love of Paris and Helen the result was soft and insipid, in contrast with the manly harshness of his contemporary themes. Such pictures seem to have been impossible for modern painters, unless they were sustained by the vehicle

of a fiery Romantic imagination like Delacroix', or translated into pure study and savor of the human figure as with Renoir.

Ordinarily it would not be to the point in a book such as this to speak of inferior works, even by leading masters, were they not so well known. One might take David's Rape of the Sabine Women (in the Louvre) and compare it with Poussin's earlier treatment of the theme in the Metropolitan Museum in New York. The Poussin is by no means one of his most successful compositions, being—for that master—somewhat cluttered in its action and artificial in its color. Yet compared to the David it is clear, strong, consistent, lively, and thoroughly thought-out, so that one can search it and continually find interesting passages. The David painting displays an attempt—typical of the new science of archeology and of archeological interests among painters (dating from the latter part of the eighteenth century)—to reconstruct antique architecture, costumes, and armor.

But what has this to do with art? Perhaps David would have done better to stick more closely to the Poussin which was undoubtedly his model, for David's own painting is melodramatic in action, soft in its modelling which was supposed to be nobly sculptural, and its background is as flimsy as a stage backdrop.

On the other hand the famous picture of Napoleon on Mont Saint Bernard, showing the young commander tightly reining in his rearing horse, the fiery temperament giving warmth to the stone-cold image and the icy mountain blasts, is a consistent and successful picture. Indeed it is in the realm of portraits that David was generally most successful. Pictures like this and the Marat are given vital force and economical form through the strong sense of immanent reality important to the motivation of a painter so seriously involved in politics. But in rendering people without necessary political involvement, people he knew, or saw sitting vividly before him, David could also be successful. And this fact makes him the first of the modern painters in point of time—if not the equal of Goya or Constable in quality—for the success of his art is dependent upon the facts of life, not the ideals: what is, rather than what might be.

Madame Récamier. This is not to say that the new art becomes qualified by literal truth. In one of David's finest portraits, that of Madame Récamier (Plate 43*a*), the artist violently altered the color of the subject's hair in accordance with the stylistic dictates of his painting, with the result that the portrait was refused and the commission given to another painter. Style is the final consideration of anything which can be called a work of art. It is simply that the range of subject matter which can be accepted as valid by the modern painter is limited to that which can be observed, sensed, intuited or otherwise experienced in the here and now. What the artist does with his subjects is another matter. But the modern artist cannot ordinarily represent ancient philosophers (as did Raphael and Rembrandt) any more than he can convincingly conceive saints or angels (as did medieval artists).

Another aspect of style in the Récamier picture can be seen if we compare it with the portrait by Charpentier (Plate 43*b*) which was long thought to be by David. On stylistic grounds one would have to give it to Charpentier because the latter was a woman.

Now art is the province of men quite as much as child-bearing is that of women. This does not mean women cannot paint pictures but that they have never created deeply significant or compelling images.

The Charpentier here is charming. But there is a peculiar softness—in the expression, in the edges, in the tones, and in the posture—and a receptivity (again in the posture, and also perhaps in the broken window) which are feminine. In addition there is a sense of the image of a girl looking in a mirror: inquisitive rather than fateful.

David's picture is of a very feminine woman, but **the style of the art is masculine.** The pictorial elements are assertive and authoritative, and above all **architectonic** (note the compelling quality of the overall triangulation).

And we recall that it is men who are the architects of society. Women may write fine novels or lyrics, but nothing with the weight or structure of a Miltonic poem. By the same token women painters tend to be either lyricists or illustrators.

View of Luxembourg Gardens. One further picture of David's cannot be ignored even in so brief a commentary: the View of the Luxembourg Gardens (Plate 45*a*) a small landscape executed while the artist was, for a short while, a political prisoner. The solid, architectural instinct of this painting, based on simple horizontals and verticals in the fence and the trees, is worthy of Poussin—

which is ironic in that there is no other indication that David had that painter in mind, whereas in David's pictures that are obviously based on Poussin the result is embarrassing. At the same time the painting boasts a complete lack of formal preconception, with the heavy accents entirely on the left, balanced only by the extraordinary extenuation of the fence and a light-struck building on the right, which give it the empirical character that makes it modern, yet the strong sense of a new-found resolution that makes it art. And the passages within—the road, the trees, the fence—are executed with a constant variety and liveliness that add to making this picture at once a forecast of the best of Impressionism, and a sober testimonial to the question: would a good measure of the painting of the first half of the nineteenth century not have been improved by a more open and ready avowal of that orientation towards landscape which proved the salvation of the second half of the century?

CONSTABLE (1776-1837)

The third originator of modern art was a far less imposing figure than either Goya or David, but his work is more purely modern than that of either the Frenchman or the Spaniard, and if less grand is of a purity and consistency that rank him among the fine painters of Europe: JOHN CONSTABLE was the Englishman who stayed at home.

With the English, the fruition of landscape painting which was the key theme of the nineteenth century, developed early and without hesitation. David, like many French painters, had been caught up in revolutionary issues. Goya belonged to an artistic tradition which simply did not and never has practiced the art of landscape.

English Landscape. In England, landscape painting, with its brilliant eighteenth century foreshadowing in the work of GAINSBOROUGH, ROWLANDSON, and RICHARD WILSON, blossomed indigenously at the turn of the century in the work of greater and lesser artist alike.

A whole school of painters in oil and watercolor (especially suited to the expression of the meteorological phenomena in the British Isles) led the world in this art at this time, and were themselves led by a genius named Thomas Girtin whose early death forestalls any estimation of what his work might have amounted to, but whose mark and significance are well enough indicated in the comment of the fabulously successful Turner: "if Tom Girtin had lived I would have starved."

What Girtin inaugurated and Constable achieved was the liberation of landscape painting from the older schematic forms and colors which in the seventeenth century had been perfect expressions of the Baroque dramatic synthesis, but by the nineteenth century were symbols of the dead hand of the past, impediments to the expression of the immediate sensation of natural phenomena which was the metaphysical passion of the new age.

Color. Thus both the Baroque swirling organizations and arbitrary color chords favoring reds and browns—referred to by the new painters as "brown sauce"—had to go. The new pictorial schemes and color groupings were at once more prosaic and more immediately conditioned by sensations and apprehensions made and received on the spot. *In the 19th century landscape painting moved outdoors.*

The most constant and at the same time most unassuming evolutionist of these principles was John Constable. For one of the major heroes of modern painting he was almost unbelievably retiring, sensitive, and modest. For ten years he waited to marry the girl he needed; the following ten years of their marriage evidently brought him an emotional stability and a focusing of his sensibilities, for this is the era of his best painting. The ten years that followed her death were marked by qualities of strain and even bombast in his art which often, though not always, weakened its effect.

Constable was indeed one of the very few landscape painters able to manage a home life without detriment to his work. Presumably this was because his work was done so close to home. Almost all his work was done within a relatively small area in the south of England, where he was born. He said himself that his art was to be found, not in grandiose vistas, but under any hedgerow; and it was he who was the author of the incisive and unequivocal statement that might fly as the banner of modern art: "*I never saw an ugly thing in my life.*"

Concentration. Eschewing by instinct the spectacular in nature whether of the time of day, or of the season, or of the physical scene, Constable directly sought to come closer to grasping and expressing the visual essences of land, sea, and sky, of

rock, tree and stream, of meadow, pond and dam, by painting them in a recurrent springlike condition, and by working over and over again at the same motif.

And here in itself is the inauguration of one of the prime features of modern landscape: the concentration on the motif. By investigating the same, self-limited scene, over and over again, under similar but always significantly variable conditions, the modern landscapist seeks to accomplish not a portrait of the landscape theme or cycle, as characterized in the art of Bruegel, Dürer, Rembrandt (or the entire Dutch Baroque landscape school)—but instead a realization of the forces of nature as revealed by their peculiar function in a focused segment of the surface of the earth or atmosphere.

Range. In one sense Constable's range was very great, for the motifs that he explored varied from shadowy interiors of forests to open meadows and ponds, to sunlit trees enframing cathedral spires to the rocks and dunes by the shore of the changing sea, the open sea itself, and finally pure cloud formations, unattached to earth. If these scenes existed largely within a few square miles, nonetheless they cover widely disparate categories of the materials, formations, and interrelations of earth, water, air, and mist. In this sense Constable is a complete painter.

In another sense, the consideration of completeness in his work has given rise to a great deal of misunderstanding, pretty well cleared up today, but so imbedded in his generation that the artist himself does not seem completely to have understood the nature of the process of his art.

Finish. In ages like the Gothic or the Baroque, where the completeness of the illusion was an aim of the art, the quality of finish was essential. One of the leading characteristics of modern art, both in itself and in distinction from the art of the past is an emphasis on what appears to be lack of finish. This of course as stated is a negative quality, and before we can see what happens and why we must state it positively.

One tendency throughout modern art is that which moves in the direction of the spontaneous, the vivid, the immediate. This operates quite as much in sculpture—whether we think of Rodin or of the abstract-expressionist sculptors in America today—as in painting, being expressed in the quick, direct touch which stimulates a corresponding sensation in the viewer. Thus to smooth over these touches or to build them up into hard, finished surfaces is to change the nature of the work.

But there is another aspect of modern art which has to do with the quality of unfinish, and which is the greater participation, of the spectator in the experience of the work itself. This means that—according to various modern styles—colors are applied directly from the tube onto the canvas, to be mixed there by the eye of the observer; so that the paint may be poured, scumbled, streaked, flecked, smeared or otherwise directly applied such that the observer not only sees but actually feels the process of application, empathetically taking part in it, or even feels the urge to continue the process itself. By the same token, parts of the canvas may be left bare, partly to add another element of tone and/or of texture to the total effect, partly to remind the viewer of the continuously vital nature of the medium, just as the nature of the brush, palette knife, or tube are called to mind and feeling by the manner in which the paint is delivered.

Strong tendencies towards this kind of aesthetic can be seen in the late, incredibly prophetic work of Michelangelo in stone, and of Rembrandt in paint. But such qualities were not to become an essential element in art until modern times: meaning the 19th and 20th centuries. Of the **three founders of modern painting, Goya, David, and Constable,** those two who happen to be the best painters, those two of whom we could say that at times they attained **absolute painting—namely Goya and Constable—are, it is no surprise, the same two who show this new attitude toward the nature and function of the medium.**

Sketch and Elaboration. The result for Constable is that his oil paintings are of three different and distinct kinds. First are the **sketches** (Plate 46*b*), **small canvases**—often many of them on the same motif—which seek to render **the sensations of a moment.** These do not represent purely visual impressions, for they often deal with the experience of texture and atmosphere, and take serious account of the placement of objects and planes in space. But they are not "composed" in the sense of being built up out of a multitude of ideas. And they tend to focus on one condition of nature, one mood, or one meteorological phenomenon, even be it a shifting one.

Now it should not be supposed that such sketches are merely pages from the author's notebooks. They are true pictures, capable of standing

by themselves, and, at their best, ravishing as pictorial experiences. Their significance is indicated in a verbal comment by Constable himself: that every truly original picture is a separate study, and governed by laws of its own; so that what is right in one would be often entirely wrong if transferred to another.

The second kind of Constable painting has often been referred to also as a sketch, but this is misleading. These pictures are of large size (usually about arm's length) and often contain a full range of visual, textural, and spatial experiences. In other words they are not at all the small, outdoor, momentary rendering of a particular and passing sensation, but full-sized studies, conceived in the studio. **These are beyond comparison Constable's finest achievements, and are the works which require us to rank him among the outstanding modern painters.**

They are not, however, the pictures that the painter sent to galleries and exhibitions. They are not the pictures that their maker recognized as being his best, or, at the very least, they are not the pictures he chose to present to the public.

The latter represent a third kind of Constable painting (Plate 46a), the "finished" form of the preceding type, elaborated versions based unimaginatively on the large "sketches" and rendered in a polished, meticulous brushwork which, being superficially like the work of the Baroque masters, was still officially considered a criterion for important painting. Whether Constable was himself confused on this point, or whether he merely sought to ingratiate the rigid 19th century public —just how rigid later innovators like Courbet and Manet were to find to their sorrow and frustration —does not matter to us, for two reasons.

First, the versions which he painted to suit himself and not anyone else fortunately exist and we may today enjoy them as his masterpieces: this should satisfy the critic. Second, the finished versions—those that he exhibited—although so far inferior to the originals as to appear intolerable once we have seen the original version, nonetheless retain enough quality, and also originality that they were quite capable of exerting immediate influence on contemporary painters, especially across the Channel. The most famous example is Delacroix' sudden repainting of the entire background of his large and important painting, the Massacre of Chios, after it was already hung for exhibition

—as a result of seeing the *finished* version of Constable's Hay Wain. And this should satisfy the historian.

We must now ask exactly why the second kind of Constable painting is so far superior to the third kind. Such a question is essential not merely to the understanding of Constable's art, but is basic to attaining a grasp of many other kinds of the best painting of the past two centuries.

If we compare the study for the Hay Wain or for the Leaping Horse—quite possibly Constable's two greatest achievements—with the "finished" version we find that the latter is actually over-finished, that whole areas have become flat, dull, stiff, and lifeless, whereas in the study—which now appears as the version which was finished in the true sense of the term—not only is every surface alive and vibrant, but the parts flow dynamically into each other: not as masses (as in Baroque art) but as passages of paint, so that there is a fluid and active, but at the same time very solid and sure texture of the entire surface of the painting established. This resulting fabric does not override the keen and rich suggestions of planes or densities or the textures of nature, but it molds them all into what we might call a painting-activity of intense and vivid sensations. These operate with such vigor and subtlety together as to remind us of the very tenuous distinction between impressionism and expressionism.

Besides the manner of paint application and the construction of a vital fabric over the entire canvas, Constable's work exhibits other features which tended to dominate 19th century landscape.

The Value of Nature. One is the profound deference to nature—as the source of truth and morality, so that its function is genuinely religious. But Constable also expressed these attitudes in words. The landscape painter, he said, must walk in the fields with a humble mind: No arrogant man was ever permitted to see nature in all her beauty. Or (he remarked on another occasion): "Everything seems full of blossom of some kind, and at every step I take, and on whatever object I turn my eyes, that sublime expression of the Scriptures, 'I am the resurrection and the life,' seems as if uttered near me."

Another feature of modern landscape painting reflected in Constable's work is, it has been observed, the **concentration on the motif.** This means both the narrowing of the scene, in an attempt to focus

more single-mindedly upon its singular character, and the persistent repetition of the motif as a theme, under varying conditions, so as further to exploit and explore its intrinsic character and inner life. Both these things happen in Constable's paintings and are prime clues to the nature of his art. They are reaffirmed in certain of his remarks, such as "I imagine myself driving a nail; I have driven it some way, and by persevering with this nail I may drive it home." His themes are down-to-earth: "The sound of water escaping from mill-dams, willows, old rotten planks, slimy posts, and brickwork, I love such things." And close to home: "Painting is with me but another word for feeling, and I associate 'my careless boyhood' with all that lies on the banks of the Stour; these scenes made me a painter, and I am grateful." *And in the end they are universal:* "My limited and abstracted art is to be found under every hedge and in every lane, and therefore nobody thinks it worth picking up."

If the motif is concentrated and repeated then each rendition of it must be more varied—to give it life. This we can see in the sketches and studies, and the metaphysics of it is expressed in Constable's remark: "The world is wide; no two days are alike, nor even two hours; neither were there ever two leaves of a tree alike since the creation of the world; and the genuine productions of art, like those of nature, are all distinct from each other."

The New Light. But the crowning expression of the new sense of the infinite variety of nature is in the conditioning power of light, and in the function of light as the source of all truth and beauty in landscape. We see this in Constable's work when we observe not only the conditioning role of light in a picture like the Hay Wain, or the marvelous sketch in the Metropolitan Museum (Plate 46*b*) but particularly the studies of clouds, often in their pure form, detached from earth. This subject Constable is the first European painter to pursue, although Goethe himself was interested in the same thing at the same time, both as artist and scientist. It must not be forgotten that Constable considered himself a "natural scientist." But this is chiefly a reflection of his modern spirit of inquiry into and respect for nature, and could not pass for a description of his role as an artist.

The importance of sunlight, however, as not just the conditioning but the all-creative element

within nature and thus within painting is indicated already in certain aspects of Constable's painting (the cloud scenes, many watercolors, like those of Stonehenge, and many oil sketches of the seaside), and in such remarks as "That landscape painter who does not make his skies a very material part of his composition, neglects to avail himself of one of his greatest aids" or, even more strongly: "It will be difficult to name a class of landscape in which the sky is not the key-note, the standard of scale, and the chief organ of sentiment." The very same was later to be voiced by Sisley, the English-French Impressionist.

TURNER (1775-1851)

And it is in the development of light as the essence of pictorial form that Constable is a true brother of his great English contemporary, JAMES MALLORD WILLIAM TURNER. In other respects the two men could not easily have been more different. Where Constable never left his native county, except to go to London (which was not far), and painted more intimately from his native soil (with the possible exception of Courbet) than any painter in the history of Europe or America, Turner ranged wide—from the remote parts of Scotland to the Alps, from long journeys on the Seine to Venice and Rome. Where Constable was a truly naturalist painter with important overtones of Romantic feeling, Turner painted Romantic scenes with the air and eye of a naturalist.

Whereas Constable is generally recognized by continental critics as an important European painter, Turner very seldom is at all, being considered by continentals instead as a man of genius who somehow or other was not really an artist. And where Constable's work was a prognostication of Corot and Courbet (in the generation following his own) and of Monet and Sisley (in the generation following that one)—Turner's effect was, in its most important aspects, ultimately to skip those generations, and to prophesy the later work of Monet, in the twentieth century, or to make us think even at times of purely 20th century cosmic expressionists like Kandinsky or Jackson Pollock.

Sources. This was, however, only in the culminating work of Turner's long career, and his first paintings were well rooted in 17th century styles. Turner was a man of such energy and such command of the medium—whether oil or water-color—that he was impelled to demonstrate his ability to do anything.

That might mean bettering the old masters at their own game. For example Claude of Lorraine, the wonderful French landscapist of the 17th century, had painted quietly luminous and romantic harbor, island, and marine scenes which for many reasons appealed to Constable and Turner both. But where Constable sought to learn from Claude such things as would help him in his own art, Turner tried to outdo the classic Baroque painter at his own style. The result was a number of paintings which in their search of technical dexterity, of fluid handling and conspicuous light effects appear shallow when compared with the more restrained but far more solid, profound, and lastingly poetic works of Claude.

Major Achievements. But when Turner turned to scenes that he experienced directly, rather than through the eyes of another painter—(and these scenes did not have to be close to home as did Constable's, but could range to any locales which he was able to take in for themselves, uninfluenced by an historical or literary aura surrounding them) —then, even from the beginning, he painted sound and electrifying pictures.

Thus scenes like the Chateau of Kilgarran, the Bridges at Walton, the Abbey at Newark, or even a spectacular Alpine scene like the Chalet Destroyed by an Avalanche, are stirring achievements, while scenes like Appulia Searching Appulus, or the Bay of Baiae with Apollo and the Sibyl, or Aneas and the Sibyl appear shallow and mannered, no matter how brilliant the performance in terms of sheer handling.

It may be apparent, when we recall that the same thing was to greater or less extent true of Goya and David, that the mythological or literary subject—which had been a genuine and vital inspiration to Renaissance and Baroque painting, was simply no longer capable of inspiring anything but bad art. Modern art, ever since the beginning of the 19th century, has seen the world in other terms.

It is not that drama is lacking in modern painting, but rather that the drama is that of nature rather than of the stage of man's activity. Some of Constable's paintings are deeply dramatic, though he was for the most part a lyrical painter.

Marine Paintings. But Turner, less intimate or convincing in immediate sensation, was one of the most sublime dramatists of nature who have ever put brush on canvas. A picture like Chalet Destroyed by an Avalanche is a striking example partly because of its exotic and tumultuous subject. But a simple painting like several done of boats sailing in and about the Jetty at Calais (Plate 47a), with thrashing waves and flashing skies, can be equally dramatic with more humble subjects. Such a drama, though exhibiting remarkable power of pictorial imagination, was not based on imaginary conceptions or arbitrary rhythms, as the 17th century painting of Rubens frequently and successfully has been. Instead Turner's was based in the most thorough, sensitive, personally experienced and consummate understanding of the movement of the waters, their foam and spray, and the marine sky. Even Courbet—in some ways a more profound marine artist—did not know nearly so much of what actually happens in and on the sea. And with Turner this data is not rendered simply as a compendium for the seaman, but is effected pictorially through artistic rhythms and organizations, the result being that they can be felt and experienced as vital by the landlubber as well as by the inveterate seagoer—which Turner was all his life—and which further can stand as abstract expressions, capable of being stood on their head and relished by the modern artist.

For Turner was a pure artist and yet one completely immersed in nature. He never married, nor showed much interest in the affairs of people. Those who knew him have reported an actually rude and callous lack of interest in anything not having to do with the world of visual experience.

Seeing of course can never be divorced from feeling. Indeed we might say that the final purpose of any serious art form is some kind of feeling or emotion. But the feelings encountered routinely in life could hardly be the field for art—they are given free in life, and their reproduction in art would demonstrate nothing but skill at rendering.

Art, of course, at times presents richer, stronger, clearer, or more intense states of feeling than life does, but such operations or achievements could hardly explain why at least a few artists must be considered among the outstanding *men* who have lived.

Was there a greater Englishman than Shakespeare? German than Beethoven? Dutchman than Rembrandt? Italian than Michelangelo? Spaniard than Cervantes? Frenchman than Cézanne?

Such achievements must be more than an intensified representation of the world, or even interpretation of it. What such men have done is

give us a new world, based on the one we know but going beyond it, carrying us further, making us men of a different order—not entirely unlike the functions of the great religious teachers. Perhaps all we can say of the artistic emotion in the end is that it attains and belongs to a spiritual order.

Turner's art, then, only starts from his ability to paint a wave with more of the feeling of a boat riding on it than other painters have achieved—or to render translucent tones of atmosphere (and their densities) with such a technique that no one yet has been able to calculate technically how this was done.

What signifies more may be seen in some of the watercolors and water-like oils such as the interiors at Petworth: *explosions of light, in which the represented objects and the paint that represents them have all been transformed into cosmic color.*

Or, in pictures like the Slave Ship (Museum of Fine Arts, Boston), the Snowstorm at Sea (Plate 47*b*), the painter achieves a sweeping rhythm, often from a central vortex, in which all the textures and lights of nature are interfused, and the result approaches a universal flux. It is this aspect of Turner's final achievement which carries him to the rank of the greatest of English painters (we may and must overlook his bad pictures, of which there are a great many), and at the same time creates a prophecy of one of the major directions in painting in our own century.

INGRES (1780-1867)

If a Spaniard and two Englishmen where among the leading lights in the *creation* of modern painting, its *course* then passed to France, where it held the leadership in art until the First World War.

David's role has been discussed. His neo-classical realism was pursued by an extraordinary draftsman, JEAN AUGUSTE DOMINIQUE INGRES. This is the man who is famed for his lifelong struggle with Delacroix, wherein the former is supposed to have represented the Classical and the latter the Romantic attitude towards life and art. It is true that they disliked each other, and Delacroix coined one of the best critiques of Ingres' art as "the complete expression of an incomplete intelligence."

Actually they were both Romantics—it was a romantic age. The significant difference, apart from some classical trappings and a misunderstanding of Raphael espoused by Ingres, was that Ingres was a linearist and Delacroix a colorist. This is

something like the difference between Holbein and Grünewald as considered earlier.

Portraiture. It may have been Ingres' origin in the south of France that seduced him into what he thought was classicism. But classicism in western European art has never been realized anywhere except in Italy, presumably because there is an ancient undercurrent there from the predispositions that were creative in ancient Greece and Rome. There is something truly classical in the work of Raphael, or even of the Norman-born Poussin who spent his life in Rome. There is very little that is genuinely classical in the works of Ingres, and he usually performs much better when he responds to a strangely Gothic strain. Also, on the whole, Ingres is much better in his earlier pictures (Plate 44*a*). The portraits of the first two decades of the century are often striking and fresh, sometimes inimitable. These include some fine self-portraits and pictures of friends, but also fashion-images of enduring authority like La Belle Zélie.

In later years he occasionally attained first-class and authoritative portraits, like that of M. Bertin (Plate 44*b*). Evidently he felt challenged here to effect a convincing posture of the man and the aspect of society which that man represented. Bertin was a prominent member of the new middle class: his singleness of purpose, even narrowness, was his power; his achievement had nothing to do with either inheritance or with social graces, but was self-made; his self-confidence bordered on arrogance. In all this he was not unlike Ingres himself, a fact which may have stimulated the objective sympathy which was able to garner these traits into a lasting image.

Ingres evidently made a number of studies of Bertin, all of them unsatisfactory, until something must have caught the disapprobation of the sitter, for in the final version he leans forward in his chair, confronting the spectator as in a challenge, fingers outspread—ready for action—upon his knees.

We may be reminded here of the famous photograph of Winston Churchill, in which the attitude is not dissimilar, and of which it is said that the photographer was unable to cajole the Prime Minister out of a benign mood (in this context quite unsatisfactory for immortalization) until with a flash of desperation or inspiration he snatched the cigar from his sitter, at the same moment flipping the shutter.

Generally speaking, however, Ingres' most effective portraits—as is true of most of his other work—were those of the early years. In this he seems very like his near contemporary Wordsworth, most of whose best work was done early in his career. This seems to be a characteristic of Romanticism: the early flame that nearly burns itself out. The portrait of Madame Rivière (1805) is superb: flaring linear accents of the drapery are perfectly resolved within an oval form and harmonized with the gracious aspect of the sitter. It is a sort of activated Holbein, lacking something of the latter's grit but more flamboyant.

Compared with this a later painting like the Portrait of Madame d'Haussonville (1845) in the Frick Collection, although boasting a technique and consistency of execution beyond the skill or conjecture of most men who have picked up a brush, is nonetheless cool and for the most part unstimulating. *The portrait element here has given way to still life*—a most significant development in the history of 19th century painting.

The Drawings. It is very often in the drawings that we find Ingres attaining the purest and most fruitful level of his art, though it is always difficult to compare the final achievements in a drawing as compared with a painting.

Ingres' drawings tend to be of two kinds. One are the portraits, often group portraits, and unexcelled—quite possibly—by anything of their kind in the history of art for freshness, variety, integrity of the represented personalities, and exploitation of the pencil medium. We find their predecessors in the portrait drawings of Holbein and of the Clouet brothers (contemporaries of Holbein in France). Such works are often superior to the Ingres in total artistic concept and an ideal characterization, but by the more modern criteria of vividness, spontaneity, and literal truth of touch Ingres stands alone. Degas' portrait drawings, which depend heavily on Ingres', do not equal the earlier master at his own game, though Degas often achieves far more in the suggestion of color value and tonal richness (which of course Ingres tended to repudiate).

Ingres and Raphael. The other kind of Ingres drawing is that of the nude figure. In this his avowed master was Raphael. The relationship here is not unlike that of the portrait drawings to Holbein. Raphael's drawings are far greater as total works of art: his volumes are more vigorous and

sure: the dispositions float ineffably in space, and the total composition in a Raphael is balanced with a harmony unexceeded by that of any western artist.

Yet Ingres was far more skillful with a pencil than Raphael, for whom the execution followed the idea. Ingres on the other hand was more than just a craftsman. The wonderful thing about his figure drawing—that which made it a favorite study for Degas, Gauguin, Seurat, and Picasso—is its abstract rhythm (Plate 44a).

Abstract Art. Now abstract in this sense has quite a different meaning from abstract as applied generally to 20th century art. The latter meaning is equivalent to **non-objective, that is, bearing little or no resemblance to specific phenomena from the visible world.** What we mean by abstract in relation to Ingres' drawings is generally what the 19th century meant by the term: shapes, lines, or tones which refer to objects but which are arbitrarily manipulated to set up independent rhythms, enjoyable or meaningful in their own terms.

Ingres versus the Gothic. In other words, the astonishing quality in Ingres' figure drawing has little to do with his observation or understanding of human anatomy, although that is his starting point and the source for his creative linear rhythms. As to these Ingres' style is different from the pure Gothic, wherein the pictorial rhythms were *a priori,* and the representation of face and figure subjected to them, so that an extraordinarily energetic and self-consistent world-view dominated the representation of that world in which Gothic man found himself living. Compared to this Ingres' work appears relatively empirical, in the sense of starting from sensation in the world-about, and working from there to artistic form.

Also, it is a mistake to suppose that this kind of abstracting necessarily results in a cold or sterile art. With Ingres sometimes it did, accountable presumably to deficiencies in his temperament. But he himself felt that, "the great painters, like Raphael and Michelangelo, have insisted on line in finishing. They have reiterated it with a fine brush and thus they have reanimated the contour; *they have imprinted vitality and rage upon their drawing.*"

The danger in all abstracting processes is mannerism, and a very good deal of Ingres' figure drawings, or the drawing of figures in his paintings, turns out facile or flabby. But at its best,

whether in many of the figure studies in Montauban and in the Louvre, or in the marvelous little painting (1808) of the Seated Bather (Plate 44a) Ingres' drawing attains miracles of pure form constantly imbued with sensation.

Landscape. We cannot leave Ingres without noting a feature in his work which reminds us of that other early classicist David. In Montauban and in the Musèe des Arts Décoratifs in Paris are certain small landscape paintings and drawings. These are not only very striking among all Ingres' work, but could hold rank with much of the landscape painting of the 19th century. When we think of the glorious achievements in landscape of Constable, Turner, and Corot in contrast with the entire latter part of Ingres' career, which was contemporary, we may raise the question, as also with David, whether a potential landscape painter has not—through sheer lack of imagination to exploit that more natural medium—been lost to the annals of art.

However it is very likely that such developments were not possible. Géricault and Delacroix—greater artists altogether, and of far greater imagination than David and Ingres—also achieved some wonderful landscape passages; but they were bound throughout their careers (one long, one very short) to themes of literature, propaganda, or the picturesque.

The strong landscape element in contemporary English and German romantic poetry may simply reflect the nature-directedness of those more northern, less anthropocentric traditions. For the art of these two richly generative artistic personalities of the first half of the 19th century in France dealt primarily with the human figure.

GÉRICAULT (1791-1824)

THÉODORE GÉRICAULT was a titan who died young. His sheer natural ability was legendary, and there is no telling what he might have accomplished had he lived longer. With some masters who die early we feel there may have been a reason for it, or that the artist's work might actually have been carried as far as he could ever have taken it. Some measure of these possibilities has been discussed earlier. With Géricault we are more likely to feel that a great work had only begun. Indeed the man died with the expressed feeling that he had not yet really accomplished anything.

This vigorous scion of the upper middle class and aristocrat by nature died as the result of infection and prolonged suffering caused by a fall from a horse. His life had been fast-moving and romantic, including involvements with married women, service with the king's musketeers, and the excitements and torments of a life reminiscent of Byron's.

And in fact he was strongly influenced by things English, especially the painting of horses. But his formal orientation was southerly, towards Rome. He was far more classical in a meaningful sense than Ingres or even David, for what he took from Raphael and above all Michelangelo was truly vital and magnificently plastic. He might be called the Michelangelo of the French, not simply for his sculpture (which though minor to his work is outstanding in the entire century) but for the robust sculptural element in his drawing and painting. For Géricault realized in a modern painting vernacular the force of the Sistine Ceiling.

There is an animal force throughout the work of Géricault (Plate 42d) which was to inspire French artists throughout his century: Delacroix immediately, then Daumier, Courbet, Degas, and—we can hardly doubt—Cézanne. Whether rendering mounted hussars, or a soldier stopped at the door of an inn, or a charge of cannoneers, or a man wrestling with a bull, or a bull market, or men taming horses or riding them full throttle cross country, or horses fighting in a stable, or a boxing match, or seated, snarling lions, or slave markets, or studies of a dead cat, or of severed human heads in a morgue, or of the mad, or of the snatching of a nymph by a satyr, or of a couple locked in love, or of a wounded deer, Géricault's vigor is prolific, but it would mean little to art history were it not effected through an intelligence of the strongest kind, with a command at once of subject and medium which makes his work a storehouse for the entire century.

Raft of the Medusa. Géricault's famous and probably his crowning achievement is the gigantic picture in the Louvre called the Raft of the Medusa. This picture reminds us of Goya and David in its derivation in propaganda. The Medusa was a ship which foundered, whence the large number of her survivors were placed upon a large raft, towed by the crew. The crew for uncertain reasons cut the raft adrift, to reach shore a longer time after, upon a harrowing sequence of suffering and atrocities which cost the life of most of the people on it. The

disaster was embarrassing to the government, and Géricault did not intend to let it be readily forgotten.

His studies and preparations for the final painting included the actual construction of a raft, upon which he lived to get the feel of the motion of the waves. Countless drawings and oil sketches experimented with the precise moment of the action to be depicted, and show not only the remarkable progress of the composition but the extraordinary variety of ideas that went into it. The final painting lacks the spontaneity and inventiveness—necessarily—of many of these sketches, but achieves an expansiveness of congealed power (the whole composition rises like a towering wave) which ranks it among the overwhelming paintings of modern history. Not the least of its importance was the immediate effect it had on a youthful romantic genius who was probably the illegitimate son of Talleyrand.

DELACROIX (1799?-1863)

The man who was to carry to fruition much of what Géricault had started lacked the former's iron and sinew, but compensated for this by an extraordinarily inventive painterly grace and temperament of dancing fire.

Delacroix and Older Art. Where Géricault's mentor was Michelangelo, EUGENE DELACROIX' was Rubens. The fuming reds and yellows that activated the latter's painting—derived from flesh and the fecund earth—were what excited Delacroix above all in the art of painting, and the dynamics of the spatial interplay of masses of color, expressed in a fluid texture of free brushstroking, inspired in part by the spontaneous accomplishments of Bonington and Constable, formed the basis of Delacroix' aesthetic.

It is in his conception of the activated use of color as symptomatic of light, and the vividness and variety of his handling that Delacroix stands as the technical forerunner of Impressionism. Goya in some late paintings like the Milkmaid of Bordeaux, and of course also Constable and Turner, showed that a new interpretation of color as expressive of a light which is momentary, ever-moving, and all-conditioning were inevitable, and indeed we can assume that Impressionism—perhaps the key stylistic feature of the 19th century—could have evolved without the existence of any of these painters.

But Delacroix, more than any of these, established a self-conscious and history-conscious bridge between the metaphysically colored techniques of the Venetians and of Rubens and Velásquez—in other words the old masters of color—on the one hand, and the sensory glories of modern color: in Manet and Renoir, Van Gogh and Cézanne, Seurat and Matisse on the other.

The Last "Civilized" Artist. For although Delacroix was a thorough Romantic—devoted follower of Walter Scott and Goethe and Byron as well as Géricault—he was at the same time of a classically limpid intelligence. He preferred Mozart to Beethoven and Berlioz, and he knew why. Dante was read to him while he painted, and that this was not an empty gesture but a moving and profound stimulus is perfectly clear in his resultant art.

Delacroix is the last of that long tradition of humanist painters which begins in the Renaissance. It was still possible for him to render a seascape in Biblical terms (Plate 48a), but of an intense commitment to nature, such that Van Gogh spoke of the "terrible sea that rises and rises on and on to the height of the frame." He was urbanely literate, conversant with the ablest people of Paris in almost any fields, a responsible and knowing critic of nearly all the arts, and the author of the finest Journal ever written by a painter—equalled, among the writings of painters, perhaps only by Leonardo's Notebooks and Van Gogh's Letters.

The Journals. It is a mistake to consider the work of Delacroix without these Journals, or without the sketchbooks which represent the middleground between the writing and the painting and at times seem to show Delacroix at his purest.

For if this educated rebel of early modern French painting lacked the weight, the iron vigor, the pithiness, or the uncompromising earthiness of his forerunner Géricault, still his fiery flashes, his knowing glances, his freshly noble gestures, and his purity of intellectual and emotional vision make him the most loved among all French masters by the painters of the second half of the century. Over his drawings the hardy Cézanne wept.

Compared to his hero Rubens, Delacroix was at once more classically restrained and more ethereal. The Frenchman's gestures are stopped here and there, congealed in a phrase—they do not roll endlessly in fluid involutions. On the other hand, in contrast with Rubens' Baroque and Flemish materiality, Delacroix' paint seems divorced from the

object—airy and light-filtered, abstract and more purely emotive. His color takes on a texture which is more that of the manipulated paint, less that of the world portrayed.

His nudes become glorious evanescences, evoking the purity of light itself: Rubens and Titian always returned to the pulsing human flesh. It is in this conception of the role of art that Delacroix leads direct to Impressionism, though it must be noted at once that only in some of his pictures does this transformation occur.

Sketch versus Elaborated Version. Like Constable, like Corot, like Courbet and Daumier to follow, Delacroix was torn between making finished pictures for the public, and creative paintings for himself. On the whole the large, finished pictures are less effective than the smaller, "sketchier" versions.

In a few instances, such as the Liberty Leading the People—which was meant to be and has proved subsequently to be a battle standard, and thus has a public, finished element in its motivation—the finished version is more striking than the sketch.

But for many of Delacroix' most famous paintings—like the Battle of Taillebourg, the Death of Sardanapolis, or the ceiling of the Gallery of Apollo in the Louvre—the sketched or private version is far more fluid, vital, and cohesive than the elaborated version.

The same is true for Corot, who largely ignored public demands, and even for that public iconoclast Courbet, who loudly flouted them. Presumably the reason for such an unprecedented state of the art of painting has to do with the changing role of the artist.

The Artist in the Renaissance. In the Renaissance and Baroque ages generally the artist was at one with his public: art itself was less specialized and so were the various professions of the patrons of art. Thus their mutual understanding was relatively harmonious. Scholars then could dine with soldiers, financiers with painters, clerics with politicians, and all talk the same language. Rubens could be at once one of the greatest painters and one of the most important diplomats of his century, Velásquez a courtier, or on the other hand Francis Bacon a writer and philosopher, and Wolfe ready to exchange his victory at Quebec for the authorship of Gray's Elegy.

The Artist in the Modern Age. But in modern times (as Goethe foresaw so clearly as to recommend that younger men join the trend rather than fight it) the future lies with the specialist, not the humanist. The deeper and more completely one pursues one's line of work the more effective one becomes, and today one is no more interested in what Professor Einstein thought of international politics than in what President Truman thought of the art of his own time and country.

Thus it is no surprise that one of the finest and most forward looking of Delacroix' paintings, called the Stove, represents a corner of his studio with a stove and a model's screen—the milieu and tools of the artist, the professional, the specialist, the one who looks inside his environment.

COROT (1796-1875)

Maker of some of the loveliest small canvases in the history of painting, JEAN BAPTISTE CAMILLE COROT considered himself a lark, as compared with Delacroix whom he admiringly termed an eagle. And though the latter was certainly a more powerful figure, Corot was a purer and in some ways a more influential artist.

It has been said that Corot painted 3000 pictures, . . . 5,000 of which are in America. Certainly he has been one of the most popular and collected Europeans in this country. Perhaps this is because he was the first continental to make his art from the fresh, vivid impulse received from outdoor nature.

But this love of the outdoors, pure if not simple, could account for little did not Corot's art render as humble, discreet, tender, and subtly passionate a feeling for nature as any sophisticate.

And this delicacy and purity should never be confused with weakness or softness. Corot's response to nature was clear and vehement. He spoke—even in words—as eloquently as anyone of the epochal experience of the rising of the sun. He advised complete consistency and singleness of approach: "Be guided by feeling alone. We are only simple mortals, subject to error; therefore listen to the advice of others, but follow only that which you can understand and unite in your own feeling. Be firm, be meek, *but follow your own convictions.* It is better to be nothing than to be an echo of other painters."

Corot and the Public. That Corot painted some pictures for the public salon and some according to his own standards does not lessen his stature,

even in commensuration with the above remarks. Only Goya (and possibly Géricault) among all the painters of the first half of the century, had the greatness to turn entirely from the public and—in the latter part of his life—to work with entire originality and consistency.

It is not the relatively public and therefore dull and artificial works of Delacroix or Corot, Constable or Turner, that concern us, for they were the inevitable due that most men render to the world of Caesar wherein they live. It is the nature of the work that they did on their own, to suit themselves and meet their highest demands that really concerns us.

There is even more difference in quality between the public and private versions of Corot's Bridge at Narni for example than the comparable versions of Constable's Hay Wain. This takes nothing from the better of the Corot's, which like many of his pure landscapes, are the most completely natural—which means the most completely lacking of artifice in composition or in feeling—of any landscapes we know.

But many of Corot's pictures do not attain this height. The viewer is urged to distinguish not only the public and private versions of certain themes, but also the pure landscapes from those which contain nymphs or shepherds, where a veil of romanticism seems to shroud and weaken the strong original impulse. Or pictures of the nude in landscape, where the two are never completely resolved (which was not the case with Giorgione or Titian, when no discrepancy was felt).

The Role of the Figure. However Corot was perfectly capable of painting the human figure successfully in landscape, so long as that figure was local and natural, in other words quite as he might often have *observed, not* as he might *conjecture.* Thus a woman gathering faggots, or a reaper's family may rank among his best pictures.

By the same token Corot's studies of figures in interiors are sometimes among his best—whether a self portrait, or the so-called Woman with a Pearl, or the Studio (which shows, like Delacroix', the stove, the implements, and the flavor of the working life). In such pictures there is always a feeling of nature, in the completely natural sense of light, of texture, and of tone. These are the realms of experience wherein Corot was one of the great masters. Yet at the same time, in such pictures, one is quite frequently startled to discover a vivid

sense of pure forms and shapes, instructive in themselves, enjoying and pursuing the medium and of an originality and inner coherence that takes us straightway to Picasso and Braque.

MILLET (1814-1875)

The work of an heroic peasant is almost as popular in this country as Corot's, but is seldom of comparable value. Though JEAN FRANÇOIS MILLET had the courage to leave the potentially profitable painting of nudes in Paris for semi-starvation in the woods near Barbizon (where along with other painters like DIAZ, ROUSSEAU, DUPRES, or from time to time Corot he contributed to what is called the Barbizon school, a group of dedicated realists and outdoorsmen)—still Millet's images are often too literary, too specifically involved with the subject matter—no matter how sincere—to carry over into good art.

Sometimes, as with the famous Sower (the prize of a roomful of Millets in the Boston Museum), the almost Michelangelesque vigor and straightforwardness of the pose overcome the usual tendency towards a romantic idealization of the subject.

There are a few landscapes—especially one after a rain, the Springtime (Plate 45b) which are masterpieces. Evidently he forgot what it was he had set out to do, and let his stronger feelings work upon what he saw, without trying to prove anything, so that the result was a creation, not a fabrication.

But all too often what happens in Millet's work, even in the famous and almost but not quite successful Angelus, is echoed in what he wrote about another painting showing a woman going to draw water: "I tried to show that she was not a water-carrier, or even a servant, but a woman going to draw water for the house, for soup, for her husband and children; that she should not seem to be carrying any greater or less weight than the buckets fill; that under the sort of grimace which the weight on her shoulders causes, and the closing of the eyes at the sunlight, one should see a kind of homely goodness, etc."

Art versus Illustration. Now to paint just what Millet has described could never be more than illustration. The very term illustration predicates that one renders in pictorial form ideas or feelings which are primarily given in another medium, for example literature. The very fact that he is able to describe in words what he wants to express in

paint proscribes any particular significance for the latter.

Narration in Art. Now such illustration should in no way be confounded with the Biblical or historical paintings of the Gothic age or even so late as Rembrandt. In these, what happens is not a picture to go along with the story, as in the *Saturday Evening Post*, but a **visual** interpretation of a theme, a problem, or a message.

The art of painting deals with things seen and felt—not with narrating a story. Painting can tell a story of course in a series of images, as Duccio did in the *Maiesta* (Plate 16a). But no matter in how many ways the images are related they are still images. And as such they take form in terms of painted shapes, lines, colors, and textures. Now these are peculiar kinds of experiences, and the painter does not deal with them simply because he has nothing else to do.

It is as true of any art—of writing as of painting —that what is "said" must be said in that medium and could not be said in any other. How many people do we know of whom we could not say, Jones ought to be a salesman, or a bricklayer? And what does this mean but that he is, by nature and orientation, potentially a manipulator of certain forces presented in nature?

But there would be no point in manipulating paint or clay or sounds or words unless through such a process it were possible to *create* something —something which could not be possible in any other medium.

The Fitness of the Medium. No one ever suggested that Shakespeare write in Italian. It is not possible to imagine Michelangelo as a graphic artist, or Rembrandt a sculptor. Chemists on the one hand and mathematicians on the other strive to find peculiar symbols and means with which to pursue and express problems and solutions for which no other means would be of value.

Therefore if Millet is able to write up precisely that which he wishes to tell us about a scene rendered in paint, then the painting is a mere illustration of the words.

Titian's Entombment and Rembrandt's Night Watch and Michelangelo's Moses leave us speechless—we feel no inclination to discuss the phenomenon in words. If Michelangelo wrote, he did so as a poet, not as a sculptor. Most artists of that time never wrote at all.

The fact that a great many artists during modern times have written more about their art than artists during the Middle Ages or the Baroque period is symptomatic of something quite different: **the growing self-awareness of the artist as a professional, as a maker of works of art, which is characteristic of the modern period.**

Naturally then the best writings of modern painters discuss what they do, or how they go about it, or what they object to in other things, or any of the variety of matters which a self-conscious performer-creator considers. But, like composers or architects they do not seek to express in words that which they necessarily must realize in paint. As it has been said at the beginning of this book, the writings of a painter can serve as an *introduction* to the painting—but never as a replacement for it.

A lot of what Millet says can be found as early as in the writings of Diderot: that is, the attempt to make an equivalent in one medium of what is natural to another. This is perhaps a tempting byproduct of the self-consciousness of the artist with his concern for technique, but it is grievously prejudicial to the process of a work of art.

What is the Test of Art? Of the latter one can always make the test—no matter at what level of seriousness—is this work necessary? Is it necessary that what was done was done at all, or in this way, or by this man, or with these materials, or towards this end?

If we feel, in the presence of the lightest, gayest, most ephemeral, remote, or on the other hand the most severe, destructive, caustic or irreverent of works that what is said could not be gainsaid, that the result is not superfluous nor idle nor beside the point nor negative—if we feel in any final way that what was done was necessary: then we must grant it its own importance.

But if a man is trying to use one medium, say painting, to "say" things actually experienced in another sphere of human functioning, then he must be wasting his time.

Actually, with Millet, although this literary or propagandist element often interferes with his art and sometimes turns it into something else, nevertheless he did sometimes create positive and artistic images. In a way he is like Dickens, whose socially-oriented experiences are often detrimental to his art, yet in spite of himself he was frequently an artist.

Propaganda in Art. Propaganda can perfectly

well be a motivation for a thorough-going work of art, such as Goya's Disasters of the War or Géricault's Raft of the Medusa or Picasso's Guernica, but only if the propaganda remains a stimulation or a starting point or "inspiration" and the work proceeds from there to become something vital in its own terms, something transcending material motivation.

Thus Millet's sincerity sometimes carried him through the barrier of representation to things more deeply, purely, and universally felt, and when this happened he was an artist.

Meanwhile another so-called realist—a man of similar motives and experiences, managed to cross the barrier of illustration more often than not (and far more often than was generally understood by his contemporaries). Daumier stands as one of the titanic artists of modern times.

DAUMIER (1808-1869)

In his day HONORÉ DAUMIER was thought a cartoonist. Baudelaire (one of the few critics contemporary with his subject who has written enduring analysis) pointed out, however, that Daumier was no mere chronicler or commentator, but one of the three great draftsmen of his time (the other two: Ingres and Delacroix), and that he created—within the medium of black and white lithography—powerful suggestions of color.

Still today Daumier is best known as a cartoonist. Countless law offices in this country hang on their walls his depictions of judge, prosecutor, or defendant—with equal irreverence for competence or motivation—based on keen experience in early years as a courthouse assistant.

Beneath the Cartoon. Like Daumier's many political cartoons, like the countless commentaries on bourgeois tastes and attitudes, generally unflattering, these are often sensed (superficially) as being savage and malicious. But this is scarcely ever so. Daumier's ridicule has almost always something underneath it, not compassion merely, but a grasp of moving forces of human nature, an inevitable tide upon which the particular circumstance is only a feature—a poignant or amusing fancy of fate.

Only perhaps in the realm of art itself does Daumier seek completely to expose or destroy. After having seen his lithograph of Narcissus, or the Menelaus Returning from Troy, it would be difficult to render such a subject on a high plane of seriousness.

Such destructiveness was as healthy as it was effective. The time when ideal classical subjects or even specific literary images could be a vital source for painting had already gone. To be involved in them any further could only mislead or dissipate a good painter, or give a false façade to a bad one.

The New Imagery. The images that he creates to replace the classical and romantic ones are paintings, drawings, and lithographs of men smoking, drinking, playing chess; butchers, washerwomen, people riding in third-class railway carriages, or emigrants struggling over rough and desolate landscape. There are scarcely more powerful images since Michelangelo and Rembrandt than some of the washerwomen carrying heavy loads and hauling their children up the steps from the steep banks of the Seine (Plate 50b), struggling and heroic figures behind whom the river and the far embankments and façades radiate an eternal glory.

The sculptural force in Daumier's figures and the rich, expansive scale to the space which they inhabit render his style truly titanic. More than one person on first seeing the Sistine Ceiling has likened it to Daumier. This is the element of sculptural expansive power. As a pure painter, however, he reminds us of Rembrandt and Titian in his unexpected **chiaroscuro** and **pure color tones.** His painting of the dead mule (discovered by Don Quixote) stands midway between the beef carcasses of Rembrandt and those of Soutine. As a draftsman he makes us think of Tintoretto, Rembrandt, and Goya. But this of course does not mean that he imitated or followed any of these men or any of the many others whom his work can call to mind.

Instead there is an elemental simplicity of force, combined at the same time with the most extraordinary fervor, energy and sensibility—which seem to come from nowhere but within the high-minded, deeply based, and richly experienced life of the man himself. Few have rendered figures so firm and full, so secure and clear within their space, yet at the same time so excitingly alive, infused with passion, and sensitive in their environment.

Daumier the Man. A photograph of Daumier convinces us at once of a tall and wide intelligence, of a devotion to that which lies around him, of a keen compassion based in suffering; and physically too one may be reminded of Dostoevski. Indeed

they are brothers in work as well as appearance. And both still stand as among the deepest spiritual forces in modern art.

Daumier's numerous paintings and drawings of themes from Cervantes and from Molière are thus in no way to be confused with literary painting. In the first place it is notable that these latter two are the most universal of writers of the southern European tradition (to which, for the most part, Daumier belongs: he was born in Marseilles).

Secondly, Daumier's treatment of Don Quixote and Sancho Panza, or of *Le Malade Imaginaire* are in no way illustrations or even interpretations of literary images. Rather they are basic commentaries on human situations, without name, without context.

The Modern Artist. Another category of subjects in Daumier's art cannot go unnoticed. This is the body of works involving people looking at pictures, in the street, in the home of a connoisseur, in the gallery, or in the artist's studio. Sometimes the artist himself, painter or sculptor, is shown, and then especially with a fine fury.

This is the first time in modern art that a specifically modern theme, namely the artist—his work—and its relation to the public, has been delved for its own meaning, as a source of life.

Corot also painted the painter's studio, and Delacroix too. So it is not an invention of Daumier, although he did it on his own. But Daumier was the first to exploit a motif which has become central to modern art, a motif based on the self-consciousness of the artist.

Although the varying appearances of the artist throughout human history have been as teacher, philosopher, revolutionary, or prophet, still the only way the artist can represent himself—*to himself*—is as a craftsman, a worker, an entertainer, technician, performer, actor, manipulator, in short the guide knee-deep in the rich river of his material.

In the stern march of professionalism in modern times the artist keeps, even leads the step. As he becomes aware of his professional role he expresses it, even if in marginal themes.

A great range of subjects—circus performers (Plate 54*a*), acrobats, singers, cafe entertainers, dancers, musicians both amateur and professional —in other words the artist in the public sense—these are themes that penetrate the work of DEGAS (1834-1917), Toulouse-Lautrec, Cézanne, Van Gogh, Picasso, Braque, Matisse, Beckmann. Such themes are vital and essential to modern art. No one realized them more vibrantly than Daumier.

COURBET (1819-1877)

"A certain dog painted by Courbet is like the story of a poetic and romantic hunt."

—De Chirico

The autonomy and self-assertion of the artist was promoted in another and comparably effective way by a rough and incredibly energetic peasant from the Doubs, a part of France adjoining north of Switzerland.

It may be questioned whether anyone in the known history of painting has more offended the public—both artistically and socially—than this grandson of a staunch Republican and unequivocal defender of the artist's right: not to offend others, but to be himself.

GUSTAVE COURBET has sometimes been unfavorably compared with Daumier in that the latter was modest, the former showing bravado in his rejection of the Academy and the state patronage of bad art and artists.

Daumier versus Courbet. But Daumier was modest by nature—at any rate since the early days during which he was incarcerated for an attack on the king. In his later career Daumier did not so much mellow, as alienate himself from the political world and turn towards problems in art. His best work—the only period of solid painting—was done in a stretch of several years when he did not do daily cartoons for newspapers, a task by which otherwise he supported his family.

It is sometimes claimed that these cartoons were necessary to his development as a tragi-comic artist. But it seems more likely that, had he been able to devote full time to painting from a relatively early age, he would stand as one of the very great painters of his century. As it is his work shows immense promise—his accomplishment, however, cannot be equalled with that of Cézanne or Van Gogh.

Courbet on the other hand could almost be said to have painted too much. He was a painter from his gut to his fingertips: we feel that no one could have either forced him to or prevented him from becoming one of the most dedicated, passionate, and instinctive of painters.

The Rebel. While his role in society was that of

rebel, and his resulting contribution to the historical career of the artist was profound, still this lay more in his posture—as genuine as it was flagrant—as a man. As an artist, Courbet merely started where others left off. Stylistically he was less revolutionary than Daumier. His art took root in the 17th century masters. In his own century he admired above all Géricault, and his earliest teacher had been a pupil of David. The directness with which Courbet approached the canvas, the immediacy with which he applied the paint, the sensitivity of his touch, and the completeness of his spontaneous devotion to the motif were hardly different in kind from the knife handling of Rembrandt, the fluid brushwork of Rubens, the objective immediacy of Velásquez, or the spontaneity of Constable.

Courbet's immense contribution to modern art chiefly stems from his later work in landscape and still-life. But what earned him a revolutionary name was the character of subjects which, in his early work he threw before the public in a form and with an advertisement they could not ignore.

Burial at Ornans. One of the grandest paintings of an illustrious century is Courbet's gigantic Burial at Ornans, now in the Louvre (Plate 50a). The author himself called it the burial of Romanticism. It is plain to see why. A score of life-size standing figures are spread across a sombre landscape above which stand the jutting rocks of Courbet's native countryside. Nothing is idealized or glamorized. Pallbearers hold their noses or turn their heads from the stench. The priest reading the Mass combines pomposity with hypocrisy. The gravedigger is bored, and the group of women mourners at the right look as if they had been paid for their performance. Yet there is nothing at all resembling caricature. For one thing, Courbet had no subtle sense of humor, at least not of the kind that can be communicated in art (in striking contrast to his fellow revolutionary Daumier). But more than that, the figures—for all their disillusionment—are so sincerely rendered, standing with such vigorous and uncompromising dignity, and the painting throughout is executed with such direct material splendor that the result has enormous weight, ringing long after, in the observer's memory, like iron-nailed boots upon that rocky soil.

It was the expansion of such a "low" or "common" or anonymous theme to a scale formerly reserved for renditions of heroic or special subjects, combined with Courbet's courageous, offensive, and inexhaustible self-advertisement that made him so notorious in his own society and inestimably important for the modern artist's independence. The violence of criticism was unexampled, before or since. But, as Delacroix (who had little reason to approve this anti-romantic art) observed, the farmer from Ornans was not the sort to be put down by a little antipathy. It would seem as if he relished it.

Even more than Constable or Corot, Courbet's reputation has suffered from some of the "compromise" pictures he painted for exhibitions. Though he was himself an uncompromising person, the need to advertise the basic values of this new realism, to hit the public over the head with it incited the artist to work up some studio pieces wherein the quality of finish could hardly be overlooked by the most academic critic or painter. The result was sometimes a virtuosity of paint-handling (for Courbet was one of those relatively few born painters, like Frans Hals, Velásquez, Manet, or Picasso). But it usually added up to bad art.

The reason for this is not simply over-painting so much as the fact that Courbet had—in order to make a good painting—to work directly from the subject, or as near to that as was possible in practice. This does not appear as a personal idiosyncrasy when we consider that the same was true for nearly every painter until the end of the century.

These studio constructions, in which an artificially posed model would be placed against a landscape backdrop, recollected all too much in tranquillity. Deer painted from carcasses rented from a butcher are stiff, dry, and damaging to the artist's reputation.

This is important to emphasize to an American public when we consider that the greatest collection of Courbet paintings on this continent—almost thirty in the Metropolitan Museum of Art in New York—usually presents as many bad pictures as good ones to public view. The result is a widespread suspicion of the author's bad taste. The French (for whom taste in general is far more important and by whom far better understood) hold no such illusions. They have always recognized in the handling as well as the composing of Courbet's prolific work a power, depth, and strength rendered all the more effective through the exquisitely passionate, lively yet sure execution of the paint surface with brush and palette knife.

A painting of a girl holding seagulls over her back against a beach and a deep sea and sky con-

tains passages of still-life not unworthy of the technique of Rubens, Rembrandt or Velásquez.

These qualities become more and more important as Courbet's style develops. From his early tendency to paint shockingly vivid genre scenes he turned increasingly to landscape. In this he stands for the general shift from Baroque to modern less literary subjects.

The landscapes are those of his native countryside—rocks, streams, and underwood, and at all seasons. Courbet was a great hunter, and his snow scenes rank high in all painting, though the deer in them might often be omitted. When they are, as in the Boston snow scene (Plate 49*a*), we find an unusual purity, intimacy and immersion in nature. If this picture is compared with a Sisley snow scene (Plate 49*b*) we see the difference between (nearly contemporary) examples of Impressionist as against Proto-Expressionist landscape.

Also, he loved to swim the ocean—the North Sea, that is, for this tempestuous mountaineer had little to do with the placid Mediterranean—and his marines are equalled in power and understanding only by Turner's. They range all the way between the two superb small pictures usually hung in the Metropolitan: the dark stormy sea (Plate 48*b*), and the calm, sunlit strand. But their exemplar is the great painting in the Louvre, variously known as the Stormy Sea, or simply, the Wave. Here is ocean without limit. The massive movements of the waves start from far beneath the scene, and the clouds tower infinitely into space. Water has no doubt been painted wetter, freer, or more joyful, but never with such incontrovertible cosmic force, nor such timeless being.

Courbet's Reputation. For a generation Courbet has been ridiculously low in public esteem, if not with artists or most connoisseurs by whom he has always been recognized. Van Gogh unreservedly admired the bronzelike solidity of his portraits. Renoir was profoundly influenced by his figure painting, and Monet by his renderings of the rock, the beach, the sea at Etretat.

In the twentieth century Matisse proudly owned a figure piece, and Segonzac one of the marvelous late paintings of a trout. Braque shows plainly the influence as well as much of the feeling of other still-lifes, in addition to the Etretat themes. Cubism proclaimed the inspiration of Courbet's direct painting. Picasso has made a version of Courbet's important picture, the Demoiselles aux Bords de la Seine.

But it is Cézanne, the most intelligent artist since Rembrandt, who most purely and evocatively expressed the attitude of many an outdoorsman and many a painter since: if the name of the master of Ornans was mentioned, Cézanne, without a word, would solemnly lift his hat.

MANET (1832-1883)

As revolutionary as Courbet, but different in nearly every other respect was the superb technician, EDOUARD MANET. An aristocrat in life and in art, his style was discriminating, at times almost effete. His compositions were as often as not borrowed from Renaissance devices, and his constructions tended to be so flat that Courbet himself denounced them as playing cards.

Yet the justness of Manet's sense of tone and of touch, combined with a color sensitivity and flair for truly creative effects through unexpected juxtapositions of tone, in delicate yet absolute authority, rank him among the pure painters of the highest rank.

Such qualities in paint were invoked by Manet to render a wide range of extraordinarily incisive sensations of taste, touch, and smell. But most important of Manet's contributions to modern art was in the relation of paint handling to the purely visual.

Turner long before had dissolved the material world into rhythms and phantasmagoria of light. Indeed a paint fabric suggesting the filtration of light and color had marked the work of Hals and Rembrandt, Velásquez and Goya, and, in the beginning, Titian.

Manet's Contribution. What Manet did was to render a lively fabric of light in terms of a paint surface of peculiarly French sensuousness,—a feeling for the mutual relationships between the material of the object chosen (above all still-life, but hardly less effectively figure and landscape), the light which reveals and activates it, and the thin, fluid, magical quality of the paint in which these terms are given.

IMPRESSIONISM

"The Sun is God" . . .
—Turner's last words

It is in this sense that Manet is properly the father of **French Impressionism**, though these paint-

ers owed hardly less to Courbet's avowal of the artist's right to paint that which counts for him; or to Delacroix' development of the principle of the vitality of juxtaposed colors.

There is impressionism in Goya, Delacroix, in Constable and Turner, in the marvelous and as of today justly popular Dutch painter of the middle of the century, JONGKIND. But Impressionism, capitalized, is usually given to refer to a few French painters—CLAUDE MONET, PIERRE AUGUSTE RENOIR, CAMILLE PISSARRO, and ALFRED SISLEY—who between 1870 and 1885 painted a broad group of astonishingly homogeneous pictures. They are distinguishable from earlier impressionist types by a sure, sensitive, and deeply felt sense for the life and love of material which has, for nearly a thousand years, been typically French. This love of the material was expressed more in their art than in the artists' lives. For the dealer Paul Durand-Ruel said, "If it had not been for American collectors, the Impressionists would have starved."

The general characteristics of Impressionist painting—may be roughly if simply given as follows: (1) a **rainbow palette**, that is, colors taken from sunlight, as through a prism, to the exclusion of earth colors (blacks and browns). This was essential to the belief that the truth of vision lay in the immediate appearance of things, that is, created by the light that bounds off the object and strikes the eye. Thus it is the light itself which purveys reality: this light is categorically sunlight.

(2) **The study of sunlight is most accurately pursued in the phenomena of shadows.** Pissarro insisted, for example, that shadow had not been analyzed by Constable and Turner.

(3) At its purest, **sunlight is experienced under conditions neither too bright nor too dull:** the former loses color in too strong reflections, the latter richness. Though maximum intensities vary according to hue, the strongest intensities generally appear in the middle value ranges. Impressionism often sought too the haze of color in very strong light.

(4) **Scenes which are offhand in subject and composition,** rather than dramatic, posed, or specially directed, are chosen, since the real subject of the painting is the light, the real hero the color.

Nevertheless this is not to say that Impressionist subjects are completely random or careless. It is not true that the Impressionists did not care what they painted. What they rejected was a preconceived view or aspect of the subject, since they wished—as Monet expressed it—to see as with the eyes of a child, that is, unprejudiced by knowledge and responsive only to visual images.

(5) **Themes.** But they cared a great deal for certain kinds of themes: Generally these have a holiday or vacation aspect, often though not exclusively summery, and almost always from the point of view of the spectator, the casual observer—the man whose eye looks for nothing in particular but is ready for anything. The observer himself is often portrayed within Impressionist pictures, corresponding to the attitude towards nature of the painter as observer.

Realism. More specifically the latter investigated a slice of nature. This represents the narrowing on the motif which begins with Constable and Corot, and continues with Courbet and Manet. A small section of nature, complete in itself, wherein the eye cannot wander (as in a Bruegel) but must take it all in at once without seeking chosen objects or events—these are the conditions requisite for an analysis of lights, shadows, and interacting tones.

Water is a natural element which promotes the active interplay of tones. Not a smooth glassy surface, certainly not the massive waves of the sea, but the rippled water of streams and ponds. Sailboats, with their ability to catch and cast reflections and the constantly shifting quality of their movement, not to mention the carefree, holiday aspect of their use, and the undirected purity of their movement, are naturals too, and it is not surprising that some of the pictures of sailboats on the basin at Argenteuil (near Paris) are as beautiful and characteristic pictures as the whole Impressionist movement produced.

Similarly, water as seen partially through trees along a riverbank, with the objects belonging to the far shore and their reflections almost interchangeable, are a favorite theme, as similar themes occur among the late, impressionistic pictures of Corot.

Other typical Impressionist themes are: outdoor eating, drinking or smoking places for folk in informal (for the time) attire, especially the famous Grenouillière just above Paris on the Seine, or dancing on the green or, railway sheds and steam engines (a theme originating with Turner) with all their vaporous variations, or ice or mist on a river, or water lilies in a pool, or suburban lanes overhung with casual foliage, or houses seen through

a network of trees, or the avenues of Paris with all their chatty, chaotic commerce viewed from a window above, or falling snow, or appleblossoms, or the grasses, paths, and poppies of an idle meadow in a perfect moment of sunlit peace.

Although French Impressionism was a remarkably cohesive movement in the annals of painting (two or more painters would often set up canvases side by side), the paintings of each man are never to be confused: each bears the mark of a specific temperament, and that too is a tenet of the style.

Monet (1840-1926) was in this sense the architect of the group. Though in all appearance casual, his canvases are always solidly constructed; the sense of planes is sure, even when established only by contrasts in tone. Also he is the most objective of the Impressionists in his interpretations of nature and of light. Cézanne was later to say of him—both in praise and blame—Monet is only an eye: but what an eye!

Sisley (1840-1899) was a slighter painter, but he often attained what we might call an absolute touch. There is a liquid tendency in his handling, a swimming evanescence in his atmosphere which mark the English strain (ever after Hogarth's wonderful Shrimp Girl of the 18th century the English have found salvation in water color). The paintings of Sisley and his wife by Renoir show a healthy even robust person. So too was Corot. Herein seems to lie the other side of Sisley, for there was much French in his ancestry. And much of his work, like Corot's, seeks a piquant, almost picturesque note in which nothing is exaggerated nor strained, yet the flavor is unforgettable (Plate 49*b*). Sisley's works should be better known by Americans, who have generally taken to Impressionism on the one hand and English attitudes on the other.

Pissarro (1831-1903)—a great teacher and something of a father confessor to many painters of that generation—was on the one hand more of a theorist, and on the other more earthy in his textural expressions of light effects than the other Impressionists. Some of his paintings gleam with a marvelous substance, rich and tangible, yet transformed into a truly religious fusion of spirit (light) with matter (soil, stone, and trees).

It would not be possible to emphasize too strongly a fact which is often ignored or given too little weight about Impressionist painting: that the latter represents in no sense a scientific approach to art (for although the studies of light by Monet

and others are strongly paralleled by the contemporary investigations of scientists proper like Chevreul and Rood, this latter work was consulted only by later painters like Seurat). Instead the prime motivation of Impressionist art is what could only be called a religious attitude toward the creative power of sunlight in nature, and its role in fusing all elements of the seen and felt universe in a marvelously alive and momentary, yet complete, recurrent, and therefore timeless unity.

Renoir (1841-1919). Such a radiance was rendered by Renoir during the early years of Impressionism in landscape, but fundamentally his was a classical temperament, and he loved above all subjects the female nude (Plate 44*c*). As Impressionism spun out and lost its force, Renoir turned to classical drawing and sculpture for an infusion of formal strength, clarity, and solidity. This in itself was hardly enough for a creative style, but towards the end of the century Renoir was able to fuse the Impressionist mode of light and color analysis with the rendering of the substantial human figure in an extraordinarily musical style which recalls Titian, Rubens, Delacroix and Courbet, but stands also very close to 20th century expressionism in its dynamic sense of color and pigment.

Rodin (1840-1917). Renoir was, along with Géricault, Daumier, and Degas, one of the leading makers of sculpture of the century, which had perhaps only one great sculptor who was not primarily a painter, namely Rodin. The latter's work—of which the best is in bronze, that is, cast from fluently modelled clay—may be considered a translation of Impressionist attitudes and technique into a highly viable medium. The 19th was not a century for sculpture. Painting had become very painterly, and sculpture either did the same, or was produced as a sideline by some of the outstanding painters.

The Late Monet. Monet never left painting. At the head of the century his art become more and more impressionistic, or vaporous, until his scenes were disembodied, and his light, from its early response to specific sensations under vivid natural conditions, took on the appearance of being self-created.

The water lilies are especially well-known. They predominate throughout the entire last part of his career (the first quarter of this century), and several examples (Plate 62*b*; tragically destroyed in 1958 by fire in the Museum of Modern Art) have recently brought loud and deserved acclaim on exhibition in

New York. They show the pursuit of a motif where-
in the artist peers into the surface of a pond, into
depths which reflect and echo the limitless spheres
of the sky through infinitely ramified submarine
spaces, so that we do not know where we are, and
the space goes beyond the bounds of earth. Yet it
always belongs to the world of floating plants and
submarine life, and the terms are those of botanical
morphology. At the end, Monet's work becomes a
prophecy of some of the most advanced painting of
the middle 20th century, especially in America.

POST-IMPRESSIONISM

We are at this point confronted with artists so
well known both through their modernity and de-
served popularity as to embarrass introduction. Cé-
zanne, Van Gogh, Gauguin, Seurat, Toulouse-Lau-
trec—these are the new old masters, and their prices
have never been higher.

All of them developed their styles by way of and
retained many of the key features of Impressionism.
For the most part they stuck to the rainbow palette,
and to bright, sunlit themes, with a keen flavor of
the out-of-doors even when painting indoor sub-
jects. They did not however retain the principle of
optical mixing with the spontaneous dash or comma
stroke which lent so much vitality and momentary
sensation to the early and typical Impressionist
paintings.

Conscious Aims. The chief aim of most of the
Post-Impressionists was to introduce to the spirit
and technique of Impressionism elements at once
more permanent and more meaningful at other
levels of experience than those of momentary sensa-
tion.

We have seen that Renoir managed to attain a
fusion of sculptural principles with Impressionism.
Cézanne did, among other things, the same for
architecture. Seurat sought a geometric patterning
of overall shapes and an intellectually controlled
manipulation of the strokes themselves in a sort of
squared-off dot technique. Gauguin introduced
broad symbolic forms often of a biologically sug-
gestive character. Van Gogh took off, so to speak,
from some of the Impressionist paintings of waving
flags or excitable visual effects and showed, through
an original and profound attitude towards human
suffering and toil, the close relationship between
Impressionism and Expressionism. Toulouse-Lau-
trec expanded and amplified the indoor Impres-

sionism of Degas—based on the sinuous and articu-
late line of Ingres and Holbein—and interjected
some of the grandeur and vigor of Michelangelo
(by way of Géricault and Daumier). The result is
a broad and lively style capable on the one hand
of producing some of the finest posters of all time,
and on the other oils, pastels, and lithographs of
extraordinary delicacy and verve.

Gauguin (1848-1903). Not a figure of absolute
greatness, PAUL GAUGUIN was still a very fine artist.
His life is well known through popular books and
moving pictures, and deservedly so, for his coura-
geous rejection of a comfortable life in favor of a
penniless existence where he could live amid the
roots of his art contributes an heroic legend in the
modern history of the independence of the artist.

Gauguin's paintings were usually of high serious-
ness and full of the sense of the life he knew and
its symbols—especially of the south seas, to which
he belonged in part by blood heritage. But they
tend sometimes to remain decorative or a little
thin. Possibly his graphic works (Plate 51*a*), above
all colored woodcuts, are the most successful, and
are being more and more appreciated for their im-
portance to 20th century Expressionism. These
should be seen in the prints pulled by Gauguin
himself (e.g., at the Chicago Art Institute) rather
than the far more frequent prints made by his son
from the original blocks after the master's death.
Some of these blocks are virtually works of sculp-
ture in themselves, so that the expressive quality of
each print depends on the peculiar way in which
it is rubbed.

Toulouse-Lautrec (1864-1901). Strikingly opposed
in temperament to Gauguin was TOULOUSE-LAUTREC,
scion of one of the oldest families of France, but a
cripple from an early age and for the most part re-
jected by his athletic father. During a career—as
well known to the public as Gauguin's—of increas-
ing alcoholism and immersion in the marginal areas
of Parisian life, this stunted genius produced im-
ages of dancers and harlots, clowns and enter-
tainers of all kinds in a life unblessed—images
which for bitter incisiveness combined with pro-
found compassion and sometimes heroic scale re-
mind us of Goya and of that most pervasively
humanitarian of all artists: Daumier.

Seurat (1859-1891). To die when you are little past
thirty is to gamble your reputation with fate.
Many of the greatest, had their careers been cut
off at this stage, would appear men of mere prom-

ise. But GEORGES SEURAT, starting young and sure, created in brief time one of the finest styles of his century and must be accounted one of its leading artists.

Refining many of the Impressionists' ideas—or perhaps it would be better to say attitudes—with intellectual rigor and a very nearly scientific approach, Seurat sought to render the tones of nature not as with a swift, impassioned sensation like Monet, but with studied care and precision (Plate 39a). He said at one point "Critics find poetry in what I do. No. I apply my method, and that is all."

In some pictures, like the famous Sunday Afternoon at the Grande Jatte, this methodicalness was pursued so far as possibly to over-refine the final result. Hundreds of studies in charcoal and oil were collated toward a large and highly complex composition of purely Impressionist subject matter: people sitting and strolling, relaxed but in Sunday dress, in the sun and shade of an island in the river. It is said that his friends helped the even progress of this long composition by cutting the grass for him.

Seurat's sketches were generally done on the motif, but he worked out the final integration of the composition at night, making carefully computed compensations for the color of artificial light. The result in this painting is superb, intellectual, and dry. For completeness and subtlety in the arrangements of shapes and the calculation of spatial relationships it has few peers. Yet many people prefer—for artistic sensibility and life—earlier, more vibrant versions such as the large and superb one now in the Metropolitan in New York.

By the same token, some of Seurat's paintings of the seaside, especially the beach and lighthouse at Honfleur, less controlled by theory and more by response to nature (Plate 39a), appear among his finest accomplishments, though less immediately striking than his large compositions. And one should never overlook the marvelous charcoal sketches, many of them concerned with interior light effects, wherein no lines are used, only such a richness and subtlety of tones that we are reminded of Goya's dictum: there are no lines in nature; give me a piece of charcoal and I will make you a picture.

VAN GOGH (1853-1890)

"Effects like the stained glass windows of Gothic cathedrals"
—Emile Bernard

There could hardly be more contrast, during that generation, between the sober, secret, formal, intellectualizing, scientifically oriented Seurat, and the self-sacrificing, obsessive genius of an ancient northern strain breathing wildness, ferocity and extraordinary tenderness, son of a preacher and the most truly religious artist since his compatriot Rembrandt.

Whereas Seurat liked to say, "I apply my method and that is all there is to it," VINCENT VAN GOGH said, "I want to paint men and women with that something of the eternal which the halo used to symbolize, and which we seek to give by the actual radiance and vibration of our colorings."

Van Gogh is one of the few suicides among outstanding artists. It is not hard to see how this was unavoidable, yet it seems a terrible loss to mankind. Had Van Gogh lived to paint more, it is conceivable that he might have produced a body of cosmic seascapes (just before he died he was planning to go to Brittany), along the path of the late work of Monet, but deeply impassioned, involved, and resolving of human emotions in contrast with the classical detachment of the Frenchman.

That quality can be seen in Van Gogh's earliest works, indigenous paintings really, where an old shoe, painted in black and brown, shows nothing of the Impressionists' interests in light reflections, but an extraordinary feeling of something belonging to a foot, resounding of the vigorous, weary, and impoverished life of the laborer in the soil. A fragment by Van Gogh often achieves what Millet, working over and over again on a conscious theme, could never quite pull off.

Drawing and Painting. This deep, vital, and unconfused passion sprang from Van Gogh into everything he touched with brush or pen. Nowhere is it more evident than in his drawings, which rank among the masterworks of graphic art. We are not surprised when he draws a stone seat in a garden overflowing with leaves, flowers, vines, and grasses, each characterized by a different kind of stroking with the reed pen, each with a distinct shape, character and patterning, each with the vital rhythm of its natural growth. But this infusion into pictorial forms of the inner life of the forms of nature extends as well to ordinarily inert forms, and we are reminded of Wordsworth's image:

"rolled round in earth's diurnal course
with rocks, and stones, and trees."

Van Gogh drew also in paint, but his paintings are

thickened by the infusion of a magic chroma, expressive (as he himself wrote) of human emotion in everything. Speaking of the study of color, he illuminates his own work:

> I am always in hope of making a discovery there, to express the love of two lovers by a marriage of two complementary colors, their mingling and their opposition, the mysterious vibrations of kindred tones. To express the thought of a brow by the radiance of a light tone against a somber background. To express hope by some star, the eagerness of a soul by a sunset radiance.

This radiance shows clearly in the pictures of orchards, of flowers and grasses, of the sun over a cornfield; but it is no less vital in the dark, thick, solid tangles of cypresses, or the artificial glare of billiard rooms and cafes after hours, or the tormented, deep-hearted turmoil of a starry night (Plate 52b) in interplanetary glory.

Superb as are Van Gogh's famous canvases done in the south of France under a burning sun, where all is aflame with passion and purity and truth, the most surpassing pictures are the last ones, done in the north again by a northerner, pictures of stirring cottages and hedgerows (Plate 59a), before or after a rain, where the line attains a complex of musical rhythms, and the light glows subtly, transcending even the keenest phenomena of nature, and creating another, more vital world without death.

CÉZANNE (1839-1906)

If, more than any other, Van Gogh inspired 20th century expressionism, wherein emotion seeks itself, or even if we concede that Van Gogh is singular among painters, along with Grünewald the most unapproachable, still we must concede that in total strength, range, and depth, Cézanne is the most formidable artist since Rembrandt.

And although this provincial Provençal came to have the most tumultuous influence—equally good and bad—amongst his own profession since the world-creating devastation wrought by Giotto, Cézanne did not think of himself as a revolutionary. He was quite serious when he affirmed: "One does not substitute oneself for the past; one merely adds a new link to the chain."

Development. Cézanne underwent an academic training, and early exercises show that he could draw quite as correctly after the model as any aca-

demic or commercial artist. By the same token his earlier paintings show far more use of correct perspective and proportions than his later work. The arbitrary representational features that developed in his style are thus based in a thorough acquaintance of such knowledge as had been developed since the Renaissance. Medieval artists, whose arbitrary rendering of space or of anatomy exceeded that of Cézanne, had based their expression on spiritual and emotive precepts, and never cared for literal nature to begin with.

Style. With Cézanne there is always a strong flavor of the life of nature as it is experienced through the senses, but all references to life experience are subjected to a compelling form which seeks—in his mature work—to do several things at once. First, to build up a strong and sure architecture of forms in space; second, to establish within that space a sculptural rounding of weighted objects so that their density as well as their position is assured; and lastly—in accordance with one of the deepest needs of modern art—to adjust all the above aspects to a pattern which may be experienced as a surface texture, constantly reminding the viewer that this is paint on canvas, consciously applied by the artist; and also necessarily referred to the size and shape of the frame.

But in addition Cézanne would infuse his work with a flood of natural light (Color Plate), which in itself must include both momentary (immediate and therefore vital) sensation, and at the same time a pervasive feeling of the timeless, monumental, and universal, for the artist wished—as he said in a letter—to render of impressionism something for the museums.

Now this character of light is effected partly by paint differences which suggest light and shade, but far more by paint used as pure color—that is, where a change in the tone of light is suggested by the juxtaposition of pure hue. Cézanne's color manages to establish space, solidity, momentary light sensation, permanent light effect, plus a texture of pure tones which in themselves unite the surface of the canvas, and in addition to all this: a character of color in any given painting which establishes a total mood, a color chord which contains within it notes that strike vibrations expressing the keenest passion felt about the objects and life of nature.

Gauguin relates a fine anecdote of Cézanne which reveals much of the Post Impressionist attitude:

Cézanne paints a brilliant landscape: ultramarine background, heavy greens, glistening ochres; a row of trees, their branches interlaced, allowing, however, a glimpse of the house of his friend Zola, with its vermilion shutters turned orange by the yellow reflected from the walls. The burst of emerald greens expresses the delicate verdure of the garden, while in contrast the deep note of the purple nettles in the foreground orchestrates the simple poem. It is at Medan.

A pretentious passer-by takes an astonished glance at what he thinks is some amateur's pitiful mess and, smiling like a professor, says to Cézanne, "You paint?"

"Certainly, but not very much."

"Indeed, I can see that. Look here, I'm an old student of Corot's, and if you'll allow me, I can put all that in its proper place for you with just a few skillful touches. Values, values . . . that's the whole story!"

And the vandal impudently spreads his imbecilities over the brilliant canvas. Dirty greys cover up the oriental silks.

"How happy you must be, Monsieur!" exclaims Cézanne. "When you do a portrait I have no doubt you put the shine on the end of the nose just as you do on the legs of the chair."

Cézanne seizes his palette, and with his knife scrapes off all of Monsieur's dirty mud. Then after a moment of silence he lets a tremendous (sigh) and, turning to Monsieur says, "Oh, what a relief!"

Color. Small wonder that Cézanne admired above all painters the great Venetians of the 16th century—Titian, Veronese, Tintoretto—that grand expansive school of pure painting who promoted the use of color to equal music. Cézanne seems to share this love of color as gorgeous fabric, and, like the Venetians, also ramifies the power of color relationships so as to construct a world deeper, richer, clearer and more harmonious than that which we inhabit.

Themes. The range within his painting is as impressive as the range of factors within any given work. Emphasis has so long and so often been put on the formal structuring within Cézanne's work that people sometimes overlook the subtle, pervasive, human, and above all natural content. There is not in Cézanne—as there is in Rembrandt—an overall searching to express an ideal of human dignity and value, turning at every point upon the relationship between outwardly visible and inwardly felt experience. But that does not mean that in Cézanne human expression is not there. Instead it subtly, even slyly, underlies the other values which dominate; but it is seldom lacking, and once seen is unforgettable.

If we look we may discover quite a good deal about the nature and attitude of Cézanne's father, his Uncle Dominic, his sadly sober wife, a few friends like the patrons Chocquet and Vollard, or the gardener Vallier, and above all the passionate, suspicious, authoritative and discreet instrument of contemplation that was the artist himself. In addition we receive keen impressions of the basic Provençal temperament expressed in card players, or a woman seated at a kitchen table.

Landscape and Still Life. But there are two other kinds of pictures that are more important than any of the pictures of people in Cézanne's work: still lifes, and landscapes. This fact seems to be far more than personal predilection, and represents a basic direction of the entire century.

Cézanne was most effective when working directly from nature. (A painting of melting snow at Fontainebleau which he did from a photograph has an unsatisfactory quality of thinness and artificiality—there is even something almost distasteful about it.) Cézanne himself noted verbally that it was necessary to work always from the motif, which for landscape meant out-of-doors. Something of the force of this is given in Cézanne's own observation: "to paint a landscape properly I must first discover the geological basis." Clearly that is a matter for experience and intuition, but hardly for scientific investigation.

But working from nature also means that the dominant element in his pictures is the world of Nature as distinguished from that of Man. It is in the realms of apples and tablecloths, of mountains, trees, rocks and waters that Cézanne achieves his richest, and most authoritative statements.

And from the motif marks a further development of tendencies already seen in Constable, Corot, and Courbet: the focusing on special, limited scenes, which are repeated over and over again, even from very nearly the same viewpoint, but seldom repetitive as pictures, for each is a new study in itself, developing from the particular character of the light, movement, density, and even temperature of the atmosphere, and the kinesthetic feelings, sensational responses, and inner attitude of the artist.

With Manet we may feel that his sense for still life dominated other scenes, like portraiture, figure painting, even landscape. With Cézanne it is the

architectural grandeur and dynamism of sunlit landscape that dominates all. In his still lifes table tops often begin to act as window sills, plants as grand arching trees, and tablecloths march like mountain crags, or descend like sturdy avalanches of snow (Plate 55a).

This does not detract from the felt density or even breakability of crockery, the firm, clean redness of apples, or the marvelously vibrating, mosaic-like fabric of the textured cloths. But one cannot escape an overall likeness to the feelings in his landscapes. For example in a work like the well known portrait of Gustave Geffroy (which took endless sittings) the figure itself rises like Mt. St. Victoire from the great plain of the table top, across which open books cut in flat diagonals like the long-worked fields of that architectural landscape near the Mediterranean and Italy itself (whence came Cézanne's ancestors). The fireplace and mantel are assembled of compacted cement—forms reminiscent of Cézanne's wonderful paintings of quarries. And the books, which on the top and bottom shelves vertically anchor the above mentioned mountain—and rock-like forms, at the long shelf which meets the head of the figure, incline with a wonderfully restrained dynamism like the rows of chestnut trees (in other paintings) leading in an avenue to Cézanne's ancestral home.

Cézanne and Older Art. This of course is only one aspect of Cézanne's art. There are so many aspects that only 50 years since his death he has become one of the most written about painters of all time. Yet one feels the surface has hardly been scratched. With Cézanne it is as with all truly rich artists: one must live with their works constantly and under many circumstances, during which process more and more things are experienced—both in the parts and in the whole—without in any way exhausting the work. At such a criterion perhaps only Rembrandt and Michelangelo outrank Cézanne among western masters of the visual arts.

Cézanne and the Future. Yet in Cézanne's last great landscapes—those done at the Chateau Noir, Lac d'Annecy, and Mount Sainte Victoire—a profound agitation of the spirit and an expressive development of the medium carrying almost beyond the bounds of art may at least remind us of those final, surpassing states attained by Michelangelo and Rembrandt themselves.

Cézanne's works mark a new direction in western art, which is foreshadowed in the work of Turner and Van Gogh: **the expansion of the visual field beyond the bounds of the normally perceived world, and the redistribution of the unit of measure into a cosmic rhythm.**

THE 20TH CENTURY

This new field of artistic activity could be approached either through the microscopic or the telescopic. The former was implied in Van Gogh's investigations into a sunflower, and may be characterized by many of the paintings of the Englishman GRAHAM SUTHERLAND, which (going back to Constable) pursue the life that lies within a blade of grass or a thorn, seeking a microcosm of the universe.

The telescopic direction was implied in Turner's snowstorms at sea (Plate 47b), or fire in the flood, where the rhythms and interrelations of material things go beyond that which is immediately sensed or describable. This direction is further characterized in the 20th century by the early (and best) work of Kandinsky (Plate 59a) where we sense operations in space, of stars and meteors and nebulae, or likewise in the work of the Americans Arshile Gorky and Jackson Pollock (Plates 59b, 63b)

Indeed one might make use of an analogy of these two basic drives as towards the world of biology and the world of astronomy. Such an analogy is too limited and not precise, for the former also verges on chemistry and the latter on physics. But we see now that the fields of modern art are comparable to the fields of modern science in that they pursue a realm at the center of which is the authority and mystery of Nature.

Another aspect of modern art is its Extremism—either of involvement or detachment. These are reflected in the antithesis of abstract as opposed to expressionist art, but are not identical with them. Such tendencies may have something to do with the extremism of 20th century life, but that seems a less satisfactory account than the outgrowth of tendencies which had been developing within the history of art ever since the Renaissance, and especially since Goya and Constable.

Another way to approach the character of contemporary art is to observe its specialization and segmentation. Like other fields of human activity in our century, art has developed its own laws, its own language, it own processes and mysteries. In an age when chemists are not readily understood

by physicists it is small surprise that painters are not readily understood by architects.

The "Isms" of Modern Art. Furthermore this direction in the history of art involves segmentation within the field itself. One aspect of this in the 20th century is the astonishing flourishing of *isms.* The process began with the beginning of modern art in the 19th century. Previous art we classify as belonging to a period style like Romanesque or Baroque (or even *Louis XVI*), and then to a place, as Flanders or Venice or Provence.

20th century art begins with **Fauvism,** of which Matisse was a leader, but which boasts as well such a fine painter as ALBERT MARQUET. Still centered in landscape, the Fauves ("Wild Beasts") are the final demonstration of how close impressionism and expressionism are in spirit.

What the "isms" imply is the growing self-consciousness of the artist, so that style is something that he adapts or seeks, rather than something that grows out of his time and place. This does not mean that the artists themselves invented the terms. For that has happened only lately, usually on the part of lesser artists, and often in self-defense, since many of the "isms" had originally derived from derogatory remarks by critics. But it does imply the artist's consciousness of the direction in which he is going. He feels himself a character in history, whereas Bruegel and Velásquez had lived consciously in the present.

Such self-awareness can also imply an inward turning. This characteristic marks the generation of Munch (Plate 53*a*), Ensor (Plate 63*a*), and Redon at the end of the 19th century, and their symbolism of the inner world of emotion is a transition to 20th century art.

None of the outstanding painters of the century are limitable to such categories. Either they go beyond it (as Matisse goes beyond Fauvism and Picasso beyond Cubism) or they are too big for it (as Klee is more than a Surrealist, Beckmann more than an Expressionist).

That, however, does not limit the meaningfulness of certain of the "isms" for our understanding of the nature of 20th century art. The two most important single movements in European painting and sculpture during the century are Cubism (chiefly French and Spanish) and Expressionism (chiefly Germanic). In these movements are reflected another kind of segmentation characteristic of modern art: the exploitation of one or another mode of experience to the exclusion of others.

Cubism and Expressionism. Thus Cubism (Plate 55*b*) exploits the intellectual, the contemplative, the ingenious, the "crafty" (which involves both the manipulation of the mind and the manipulation of the material). Expressionism cares only incidentally for such factors and seeks instead the emotional, the emphatic, the incisive, the compelling. Cubism is detached, Expressionism (Plate 53) is involved. Cubism concerns itself primarily with the life of forms, Expressionism with the life of meanings. The two are of course both essential to a genuine work of art—and in the end form and meaning are inseparable. But we might say that *Cubism gets its meaning from its forms, Expressionism its forms from its meanings.*

Despite their emphasis on the "inventive," serious modern styles like Cubism and Expressionism cannot be considered—at its best—as "experimental" art. The experimental has a place in art (think of Leonardo) just as it does in science, but that does not characterize the field. Art is by definition a solution, or resolution—it could not be *only* an experiment.

This was affirmed by Matisse when he said, "For me all is in the conception—I must have a clear vision of the whole composition from the very beginning." And also by Picasso: "To search means nothing in painting. To find is the thing . . . The idea of research has often made painting go astray, and made the artist lose himself in mental lucubrations. Perhaps this has been the principle fault of modern art."

The difference between these two poles of modern art is sometimes described as that between the intellectual and the emotional, or as that between the "mechanomorphic" and the "biomorphic." Such suggested polarities have certain descriptive value but are not good analyses because they are neither real oppositions (mutually exclusive) nor truly applicable to art.

For Cubism deals to a considerable extent with the world of sensations, both active and passive, which stimulate emotion; and Expressionism, no matter how impulsive, is keenly aware of the devices it employs (in contrast with childlike or primitive art) and thus contains an important intellectual element.

As for mechanomorphic or biomorphic: the so-called mechanical forms in Cubism are full of a

restrained but pulsating life, while the so-called biomorphic forms of Expressionism are subjected to a number of severely abstract means of shaping, coloring, and organization.

Form and Theme. The characterization of this basic dichotomy of modern art as that between **form and theme** may prove more illuminating, especially if we consider that the "form" school is represented by the older cultural traditions of France and Spain, and the "theme" school by the younger attitudes of the Germanic countries. For it would seem that the original motive in art is theme, for which forms are found to render it effective. And when the theme has lost its vitality the empty form remains.

Braque (1882-). This sounds like Mannerism, and in several aspects Cubism is analogous thereto. If we examine a Cubist painting by GEORGES BRAQUE (Plate 55*b*), we see the same narrow space, the ambiguity of planes, the precarious equilibriums, and the off-beat coloration that we found in the mannerism of El Greco. Throughout there is also a nervous agitation which is analogous (Cézanne's "anxiety" appealed as much to the Cubists as did his abstract formulation of shapes).

Unlike El Greco's, Braque's picture carries no religious import nor any *explicit* meaning of any kind. Any possible recognition of known visual forms is obviated by a most ingenious and inventive breaking up of shapes and reconstitution of remoter groupings—by continuing a line where not expected or breaking it off, so that a tight network of interweaving planes, shapes, and areas is created, but always ambiguous. For we are not sure when one plane is ahead of another, because part of it seems in front and part behind. This means that in fact there are no cubes at all in Cubism: "cubism" in the formal sense would be better applied to Raphael.

Picasso, indeed, has claimed that "Cubism is no different from any other school of painting. The same principles and the same elements are common to all." In this sense we can discuss Cubism *stylistically* quite as well as the style of El Greco or Rubens. We can say, for example, that Cubist forms are something like an assortment of playing cards, mostly parallel to the picture plane and within a very narrow space, but cards which are irregular and incomplete, and highly agitated in their parts. We could say that the single stroke is the basic element here as the stroke patch was to

Impressionism or the spotlight or area grouping to the Baroque.

Picasso also insisted, "When we invented Cubism we had no intention whatever of inventing Cubism. We simply wanted to express what was in us." And to some extent we can separate a Picasso cubist picture like "Ma Jolie" from a Braque despite the closeness in style. The Picasso seems to be dominated by a more rigorous, arbitrary overall composition, the Braque to be more discretely disposed. At the same time the latter, a Frenchman, is somewhat more sensual in his handling of the paint.

Despite this emphasis on considerations of form, there is a consistent *thematic content* in Cubism proper. The most frequently occurring parts of things which we can identify belong to tables, books, bottles and glasses, cigarettes and pipes, and perhaps above all musical instruments. Now these are objects of still life, but unlike fruit and flowers this is still life of a more permanent and quiet kind, usually manufactured and thus already abstract in shape: these are objects that are used by people in times and places of relaxation and contemplation.

Matisse (1869-1954). Much of this attitude appears in the work of HENRI MATISSE, who had nothing to do with Cubism, but who pursued to some extent line and shape, but especially the world of abstract color. What the manufactured object is to Braque and Picasso, the nude and flower is to Matisse. Renoir loved the same things, but in contrast with the earthy sensuousness of Renoir, Matisse developed an inventiveness of coloring which sought less the sensations suggested in flesh or fabric, more the sensations aroused by unexpected and extraordinarily subtle juxtapositions and interplays of pure color (Color Plate).

Behind this all the way is a long coloring tradition involving Manet, Delacroix, Watteau, Rubens, Velásquez, and ultimately the Venetians, just as behind the interest in form on the part of Cubism is that of Seurat, Cézanne, Courbet, Ingres, Poussin, Raphael, Uccello, Giotto. In each instance the 20th century painters pursue the abstract relationships primarily for their own sake, rather than their ability to clarify things seen or felt in nature.

The art of Braque or of Matisse is in the final judgment thinner, narrower, and less ambitious than that of Titian or of Cézanne. But the best work of Braque and Matisse is nonetheless of absolute quality: honest, dedicated, inventive,

strong, and pure. You can spend a great deal of challenging and rewarding time with such pictures, and they can change your life.

The same is true if we compare the best Expressionist pictures with earlier, more comprehensive painting which incorporated strong expressionist features and purposes, like the work of Dürer, Grünewald, Daumier, and Van Gogh.

Kirchner (1880-1932) A colored woodcut by KIRCHNER, the Ladies in the Street (Plate 53d) 1922, works upon a strong and pervasive rhythm of sweeping curves and jarring diagonals, all executed in a bitter, incisive line and roughened texture reminiscent of Gothic sculpture or manuscript illumination. The colors are garish reds, yellows, blues, and blacks so related to strike a clanging sound similar to that created in the lines and shapes. But unlike Gothic expressionism, which was created in the service of a Last Judgment, the expression here is of post-war poverty, apprehension, conflict, and chaos.

In contrast to Cubism the nerves of Expressionism are epochal and relentless, and the formal means remain means, forcing out of the recalcitrant material situations critical to society, feelings pervasively agitating and compelling to the artist.

Compared with the Apocalypse (Plate 27a) woodcuts of Dürer, Kirchner's are less complex, less rich, less sure. But they can attain absolute integrity (especially in the landscapes), which in the grip of such emotion produces a strong and pure vibration, and their artistic inventiveness—comparable to but in an opposite direction from that of Braque—renders their continued study keen and unforgettable.

Munch (1863-1944). The best artists of our time frequently call to mind earlier styles or attitudes in the traditions of western Europe: EDVARD MUNCH (Plate 53a) makes us think of Daumier and Gauguin, although his work is filled with a strangely northern, abstract, otherworldly light: that indefinable light beyond the Arctic circle, in contrast with Turner's.

Ensor (1860-1949) and Redon (1840-1916). JAMES ENSOR and ODILON REDON both recall the fantastic images of Jerome Bosch—Redon in a richly detached and subtly poetic refinement of lithography, Ensor in an earthy (Plate 63a), vivid excitement of highly variegated oil painting. And both, although chiefly 19th century artists, work in the cosmic rather than the earthly realm.

Klee (1879-1940). The Swiss, PAUL KLEE, brings to mind that wonderfully minute and imaginative world of the medieval manuscript (Plate 53c) or the tiny oils of the Van Eycks, though his well known symbolism is highly sophisticated and the handling delicately musical. In Klee's work we find extraordinary sophistication of material. Where the older artists used paint to suggest flesh, or stone, Klee uses paint to suggest fabric, wood, encaustic, mosaic, painting, writing—in other words, the **materials of art rather than nature.**

Nolde (1867-). Some of the work of EMIL NOLDE (Plate 53b) calls to mind Gothic woodcut at its strongest; yet, ironically, although this is a woodcut, it has a fluid quality suggestive of the (more self-conscious) technique of a wash-drawing.

Rouault (1871-1958). The French Expressionist, GEORGES ROUAULT echoes the deep, resonant mystery of Gothic colored stained glass windows and even re-creates some of their devices, although, like Daumier whom he also resembles, his images—whether of Christ or judges or tragic clowns—are non-specific, for their purpose is internal expression, not explicit doctrine as within Gothic art.

Mondrian (1872-1944). The Dutch abstract painter, PIET MONDRIAN re-creates the cool, clear, clean, sober yet rich and sparkling atmosphere—in pure lines, shapes, and colors—of the painting of his countryman Vermeer and architectural painters like Saenredam of the 17th century.

Modigliani (1884-1920) and Soutine (1894-1943). MODIGLIANI shows again the Italian love of the nude (Plate 54c), but in terms of a thinned-out Cézannesque style. SOUTINE reminds us again and again of Rembrandt, whom he revered, not only in style but even in themes, such as the beef carcass. But the expressionism of Van Gogh, another Rembrandt lover, was a necessary intermediary. Some of Soutine's twisted trees against a flashing sky seem to come right out of Van Gogh; or we might say that there is a sort of duck-tailed brush stroke in Van Gogh which becomes an entire pictorial motif for Soutine.

Kandinsky (1866-1944) and Chagall (1887-). Two of the most important painters of the century show little connection with earlier European traditions. WASELI KANDINSKY and MARC CHAGALL, both born in Russia, and both incarnating a rich and vibrant Russian spirituality, have devised without historical contexts new abstract and representative forms to embody marvelous fantasies.

Other Influences. The reader will have observed the omission of reference to the influence on modern

art of primitive, near-Eastern, and oriental art. This influence is readily documented and may be seen as early as in Manet in the middle 19th century (actually an oriental vogue can be found in 18th century France but its significance was ornamental), and is striking in the work of Degas, Van Gogh, Gauguin, Picasso and many artists of our century.

Such interests are a symptom of the catholicity, urbanity, and far-ranging sophisticated modern taste, and as such have more importance than as vital stimulus. The basic art movements of our time would have been achieved without them. Aztec images could have some genuine meaning for modern Mexican painting, but little for French or German other than in the example of their expressive directness and abstract purity.

As in the 19th century, much of the best sculpture of the 20th century has been done by painters: Picasso, Matisse, even Modigliani, not to mention the 20th century sculpture by chiefly 19th century artists like Degas and Renoir.

Sculpture. There are in this century pure sculptors, but they tend to be limited in style and range. MAILLOL has made a new classicism of robust innocence, but he is not so creative as Renoir, on whom his work is in large part based. CHARLES DESPIAU's work carries great distinction, but is not as inventive, say, as GIOCOMETTI's, which is, however, limited and repetitive.

In Germany BARLACH and especially LEHMBRUCK demonstrate vigor and enthusiasm, but their work is less compelling than that of the best German painters or graphic artists. In England HENRY MOORE—whose style derives ultimately from certain aspects of Picasso's painting—is unable to hide an intrinsic English landscape-feeling: his so-called figures are more like mountain ranges, and his sculpture is viewed at its best when mounted out of doors and against a landscape background. Possibly Moore's best work is his drawings: its nervousness and formal inventiveness make it challenging.

Pure and original sculpture is seen in the work of CONSTANTIN BRANCUSI. Here the reduction of the representational element in favor of the assertions of simplicity of form, and the exploitation of the qualities of the material as the main artistic aim, have had a healthy influence on sculpture and painting both. Works like the Bird in Flight or the Fish are by no means as simple as they may at first appear: the subtlety of the shaping combined with the refinement of textural possibilities renders them worthy of continued contemplation. Brancusi's work is most effective when seen in its own company where the mutual character is enriched.

Dada. Many of the best known 20th century artists are limited in other ways. Some of the work of the Dada school (e.g., the Fur-Lined Teacup) is genuine, even impressive, being born of the interest in inventiveness and the manipulation of the unexpected, and being pursued by people both serious and sensitive. But the lack of ambition and scope marks an ultimate lack of problem or of purpose.

Surrealism. There are two kinds. The "literary" Surrealists play games with psychic elements which they manipulate in ways that do not correspond to psychological reality. SALVADOR DALI is an exhibitionist—by his own admission, and Yves Tanguay though attaining some plastic quality, lacks significance.

Creative Surrealism is represented in the delightfully imaginative work of JOAN MIRO, of biomorphic overtones in free-floating associations. Still, Miro is a link with the past, for he has been inspired by Romanesque Catalan and even Egyptian frescoes, and likes to paint eyes—ideational and dream-like. Leonardo too was obsessed by eyes, but it was necessary for the Renaissance artist to have a head to put them in. Another creative Surrealist is ANDRÉ MASSON who continues to be a fine performer, often fusing a play on materials with the themes and forms of his pictures and prints.

Primitivism. Primitive painters like BOMBOIS and especially THE DOUANIER ROUSSEAU have sometimes created unforgettable images of native strength and vision. It is noteworthy of Rousseau that he was less ingenuous than sometimes appears: his studies are close to impressionism and also to Seurat's studies. Often the most creative aspects of his finished pictures are the more sophisticated landscape elements (Plate 51b) rather than the more primitive figure pieces. This is in striking contrast with Chagall, for example, whose ingenuousness is appropriate in the younger tradition of eastern Europe.

Dufy (1880-1953) and Utrillo (1883-1955). Certain of the best known European painters like RAOUL DUFY or MAURICE UTRILLO are popular because they have flair without really challenging the viewer. Dufy's early works show a similarity to and something of the promise of Matisse: later on Dufy, admirable and courageous as a person, became in his art decorative and slight. Utrillo likewise in his early

work indicates some of the possibilities for modern art of the vision and textural creation of Corot and Courbet, but Utrillo too often becomes repetitive and murky. Perhaps for just these reasons—a look of modernity without any disturbing force—Dufy is today so often found in drawing rooms and Utrillo in law or business offices.

Other 20th century painters like Picasso, Braque, Matisse, Klee, Kirchner or Beckmann deserve no less than their reputations. Two of these at least have achieved, late in their careers, consummations devoutly to be wished, with the result that the fabulous art of Western European painting—perhaps the richest of all the world's painting traditions—might go out not with a whimper but a bang.

Picasso (1881-) and Beckmann (1884-1950). PABLO PICASSO in the Guernica (Plate 57*a*), and MAX BECKMANN in the Departure (Plate 57*b*), have climaxed what now appears as the last Indian Summer of European painting. With Fragonard and Tiepolo—wondrous reflectors of the final stage of Baroque civilization—it must have seemed that European painting was over. Then came Goya, and Delacroix, and Daumier, and Cézanne, at each stage provoking new explosions of glory. Again with Cézanne all seemed over to those who looked for a comprehensive interpretation of the visible world.

But early 20th century Europe, again resurgent, produced the fine schools of Cubism and Expressionism. During the first World War these lost their vitality. The Twenties and early Thirties was a period of artistic dissipation.

Then in the middle to late thirties, as if sensing the coming catastrophe (just as artists had done before 1914) at least two masterpieces appeared. They represent a final triumph of will over a dying art tradition, and a commanding synthesis of the two vital forces in earlier 20th century art.

In Picasso's Guernica and in Beckmann's Departure the relentless experiments in abstract line, shape, mass, space, color and light of the Cubist and Abstract painters are developed as vehicles of the most uncompromising expression of the issues of their time, their society, and their own insides—the ground for which had been spaded by the Expressionists and the Surrealists.

The Guernica grew directly and swiftly and acidly in protest to the atrocity bombing of a non-military objective, the Basque town of that name (and birthplace of the artist's mother) in 1937. It is in the tradition of Goya's horrors of the Wars (Plate 42*a*), though less specific, being a general indictment of war's destruction. If this is propaganda, so is a Gothic Last Judgment.

Gothic too is the Departure which actually takes a tripych form, though not as a folding altarpiece but to provide a symphonic sounding of the contrast of central and accompanying themes.

The painting unmistakably trumpets the agony of its country's descent into darkness and anti-humanity: indeed it was necessary to label it "Scenes from Shakespeare's Tempest" for it to pass innocently through the hands of Hitler's inspectors who had already destroyed many of Beckmann's paintings as subversive. Yet like the flower springing from the broken sword in the Guernica, there is a strong sound of hope in the midst of the torture, destruction, horror and despair of the Departure. In the central panel, brave and serene figures stand in a boat in bright sun upon the open sea. They seem to take leadership over blind forces, and give direction from chaos.

Beckmann himself, though insisting that the picture speaks of things impossible to put into words, has remarked, "Departure, yes departure from the illusions of life towards the essential realities that lie hidden beyond." And one may call to mind an even more specific image: that of the Northmen of a thousand years ago, setting out through the unknown toward whatever lay beyond—which happened to be the American continent.

If the American art tradition has become, since Picasso and Beckmann and the Second World War, the most vital in the world, it cannot yet claim anything approaching the importance of its European parentage; nor is it likely to, for—as opposed to Europe—the strongest and most creative traditions in America have never been those of the arts, but instead belong to the realm of politics, economics, science, and law.

Nevertheless American art is formidable, vital, and promising.

AMERICAN ART

The oldest civilized art of the Americas came from the extraordinary "medieval" culture in Mexico, Central America, and Peru—a civilization clearly autochthonous despite its similarity in temper to some aspects of Egyptian civilization. For it too built unbelievably precise pyramids in stone, and was devoted to hierarchic as well as hieratic social forms. By the time it was wiped out by a handful of Spanish musketeers in the 16th century, it had developed a civilization far in advance—in subtlety and extent of political and economic organization—of its European destroyer.

The art belonging to this civilization is usually distinguished by the term **Pre-Columbian,** and shows a rich symbolic character and immense plastic vigor, especially in its compact **stone sculpture** which has provoked great interest among both laymen and artists of 20th century Europe and America.

Mexican Art. Modern Mexican art is another class of phenomenon. Choosing mosaic and fresco painting, and oil painting often on a large scale, its style shows a mixture of the Pre-Columbian with Spanish (especially in the death image) and native Mexican, as well as advanced abstract and above all expressionist art of 20th century Europe. Either this is too diffuse a background, with no one leading element, or this is not the time and place for the appearance of a significant painting style.

Despite the noteworthy talent of such painters as JOSÉ OROZCO (the best), DIEGO RIVERA, DAVID SIQUEIROS, or RUFINO TAMAYO the results are seldom entirely convincing as art. The theme is too programmatic, the style not sufficiently resolved in its own terms. Political or social commitment should not necessarily interfere with art, indeed it may well spur it (viz. Goya, David, Géricault, Picasso). But the result with 20th century Mexican painting—for whatever reason—is a painting style that appears too often muddled, blatant, confused, or even superficial when compared with German Expressionism of the early part of the century, which it emulates, or with North American Abstract Expressionism of the middle part of the century, which at its best attains a pure, strong, rich and creative style, not borrowed or conjured, but original and necessary. (The "primitive" revival of Aztec forms, by way of example, appears self-conscious, apart from the fact that there was nothing primitive about the great age of Aztec art.)

North American Art. American Art, as the term is generally employed, refers to the produce of the North American civilization established by Europeans in the 17th century. To a great extent it derives from European art traditions, to some extent it is surprisingly indigenous.

For example, the pictures by anonymous "limners" of colonial times were for the most part untutored by European styles, and show a wonderful primitive strength and inventiveness. They also show an incisive ability to penetrate personality and social role. This helps to distinguish them from much that we usually call primitive art. Though tending to be flat and linear, they are not without spatial grasp or sensitivity to the environment, which itself is quite keenly characterized. Perhaps most striking in such works is the forceful arbitrary shaping and distribution of deceptively simple elements, setting up a design ingenious in the use of repetitions and alternatives, and ingenuously expressive in a stiff and vital delineation of character or activity.

Copley (1738-1815). With JOHN SINGLETON COPLEY America produced her first painter of international importance. Copley's style and subjects are American, but he was familiar with certain kinds of European painting (the portrait vivacity of Van Dyck, the architectural sobriety of Poussin). The result in Copley's best work is an impeccably clear and rigorous design, but by now subtle and articulate as contrasted with much of the work of the limners. By the same token his characterizations (Plate 60a) carry fine overtones of complex expression and self-awareness on the part of the sitter, and are for a provincial colony highly civilized works. Yet in retaining such extraordinary directness in presentation and forthrightness in attitude, they mark themselves as belonging to an uncompromising frontier and a new brand of society.

With fame, Copley was enticed to Europe where the effete, diffused and melodramatic tendencies of the late Baroque contemporary British style of portrait painting overcame his native sense and then his strength, and his work was ruined. This was the beginning of a long, and to Americans devastating, trail of native talent whose art was damaged, wrecked or dissipated by return to the old country. Americans have never been guaranteed success by remaining in Kansas; only have they been more or less assured of emasculation by too long a stay in Europe.

Stuart (1792-1866). Compared with the sterling veracity and command of Copley's best work, the distinguished paintings of GILBERT STUART appear sophisticated and mannered, although the capture of personality and character is often striking. Their stylistic pedigree is superb, for it summons images of the technique of Gainsborough and behind him Van Dyck, Rubens, and ultimately Titian. In some of Stuart's famous paintings of George Washington (which probably are dubious resemblances, since they were done later in life) there are to be found marvelous passages of painting.

Other Figures. Between Copley and the great trio at the end of the century consisting of Ryder, Eakins, and Homer, there stands a vast quantity of American painting comprising only a few isolated artistic personalities of interest for more than documentation of contemporary themes.

GEORGE CALEB BINGHAM is one. His pictures not only show a wonderful quiet rich flavor of life on and near the Mississippi, but also are composed with a thoughtful monumentality and classic economy that recalls Poussin in temperament and style alike.

MARTIN JOHNSON HEADE has come in lately for long-overdue recognition as an indigenous painter of varying success, but at his best of clear integrity and striking originality whether in the sultry exoticism of a tropical still life, or the dark excitement of an approaching storm off a New England shore.

GEORGE INNESS, in some of his smaller and freer pictures attained a spontaneity in light and even an expressionism in paint which should not be overlooked; and a few painters of the **Hudson River school** sometimes attained genuine originality and substance, inspired along the banks, crags, and palisades of one of the noblest rivers to be found anywhere.

Whistler (1834-1903). JAMES ABBOTT MCNEILL WHISTLER though American born belongs really to English painting. He ranks as an Impressionist, though perhaps more for his etchings than his paintings, and possibly more than either for the publicity brought to the autonomy of the artist's role through his famous lawsuit brought against John Ruskin (Whistler was awarded damages of a farthing which he wore for a long time on his watchchain).

JOHN SINGER SARGENT's artistic substance is spread even thinner than Whistler's. An American cosmopolite, he travelled widely, worked anywhere though chiefly in a context of high society, and produced works of ingenious and charming paint quality but little originality or weight. His work might be thought of as a superficial popularization of Manet's sophisticated and richly artistic innovations.

Homer (1836-1910). WINSLOW HOMER was also a popular painter in that his work had its beginning in illustration or in illustrative painting. Even there however his style carries an integrity, a blunt facing of the subject, and an objective breadth which carry it beyond mere contrived illustration. Later Homer became a recluse on the coast of Maine, painting grand marines of waves and rocks, handsome and full of a feeling of cold, desolate, and impersonal nature, though if compared with similar themes by Turner or Courbet, Homer's are paler in depth, richness, imagination, or vital movement.

Probably Homer's most effective works are watercolors (Plate 58a), especially those of northern streams, rapids, and fishermen, where the spirit of outdoor life, action, danger, and natural sport are fused with a feeling for the fluid sparkle, decisive movements and raw tones of nature's environment.

Eakins (1844-1916). THOMAS EAKINS, one of our finest and strongest painters was a cool and sober student of vision and anatomy. His pictures are analytical and severe, but so marvelously inventive and directly spontaneous as to be full of life. This is far more true of the crystalline sailing and sculling pictures, structured by bridges and riverbanks (Plate 60b), than of the portraits and medical pictures which, despite fine distinction and characterization, seem a little soft, less authoritative or resolved.

Ryder (1847-1917). For it would seem as in Europe that landscape counts for more with our 19th century painters than other subjects. This is emphatically true of our greatest painter of that century, perhaps of all American painting: ALBERT P. RYDER. At first view a romantic and mystic Ryder

turns out to be an astonishingly solid, rich, and sober painter, whose works are deeply founded on the experience of nature. His small panels were built up painstakingly over months and years, until the forms were moulded nearly into three dimensions—and then he was never satisfied. He would quote Browning:

"The little more, and how much it is;
The little less, and what worlds away."

Ryder's pictures do not represent a dream world so much as a night-world. Anyone who knows intimately the moonlight, the sea, small working boats, or the night sky feels keenly alive in the presence of these small pictures (Plate 50c) which outweigh so many vast canvases of our countless academic painters. Ryder put the entire problem in words which can stand for all art: "What avails a storm cloud accurate in form and color if the storm is not in it?"

The so-called **Ash Can** painters of the turn of the century are often overrated as artists, though their contribution to the thematic content of American painting is considerable, since by stressing the significance of low-life subject matter they promoted an ingenuousness and immediacy of response that could lead to purer, more vital painting.

CONTEMPORARY AMERICAN ART

20th century American painting is prolific, frequently vigorous, often interesting, sometimes very good. We have had at least a few painters who demand serious attention, whose works are genuinely original, substantial, and will stand long looking.

JOSEPH STELLA's views of the Brooklyn Bridge take a good deal from European cubism, but are more than an American vernacular thereof, for they take their terms and activities from a native and forceful ambition, expansiveness, and cool analysis. They deal at a serious and creative level with the theme of the machine, which becomes here more vital to art than most of the contrived "mechanized" pictures of Léger. At the other end of the range of American subject matter is the mystical poetry of MARK TOBEY and MORRIS GRAVES. Something the same can be said for CHARLES DEMUTH, who however is far more delicate, and whose most effective works —the least mannered—are still lifes of flower motives.

Another watercolorist, MAURICE PRENDERGAST, made wonderfully substantial lyrics out of light and gay impressionist touches of color, establishing surreptitiously solid, deeply vital and freshly innocent scenes glorying in relaxed activities especially connected with the river and seashore.

Marine Painting. Indeed the marine is one of the strongest and most important traditions in American art. After Homer and Ryder, the outstanding American sea painters are MARSDEN HARTLEY and JOHN MARIN and ARTHUR DOVE (perhaps the most underrated of American painters). Hartley created firm, rich expressionist waves and rocks reminiscent of Courbet (Plate 61b) but germane to Maine; Marin, chiefly in watercolor, rendered sprightly, dashing whitecaps, sailboats, and spray, with abstract overall patterns (Plate 61a), and something of an oriental shorthand calligraphy. Dove (Plate 58b) was one of our most inventive artists, quietly forcing through to a genuinely modern style, without the mannerisms that sometimes afflict Marin, or limit a painter like Georgia O'Keefe.

By the early 1940's American painting was no longer dependent on European. American painting of the mid-century leads the world in power, creativity, and originality, and although European or for that matter Oriental influences and stimulations still have effect, we are most impressed by the inner development of our own art.

Abstract Expressionist Painting. In this art "abstract" refers generally to a form conception that refuses to present recognizable *shapes*, much less objects, and "Expressionism" to a freedom and spontaneity which is felt by the artist to take action from the unconscious. The work of the late ARSHILE GORKY (Plate 59b) and JACKSON POLLOCK, or of WILLEM DE-KOONING, or FRANZ KLINE (Plate 64b), for example, show an expansiveness, a vigor, and freedom from reference to any other kind of art which is unexampled in European painting. Gorky represents a transition from the cosmos of Kandinsky and the fantasy of Miro. Kline at times recalls Gothic woodcut or Rembrandt's action drawings. All tend toward extensive size for a new reason: a large oil painting like the Tintoretto Loaves and Fishes in the Metropolitan Museum is meant to be *taken in* from some distance as part of a grand room-decoration. A Pollock of comparable size is meant to be *gone into*. The spectator fights his way around in such canvases, he is not likely to sit back and be entertained: his time and energy are involved: the spaces are vast, the substances incredibly activated yet compelling and authoritative.

Pollock's works are typically (Plate 63*b*) very large not in order that we stand back as in a Baroque mural, but so that we are forced to come up close and lose ourselves in a vaster space than that which we usually inhabit. The painting forms show on the one hand the autonomy of the artist—his inventive actions as he works with the paint; and on the other hand a power to suggest deep transparent planes and endless cosmic motion. *But unlike a photograph of the heavens, which might show the specific appearance as light of heavenly bodies and movements, such paintings give what photography or even scientific description never could: a sense of immeasurable scale, a response to infinite motion, and an intuition of the vital creative force of the cosmos.*

DeKooning's famous "Woman" (Plate 64*a*) paintings are taken thematically from unidentified denizens of Manhattan, yet by the time the images emerge on large canvas they carry a haunting primeval force, part prophetic, part demonic. If we look again (and these pictures must be seen in the original) the piling up of sunlit passages and stormy sweeps breathes like the untamed snowy peaks of the western continent. Inextricably mixed with reminders of ancient violence is the sharp but remotely seen universe of the explorer yet to come. The work is abstract in the sense that it is directly apprehended as passages in paint (the spectator is aware of the painter painting)—the success of which requires years of hard experience of a high order. But a work cannot be purely abstract or it would be merely decoration. Herein are important issues of the artist's time. Over all is an indescribable sense of fate.

Sculpture. Of comparable temper is the work of the sculptor, THEODORE ROSZAK, who sometimes recognizes an explicit title, like the Spectre of Kitty Hawk, or states a particular purpose:

the forms that I find necessary to assert are meant to be blunt reminders of primordial strife and struggle, reminiscent of those brute forces that not only produced life but in turn threatened to destroy it. I feel that if necessary one must be ready to summon one's total being with an all-consuming rage against those forces that are blind to the primacy of life-giving values.

Contrary to some popular suspicion (augmented by exaggerated popularizations of the life of Van Gogh), artists are seldom violent or destructive except within the forms of their art and then chiefly for the purposes of creation. Far from art being a negative sublimation of our baser nature, it is a positive and productive activity. For the artist has nerves—the source at once of pain and exaltation—in high degree. But as Tolstoy said, "art should cause violence to be set aside. *And it is only art that can accomplish this.*"

Architecture. When we speak of art today we refer primarily to painting and sculpture. There are great architects and a great future for architecture, but it is today an engineering and designing art which deals with material and social problems. It is not the kind of art which can change the meaning of life—our grasp of the universe.

Architects and students of design recently are wont to look to a reunification of the arts with architecture at the top, or the center. This was actually tried in the Bauhaus movement of the Twenties, and resulted in valid architecture and the designing of objects, but no painting or sculpture of importance.

The unavoidable historical fact is that painting (with sculpture in attendance) has grown ever further away from architecture since at least as early as the 16th century. Furthermore it is painting which has taken over the role of the dominant visual art. This basic trend of our civilization can only become more and more pronounced, and we may as well take advantage of it.

The fact is that at no time in known history were the arts of architecture, sculpture, and painting in a true state of equilateral balance. Always one dominated and the others either followed—as in V century Greece, XVIII century France, or XVI century Italy—or else they went their own ways. Today architects on the one hand and painters on the other take little cognizance of each other, nor is there any reason why they should: their problem, their realm is entirely different, though not mutually exclusive, or necessarily at odds.

FRANK LLOYD WRIGHT has made American architecture justly renowned throughout the world. It remains to be seen what our painters can do.

ART AND LIFE

As painters they must (as Hartley said) paint for their own edification. A painter is neither a poet nor a philosopher, though their ultimate ends may be comparable. Each must work in his own language and vocation.

It is sometimes said today, there is no art, only artists. But this is meaningless. It is like saying there are men but no society. An artist always stands somewhere in a vital tradition even if (like Giotto) he is in part responsible for giving it life.

We still belong to the tradition of western art, in which the experience of space is a central problem and reality. Today the "Old Masters" are Picasso, Matisse, Klee. We repudiate them—as they did the Baroque masters—but not what they stand for. The space problem is to painting what "aesthetic pace" is to music. Beckmann set the strict reminder that

> height, width, and depth are the three phenomena which I must transfer into one plane to form the abstract surface of the picture, and thus to protect myself from the infinity of space. . . . If the canvas is filled only with a two-dimensional conception of space we shall have applied art, or ornament. Certainly this may give us pleasure, though I myself find it boring as it does not give me enough visual sensation. *To transform three into two dimensions is for me an experience full of magic, in which I glimpse for a moment that fourth dimension which my whole being is seeking.*

Theoretical science has glimpsed an "expanding universe" and something like that seems to have appeared in our painting, where we find the artist "moving about in worlds not realized." To speak of a fourth dimension or an expanding universe can have meaning only in the strictest theoretical context, and when used in connection with the visual arts serves as a metaphor.

It is metaphorical as well to describe the artist as a prophet, yet that has been one of his persistent historical roles. Artists anticipated the world conflicts of 1914 and 1939 with greater sureness and vividness than most politicians. By this it is not meant that the artist predicts specific historic events; we refer rather to his sense, in our time, of violence, and of the portent of catastrophe—of error and disaster. Certainly what the artist foretells and what he constructs must come out of integral experience. Dr. Griswold in a recent address at Yale has warned that "Creative ideas do not spring from groups. They spring from individuals." The individual artist is a functioning part of society, but his work must be independent and self-drawn.

This would appear to indicate a danger to our most promising artists in New York (the center of artistic energy) today. It was also a clear-cut danger in late 19th century Paris, and Degas warned,

> If the artist wishes to be serious—to cut out a little original niche for himself, or at least preserve his own innocence of personality—*he must once more sink himself in solitude. There is too much talk and gossip; pictures are apparently made,* like stock-market prices, by the competition of people eager for profit . . . all this traffic sharpens our intelligence and falsifies our judgment.

What the artist does and how he goes about it is not only his own business but his alone to judge. Today serious and knowing people speak of art as the salvation of society—almost like a new religion. And it is true that the artist is one of the few who are honest about all else—because they can conceive of being nothing else. But no artist worthy of the name thinks of himself as a Saint, or worries about religion.

He worries about feeding the children, and his passionate concern is with the progress of his art. And from time to time—when his resources near exhaustion and all his knowledge and experience seem to lead nowhere—he does what seems to be a recurrent necessity for revitalization and a sense of value: as John Marin urged, "the true artist must perforce go from time to time to the elemental big forms—Sky, Sea, Mountain, Plain—and those things pertaining thereto, to sort of retrue himself, to recharge the battery. For these big forms have everything."

But why our concern for the future of the artist? Does he only embellish or enrich our lives? Is he an adornment of society? The answer is: sometimes, but that is unimportant.

More important is the way the artist lives, his deliberate choice and his sacrifice are of supreme value and example for us as social beings. Thoreau could have said it, but Nietzsche did: "Only artists hate this slovenly life in borrowed manners and loosely fitting opinions; *they unveil the secret—everybody's bad conscience—the principle that each human being is a unique wonder.*"

Yet, even beyond what the artist stands for is what he creates: the living work. And what—of any ultimate value—does this provide? The painter Redon, speaking at once as artist and spectator, found that "the least scrawl of Delacroix, of Rembrandt, of Albrecht Dürer makes us start to work and produce. One would say that it is life itself they communicate and transmit to us."

THE CATEGORIES OF ARCHITECTURE, SCULPTURE, AND PAINTING

Although sculpture is not always or absolutely distinguishable from architecture on the one hand or painting on the other, it does nevertheless occupy a generally recognizable realm. Architecture tends to be utilitarian; whereas sculpture tends to be figurative or representational.

Painting tends to be **two-dimensional,** sculpture **three-dimensional,** although a painting surface can build up inches thick, and sculpture can be thinned out to scratchings on stone, from which in some cases prints (which belong to the realm of painting) can be taken.

Perhaps the simplest way to distinguish sculpture from painting is through its material: sculpture tends to be made with **substantial materials** like stone, wood, clay, or metal; painting tends to be made of **fluid materials** like oil, plaster, egg, ink, or water.

Sculpture may be distinguished from architecture usually by its role. A rain spout on a roof is in origin architectural. But if it is carved in the form of animal, demon, or pilgrim—as often happened on Gothic cathedrals—it may become a **gargoyle,** which is sculpture whether or not it retains its function as a waterspout, because its transcendent value here is as decoration, expression, or symbol.

Architecture, sculpture, and painting may all range greatly in size. Architectural size can vary from a tiny crypt to a pyramid or a cathedral. Sculpture may range from huge figures cut into mountains to figurines barely discernible. Painting size may range from a minute manuscript illumination to the vast vault of a Sistine ceiling or a roaming cave.

In **material** architecture may range from straw to steel; sculpture from the most intractable of stones to the most viable waxes or wires; painting from the thinnest washes of watercolor, or transparent glazes of oil twenty or thirty layers deep, to fresco plaster that has hardened and become a part of a wall, or mosaics of stones, metals, and gems.

To **experience** architecture it is usually necessary to be on the scene and to move about within, without, or even up and down the building. Sculpture may be transported, but it must be seen or handled in the original, or in a cast. Painting is more readily transported, but still must be experienced in the original. Graphic art produces prints, in other words, many originals, though cast sculpture can do the same. Some kinds of painting, drawing, or graphic work can be reproduced so accurately by photography as to be indistinguishable visually from the original, but as yet no satisfactory reproductions have ever been approximated for a complex oil painting by Rembrandt or Velásquez. The photographic reproduction of painting as of today might be said to be comparable to the shellac (78 rpm) **reproduction** of music.

Photography of architecture can be very useful if the color is good enough and if the movement of the camera is not arbitrary, but even three-D architectural photography cannot reproduce such extremely important experiences as orientation, scale, texture, and the immanent psychological sensations of volume, space, weight, mass or movement. In addition architecture usually has an important geographical context, which can only be partially indicated by photography.

Photography of sculpture has many of the illuminations of that of architecture, though it has the advantage of control over two problems faced by the sculptor: the source of light and the position of the spectator. Generally there is no reason to suppose that photography will not improve in its capacity to represent works of art; and already it has distinct advantages: Some experience is better than no experience; certain kinds of controls are more helpful than they are limiting; changing of size can be essential for home ownership or for study; it is impracticable for most people to travel to Cambodia, or even to charter a plane to fly over the cathedral of Chartres.

Most private owners of important works of art show a keen sense of responsibility to both artist and public in making it possible for their works to be seen, but there are interesting exceptions: the Barnes Foundation, in Merion, Pennsylvania, will not admit the public to see its extensive collection of masterpieces of 19th and 20th century painting.

Many crucial questions of art at law, indeed, are so far unresolved. Does an artist have the right to alter a work after he has sold it? Does the purchaser—whether public or private—own a work in the sense that he may destroy it? Is a work of art a commodity, or does it have values which call for a new legal classification? Most courts, when faced with such issues, have understandably avoided them and sought some other solution. The field seems to be wide open.

These social and legal questions may apply differently to architecture, sculpture, painting. We return at the end to observations of how the visual arts are inter-related.

Although each represents a locatable area, the areas overlap irregularly and in a triangular disposition. For example, **architecture and sculpture** tend alike to be of solid, space-consuming materials such as stone, wood and metal. Also they can be combined in the same piece of work, as in a Michelangelo tomb. This is different from what is meant in saying that Michelangelo's architecture itself (e.g. the apse of St. Peter's) is sculptural in character. And architecture and sculpture may be physically overlapping as in columns and statues.

The kinship between **sculpture and painting** is perhaps more obvious. Both create images, and represent —in such a time as ours—the imaginative as opposed to

the utilitarian arts. They can be mechanical, but the mechanism has no function outside an aesthetic one, (unless we are to consider a bell buoy a piece of sculpture, which is not the way in which the terms are used in this book). Such a relative purity of aesthetic also involves elements of surprise and the unconscious, expressed often in the handwriting, or "touch." Finally sculpture and painting tend to be affective arts, which architecture may but need not be. They are connected of course at many points—painted statuary, incised relief, and in the origin of printmaking: probably in rubbings from inked sculpture.

The kinship between architecture and painting on the other hand is less obvious and very interesting. Both are in a sense non-physical, that is they are not meant to be handled, as sculpture typically is, nor do they deal centrally in such properties as felt weight, density, or mass. Architecture and painting are then abstract in inception, and conjectural in experience. Where a sculpture is either freed or molded with the hands, and experienced either by the hands of the spectator or by visual processes closely related to handling, a building exists first as a series of abstract drawings on sheets of paper. It is then assembled by people who may but need not have anything to do with its artistic experience. This is later undergone by a spectator who walks in and around, views from afar or from the air, and must retain at once all these images in different sequences for a complete experience of the work.

And a painting may begin almost in a dream—or be motivated by morality or science. It is the supreme affective art, for we may say almost in definition that, in order to be art, paint must be transformed into color, line into rhythm, pattern into space. Painting and architecture overlap of course in mosaic, fresco, and stained glass window, or on the other hand in painted architecture (which in the Renaissance, for example, was often more advanced than built buildings).

But it is in their abstractness of conception and experience that architecture and painting are noted here for their similarities. In the West they have, at their most creative, been *remote* arts, as compared with the intimacy and presence of sculpture. It is hardly accidental that cathedrals and detached oil paintings are the most significant of the visual arts of the West.

TECHNIQUES OF SCULPTURE

by DUSTIN RICE
Sculptor, and Associate Professor in the History of Art,
Columbia University

Essentially there are two types of sculpture almost diametrically opposed, and best defined in terms of technique. On the one hand is the art of **carving**, that is, of removing material from a given physical mass. Opposed to this is the art of **modelling**, where the mass of the sculpture is built into empty space. Michelangelo, of vehemently plastic temperament, considered only the first method as worthy of being called sculpture, whereas Rodin, a more pictorial artist, accepted both types in the category of being properly sculptural.

Carving. In the art of carving the problem has changed little from ancient Egypt to modern times. In fact, from the time of Ancient Greece until the end of the 19th century even the basic tools remained the same. As one of the basic factors in the art of carving it must be remembered that stone is most readily quarried in oblong blocks and that this shape tends to dominate the resultant figure especially as in Egypt and Mesopotamia the artist worked essentially with abrasives which wore the stone down much as if he were employing a file. This meant that the artist tried to get the maximum results with the minimum amount of cutting and thus the figure in its final shape always maintains an overall blocklike form.

Although early in the first millennium B.C. the Greeks had started to use bronze, and then iron tools; they essentially followed earlier Mediterranean concepts of reducing the original block gradually down to the figure, and it was not until the fifth century B.C. that they invented those tools which are still used today: tools which freed the figure from the confines of the block and furnished its articulation.

Tools. These basic tools can be summed up as follows: the **point**, which is rather like a very heavy lead pencil, but made of steel, is used to cut the general outlines of the figure down to approximately one inch from the desired final surface. The **tooth chisel**, which is a serrated ordinary flat chisel, varying in size and number of teeth, is used then to cut the stone down to within an eighth of an inch from the desired surface. Finally the **flat chisel** takes the sculptor down to the final surface, preparatory to polishing.

The polishing of stone is accomplished by rubbing with a series of **abrasive stones**, each of which becomes finer and finer until the original receives its desired sheen. Every kind of stone has its own character, just as each type of jewel has its peculiarities; thus the choice of the stone and its finish is uppermost in the sculptor's mind when he undertakes the work.

Although the **drill**—which facilitates cutting—was introduced by the Greeks, it found its most widespread employment among Roman and Byzantine sculptors who had less insistence than the classic Greeks on the purity of chiselled planes and surfacing.

Modelling. The other basic type of sculpture—modelling—builds up the mass in clay, wax, plaster, or some other medium soft enough or pliable. The sculptor starts with a **wire skeleton**, or **armature**. This is an additive process rather than a detractive one, as in carv-

ing. Gradually the artist adds more and more of his soft material as he searches for the precise application to bring the image to completion. When the work is done it is often turned over to a craftsman who produces the image in bronze or stone according to the original plan.

The problem of casting in bronze was dramatized by Benvenuto Cellini in his *Autobiography*. The technique today is essentially the same as used in the Renaissance. The most frequent method is the *cire-perdue* or "lost wax" process, in which the original wax is melted out of the mold (usually a heat-resistant plaster) and substituted by bronze. This can be repeated and each bronze is a unique original cast.

The bronze may then be left rough, resembling the texture of the originally worked clay, or it may be highly polished, developing a sheen of its own. In the course of time it will tend to turn greenish grey in a chemical change which produces **patina,** often delectable to connoisseurs.

Also the bronze may be painted. As indeed most sculpture was until the Renaissance. Since then sculptors have taken a more puristic attitude toward the nature of the original material.

A freestanding figure meant to be seen from all sides is sculpture **in the round,** although such sculpture can also be mounted on architecture. **Relief** sculpture is either carved or modelled from a plane. If it is fairly deep, say more than half-rounded, it is called **high relief.** If shallower, to the extent of telescoping planes or even etched lines, it is called **low** or **bas relief.**

The modern sculptor, aware of all these techniques and possibilities, makes his choice depending on what he seeks to express. Also he has at his command certain new techniques, the most significant of which is the acetylene torch, which makes **braising** and **welding** possible in the studio. In this technique the sculptor adds metal to metal in the same way that older artists added clay to clay. This obviates the casting process.

The modern sculptor on the other hand has reverted to the old technique of carving stone which is called **"taille directe,"** that is, direct carving without making a preliminary sketch in clay; this term has been extended to include all handling of materials in which no preliminary sketch is made.

All the same time the modern sculptor is willing to employ wide varieties of manufactured parts (e.g. nuts and bolts) or even entire objects (e.g. automobile or plumbing parts) in his work, since to him any plastic organization conceived by the human hands, no matter what the technique, can be art.

TECHNIQUES OF PAINTING AND THE GRAPHIC ARTS

by GILBERT F. CARPENTER
Painter, and Instructor in the History of Art, Columbia University

A painting is an object. Its object-character is often subordinated to the more or less carefully simulated objects that it may depict, but as an object it has a complicated structure that demands the deliberate attention of the artist. This structure usually consists of three parts: **the support, the ground, and the paint layer.** The **support** is normally a wooden panel or a cloth (canvas) stretched on an inner frame, or, for fresco, the wall of a building. The **ground,** as an intermediate layer, is included to provide an ideal surface for the application of the paint layer. It can be white in color or variously toned; it can be worked down to a perfectly smooth surface or textured in a variety of ways. The **paint layer,** regardless of media, is composed of colored powder (pigment) and a **binding agent.** The pigments for all kinds of painting are approximately the same, but the various binding agents have decidedly different properties and therefore have a marked effect on the final appearance of the painting.

Water Color. The simplest binder is a water-soluble glue (gum arabic) which is the basis of the **water-color** technique. Applied in a thick layer the paint is so susceptible to atmospheric moisture that it is not very durable. However when it is applied in a liquid consistency it allows effects of transparency and spontaneity that cannot be attained in other media. Watercolor paintings are usually executed on paper. The absorbency of the paper demands firm decision on the part of the artist, since errors are not easily covered. In the last century this technique has become particularly popular, perhaps because of the developed preference for landscape painting. The equipment for water color painting is light and portable, the method rapid. This makes the technique ideal for working outdoors before the subject.

Tempera. The tempera technique was standard for small paintings in Europe well into the Renaissance. The binding agent here was traditionally one of the natural emulsions (a solution of watery and oily constituents): the yolk or the white of egg, or casein derived from milk. The usual ground for a tempera painting was a carefully smoothed layer of **gesso** (glue and white chalk) on a wooden panel. This ground was very absorbent. Therefore, when the tempera paint was brushed on, the watery elements of the emulsion sank into the ground, and the paint "set up" (half dried) almost immediately. In this condition the paint could not be freely moved around; transitions of tone were necessarily built up of thousands of tiny but separate brush strokes. This makes the process systematic and the product strongly linear. The oily elements of the emulsion dried slowly producing a stable paint film with a wax-like gloss on the surface. Historically, tempera painting was largely displaced by oil painting in the 15th century.

Oil. The oil technique uses as a binder a natural drying oil such as linseed oil or one of various nut oils. In

the fully developed technique the support was usually a linen canvas with a ground of white lead in oil. This ground was non-absorbent. The oil paint was pasty—about like tooth paste—and it "set up" so slowly that it remained workable on the canvas for from 24 to 72 hours. Therefore the paint could be worked in thick, pasty layers (impasto) and blended with greater variety and facility than tempera. The depth and opacity of the color allowed a greater dark-light range than tempera. For effects of transparency the paint could be diluted to almost any extent and applied as thin veils of color. This is known as glazing. This variety of effect and freedom of handling was not obtained without some sacrifice. Unlike the yolk of an egg which loses its color soon after it dries, linseed oil tends to yellow. In cases where excessive oil was used this yellowing has considerably altered the original colors of the picture.

Fresco. The technique of fresco painting was commonly used for mural paintings (permanently fixed to the wall in contrast to the movable easel painting). In fresco the pigment is mixed only with water before it is brushed onto the fresh, wet plaster of the wall. The brushing action disturbs superficially the film of lime on the plaster surface. The lime is incorporated with the pigment and, on drying, becomes the binder. The large size of mural paintings makes it necessary to paint them over periods of weeks, months, or even years, but each day's work must be completed in the three to six hours before the plaster hardens. It is difficult to match one day's work exactly with another's because of the color changes that occur during the drying stage when the plaster turns from the grey of the wet state to brilliant white. Therefore in the work of even the best artists it is usually easy to pick out the day marks. If it is necessary to make a correction in any part of the dried work, the affected part must be chiselled out, replastered and painted. It is usual for the artist to begin work on the wall at one of the top corners, then to continue systematically back and forth across the wall until he finishes in one of the lower corners. This system has no relation to the compositional or interpretative problems posed by the particular painting; these problems must be completely solved before the painting is begun. For this reason the work on the wall is usually preceded by unusually comprehensive preliminary studies which include a full-sized working drawing or cartoon. The fresco technique is ancient. The works are as permanent as the walls upon which they are painted. The pigment is necessarily applied in a thin layer, for any pigment that is not bonded with the lime will soon dust off. This limits both the darkness and the brightness of the color because some of the white lime always glows through the pigmented surface.

Stained Glass and Mosaic. Stained glass and mosaic were also widely used in conjunction with architecture. In some of the earliest and finest stained glass windows unmodulated sheets of colored glass were cut to proper size and shape, then secured in the desired pattern by lead strips. Only the most essential details were added to certain panes by dark lines which were baked onto the surface of the glass. In later periods technical facility yielded more and more variation of color and tone within the individual panes.

A **mosaic** is composed of small pieces of colored material (tesserae) embedded in plaster to secure them to the wall. The tesserae were squared pieces of stone or of colored glass. The technique was slow, cumbersome, and indirect, but the color body and the faceted surfaces of the tesserae impart to the wall a glistening richness that is unmatched in other techniques.

Graphic Arts. In certain periods social and economic conditions made it desirable for artists to produce their works in multiple copies. The various methods devised for this purpose are generally grouped under the heading graphic arts. For our purposes the intaglio printing processes are the most important. In intaglio printing the lines inscribed in the plate are printed on the paper. To do this ink is applied to the whole surface of the plate, then wiped from the high parts and left in the lines. A paper is then printed by placing it on the wiped plate and subjecting it to sufficient pressure to pick up the ink out of the recessed lines. In contrast to this the relief printing of the wood or linoleum block prints the high parts of the plate and leaves the recessed areas white. The principle intaglio techniques are engraving, etching, and dry point. In each case the design is executed on a polished metal plate. The printed sheet (*proof*) reverses the design on the plate.

In engraving, the line is inscribed with a burin, a steel rod of triangular cross section with a beveled point, which, when it is pushed across the plate, removes a thread-like strip of metal from the surface. This engraved line can vary in width and is extremely clean, sharp and clear, but the muscular discipline required by the task limits the freedom and spontaneity of the line.

To make an etching the metal plate is first covered with a layer of wax. The drawing is made on this wax with a sharp point which exposes the metal. The plate is immersed in acid. The exposed lines on the plate are attacked by the acid, and a pattern of depressions matching the drawing is produced on the plate. Slightly below the surface of the metal, the acid eats outward as well as downward and undercuts the etched line in contrast to the V-shaped trough of the engraved line. This limits the life of the plate and gives to the etched line a somewhat ragged appearance. These disadvantages are offset by the ease with which the artist makes his original drawing. The wax offers no resistance to the drawing point; there is no limit to the variety or complexity of the linear development.

A dry point is produced by scratching the plate with a sharp point. Unlike engraving, the metal is not actually removed, but is displaced to one side of the furrow or the other. The line really consists of two parts, the depression and this displaced curl of metal called the burr. The burr retains the ink during the wiping process and gives to the dry point line a distinctive fuzziness when it is printed. The dry point plate is comparatively fragile because the burr soon begins to flake off under the pressure of the press. An edition of only 25 to 50 proofs is normal.

Lithography, a technically more complex print medium, came into widespread use in the 19th century and remains one of the most popular of print media. It allows special effects of tonal density and gradation. The drawing is done with an oily pencil or ink on porous stone. In the subsequent treatment of the stone the parts touched by the drawing media develop an affinity for the printing ink, the other parts repel it. Therefore the proof taken has all the qualities of the original drawing except that it is a mirror image.

Another new and popular print medium is the **silk screen.** This is essentially a stencil process. A fine silk cloth is stretched on a porous frame. To achieve the design the porous structure of the cloth is filled at places by an application of plastic (this can be brushed on or applied as a film). The prepared cloth is then placed on a paper and ink is forced through the porous parts of the cloth, thereby transferring the design to the paper.

APPENDIX B
LIST OF ARTISTS
MENTIONED IN TEXT

The following is an alphabetical listing of artists,
their school, birth and death.

Altdorfer, Albrecht	German	1480-1538
Angelico, Fra (Giovanni da Fiesole)	Italian	1387-1455
Baldung, Hans	German	1476?-1545
Barlach, Ernst	German	1870-1938
Beckmann, Max	German	1884-1950
Bellini, Giovanni	Italian	1426?-1516
Bellows, George Wesley	American	1882-1925
Bingham, George Caleb	American	1811-1879
Bosch, Hieronymus	Dutch	1462?-1516
Botticelli, Sandro	Italian	1447?-1510
Boucher, François	French	1703-1770
Boudin, L. E.	French	1824-1898
Brancusi, Constantin	Roumanian	1876-1957
Braque, Georges	French	1882-
Brouwer, Adriaen	Flemish	ab. 1605-1638
Bruegel, Pieter (The Elder)	Flemish	1525?-1569
Brunelleschi, Filippo	Italian	1377-1446
Caravaggio, Michelangelo Amerighi	Italian	1569-1609
Cassett, Mary	American	1845?-1926
Cézanne, Paul	French	1839-1906
Chagall, Marc	Russian	1887-
Chardin, Jean Baptiste Siméon	French	1699-1779
Charpentier, Constance	French	1767-1849
Constable, John	English	1776-1837
Copley, John Singleton	American	1738-1815
Corot, Camille	French	1796-1875
Courbet, Gustave	French	1819-1877
Cranach, Lucas (Müller)	German	1472-1553
Dali, Salvador	Spanish	1904-
Daumier, Honoré	French	1808-1869
David, Jacques Louis	French	1748-1825
Degas, Edgar	French	1834-1917
DeKooning, Willem	American	1904-
Delacroix, Eugene	French	1799?-1863
Demuth, Charles	American	1883-1935
Despiau, Charles	French	1875-1946
Donatello	Italian	1386-1466
Dove, Arthur	American	1880-1946
Duccio di Buoninsegna	Italian	1260?-1339?
Dufy, Raoul	French	1880-1953
Durer, Albrecht	German	1471-1528
Eakins, Thomas	American	1844-1916
Ensor, James	Flemish	1860-1949
Eyck, Hubert van	Flemish	1370?-1426
Eyck, Jan van	Flemish	1390?-1440
Fouquet, Jean	French	1415?-1480?
Fragonard, Jean Honoré	French	1732-1806
Francesca, Piero Della	Italian	1420?-1492
Gainsborough, Thomas	English	1727-1788
Gauguin, Paul	French	1848-1903
Geertgen Tot Sint Jans	Dutch	c. 1465-1493
Géricault, Théodore	French	1791-1824
Ghiberti, Lorenzo	Italian	1378?-1455
Giorgione da Castelfranco	Italian	1478?-1511
Giotto di Bondone	Italian	1276?-1337?
Goes, Hugh van der	Flemish	?-1482
Gogh, Vincent van	Dutch	1853-1890
Gorky, Arshile	American	1904-1948
Goya, Francisco	Spanish	1746-1828
Graves, Morris	American	1910-
Greco, El (Dominico Theotocopuli)	Spanish	1548?-1625
Grünewald, Matthias	German	fl. 1500-1530
Guardi, Francesco	Italian	1712-1793
Hals, Frans	Dutch	1581?-1666
Hartley, Marsden	American	1877-1943
Heade, Martin Johnson	American	1819-1904
Hogarth, William	English	1697-1764
Holbein, Hans (The Younger)	German	1497?-1543
Homer, Winslow	American	1836-1910
Ingres, Jean Auguste Dominique	French	1780-1867
Inness, George	American	1854-1926
Jongkind, J. B.	Dutch	1819-1891
Jordaens, Jakob	Flemish	1593-1678
Kandinsky, Wassili	Russian	1866-1944
Kirchner, Ernst Ludwig	German	1880-1932
Klee, Paul	Swiss	1879-1940
Kline, Franz	American	1910-
La Tour, Georges de	French	1600-1652
Lehmbruck	German	1881-1919
Le Nain, Louis	French	1593-1645
Leonardo da Vinci	Italian	1452-1519
Leyden, Lucas van	Dutch	1494-1533
Lorrain, Claude (Claude Gelée)	French	1600-1682
Maillol, Aristide	French	1861-1944
Manet, Edouard	French	1832-1883

Mantegna, Andrea	Italian	1431-1506
Marin, John	American	1870-1943
Marquet, Albert	French	1875-1947
Masson, André	French	1896-
Masaccio	Italian	1401-1428
Master of Flemalle (Robert Campin)	Flemish	1379?-1444?
Matisse, Henri	French	1869-1954
Memling, Hans	French	1430-1495
Michelangelo Buonorroti	Italian	1475-1564
Millet, Jean François	French	1814-1875
Miro, Joan	Spanish	1893-
Modigliani, Amedeo	Italian	1884-1920
Mondrian, Piet	Dutch	1872-1944
Monet, Claude	French	1840-1926
Moore, Henry	English	1898-
Munch, Edvard	Norwegian	1863-1944
Myron	Greek	fl. B.C. ab. 450
Nolde, Emil	German	1867-1956
Orozco, José Clemente	Mexican	1883-1949
Prendergast, Maurice	American	1859-1924
Perugino (Pietro Vannucci)	Italian	1446-1523?
Phidias	Greek	B.C. 500?-432?
Picasso, Pablo	Spanish	1881-
Pissarro, Camille	French	1831-1903
Pollock, Jackson	American	1912-1956
Poussin, Nicholas	French	1594-1665
Raphael Santi	Italian	1483-1520
Redon, Odilon	French	1840-1916
Rembrandt van Rijn	Dutch	1606-1669
Renoir, Pierre Auguste	French	1841-1919
Rivera, Diego	Mexican	1886-
Rodin, Auguste	French	1840-1917
Roszak, Theodore J.	American	1907-
Rouault, Georges	French	1871-1958
Rousseau, Henri Julian	French	1844-1910
Rubens, Peter Paul	Flemish	1577-1640
Ruisdael, Jacob	Dutch	1628?-1681
Ryder, Albert Pinkham	American	1847-1917
Sargent, John Singer	American	1856-1925
Schongauer, Martin	German	1445?-1491
Seurat, Georges	French	1859-1891
Signorelli, Luca	Italian	1441-1523
Siqueiros, David	Mexican	1898-
Sisley, Alfred	French	1840-1899
Sluter, Claus	French	1345-1405
Soutine, Chaim	Lithuanian	1894-1943
Stella, Joseph	American	1880-1946
Stuart, Gilbert	American	1755-1828
Sutherland, Graham	English	1903-
Tamayo, Rufino	Mexican	1899-
Tiepolo, Giovanni Battista	Italian	1696-1770
Tintoretto (Jacopo Robusti)	Italian	1518-1594
Titian (Tiziano Vicellio)	Italian	1477-1576
Toulouse-Lautrec, Henri de	French	1864-1901
Turner, Joseph Mallord William	English	1775-1851
Uccello, Paolo (Paolo di Dono)	Italian	1396-1475
Utrillo, Maurice	French	1883-1955
Vanbrugh, John	English	1664-1726
Van Dyck, Anthony	Flemish	1599-1641
Van der Goes, Hugo	Flemish	?-1482
Van Gogh, Vincent	Dutch	1853-1890
Velasquez, Diego	Spanish	1599-1660
Vermeer, Jan (Jan van der Meer)	Dutch	1632-1675
Veronese, Paul (Paolo Cagliari)	Italian	1528-1588
Verrocchio, Andrea del	Italian	1435-1488
Vinci, Leonardo da	Italian	1452-1519
Watteau, Jean Antoine	French	1684-1721
Weyden, Rogier van der	Flemish	ab. 1400-1464
Whistler, James Abbott McNeill	American	1834-1903
Wright, Frank Lloyd	American	1869-

INDEX AND GLOSSARY

159

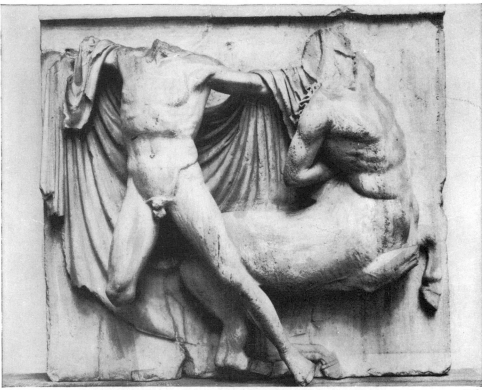

(*a*) CENTAUR AND LAPITH. METOPE 27 FROM THE GREEK PARTHENON (MARBLE). 5TH CENT. B.C.

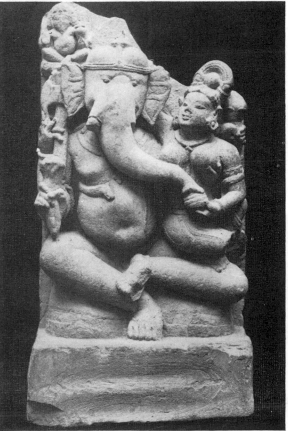

(*b*) GENESA WITH A SAKTI (GUPTA INDIAN STONE).
A.D. 6TH CENT.

Plate 1. Sculpture, sport, and the dance. The human orientation and economical rhythm of the Greek; the transforming imagination and sensual charm of the Indian. Man and animal as rationally antithetical compared with the two as interacting and enriching.

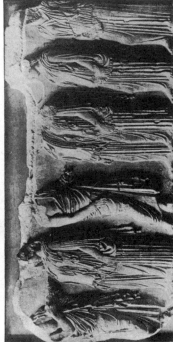

(c) PARTHENON. EAST PEDIMENT. THREE FATES.

(d) PARTHENON. NORTH FRIEZE. CAVALRY.

(e) PARTHENON. EAST FRIEZE. PROCESSION OF MAIDENS.

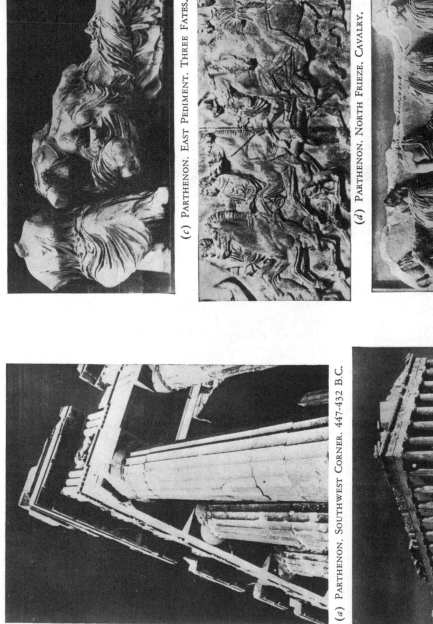

(a) PARTHENON. SOUTHWEST CORNER. 447-432 B.C.

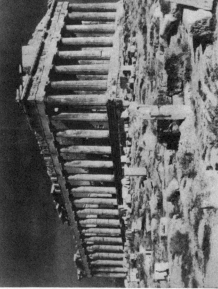

(b) PARTHENON. WEST END AND NORTH SIDE.

Plate 2. Fragments of the greatest remaining Greek monument.

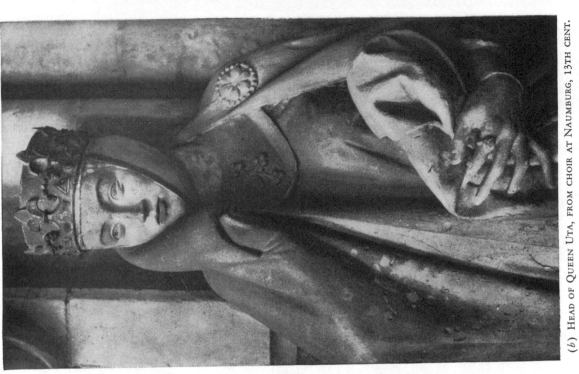

(*b*) HEAD OF QUEEN UTA, FROM CHOIR AT NAUMBURG, 13TH CENT.

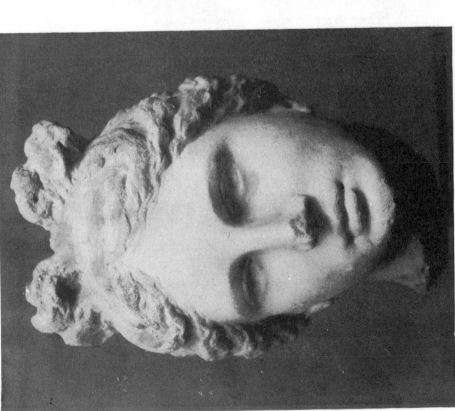

(*a*) HEAD OF APHRODITE. GREEK. STYLE OF PRAXITELES (PARIAN MARBLE). 4TH CENT. B.C.

Plate 3. Freshness, immediacy, and tangible beauty of the Greek physical ideal compared with poignancy, remoteness, and inner awareness of Gothic spiritual expression; placidity vs. intensity, acceptance and aggressiveness, the hinting, and the haunting.

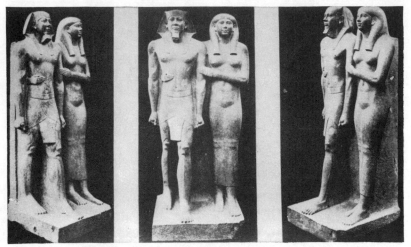

(a) MECERINUS AND QUEEN (3 VIEWS). EGYPT, 320 MILLENNIUM.

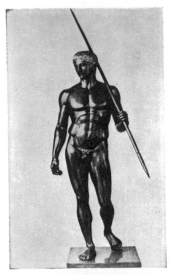

(b) POLYCLITUS; DORPHOROS.
RECONSTRUCTION.
5TH CENT. B.C.

(c) PORTRAIT OF UNKNOWN
ROMAN (TERRACOTTA).

(d) CHARTRES, CATHEDRAL, NORTH
TRANSEPT PORTAL, HEAD OF MOSES.
C. 1389.

(e) AMIENS, CATHEDRAL, WEST FACADE,
CENTRAL PORTAL, TRUMEAU:
BEAU-DIEU. 13TH CENT.

Plate 4. Egyptian, Greek, and Gothic conceptions of the figure. Roman and Gothic heads. Compare
with Greek head, Plate 3(a). The Roman head is separate, the Gothic part of a
full figure and of architecture.

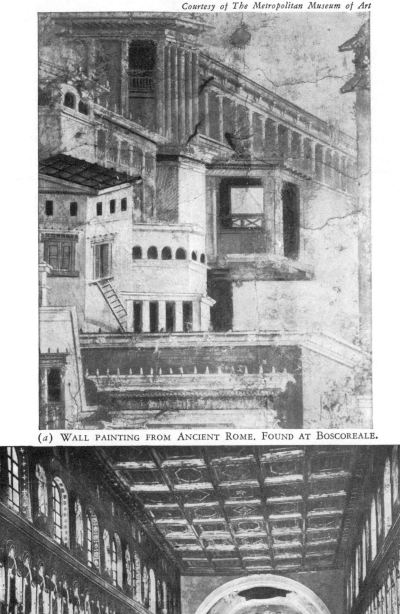

(*a*) WALL PAINTING FROM ANCIENT ROME. FOUND AT BOSCOREALE.

(*b*) APOLLINARE NUOVA. RAVENNA, ITALY, 6TH CENT. A.D.

Plate 5. Roman and Byzantine art in Italy. Although a painting, in the Roman work architecture predominates; the Byzantine is a work of glowing surfaces that emerge remote from earthly structure.

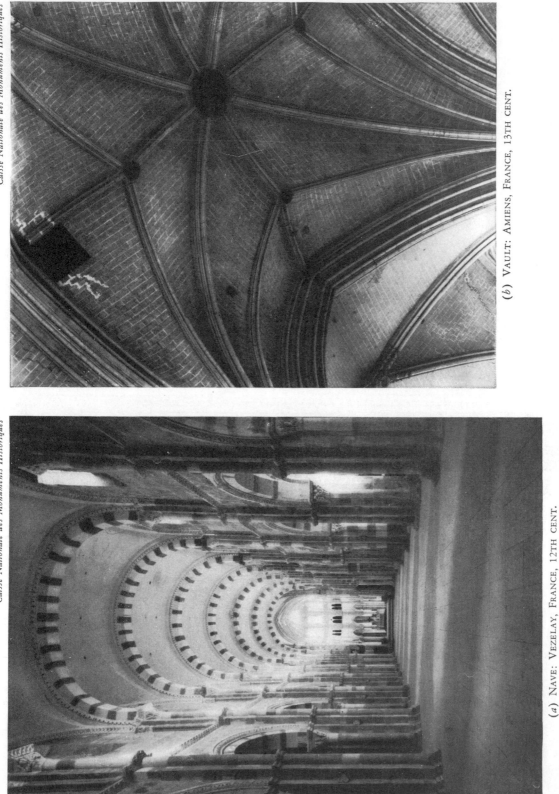

(*b*) Vault: Amiens, France, 13th cent.

(*a*) Nave: Vezelay, France, 12th cent.

Plate 6. Romanesque clarity and distinctiveness; Gothic continuity and energy: though both emphasize force and articulation.

166

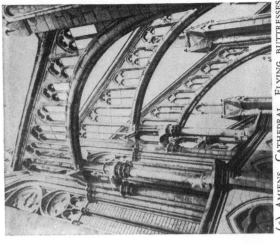

(a) BATHS OF CARACALLA. RESTORATION OF TEPIDARIUM. ANCIENT ROME.

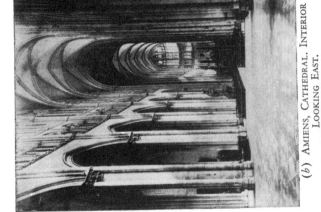

(b) AMIENS, CATHEDRAL. INTERIOR LOOKING EAST.

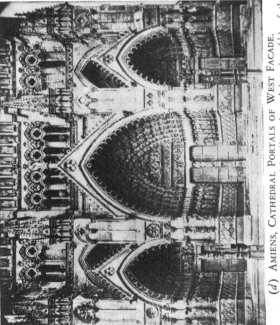

(c) AMIENS, CATHEDRAL. FLYING BUTTRESSES OF CHOIR.

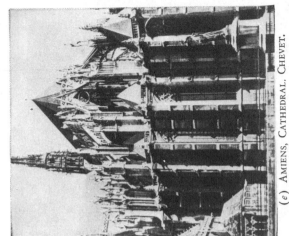

(e) AMIENS, CATHEDRAL. CHEVET.

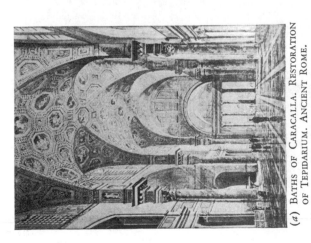

(d) AMIENS, CATHEDRAL. PORTALS OF WEST FACADE.

Plate 7. The spiritually oriented interior (b) of the Gothic cathedral compared with (c) and (e) its external engineering exposition, the transitional portals (d); and (a) with the practical spaciousness of a Roman Bath (upon which Pennsylvania Station in New York City is modelled).

(a) AMIENS, CATHEDRAL, WEST FACADE, CENTRAL PORTAL, SOUTH SIDE.

(b) AMIENS, CATHEDRAL, WEST FACADE, NORTH PORTAL, LABORS OF THE MONTH: MARCH, APRIL, MAY.

(d) F. L. WRIGHT: KAUFMANN HOUSE. BEAR RUN, PA. (NIGHT VIEW). 1930's.

(c) S. PETER'S APSE. ROME, 16TH CENT.

(e) F. L. WRIGHT: KAUFMANN HOUSE. *Detail.*

Plate 8. In the Gothic, sculpture is essential for articulation as well as meaning. The Renaissance building is sculptural without having sculpture. The modern work is architecture in an engineering sense, related to nature.

(*a*) Donatello: Commemorative Portrait of Gattamelatta
(Bronze, over life-size). Padua, 1447.

(*b*) Vanbrugh: Front of Blenheim Palace, England.

Plate 9. The militant Renaissance in architecture and sculpture: a monument to a soldier of fortune
and the gift of a nation to a victorious captain. Alexander Pope wrote an epitaph for Vanbrugh:
"Lie heavy on him, Earth, for he
Laid many a heavy load on thee."

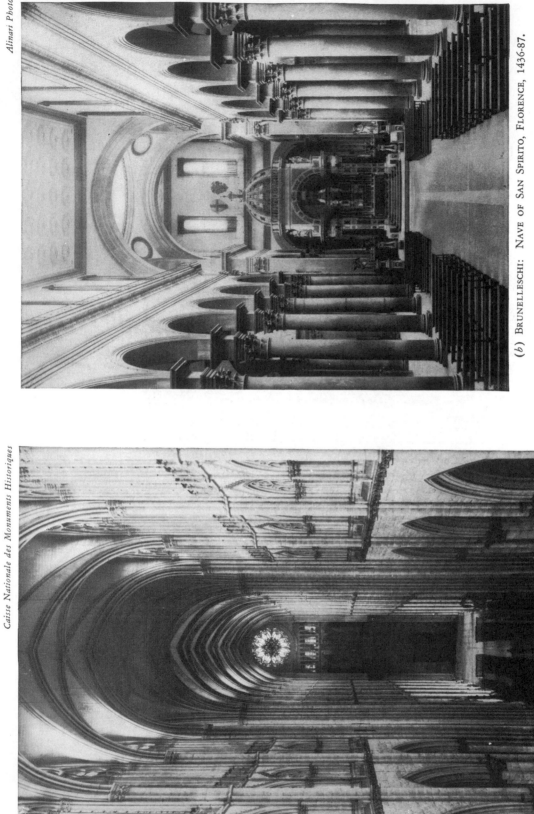

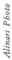

(*b*) BRUNELLESCHI: NAVE OF SAN SPIRITO, FLORENCE, 1436-87.

(*a*) NAVE OF AMIENS CATHEDRAL. LOOKING WEST.

Plate 10. The Gothic upward and beyond compared with the Renaissance near and present. The Gothic Nave looks westward here, emphasizing its residual clarity, like that of the Renaissance and unlike that of the Byzantine, Plate 5(*b*).

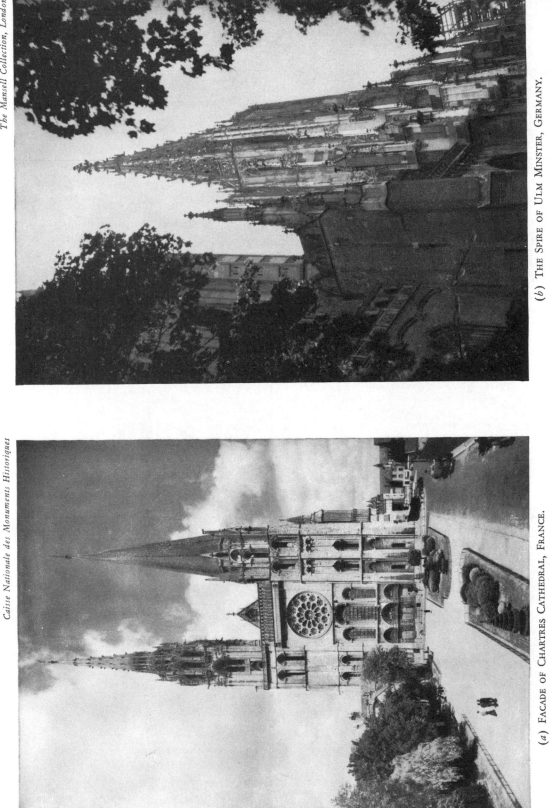

The Mansell Collection, London

(*b*) THE SPIRE OF ULM MINSTER, GERMANY.

Caisse Nationale des Monuments Historiques

(*a*) FACADE OF CHARTRES CATHEDRAL, FRANCE.

Plate 11. French reason, charm, order and sensibility compared with German picturesqueness, aspiration, and remoteness—yet both remain Gothic.

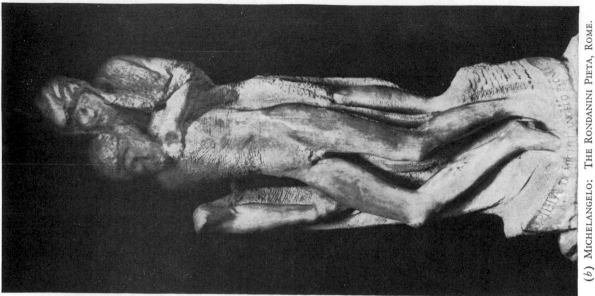

(*b*) MICHELANGELO: THE RONDANINI PIETA, ROME.

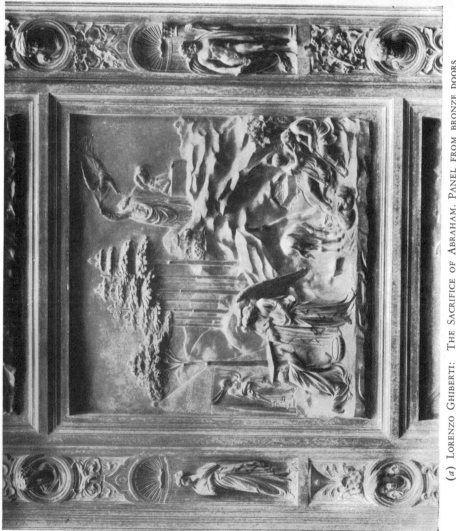

(*a*) LORENZO GHIBERTI: THE SACRIFICE OF ABRAHAM. PANEL FROM BRONZE DOORS
OF BAPTISTRY, FLORENCE, 1425-52.

Plate 12. Renaissance Sculpture from physical beauty to spiritual rigor; from the wall relief to
sculpture in the round. Yet both are pictorial, even musical: compare with antique plasticity,
Plate 1(*a*).

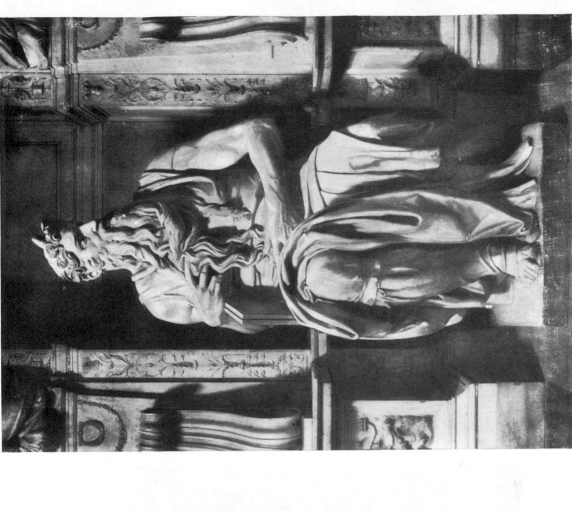

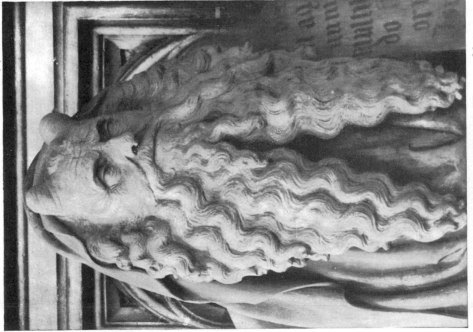

(a) CLAUS SLUTER: MOSES, FROM THE WELL OF MOSES, DIJON, FRANCE, C. 1389.

Plate 13. Problematic incarnations of Moses. Compare also with the Gothic, Plate 4(e). Progression from saint to sage to prophet; in type from the spiritual to the disillusioned, to the leader in life.

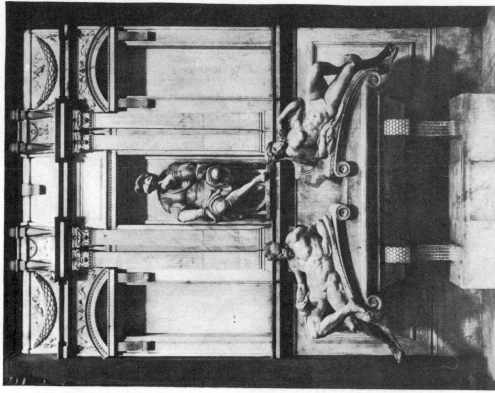

(*b*) MICHELANGELO: TOMB OF LORENZO DE' MEDICI.

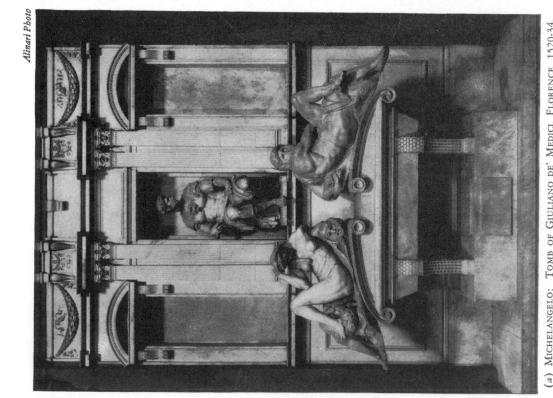

(*a*) MICHELANGELO: TOMB OF GIULIANO DE' MEDICI, FLORENCE, 1520-34.

Plate 14. The Medici Tombs: they stand opposite each other in the mortuary chapel at San Lorenzo, Florence.

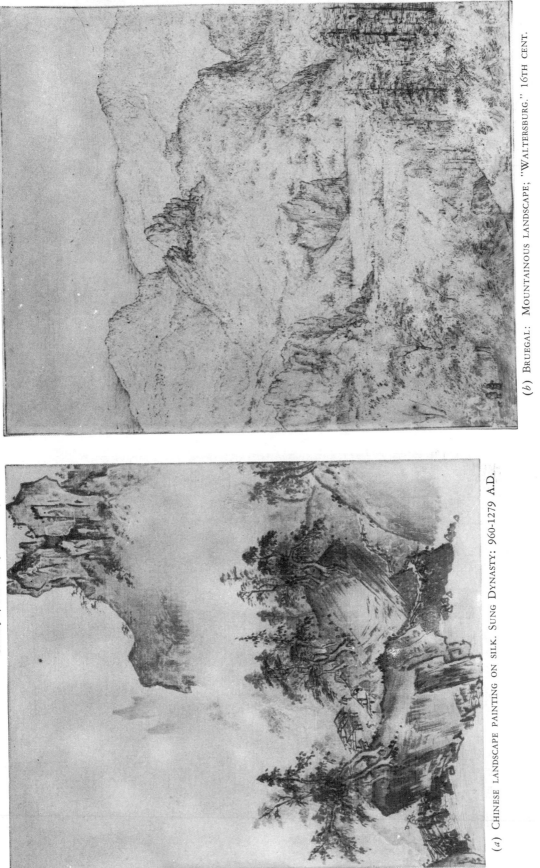

(*b*) BRUEGAL: MOUNTAINOUS LANDSCAPE; "WALTERSBURG." 16TH CENT.

(*a*) CHINESE LANDSCAPE PAINTING ON SILK. SUNG DYNASTY: 960-1279 A.D.

Plate 15. Differences between Oriental landscape art and one of its nearest counterparts in the West. Oriental economy and decorativeness contrasted with occidental profusion and tension.

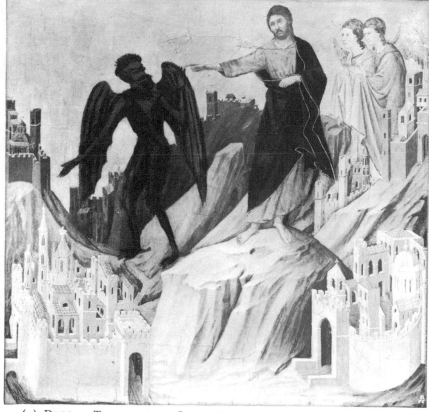

(*a*) DUCCIO: TEMPTATION OF CHRIST. PANEL FROM MAIESTA, SIENA, 1308-11.

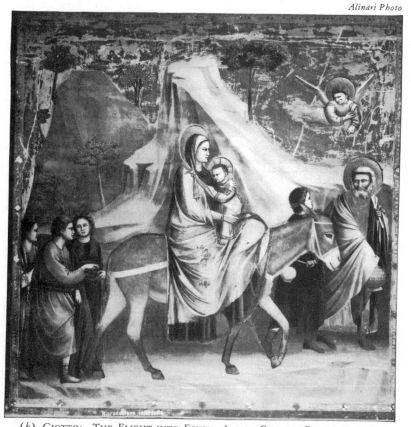

(*b*) GIOTTO: THE FLIGHT INTO EGYPT, ARENA CHAPEL, PADUA, c. 1305.

Plate 16. Sienese and Florentine painting; contemporary examples of Gothic elegance and proto-Renaissance monumentality.

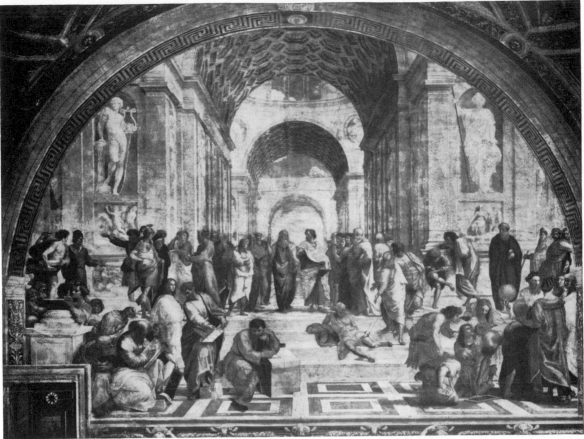

(*a*) RAPHAEL: THE SCHOOL OF ATHENS, VATICAN, ROME, 1509-11.

(*b*) INGRES: APOTHEOSIS OF HOMER. LOUVRE, 1827.

Plate 17. Effective and ineffective erections and scope upon similar themes: relative vitality in different periods (See Part Four, Raphael, the School of Athens).

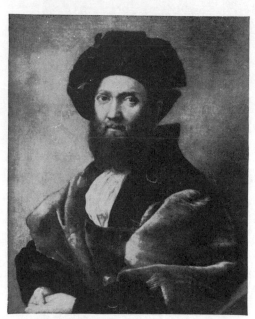

(*a*) RAPHAEL: PORTRAIT OF CASTIGLIONE. LOUVRE.

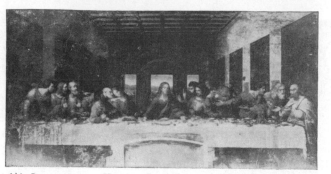

(*b*) LEONARDO DA VINCI: LAST SUPPER. SANTA MARIA DELLE GRAZIE, MILAN, C. 1495.

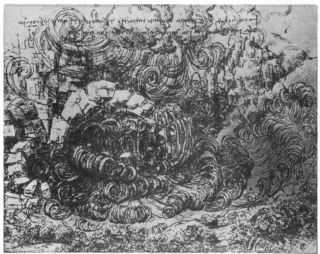

(*d*) LEONARDO: THE DELUGE (DRAWING).

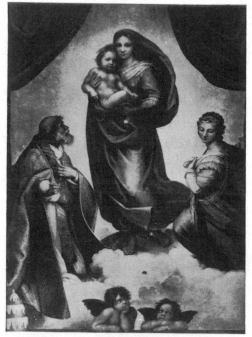

(*c*) RAPHAEL: SISTINE MADONNA. DRESDEN MUSEUM. 1515.

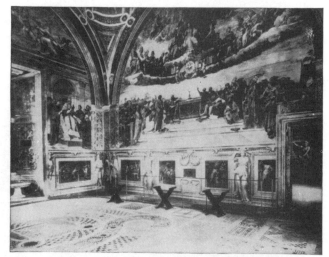

(*e*) RAPHAEL: THE CAMERA DELLA SEGNATURA, VATICAN, 1509-11.

Plate 18. Varieties of High Renaissance art: classicism followed by mannerism in Raphael; the composed versus the conjectured in Leonardo; the idea of painting as part of a room, and the dependence of perspective on the position of the spectator.

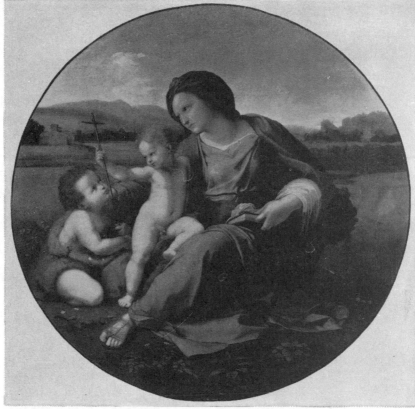

(*a*) RAPHAEL: THE ALBA MADONNA.

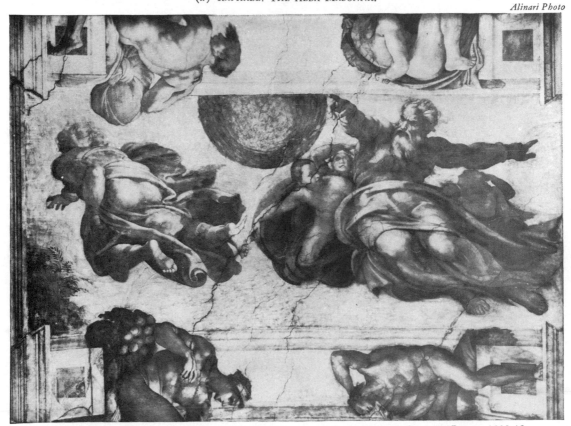

(*b*) MICHELANGELO: THE CREATION OF THE SUN AND MOON, SISTINE CEILING, ROME, 1508-12.
Plate 19. Varieties of individual temperament in the same time and place: Raphael's geometric harmony and Michelangelo's tumultuous power. Compare the clarity of this Raphael Madonna with the trickery in the Sistine Madonna. Compare the plasticity of Michelangelo's cosmic force with the pictorial imagination of Leonardo's.

179

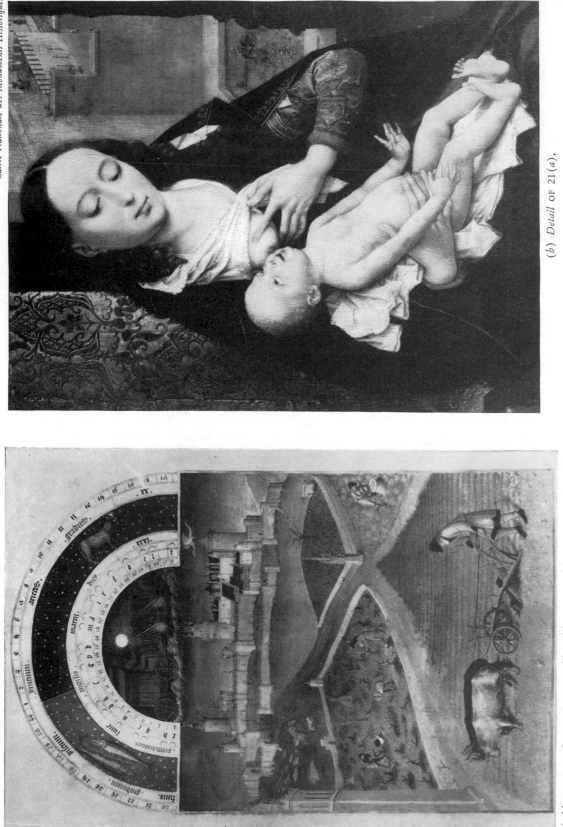

(b) *Detail* of 21(a).

(a) MANUSCRIPT ILLUMINATIONS: THE MONTH OF MARCH, FROM LES TRES RICHES HEURES: DU DUC DE BERRI. FRENCH, EARLY 15TH CENT.

Plate 20. From cosmological episode in a series to the cosmos in one picture—the center of an altarpiece—but complete in itself. From a calligraphic medium to calligraphy in painting.

(b) *Detail* OF 21(a).

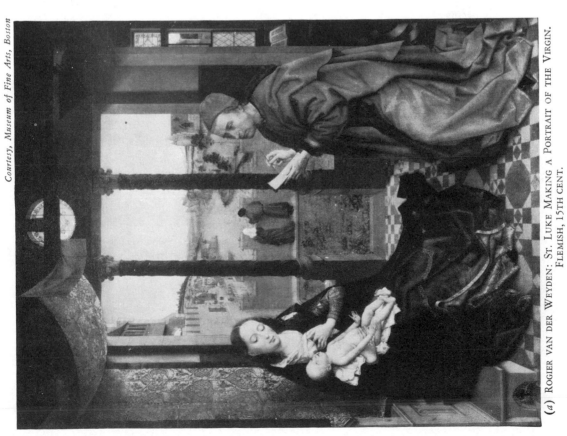

(a) ROGIER VAN DER WEYDEN: ST. LUKE MAKING A PORTRAIT OF THE VIRGIN. FLEMISH, 15TH CENT.

Plate 21. The world of symbol and present experience infinitely ramified. Notice the 2 figures (a) who are spectators related to the foreground and are echoed (b) as actors yet still spectators in the background scene itself.

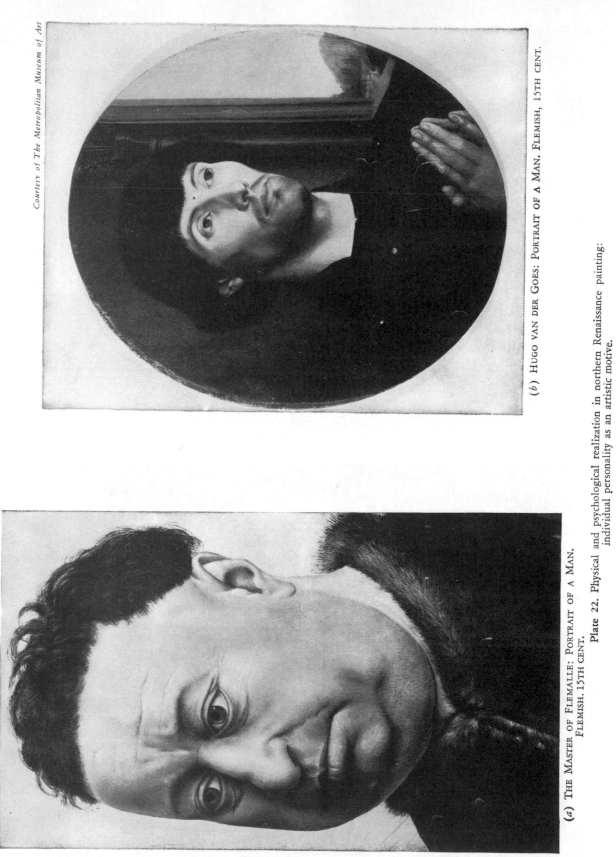

(b) HUGO VAN DER GOES: PORTRAIT OF A MAN. FLEMISH, 15TH CENT.

(a) THE MASTER OF FLEMALLE: PORTRAIT OF A MAN. FLEMISH. 15TH CENT.

Plate 22. Physical and psychological realization in northern Renaissance painting: individual personality as an artistic motive.

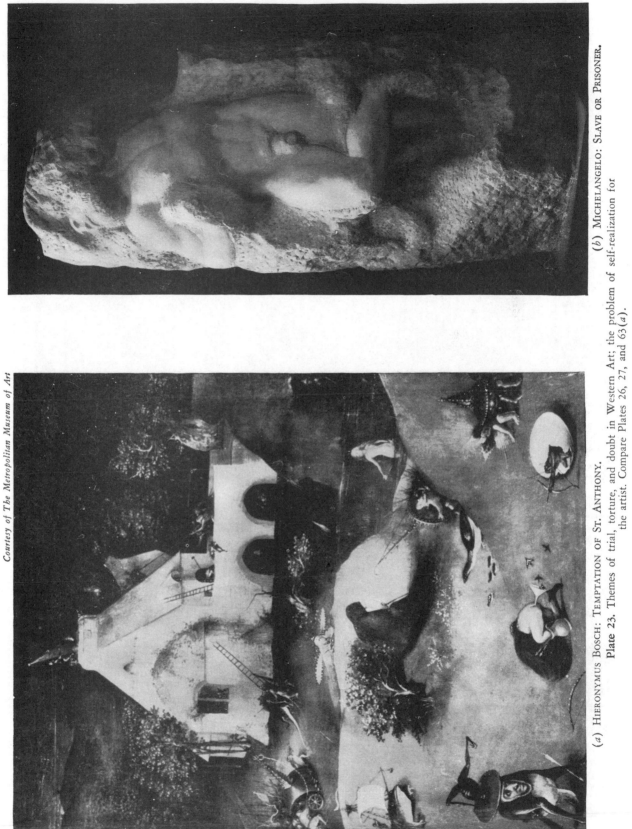

(a) HIERONYMUS BOSCH: TEMPTATION OF ST. ANTHONY.
(b) MICHELANGELO: SLAVE OR PRISONER.

Plate 23. Themes of trial, torture, and doubt in Western Art; the problem of self-realization for the artist. Compare Plates 26, 27, and 63(a).

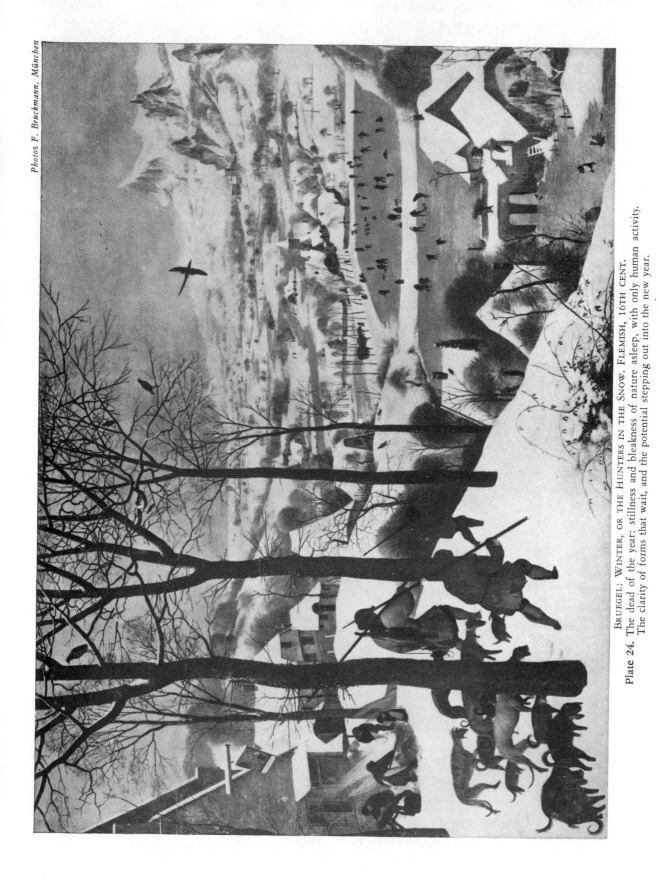

BRUEGEL: WINTER, OR THE HUNTERS IN THE SNOW. FLEMISH, 16TH CENT.
Plate 24. The dead of the year: stillness and bleakness of nature asleep, with only human activity.
The clarity of forms that wait, and the potential stepping out into the new year.

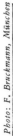

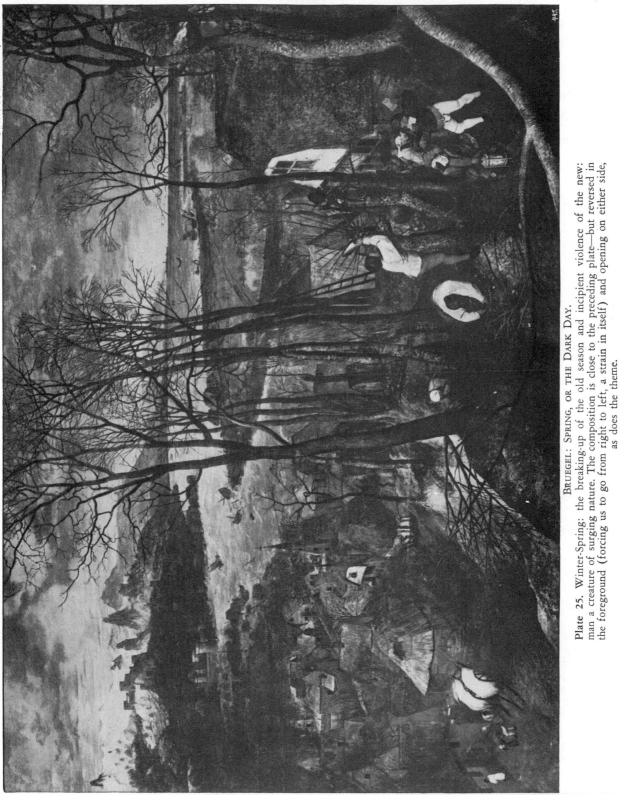

BRUEGEL: SPRING, OR THE DARK DAY.

Plate 25. Winter-Spring: the breaking-up of the old season and incipient violence of the new: man a creature of surging nature. The composition is close to the preceding plate—but reversed in the foreground (forcing us to go from right to left, a strain in itself) and opening on either side, as does the theme.

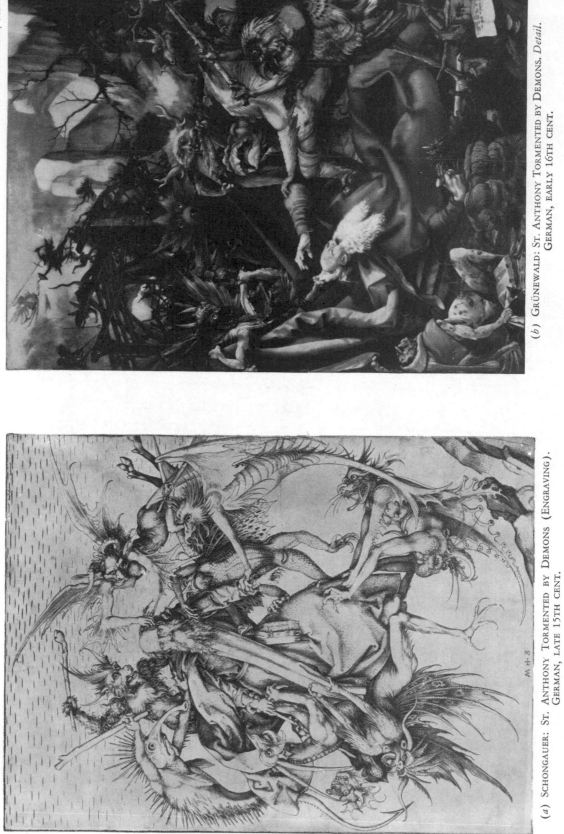

(b) GRÜNEWALD: ST. ANTHONY TORMENTED BY DEMONS. *Detail.*
GERMAN, EARLY 16TH CENT.

(a) SCHONGAUER: ST. ANTHONY TORMENTED BY DEMONS (ENGRAVING).
GERMAN, LATE 15TH CENT.

Plate 26. Examples of the daemonic and cataclysmic in German art. Compare Dürer, Plate 27, and the more pictorial Flemish tradition in Bosch, Plate 23(a). The Schongauer is a small engraving, the Grünewald one of the climactic panels in a gigantic altarpiece.

(b) DÜRER: THE KNIGHT, DEATH AND THE DEVIL (ENGRAVING). EARLY 16TH CENT.

Plate 27. The broad vigor of woodcut and the metallic articulation of engraving; themes of destiny in Western Art. Compare Plates 9(a), 37(a).

(a) DÜRER: THE FOUR HORSEMEN OF THE APOCALYPSE (WOODCUT). LATE 15TH CENT.

187

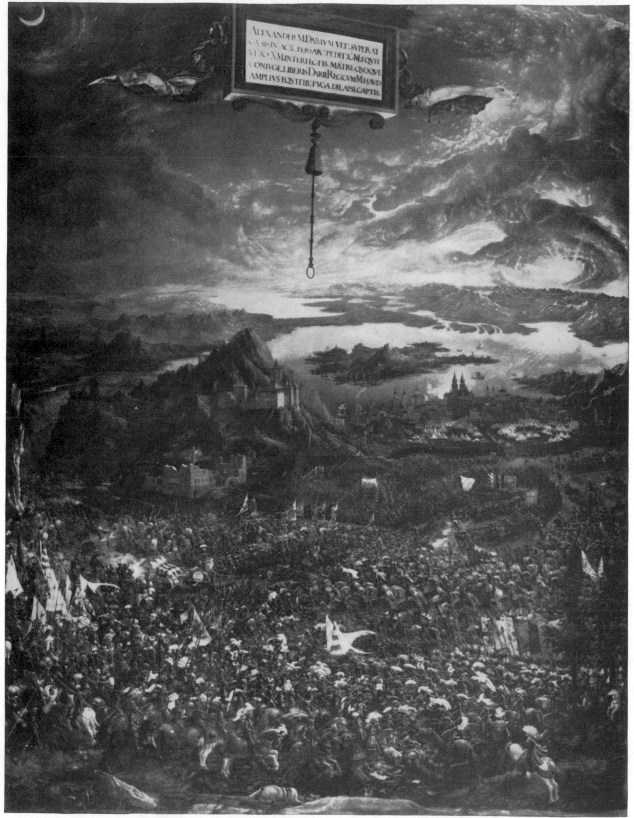

ALTDORFER: THE BATTLE OF ALEXANDER AND DARIUS. EARLY 16TH CENT.

Plate 28. Panorama of world conflict: the drama of man and nature as interacting. Compare Plate 25. Grandeur of cosmic proportion. Compare Plates 62(*a*), 63(*b*).

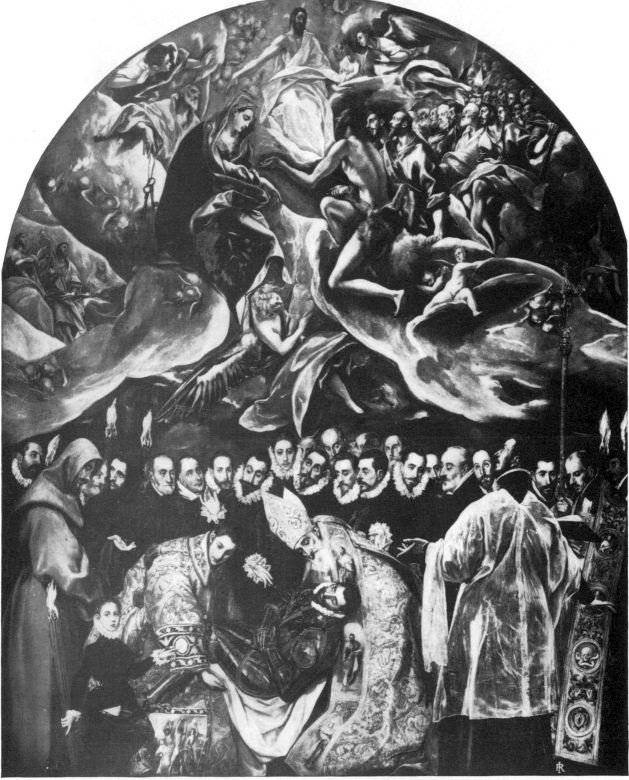

EL GRECO: THE BURIAL OF COUNT ORGAZ. TOLEDO, SPAIN, C. 1584.

Plate 29. Possibly the artist's masterpiece. The world as theatre: curtained, flagged, and stage-lit: as in the picture opposite, though the themes contrast.

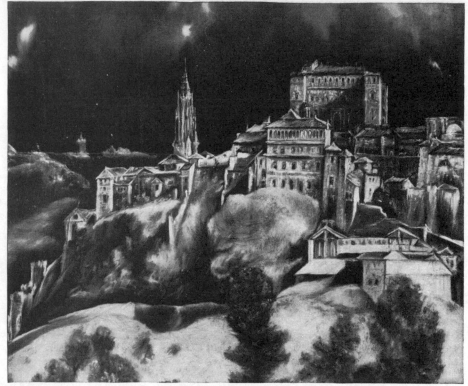

(*a*) EL GRECO: VIEW OF TOLEDO. *Detail.*

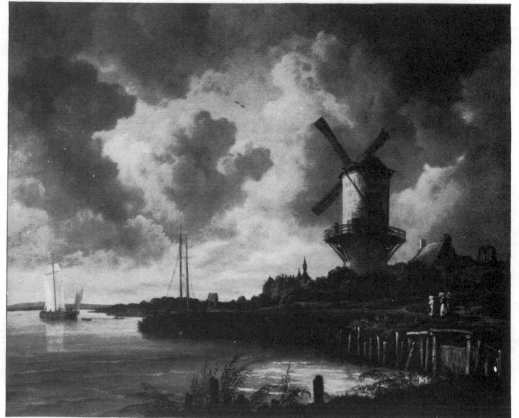

(*b*) JACOB RUISDAEL: THE MILL. DUTCH, 17TH CENT.

Plate 30. A passage of rare Spanish landscape and an outstanding example of the profession of landscape in the Dutch school: each dramatic, but the one infusing landscape with spiritual and associative values, the other experiencing the drama in direct terms of buildings, wind, water, and shifting light.

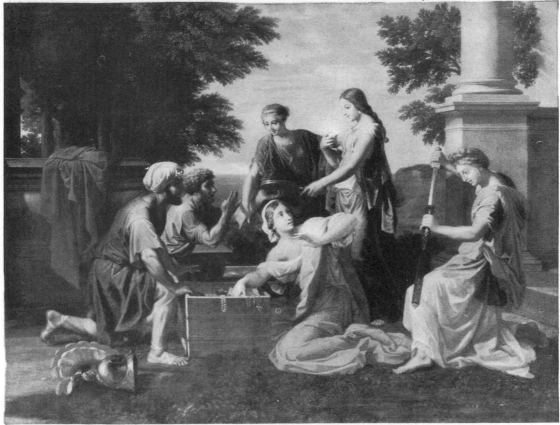

(*a*) POUSSIN: ACHILLES ON SKYROS. FRENCH, 17TH CENT.

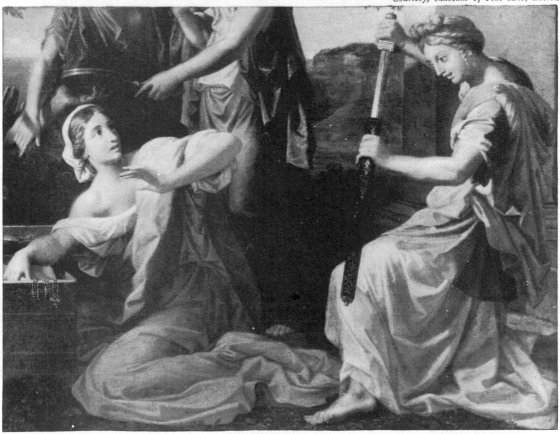

(*b*) *Detail* OF 31(*a*).

Plate 31. The classical disposition formal staging, and rational formulation of the French Baroque.

191

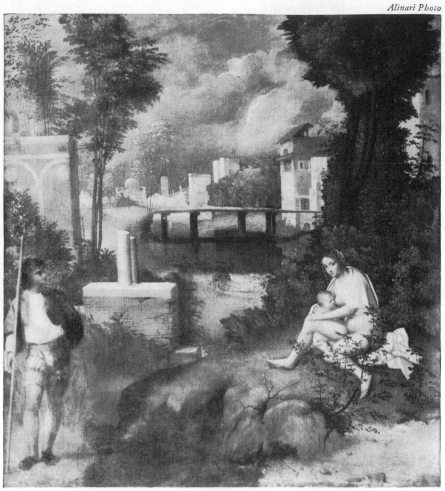

(*a*) GIORGIONE: THE TEMPEST. VENETIAN, 16TH CENT.

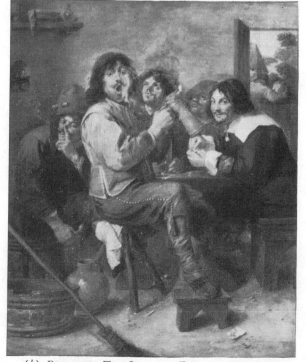

(*b*) BROUWER: THE SMOKERS. FLEMISH, 17TH CENT.

Plate 32. Social and geographical traditions: the private party in aristocratic Venice and in earthly Flanders.

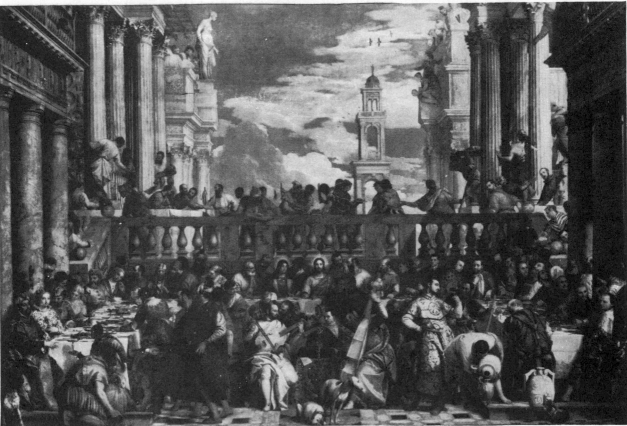

(*a*) Veronese: The Marriage at Cana. Venetian, 16th Cent.

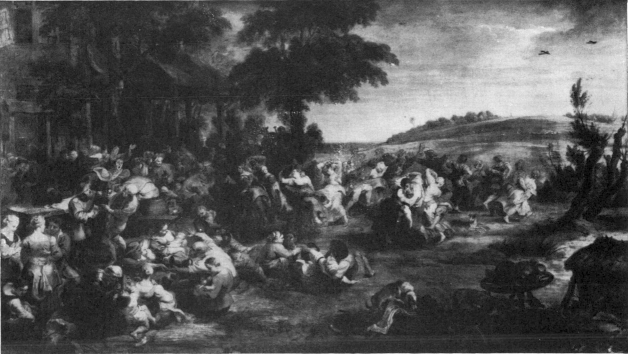

(*b*) Rubens: Kermesse or Peasant Dance. Flemish, 17th Cent.

Plate 33. The public festival in Venice and Flanders: Relative role of music and the dance.

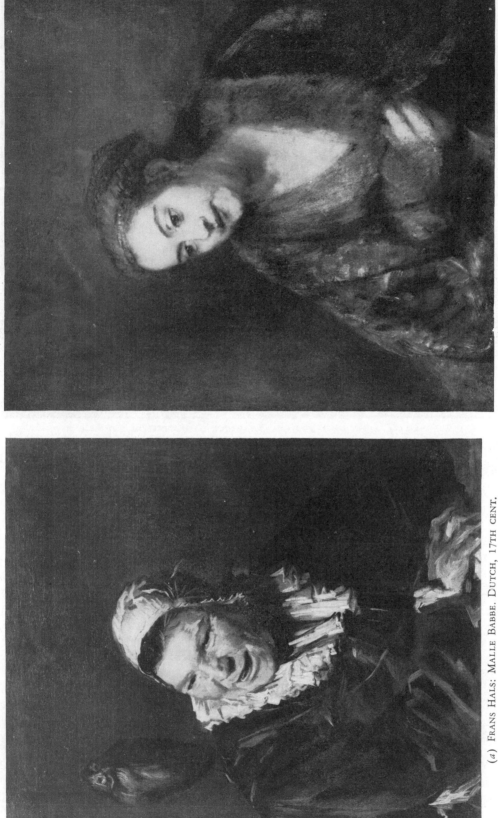

(*a*) Frans Hals: Malle Babbe. Dutch, 17th cent.

(*b*) Rembrandt: Portrait of Hendrickje Stoffels. 17th cent.

Plate 34. Hals and Rembrandt on womanhood: mastery of the picturesque theme and vivid technique surpassed only by spiritual sublimity.

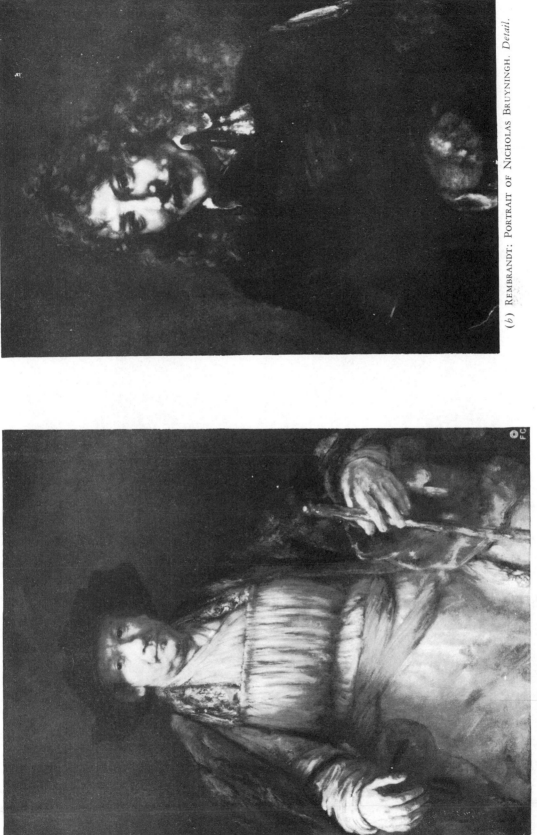

Photo: The Mansell Collection, London

(b) REMBRANDT: PORTRAIT OF NICHOLAS BRUYNINGH. *Detail.*

Copyright, The Frick Collection, New York

(a) REMBRANDT: SELF-PORTRAIT.

Plate 35. Portrait and self-portrait: objectivity through identification and sympathy through observation. The poetry of the external portrait compared with the ultimate seriousness of the self-portrait.

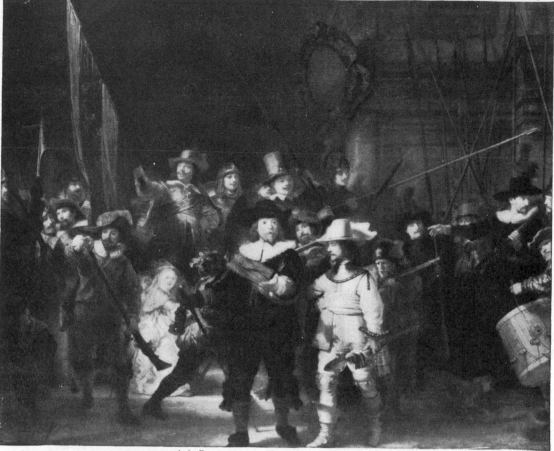

(*a*) REMBRANDT: THE NIGHT WATCH.

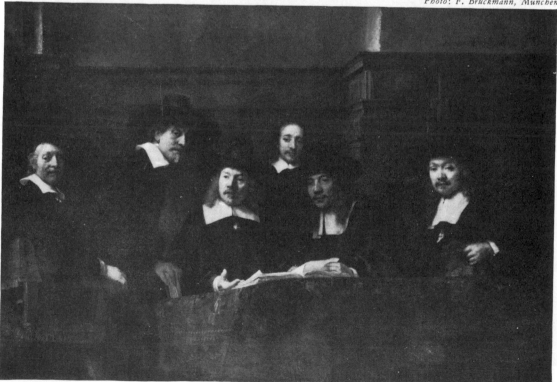

(*b*) REMBRANDT: THE SYNDICS.

Plate 36. The group portrait. Compare Plate 41. The symphonic splendor of the artist's middle period and the brevity and psychological imagination of his late development.

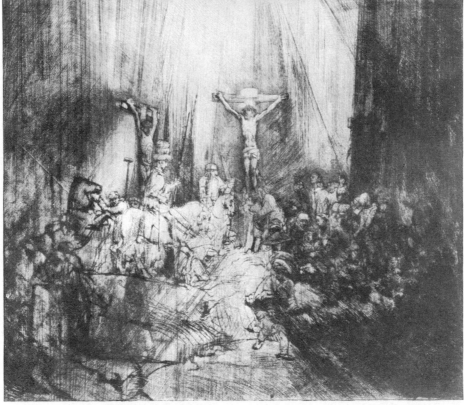

(*a*) REMBRANDT: THE THREE CROSSES (ETCHING).

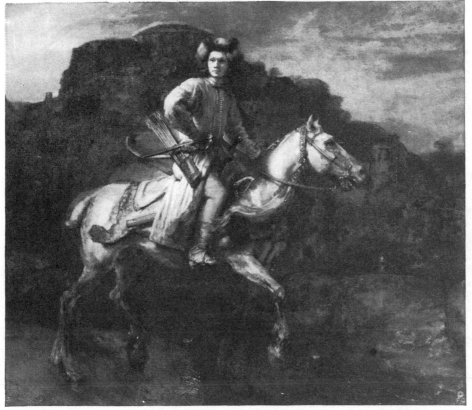

(*b*) REMBRANDT: THE POLISH RIDER.

Plate 37. A summit of the pictorial achievement of the West: etching and oil painting at the hands of Rembrandt. Expressionism of light and line; the musical rhythm of endless purposeful excursion, infinitely echoing in the landscape.

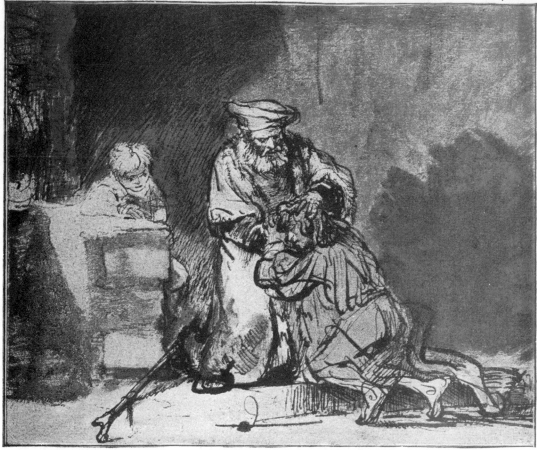

(*a*) REMBRANDT: THE PRODIGAL SON (DRAWING).

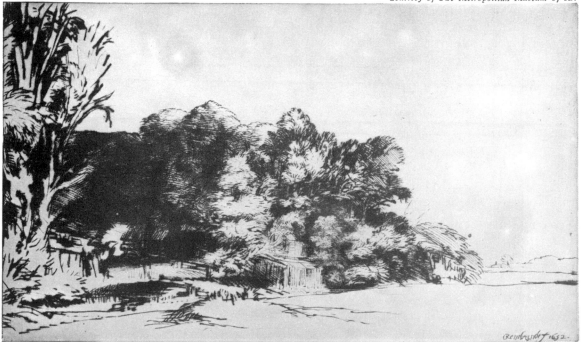

(*b*) REMBRANDT: CLUMP OF TREE WITH A VISTA (ETCHING AND DRYPOINT).

Plate 38. The drawing's vigor of action and vividness of gesture contrasted with the drypoint's delicate configuration and luminous textures. Contrast the subjective drama and issue of Rembrandt's landscape with that of his contemporary, Vermeer, Plate 39(*b*).

(*a*) SEURAT: LE CROTOY D'AVAL. FRENCH, 19TH CENT.

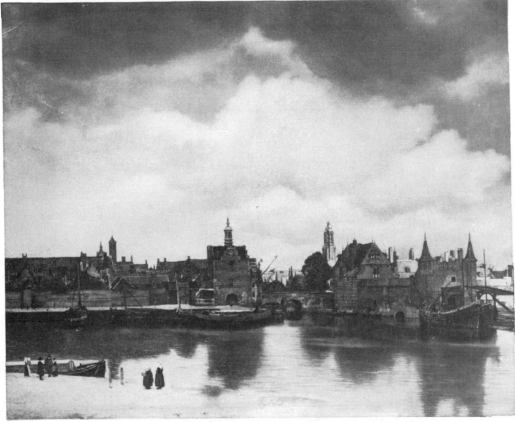

(*b*) VERMEER: VIEW OF DELFT. DUTCH, 17TH CENT.

Plate 39. The impassive, geometric gives "still-life" temper in landscapes two centuries apart. Compare with Dutch contemporaries of each, Ruisdael, Plate 30(*a*), and Van Gogh, Plate 52(*a*) and (*b*).

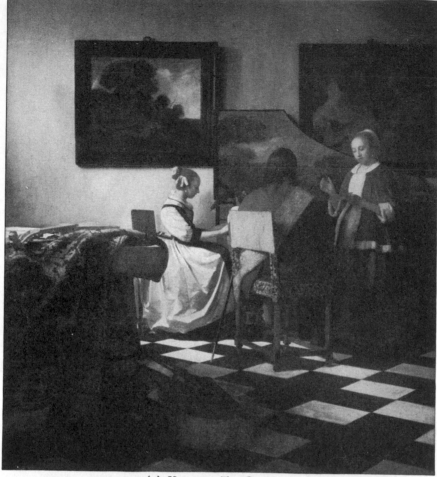

(*a*) Vermeer: The Concert.

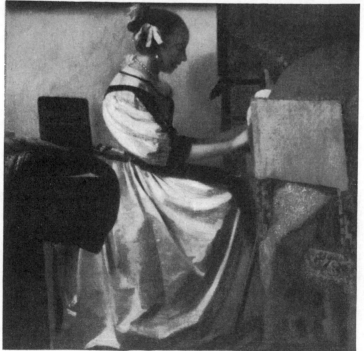

(*b*) *Detail* of 40(*a*).

Plate 40. The art of genre rendered in terms of still-life. Contrast Plates 42 and 50, and compare with isolated still-life themes in Plate 55. The musical theme is appropriate to the "musical" composition of shapes and accents ever berating in and out, but with a premium on precision, as opposed, say, to Rembrandt's mystery.

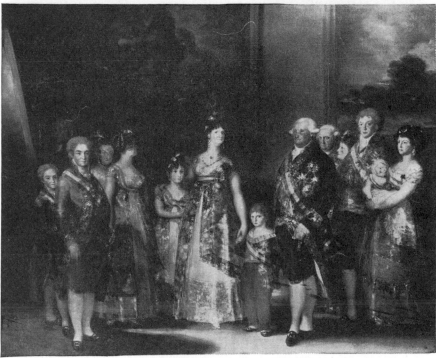

(*a*) VELÁSQUEZ: THE MAIDS OF HONOR. SPANISH, 1656.

(*b*) GOYA: FAMILY OF CHAS. IV. 1800.

Plate 41. Baroque and Modern versions of the royal group portrait in Spain.
(See discussion, Part Six Goya.)

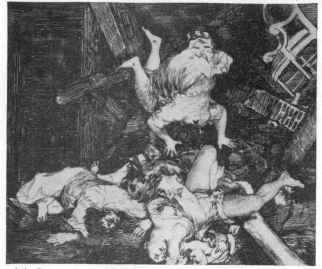

(*a*) Goya: From the Disasters of the War (Etching).

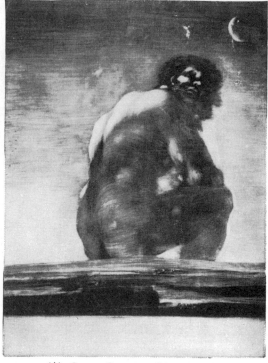

(*b*). Goya: Colossus (Aquatint).

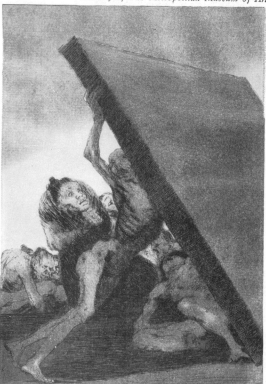

(*c*) Goya: "And Still They Won't Go" (Aquatint).

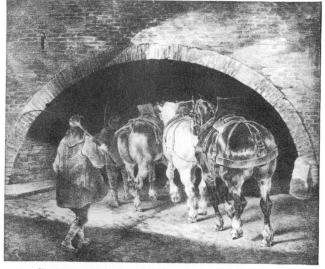

(*d*) Gericault: Entrance to the Adelphi Wharf (Lithograph). French, early 19th cent.

Plate 42. Printmaking at the inception of modern art: the development of etching with aquatint into an ever more pictorial medium, logically succeeded by lithography. The growing directness of symbolism and anonymous power of modern imagery.

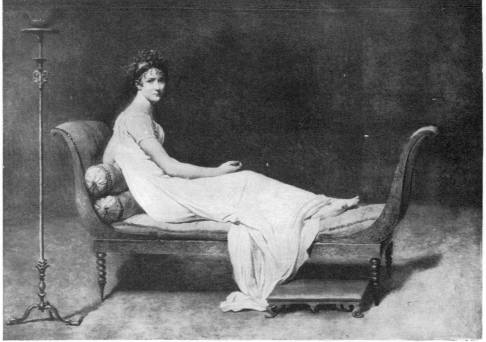

(*a*) J. L. DAVID: PORTRAIT OF MME. RECAMIER. FRENCH, EARLY 19TH CENT.
Courtesy of The Metropolitan Museum of Art

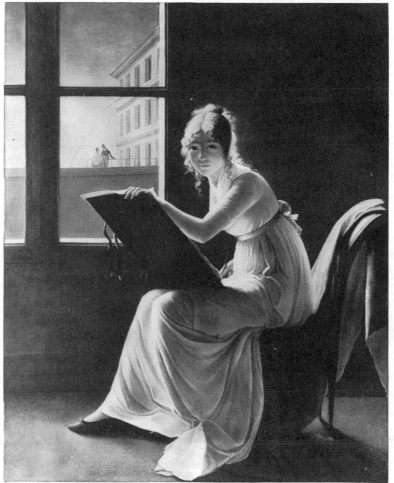

(*b*) CHARPENTIER: PORTRAIT OF MME. CHARLOTTE, DU VAL D'OGNE.
FRENCH, EARLY 19TH CENT.

Plate 43. Possible distinctions between the male and female artist, on closely related themes.
(See discussion, Part Six David.)

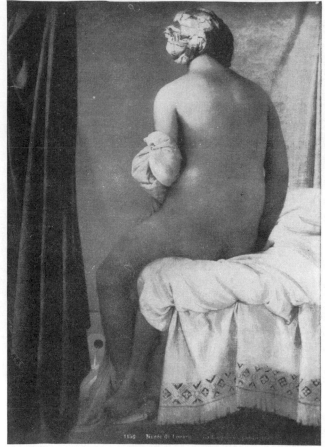

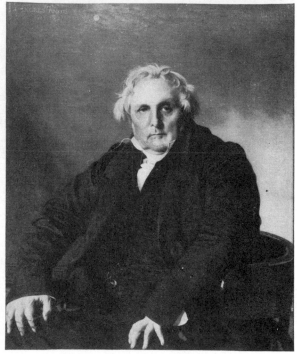

(*b*) INGRES: PORTRAIT OF M. BERTIN.

(*a*) INGRES: BATHER. FRENCH, EARLY 19TH CENT.

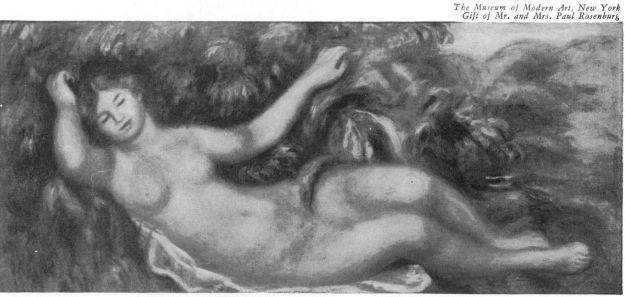

(*c*) RENOIR: NUDE. FRENCH, LATE 19TH CENT.

Plate 44. Ingres' poetry of the nude and prose of the portrait. Figure animation of line and tone compared with that of color and texture.

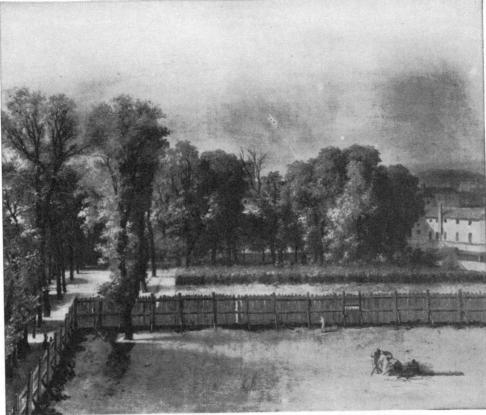

(*a*) J. L. David: The Luxembourg Gardens. French, early 19th cent.

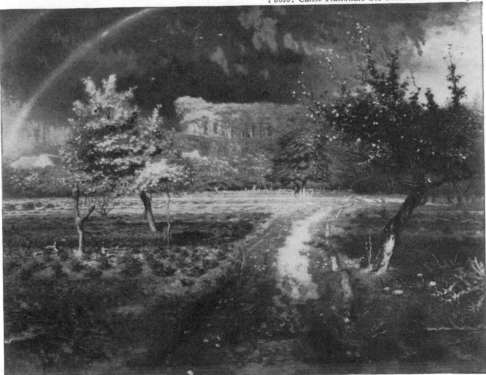

(*b*) Millet: Spring. French, mid-19th cent.

Plate 45. Lesser-known landscapes by artists (in a century of landscape) who did not but probably should have pursued the subject. Classicism and Romanticism are united in each with realism, without loss of power, as often in other ventures by the same artists.

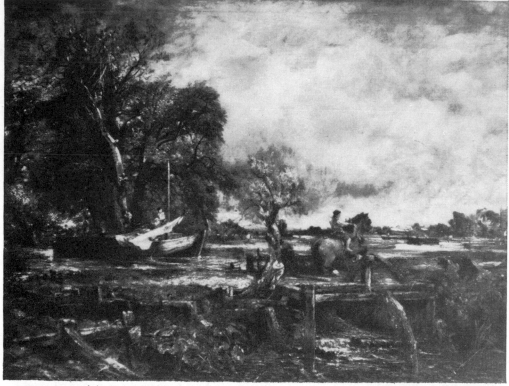

(*a*) Constable: The Leaping Horse. English, early 19th cent.

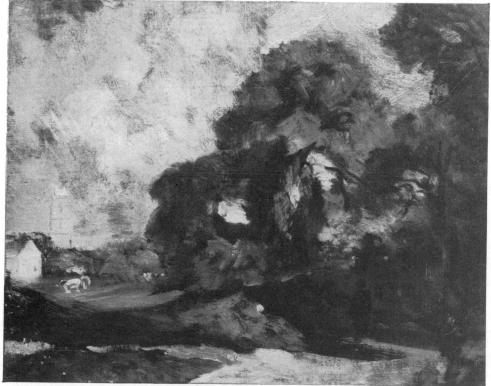

(*b*) Constable. View at Stoke (Oil Sketch).

Plate 46. A large finished painting and a small sketch by the same artist: their different roles and quality. Bravado and elaboration versus intimacy and spontaneity in handling.

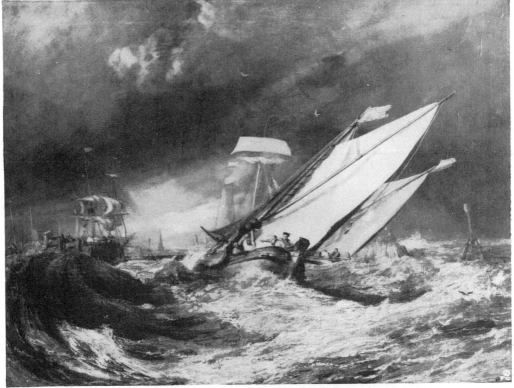

(*a*) TURNER: FISHING BOATS ENTERING CALAIS HARBOR. ENGLISH, EARLY 19TH CENT.

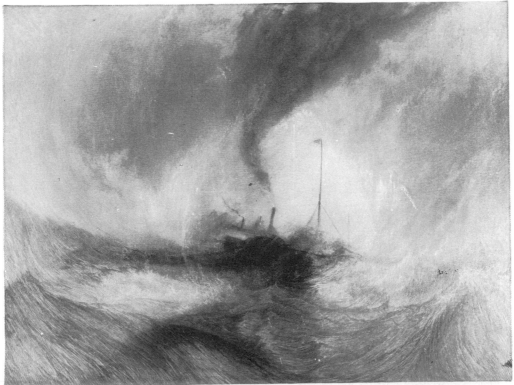

(*b*) TURNER: SNOW STORM AT SEA (ENGRAVING AFTER THE PAINTING).

Plate 47. The relation of art to nature in the early and in the late work of Turner. Much of Turner's developed technique is so incalculable in effect as to be rendered better in an engraved interpretation 47(*b*) than a pallid photograph of the original.

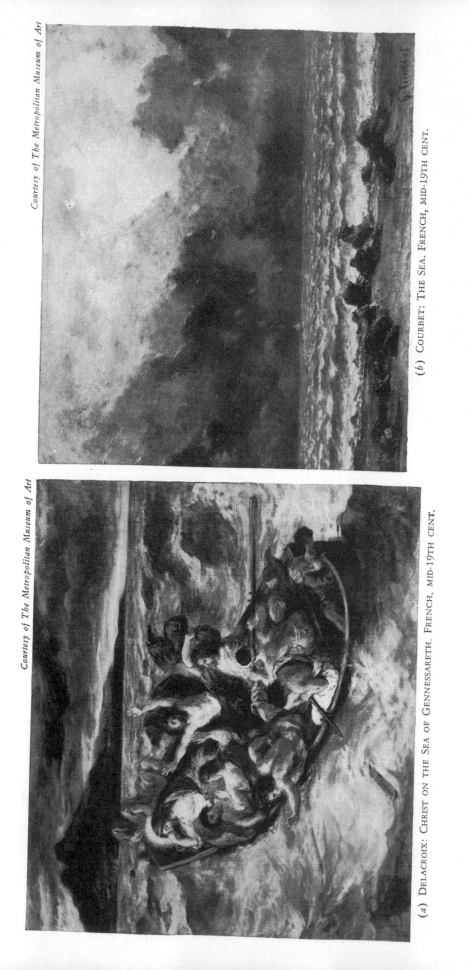

Courtesy of The Metropolitan Museum of Art

Courtesy of The Metropolitan Museum of Art

(*a*) DELACROIX: CHRIST ON THE SEA OF GENNESSARETH. FRENCH, MID-19TH CENT.

(*b*) COURBET: THE SEA. FRENCH, MID-19TH CENT.

Plate 48. Romanticism and Realism in a key 19th century element and theme: Sea and Storm.

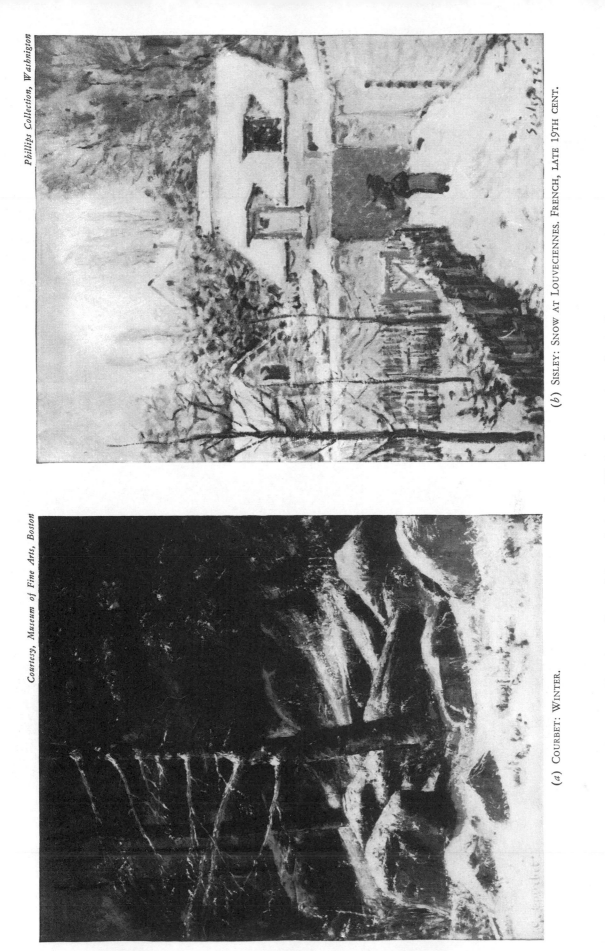

(a) COURBET: WINTER.

(b) SISLEY: SNOW AT LOUVECIENNES. FRENCH, LATE 19TH CENT.

Plate 49. Realism and Impressionism in differing interpretations of snow themes.
Compare Bruegel, Plate 24.

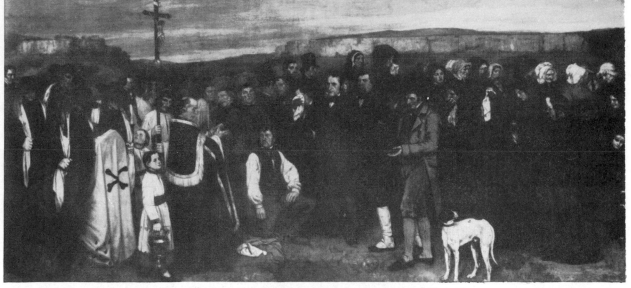

(*a*) COURBET: BURIAL AT ORNANS (20 FEET LONG).

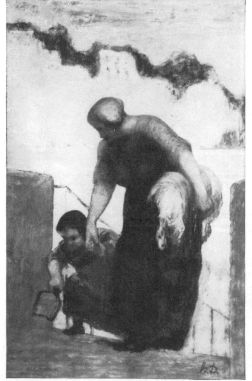

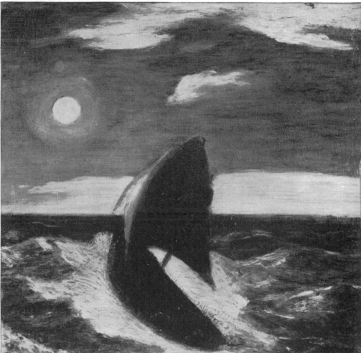

(*b*) DAUMIER: THE LAUNDRESS (SMALL PANEL),
FRENCH, MID-19TH CENT.

(*c*) RYDER: TOILERS OF THE SEA (SMALL PANEL).
AMERICAN, LATE 19TH CENT.

Plate 50. Primitivism in Modern Art (I): the artist turns to primeval themes within his own
environment. Result: plastic coherence, inventiveness, and dramatic power.

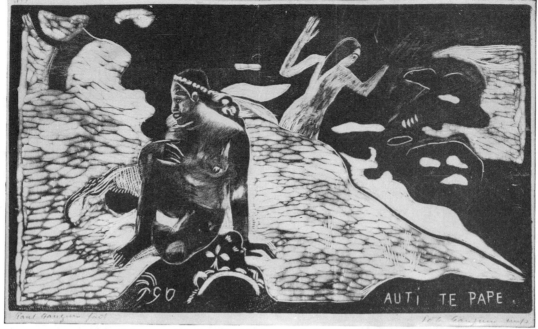

(*a*) GAUGUIN: AUTI DE PAPE (WOODCUT). FRENCH, LATE 19TH CENT.

(*b*) ROUSSEAU: THE WATERFALL. FRENCH, LATE 19TH CENT.

Plate 51. Primitivism in Modern Art (II): the artist turns to visionary and exotic themes. Result: imaginative richness, symbolic form, and decorative excursion.

(*a*) VAN GOGH: HOUSES AT AUVERS. DUTCH, LATE 19TH CENT.

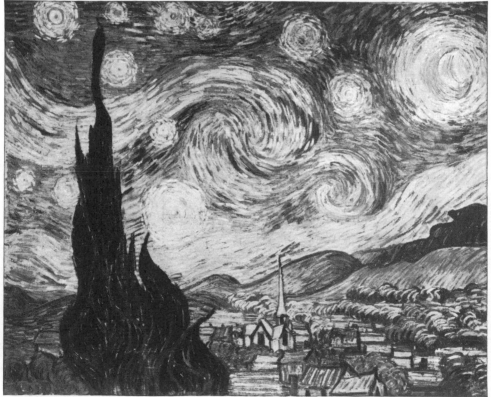

(*b*) VAN GOGH: STARRY NIGHT.

Plate 52. The beginning of Expressionism: from music-like development to cosmic rhythm.
A storm is rising.

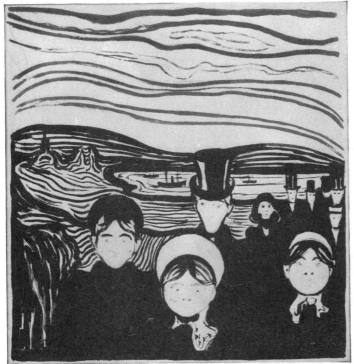

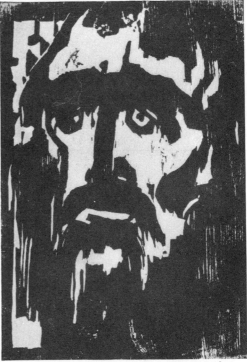

(*a*) MUNCH: ANXIETY (COLOR LITHOGRAPHY). NORWEGIAN, EARLY 20TH CENT.

(*b*). NOLDE: THE PROPHET (WOODCUT). GERMAN, EARLY 20TH CENT.

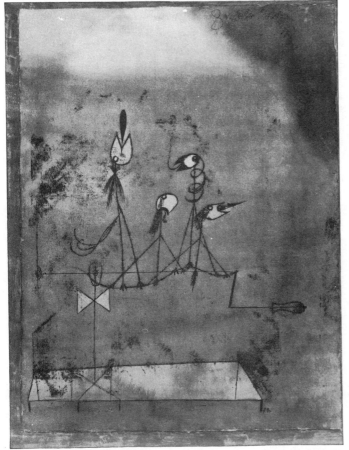

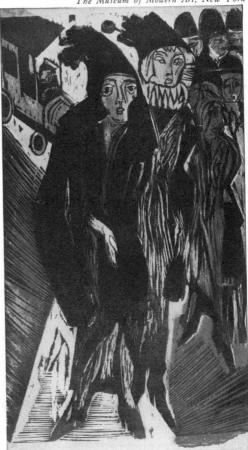

(*c*) KLEE: TWITTERING MACHINE (WATERCOLOR, PEN AND INK). SWISS, EARLY 20TH CENT.

(*d*) KIRCHNER: STREET SCENE (1922 COLOR WOODCUT AFTER A PAINTING OF 1914). GERMAN.

Plate 53. Expressionism of the early 20th century. Themes of tragedy, anxiety, prophecy, and wit.

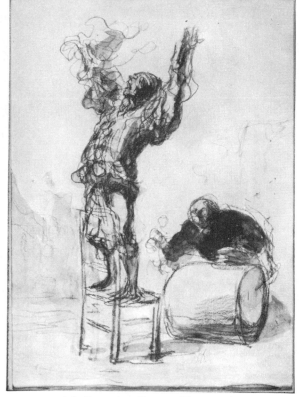

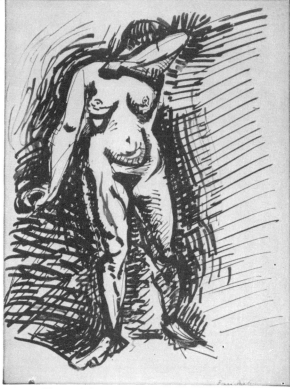

(*a*) DAUMIER: CLOWN (DRAWING).

(*b*) MATISSE: FIGURE STUDY (PEN AND INK).

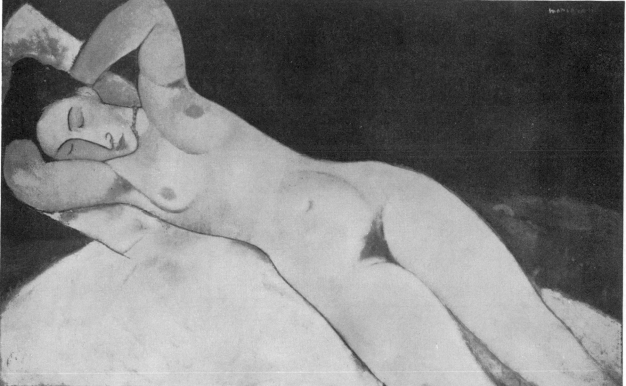

(*c*) MODIGLIANI: NUDE.

Plate 54. Varieties of the use of line in modern art: dynamics of gesture, activation of environment, and seductive contour. Line as a distinctive element in watercolor, drawing and painting.
Compare Plates 38 and 53.

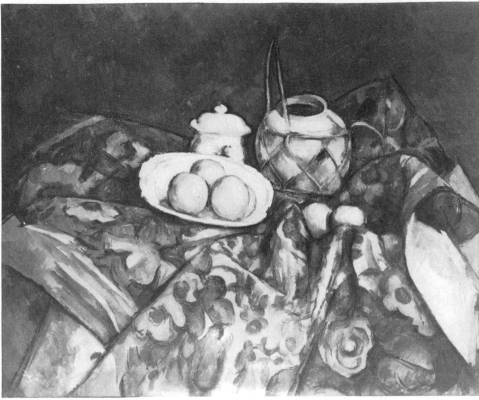

(*a*) Cézanne: Oranges. 1895-1900.

(*b*) Braque: Oval Still Life. 1914.

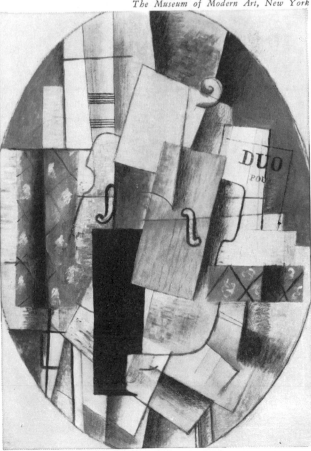

Plate 55. The still-life theme and abstract composition: from Cézanne's imperious organization and monumental orchestration to Braque's Cubist sensitivity, and formal abstraction.

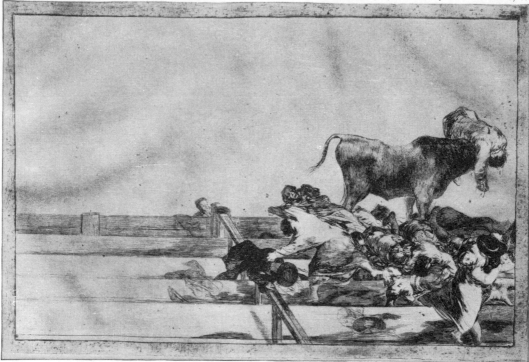

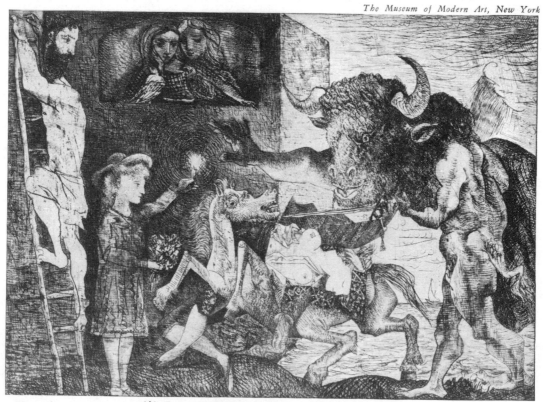

(*a*) GOYA: DISASTER IN THE BLEACHERS OF THE ARENA (ETCHING AND AQUATINT). EARLY 19TH CENT.

(*b*) PICASSO: MINOTAUROMACHY (ETCHING). 1935.

Plate 56. Examples of a black-and-white extremism in the Spanish tradition. The perennial image of the bull with its symbolism of power and terror.

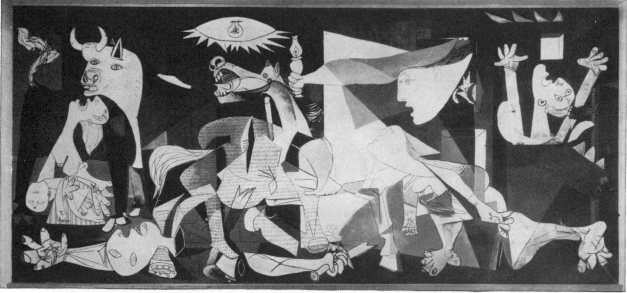

(*a*) PICASSO: GUERNICA. SPANISH, 1937.

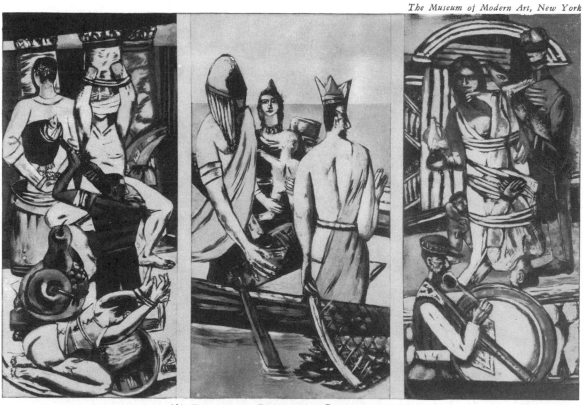

(*b*) BECKMANN: DEPARTURE. GERMAN, 1932-35.

Plate 57. Culminating masterpieces of 20th century European painting.

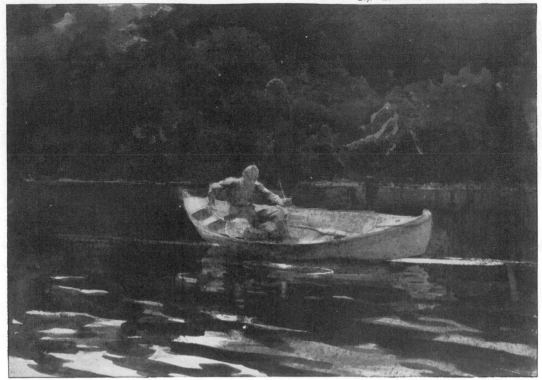

(*a*) WINSLOW HOMER: FISHING IN THE ADIRONDACKS
(WATERCOLOR). AMERICAN, LATE 19TH CENT.

(*b*) ARTHUR DOVE: GOLD, GREEN AND BROWN. AMERICAN, 1941.

Plate 58. From the prosaic to the imaginative, and from nature to abstraction in marine themes in indigenous American painting. Compare the organic kind of abstraction here and opposite with the mechanical, Plate 56(*b*).

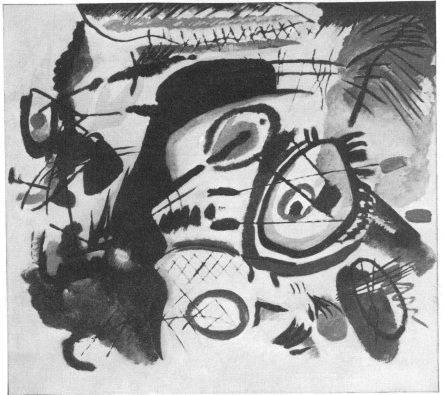

(*a*) KANDINSKY: COMPOSITION VII, FRAGMENT I. RUSSIAN, 1913.

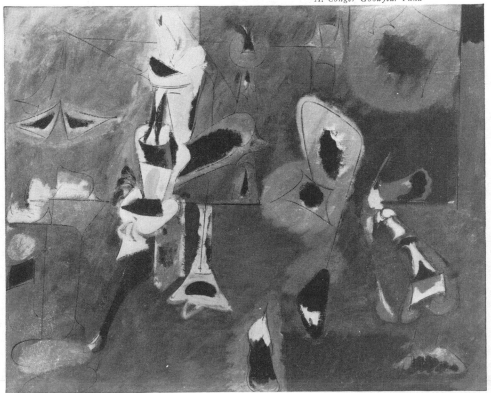

(*b*) GORKY: AGONY. AMERICAN, 1947.

Plate 59. Examples of the transition from European to American abstract expressionism. Both Kandinsky (*a*) and Dove, Plate 58(*b*), arrived at abstract art at the same time (around 1910) and independently.

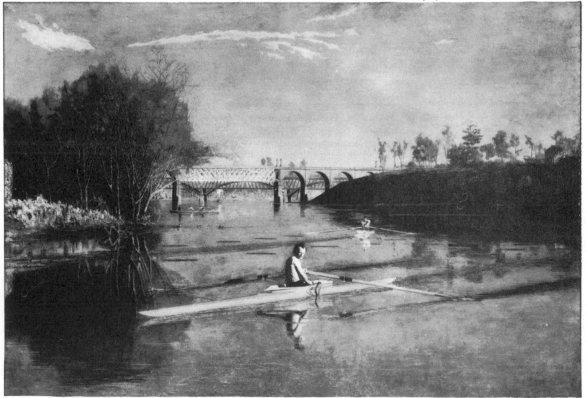

(a) J. S. COPLEY: EBENEZER STORER (PASTEL).
AMERICAN, LATE 18TH CENT.

(b) THOMAS EAKINS: MAX SCHMIDT IN A SINGLE SKULL. AMERICAN, LATE 19TH CENT.

Plate 60. Literalness, incisivness, and inventiveness as propensities in American portraiture. From portrayal of man in society to man in and of nature: then to the portrayal of nature itself (opposite).

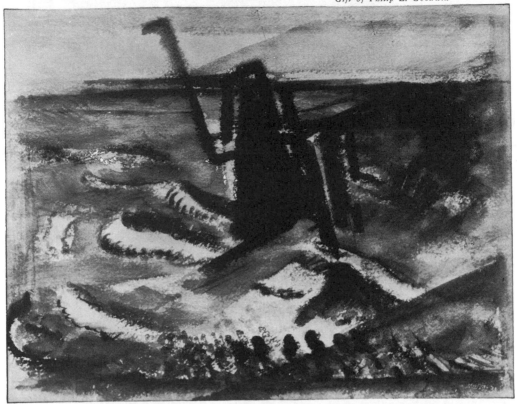

(*a*) JOHN MARIN: BUOY, MAINE (WATERCOLOR). AMERICAN, 1931.

(*b*) MARSDEN HARTLEY: EVENING STORM, SCHOODIC, MAINE. AMERICAN, 1942.

Plate 61. Seascape and its role in the development of American abstract art.

(*a*) RUBENS: FALL OF THE DAMNED. FLEMISH, 17TH CENT.

(*b*) MONET: WATER LILIES. FRENCH. 1925. DESTROYED BY FIRE, 1958.

Plate 62. 17th and 20th century European backgrounds to abstract expressionism: Realms of the chaotic and the cosmic (of Walt Whitman's "gangs of cosmo").

(*a*) Ensor: Tribulations of St. Anthony. Flemish, 1887.

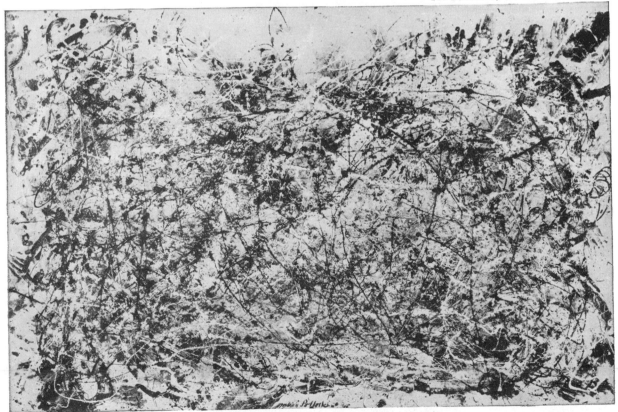

(*b*) Jackson Pollock: Number 1. American, 1948.

Plate 63. St. Anthony becomes the artist, and Tribulation the process of the work of art. Compare Plates 23, 26. The consummation of the Apocalyptic in European painting.

(*a*) WILLEM DE KOONING: WOMAN I.
AMERICAN, 1950-52.

(*b*) FRANZ KLINE: CHIEF.
AMERICAN, 1950.

Plate 64. Monuments of mid-century American art: ruggedness, directness,
independence, and will to change.